W9-AIB-543

THE WAR IN IRAQ

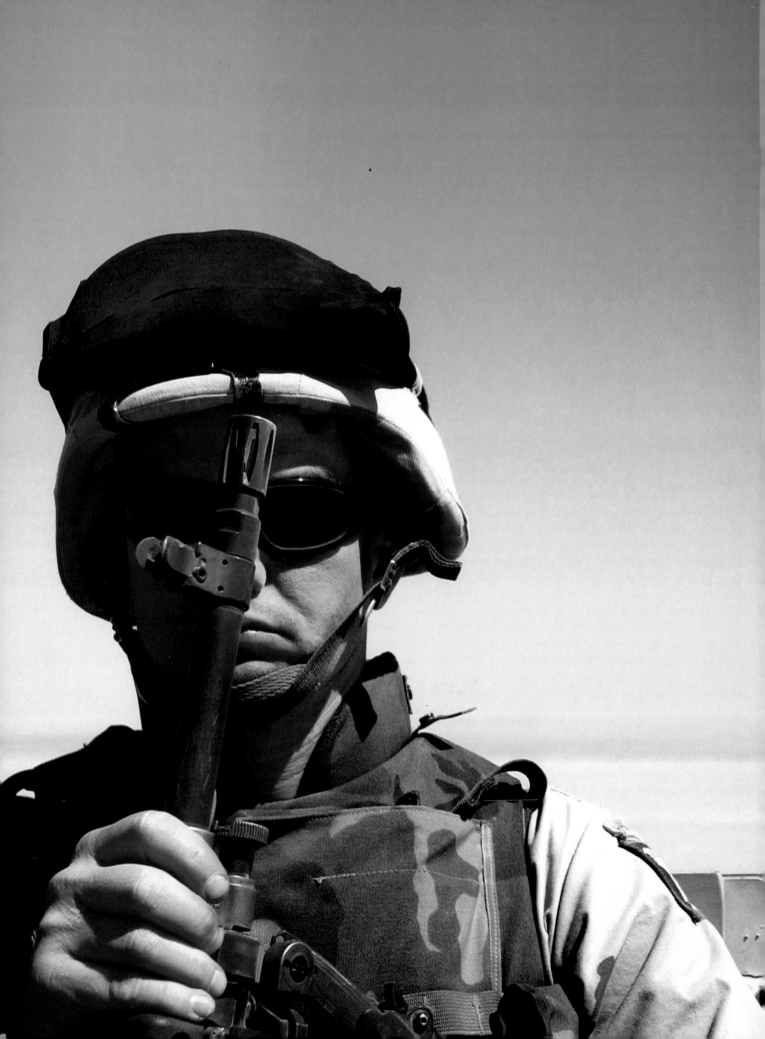

THE WAR IN IRAQ

A Photo History

HOWARD COUNTY LIBRARY
BIG SPRING, TEXAS

ReganBooks

An Imprint of HarperCollinsPublishers

THE WAR IN IRAQ. Copyright © 2003 by ReganBooks. All rights reserved.
Printed in the United States of America. No part of this book
may be used or reproduced in any manner whatsoever without
written permission except in the case of brief quotations
embodied in critical articles and reviews.
For information address HarperCollins Publishers Inc.,
10 East 53rd Street, New York, NY 10022

HarperCollins books may be purchased for educational, business,
or sales promotional use. For information please write:
Special Markets Department, HarperCollins Publishers Inc.,
10 East 53rd Street, New York, NY 10022.

FIRST EDITION

Designer: Gabriel Kuo/BRM
Photo Editor: Larry Schwartz

Jacket/cover design by Lauren Prigozen and Susan Carroll
Front jacket/cover photograph by Oleg Popov/Reuters
Hardcover back jacket photograph by Kia Pfaffenbach/Reuters
Paperback back cover photograph by Newsha Tavakolian/Polaris
Hardcover back flap photograph by Kuni Takahashi/*Boston Herald*/ReflexNews

Printed on acid-free paper

Library of Congress Cataloging-in-Publication Data has been applied for.

ISBN 0-06-058286-3 (hardcover)
ISBN 0-06-058437-8 (paperback)

03 04 05 06 07 ❖/QW 10 9 8 7 6 5 4 3 2 1 (hardcover)
03 04 05 06 07 ❖/QW 10 9 8 7 6 5 4 3 2 1 (paperback)

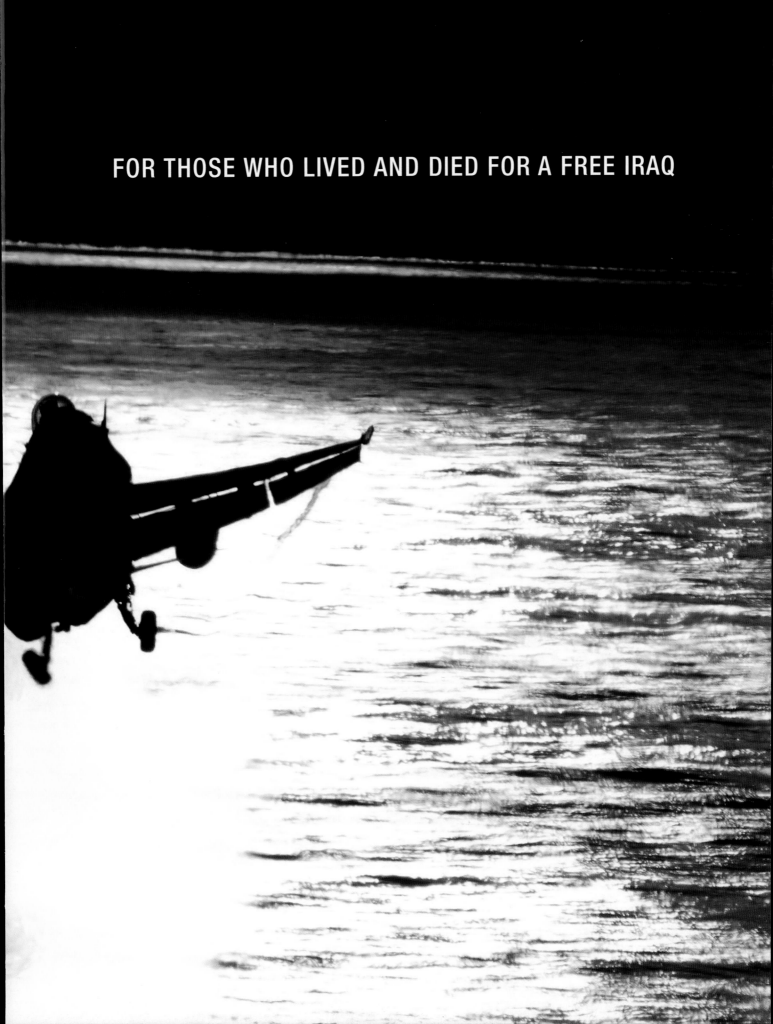

FOR THOSE WHO LIVED AND DIED FOR A FREE IRAQ

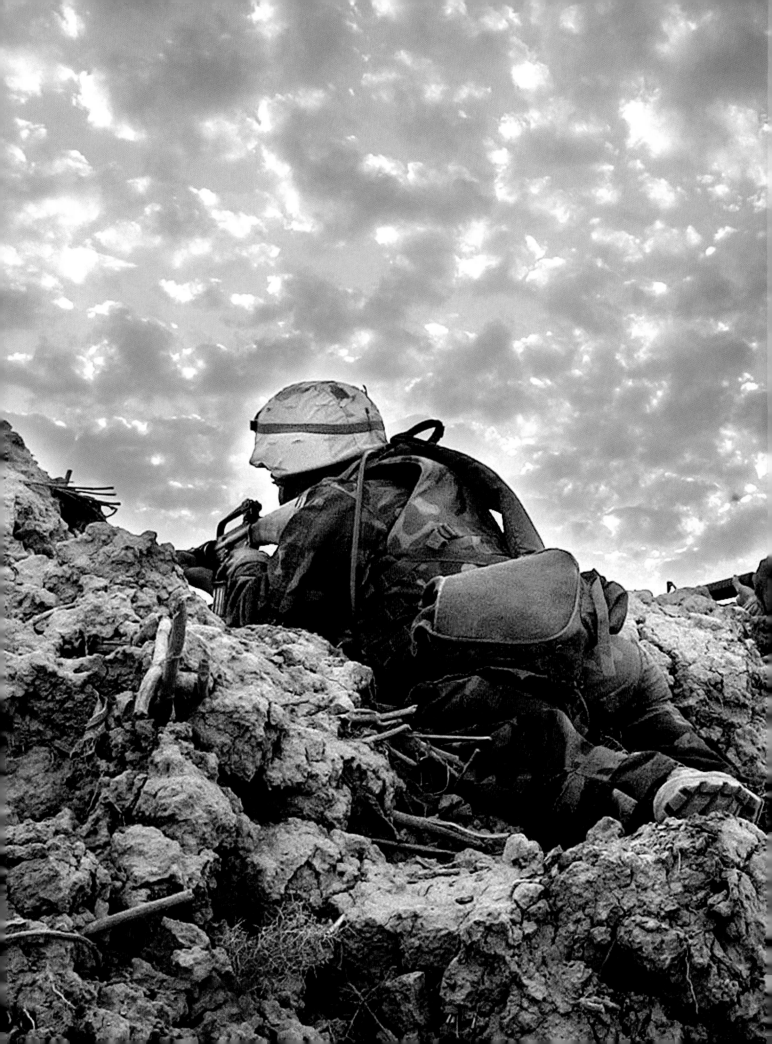

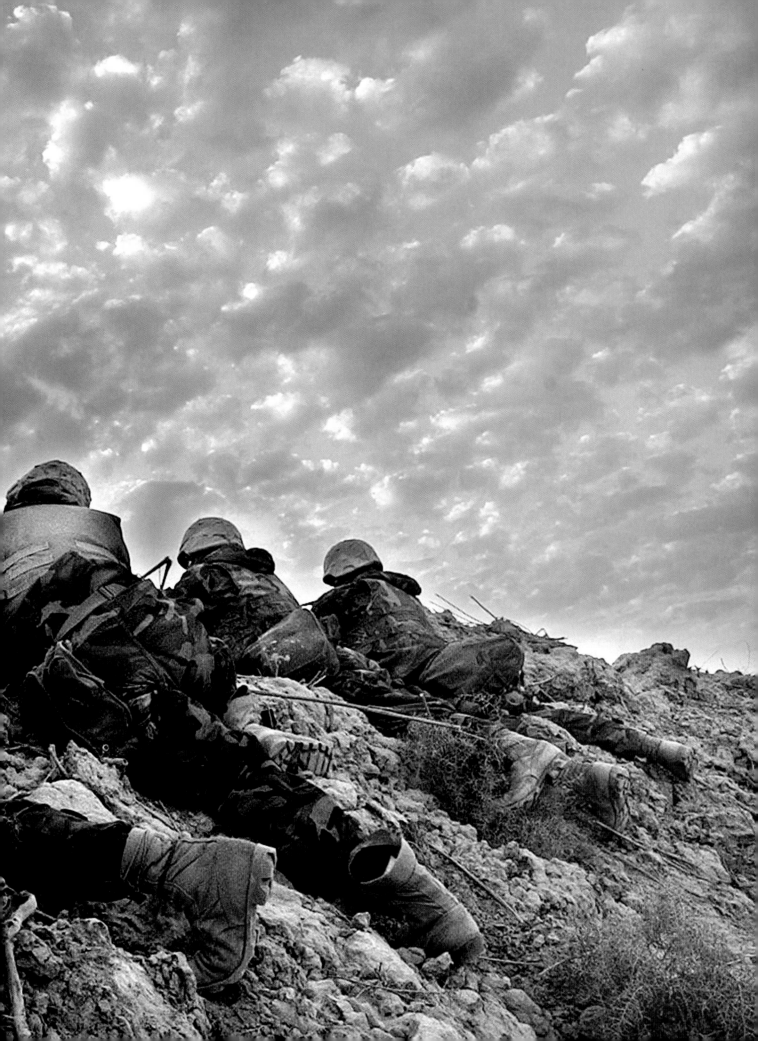

INTRODUCTION

The real war will never get in the books, Walt Whitman wrote late in life, reflecting on the great war of liberation that had shaped the American age he lived in. In one sense, of course, he was right: uncounted stories are left behind in war, lost to history even as we remember the fallen heroes who lived them. And yet, ever since the Civil War of which Whitman wrote, the truths and triumphs of war have been captured and preserved—through the lens of the photojournalist.

And never has the drama of war been captured more thoroughly, or unforgettably, than in the work of the hundreds of photographers who covered Operation Iraqi Freedom. From the first strikes on Baghdad through the end of combat announced on May 1, 2003, this new war of liberation lasted only forty-one days. Yet the emotions woven through it are ageless, as the photographs in *The War in Iraq* so eloquently attest. Here, in more than 250 stunning images, are the stories of this modern war played out against an ancient desert backdrop: the heartless Iraqi dictator, and the resolute American president who ended his reign of terror; the eerie crimson isolation of the early sandstorms, and the surreal spectacle of Saddam's ruined palaces; the convoys of American troops prepared for fierce resistance, and the Iraqis who greeted them— some with hostile fire, but many more with white flags and faces brightened with relief.

The faces of this war, like those of any war, may be what we remember most. And in these photographs they look toward us from half a world away, with every expression imaginable. A young American

girl bids farewell to her mother as she goes off to battle; a young boy in Basra revels amid a windfall of pure sugar after years of deprivation. Joyous Iraqi men welcome the troops with homemade American flags, and topple images of Saddam with anger and euphoria. An American soldier at rest is watched with curiosity by two elderly women in a nearby doorway, their traded whispers almost audible. Flush with victory, coalition troops romp unabashed through the dictator's abandoned living quarters. A beaming British servicewoman takes a moment to greet a local schoolgirl in Umm Qasr. A twelve-year-old boy, orphaned by the war and badly burned, confronts our gaze.

As the first air strikes landed in Baghdad, the words "shock and awe" were used to characterize their impact. Now, in the earliest weeks of Iraqi freedom, those simple words have taken on fresh meanings. The American public may have been shocked at how quickly the Iraqi defenses crumbled. The Iraqi people now face the awesome opportunity and challenge of remaking their nation. As Whitman suggested, it may be impossible to capture in words every emotional nuance of an event as tumultuous as a war. But the photographers who risked their lives to chronicle Operation Iraqi Freedom have done history a profound service: on digital files and videotape and 35mm film, they have compiled a crystalline visual record of this extraordinary moment in our history.

They have got it in the books.

The Editors

THE ROAD TO WAR

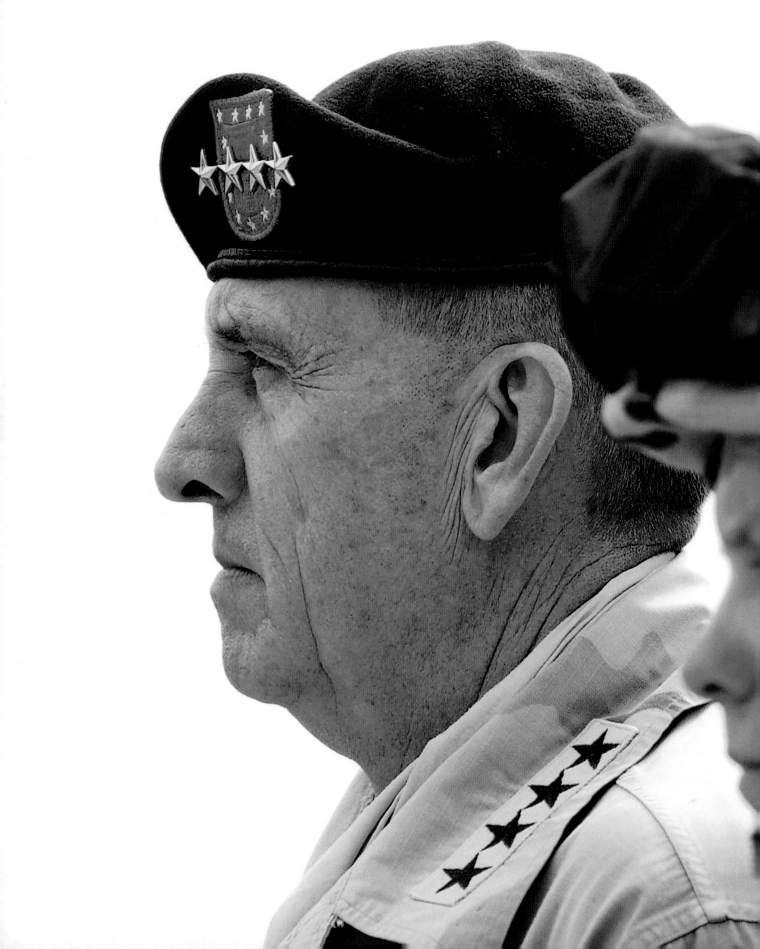

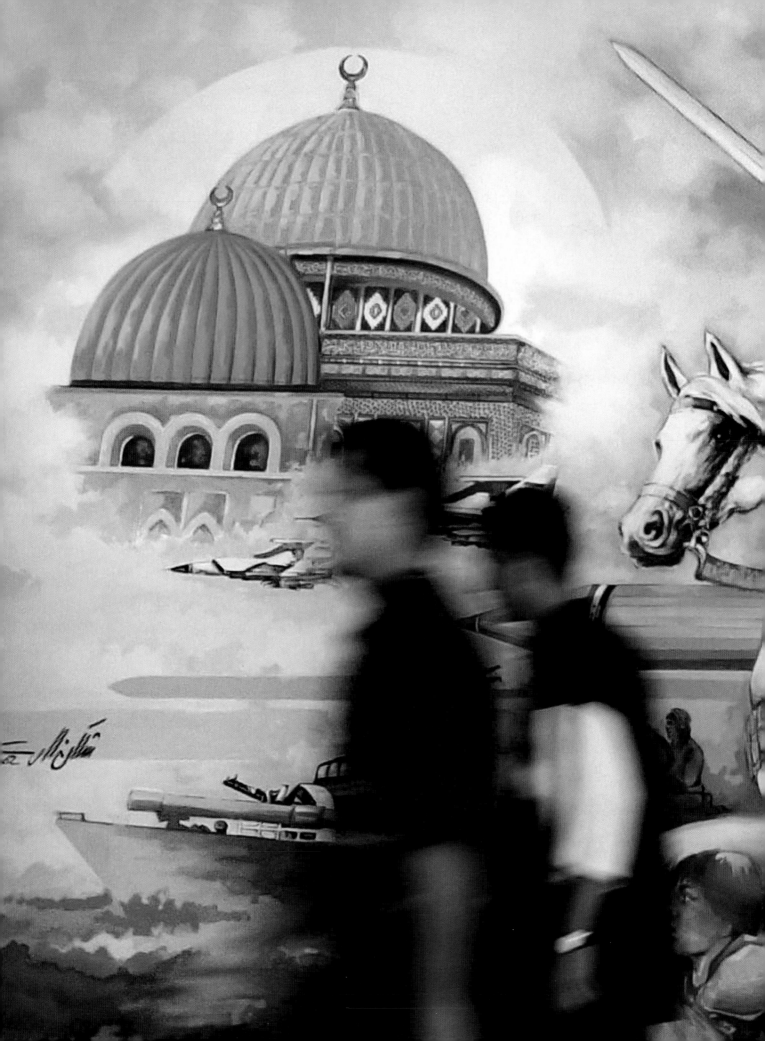

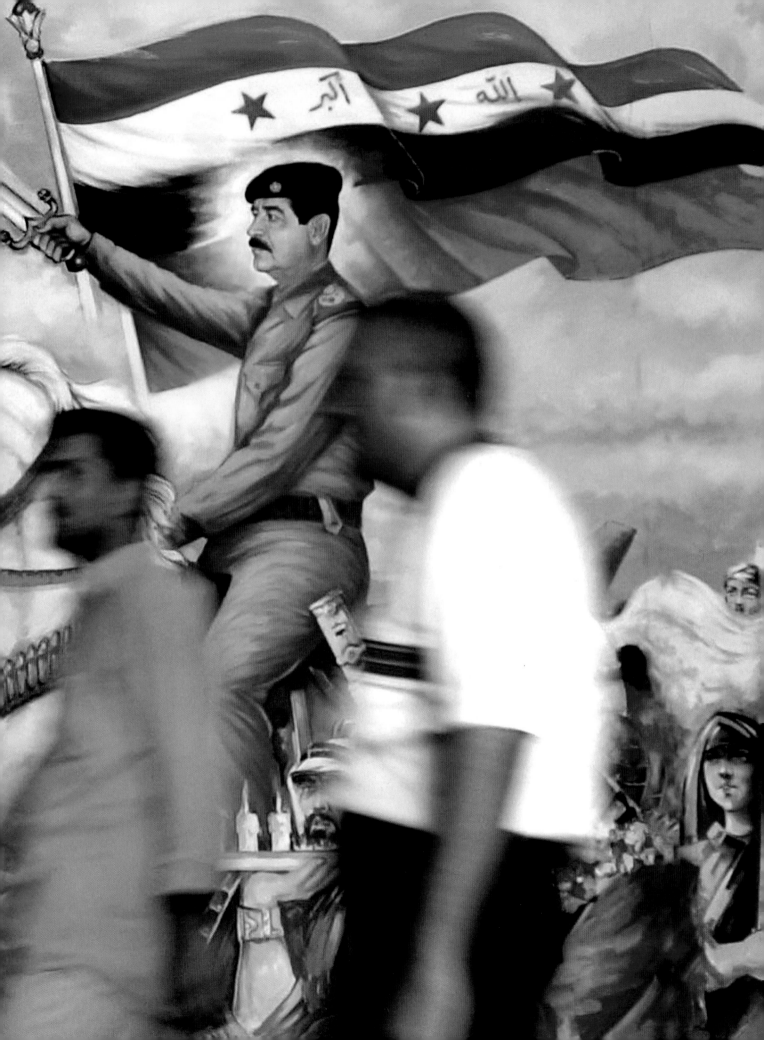

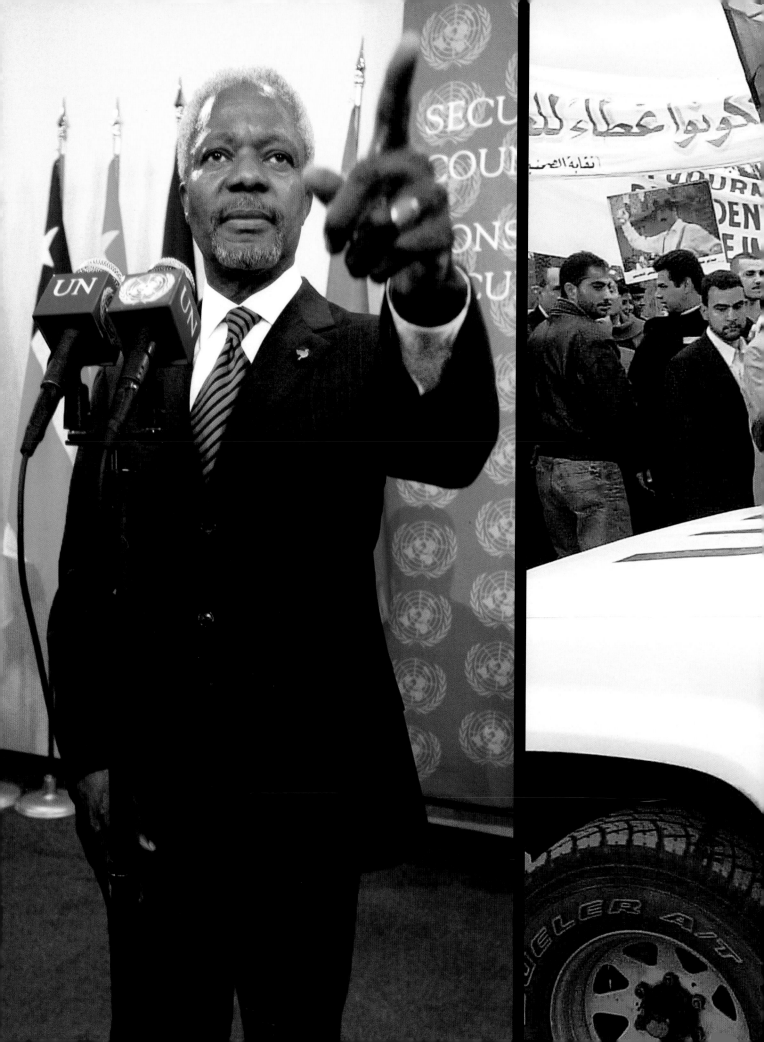

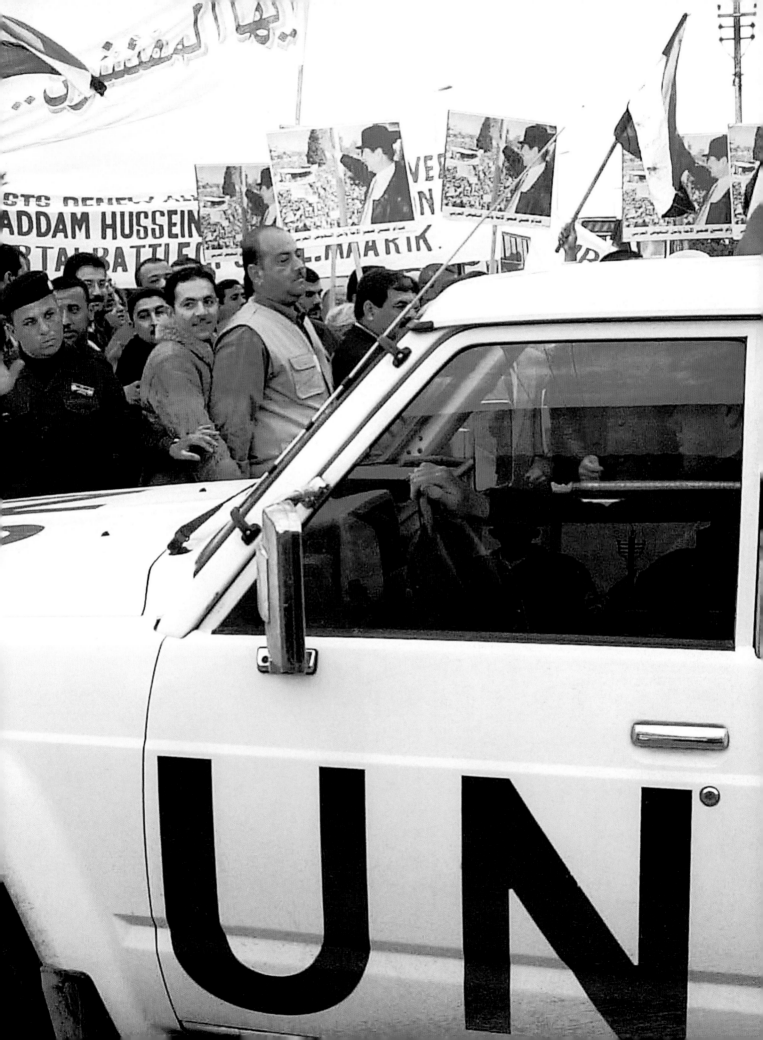

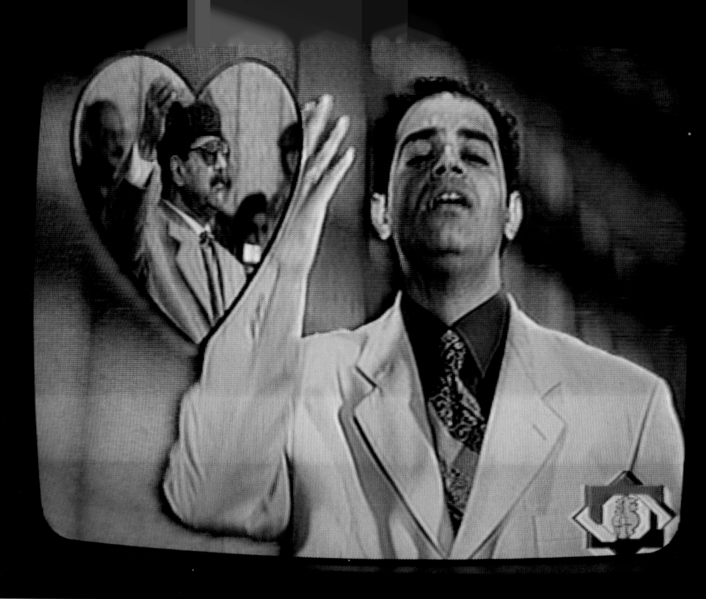

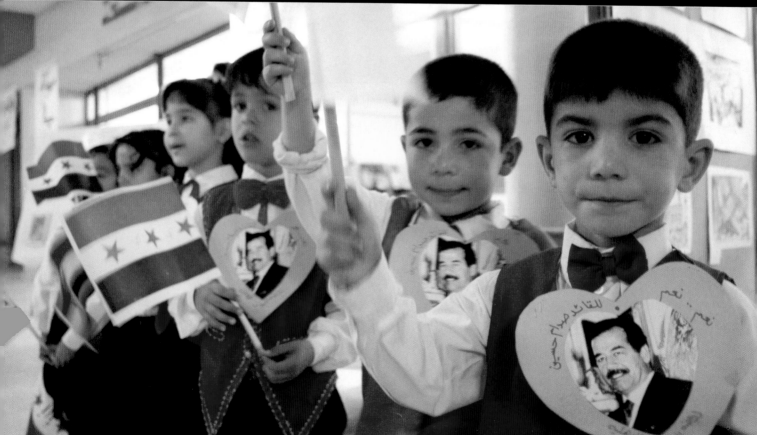

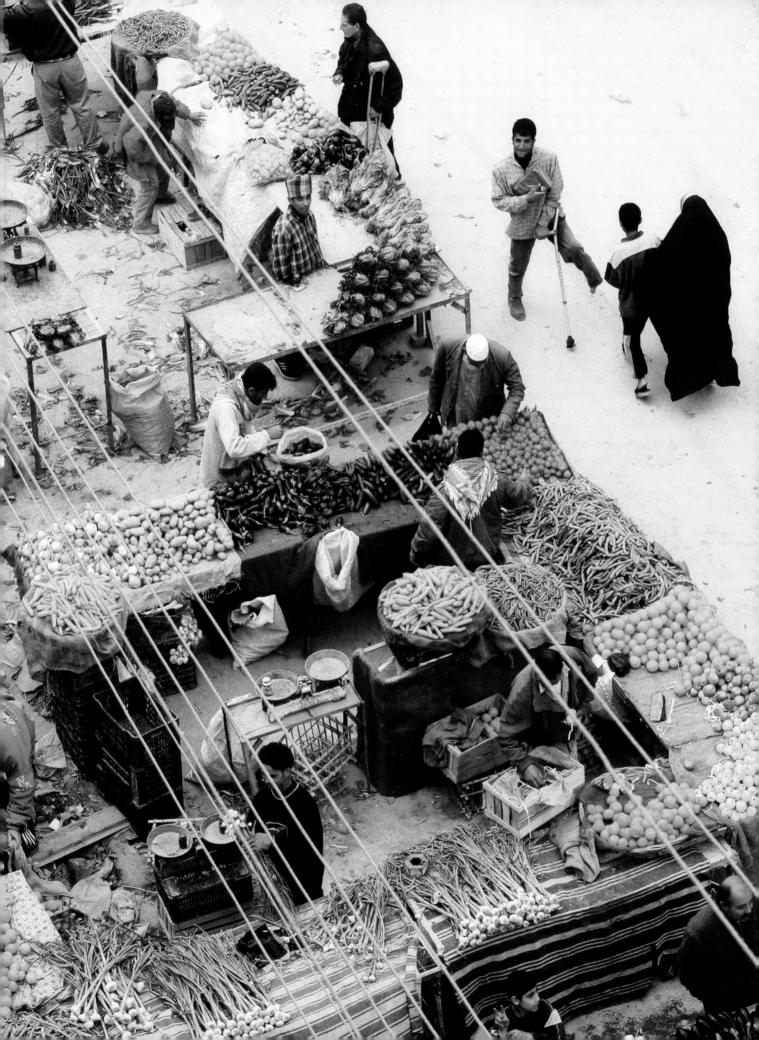

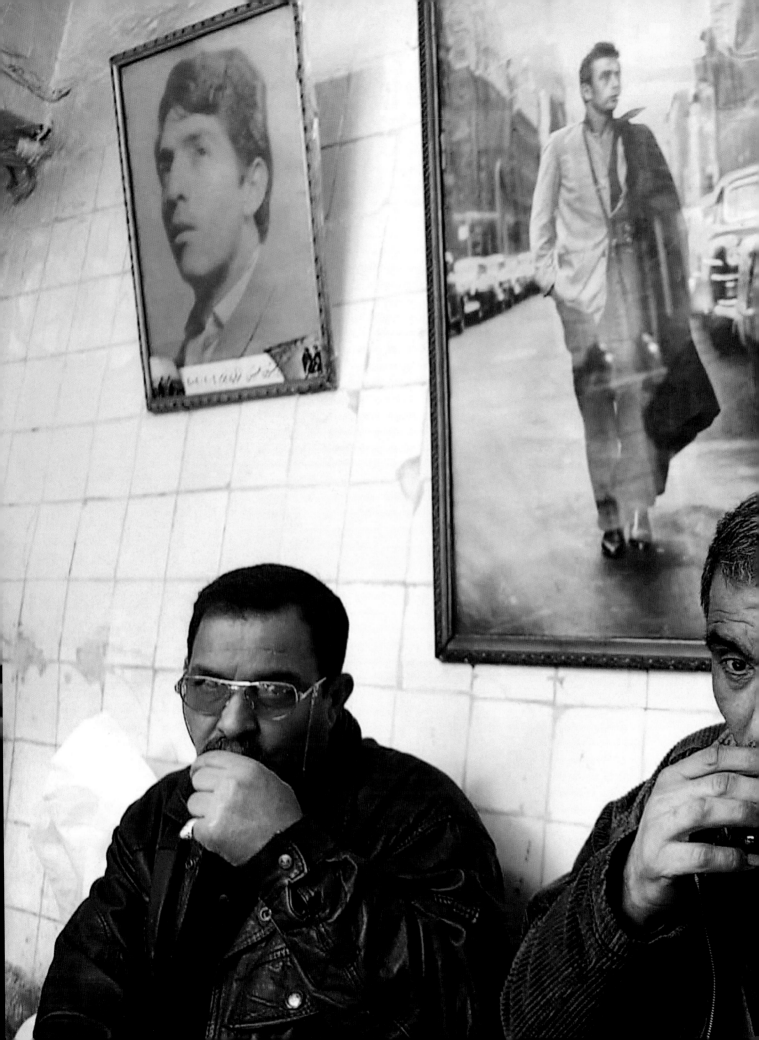

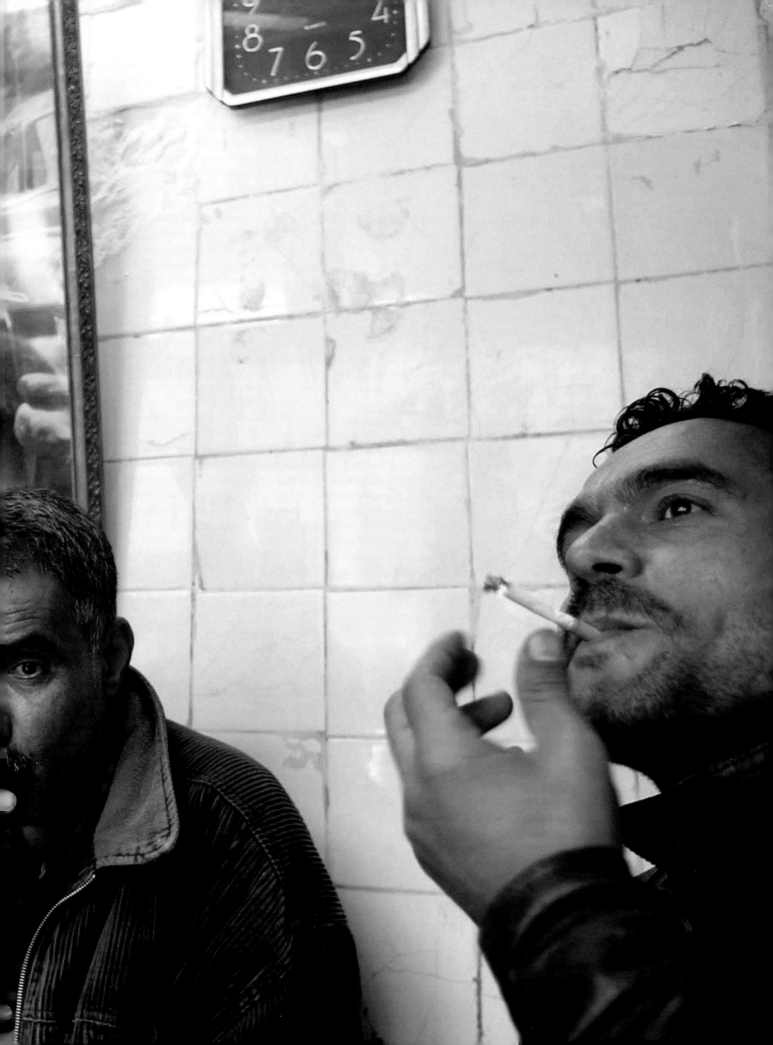

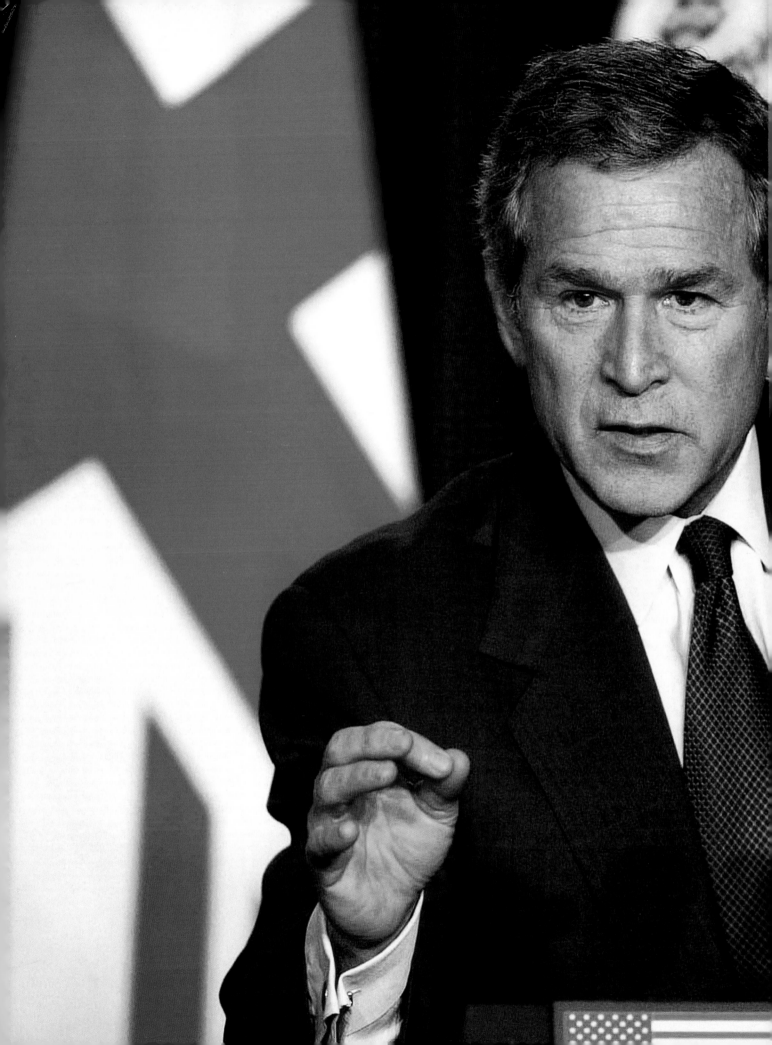

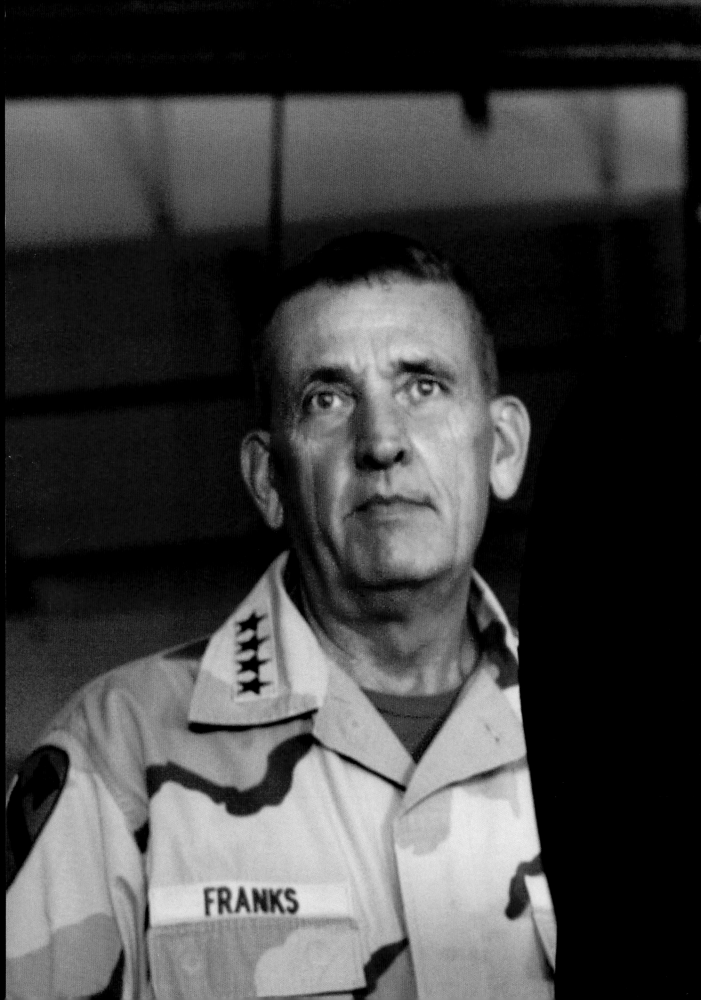

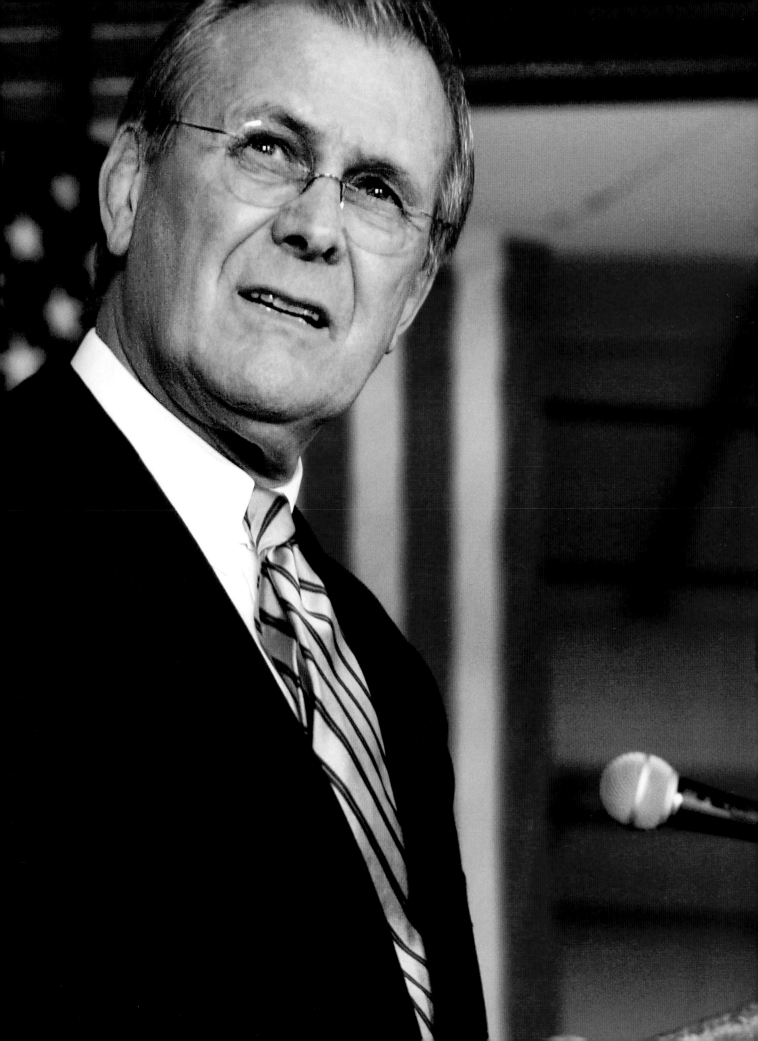

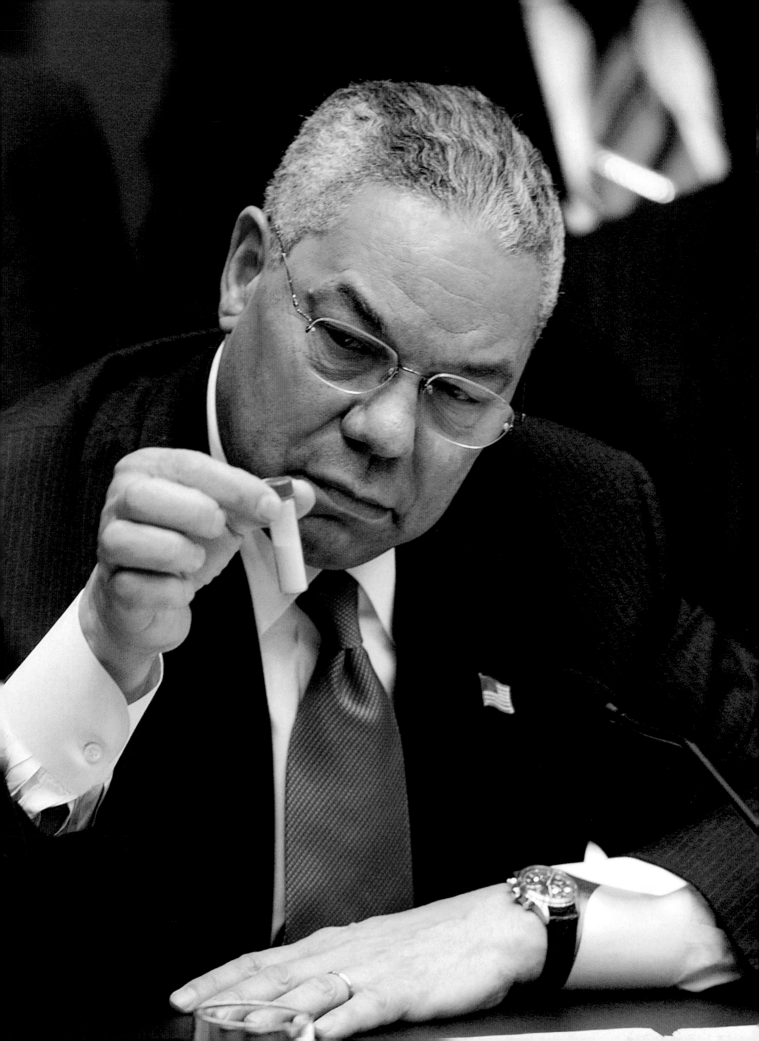

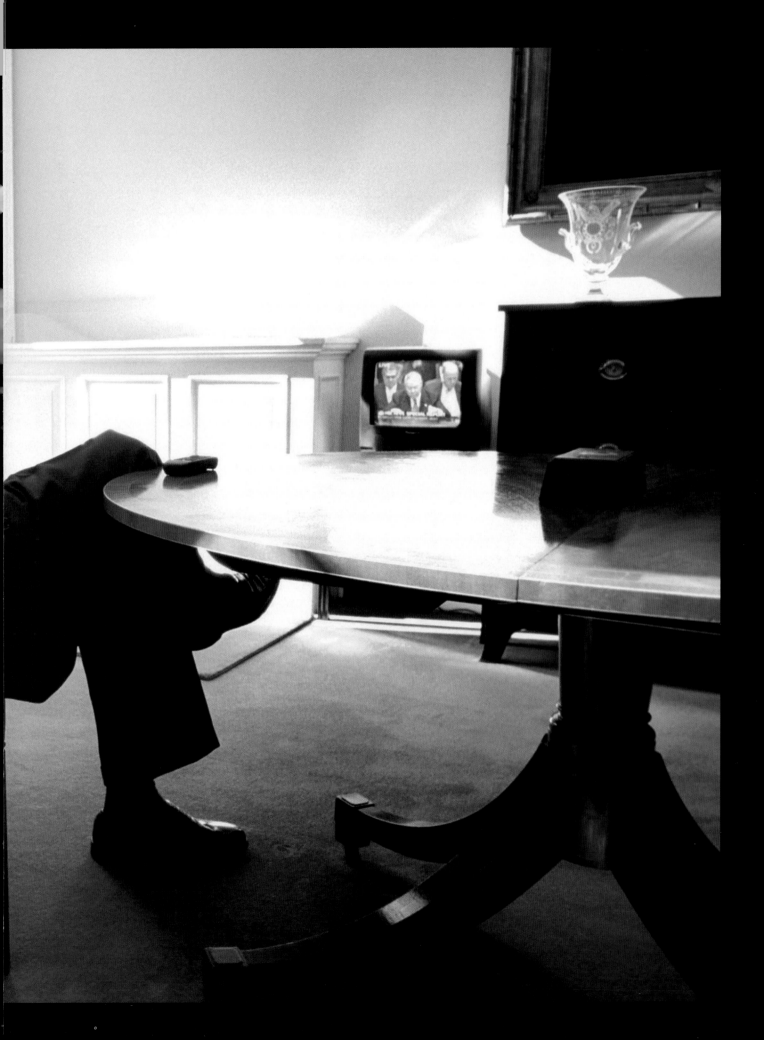

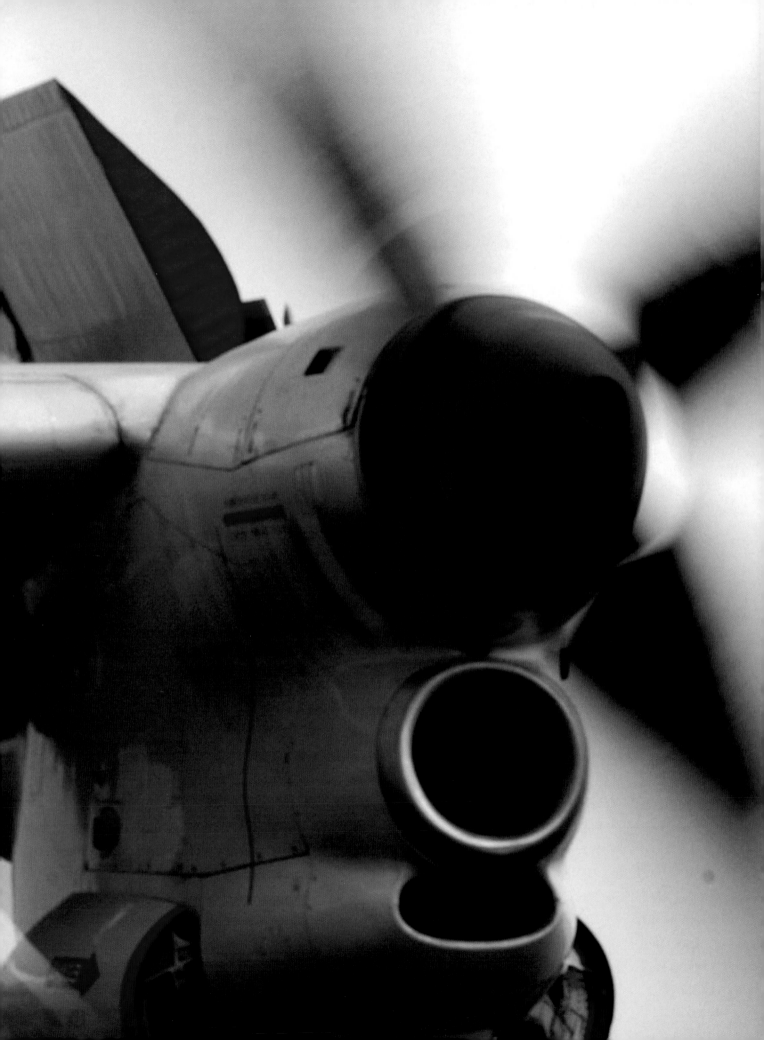

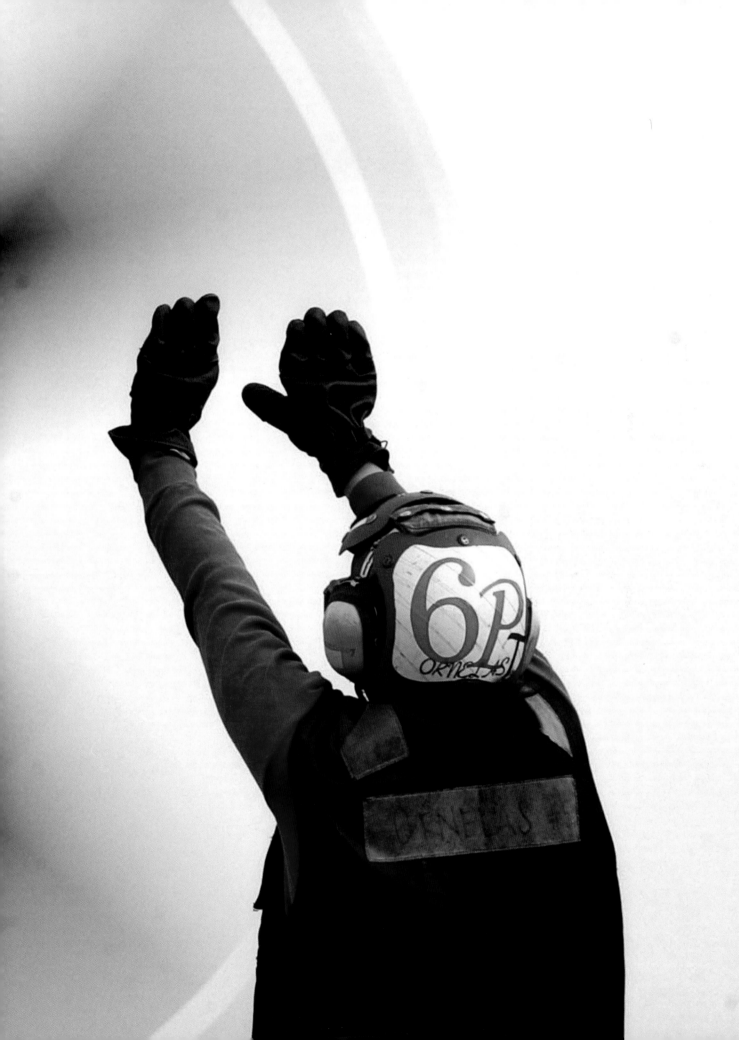

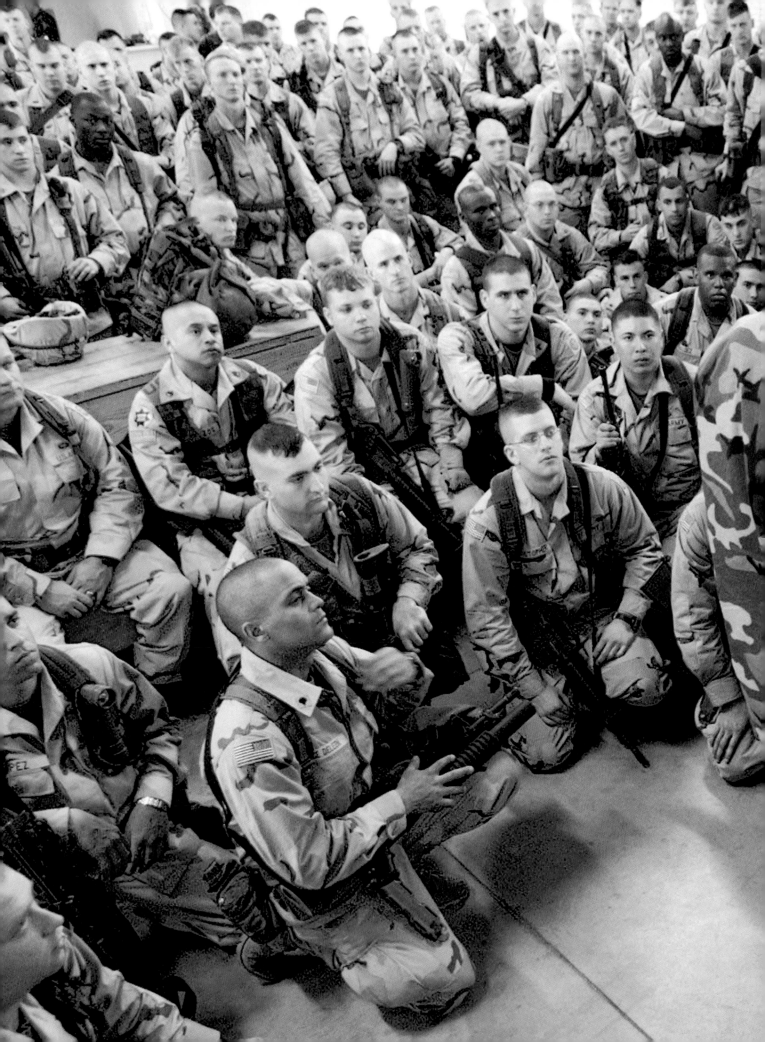

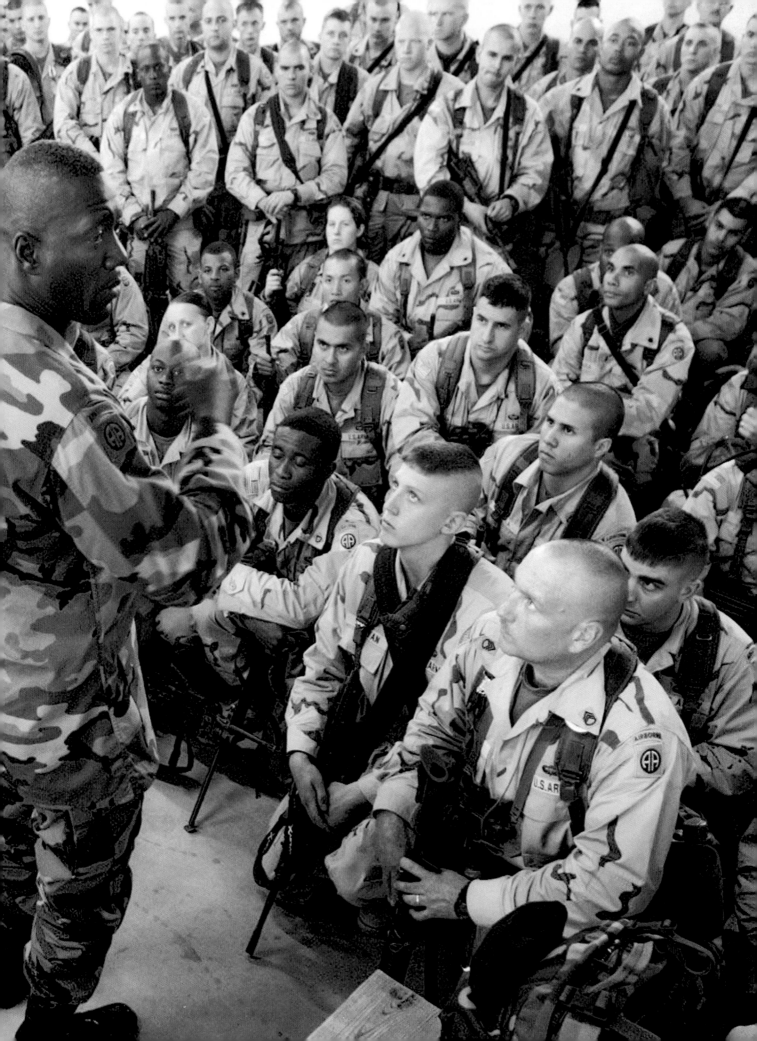

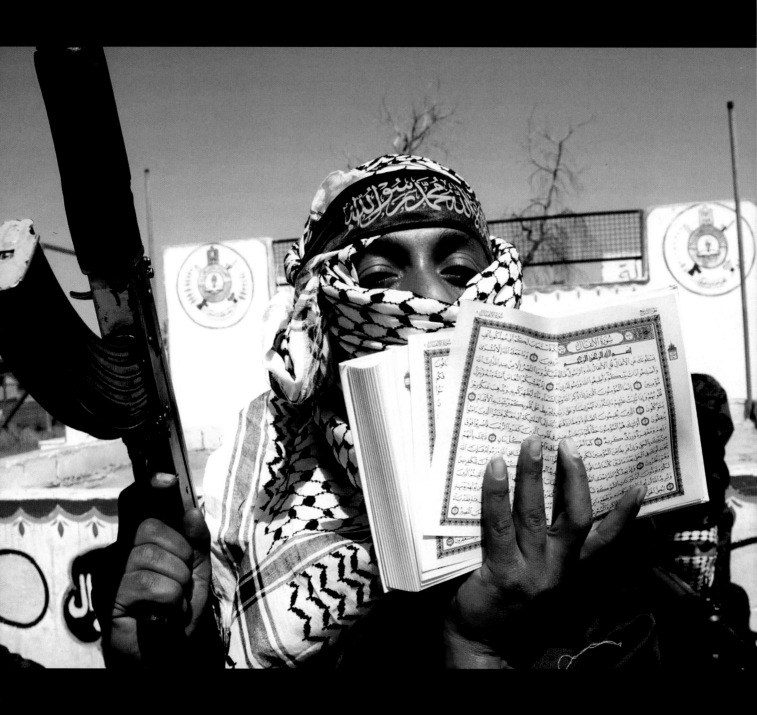

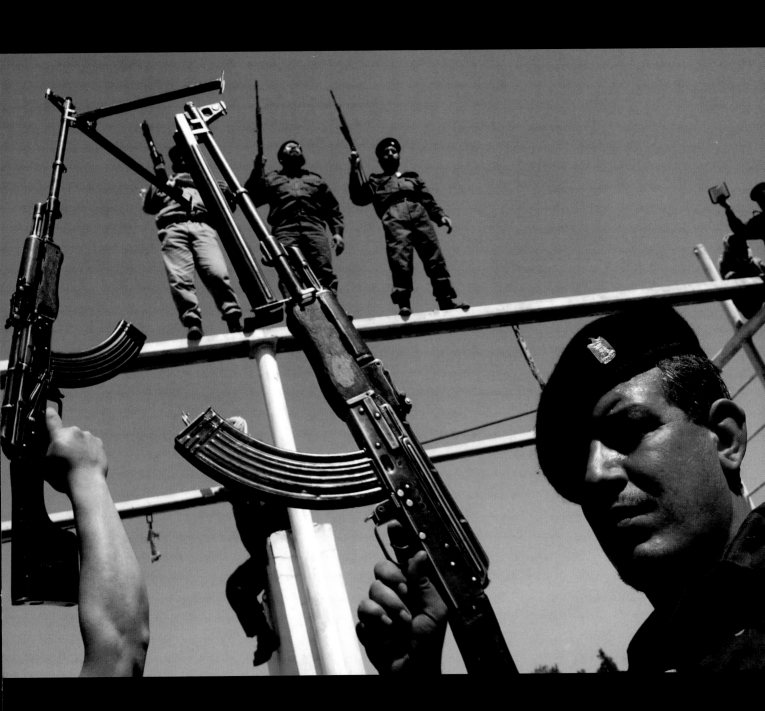

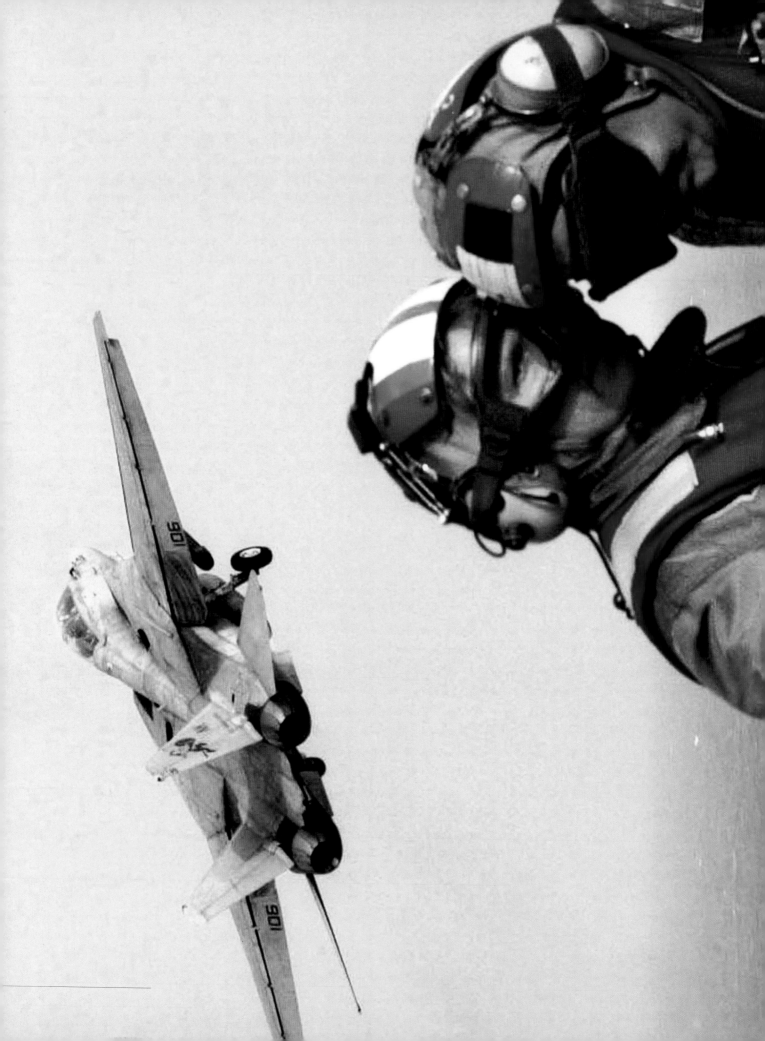

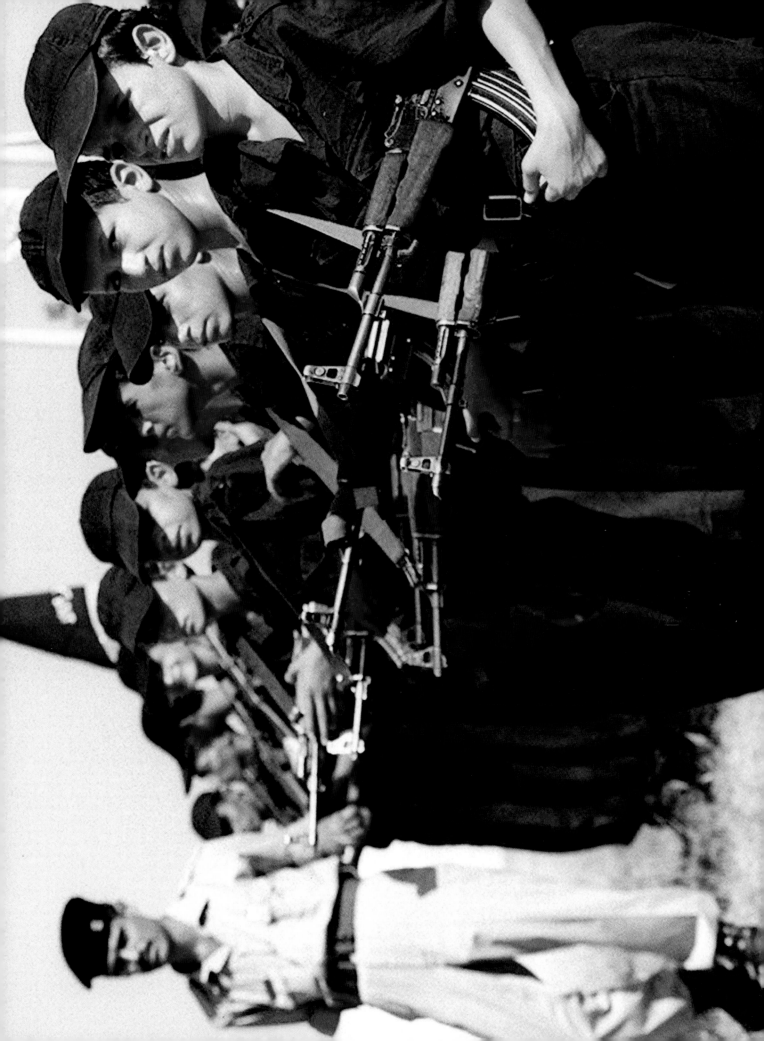

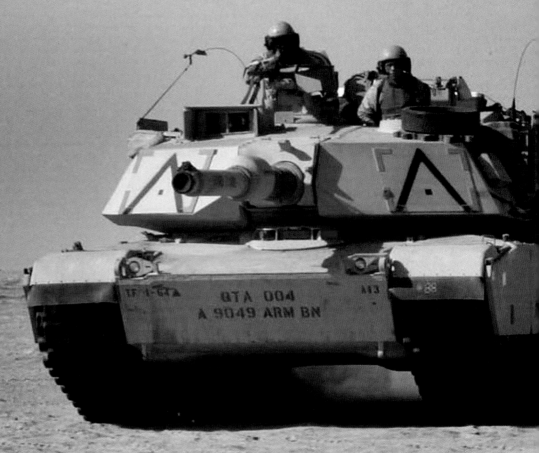

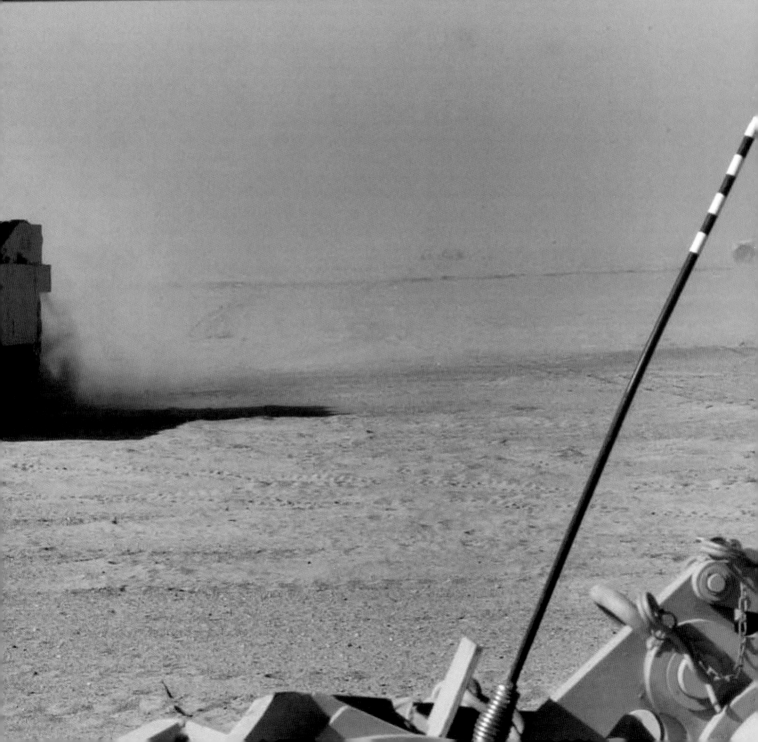

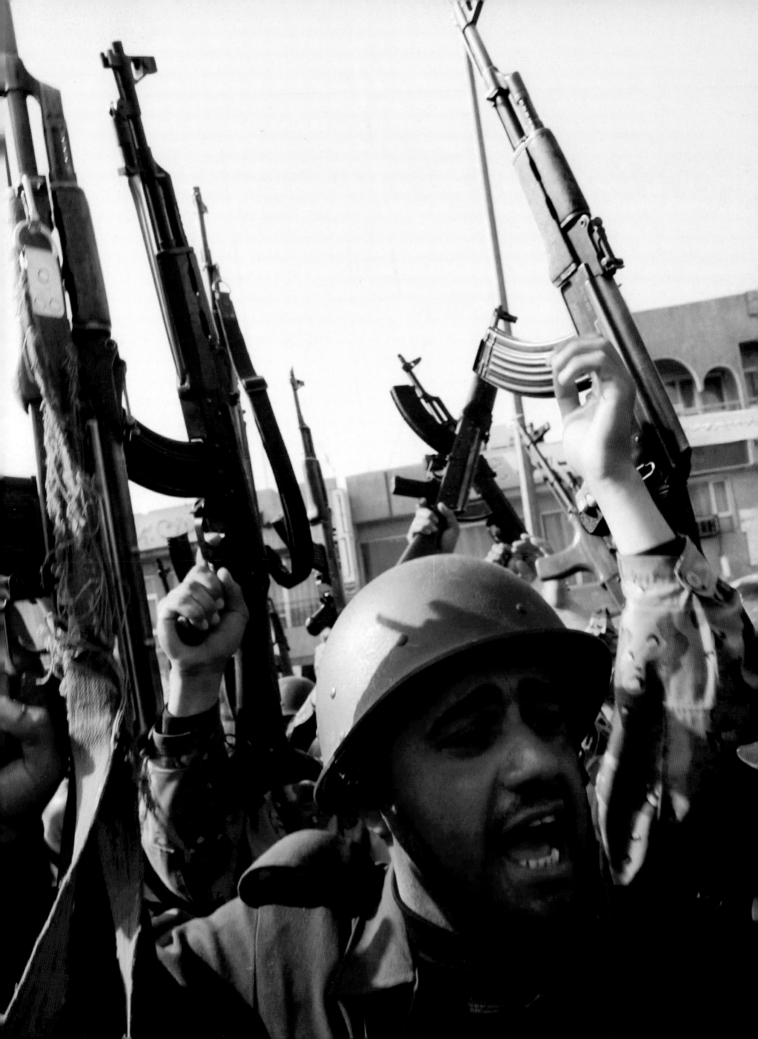

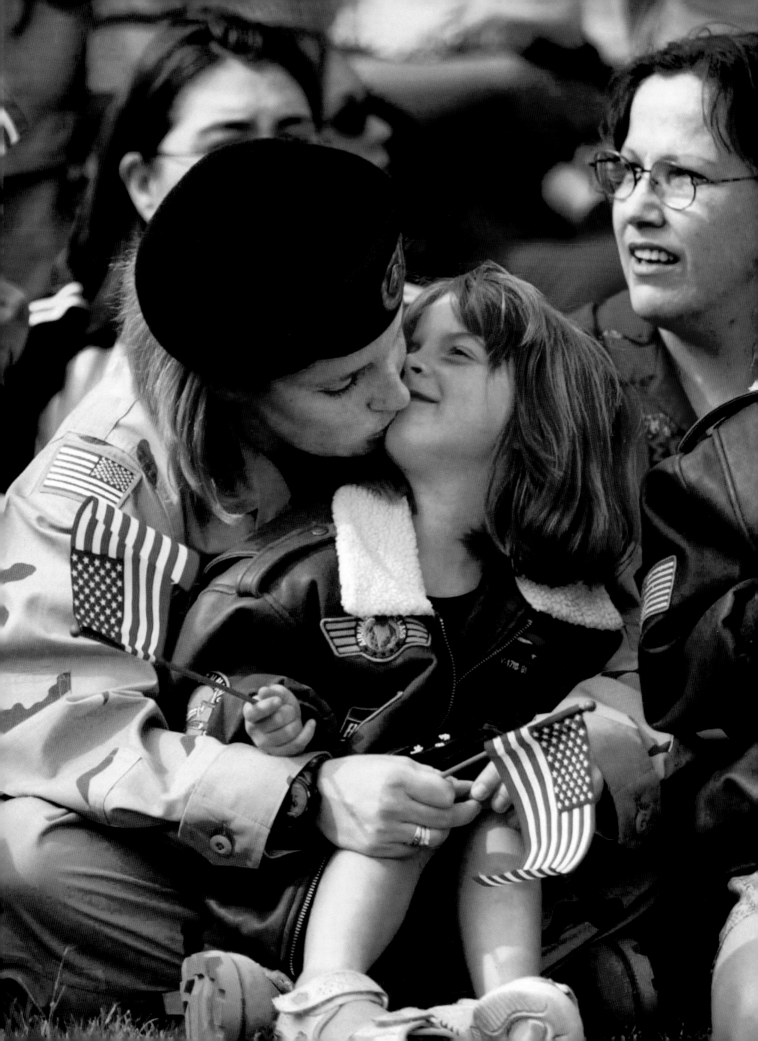

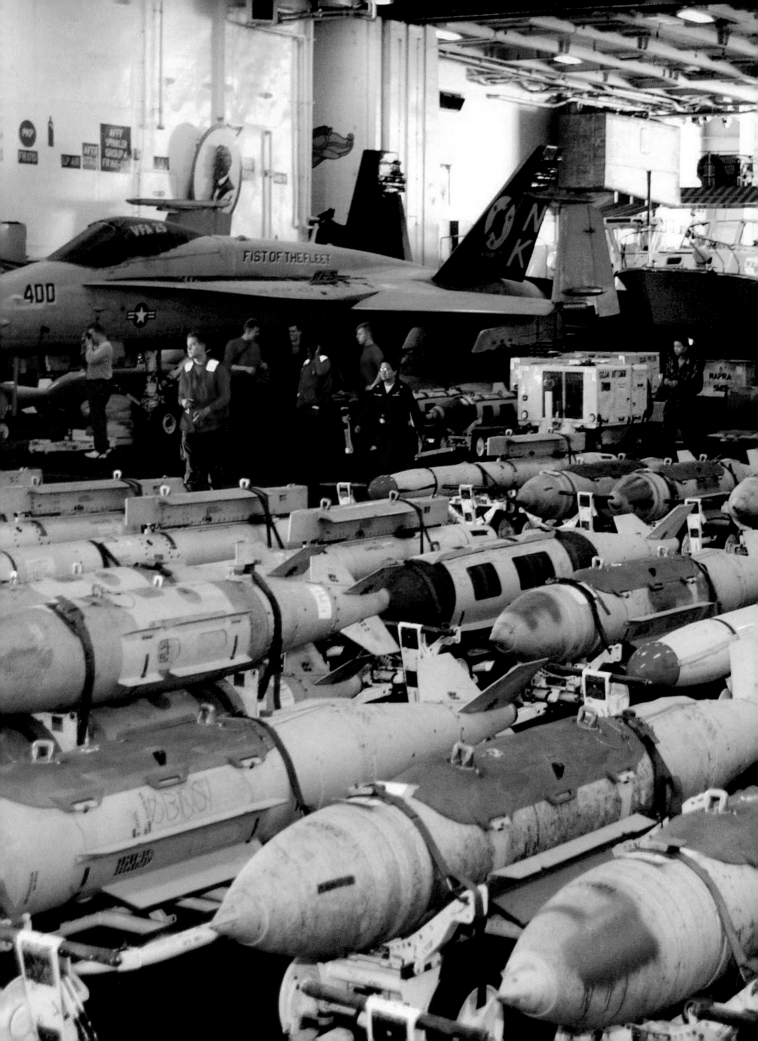

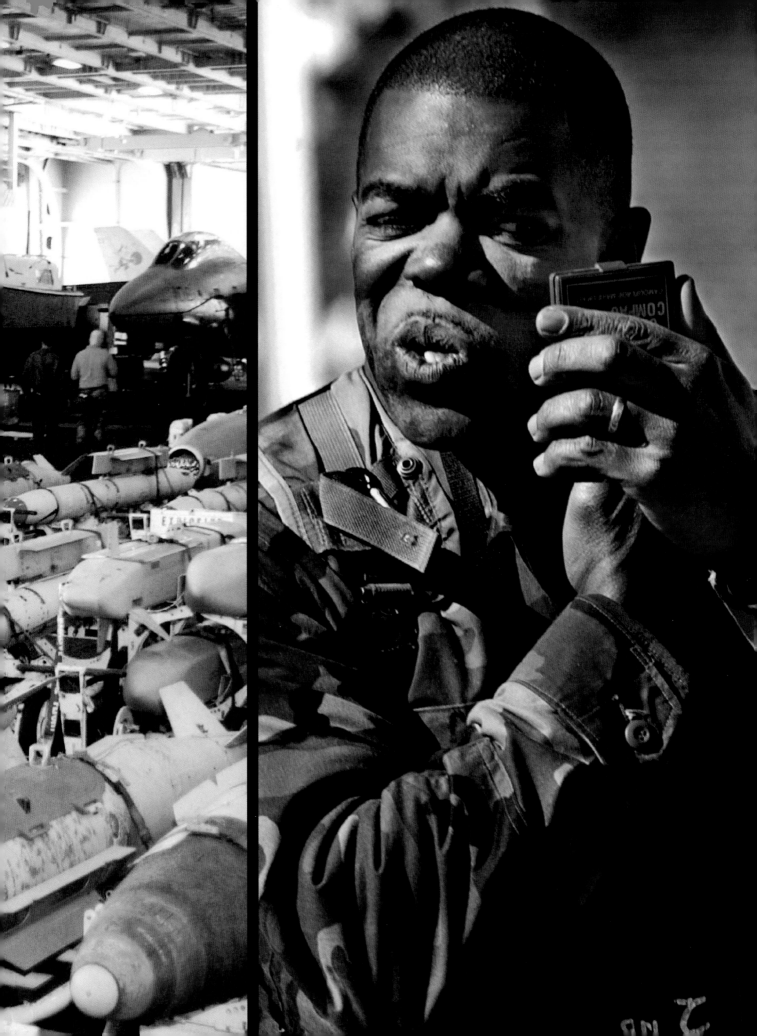

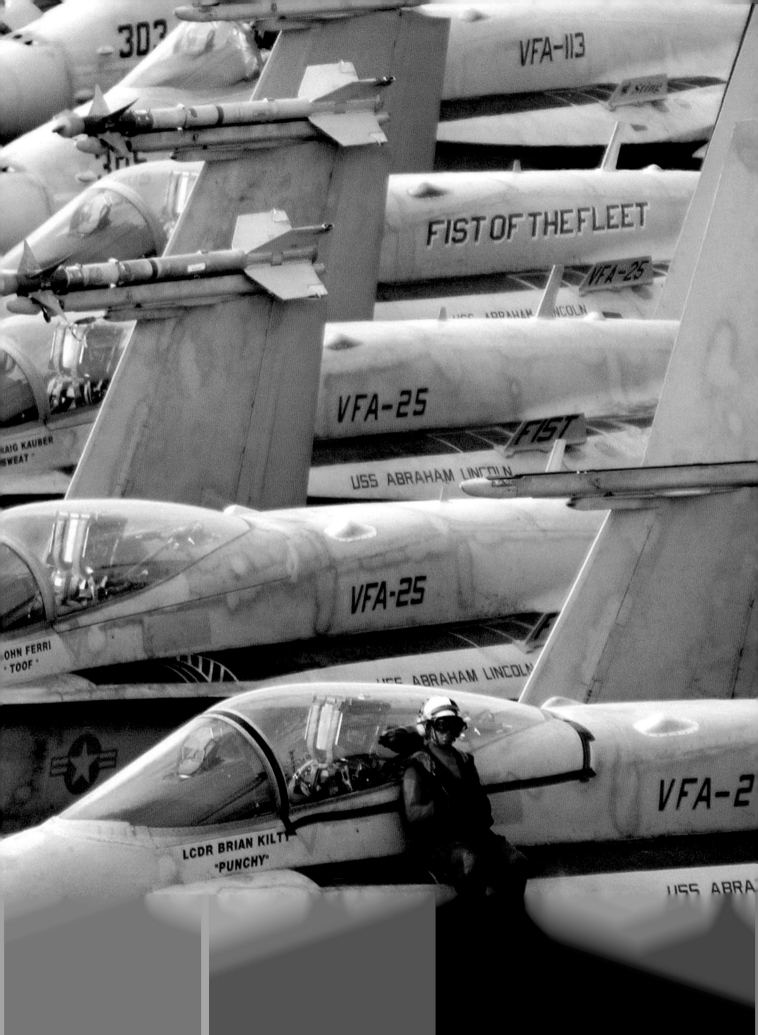

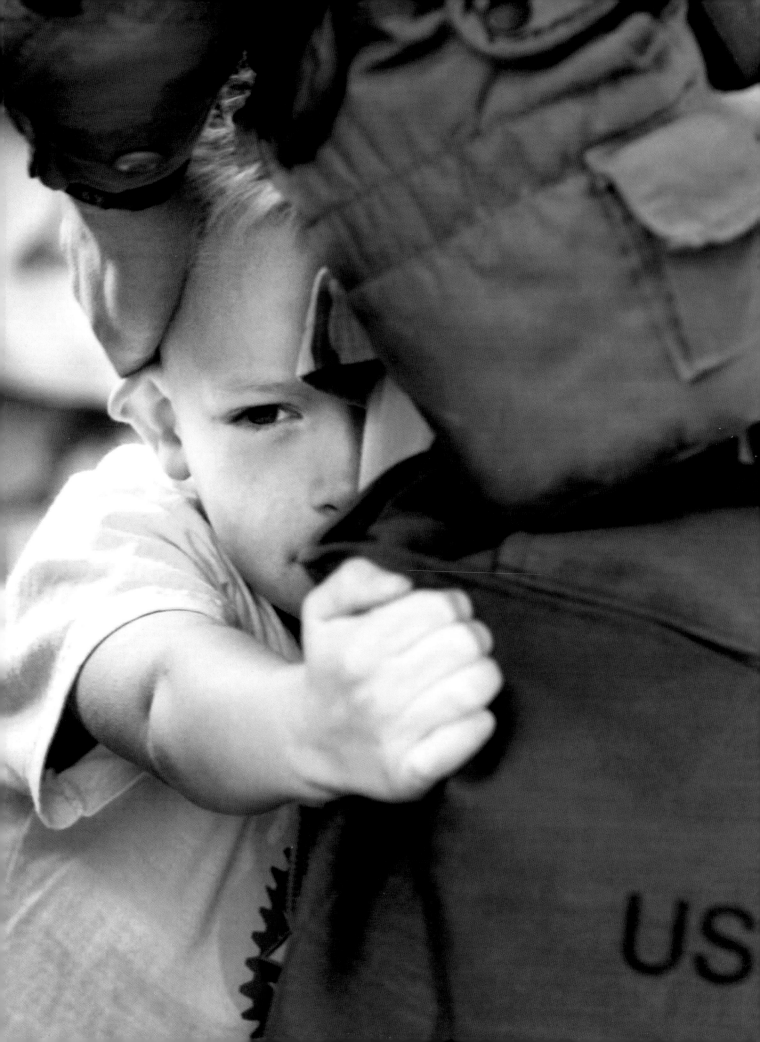

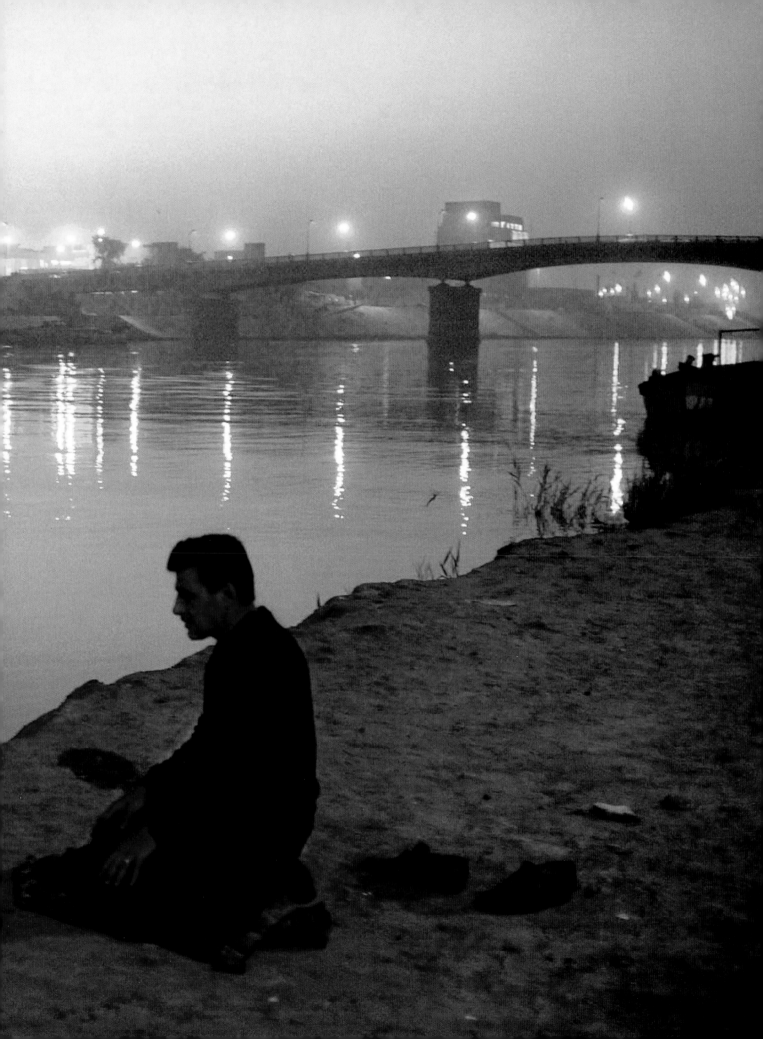

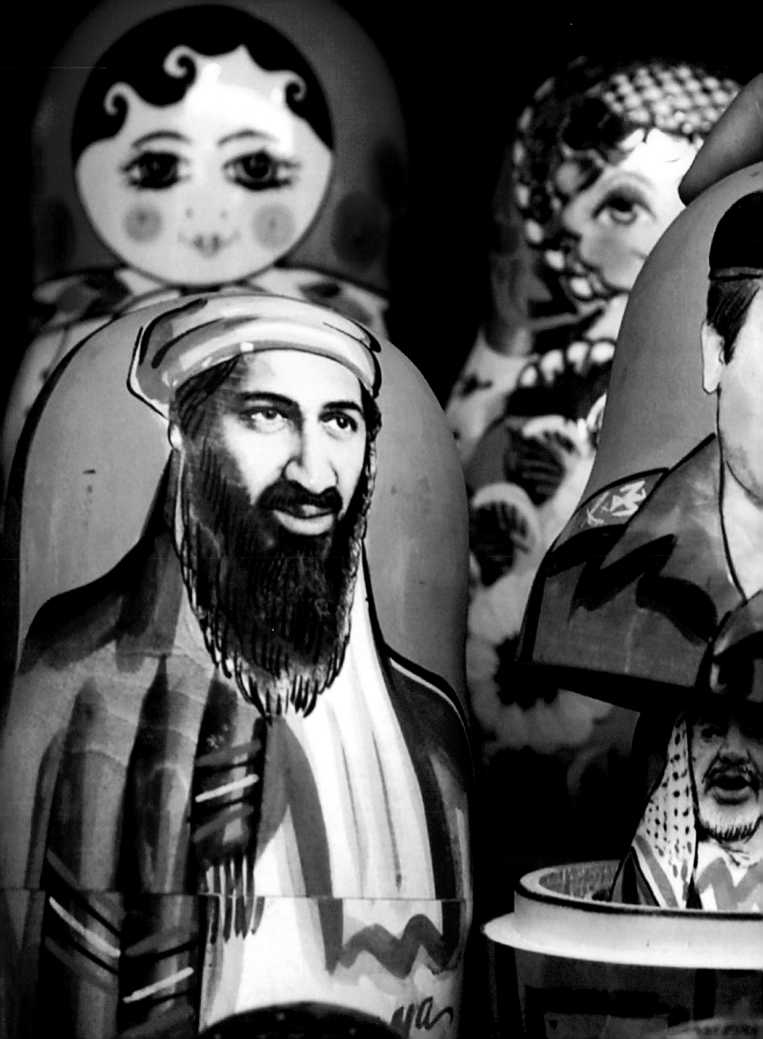

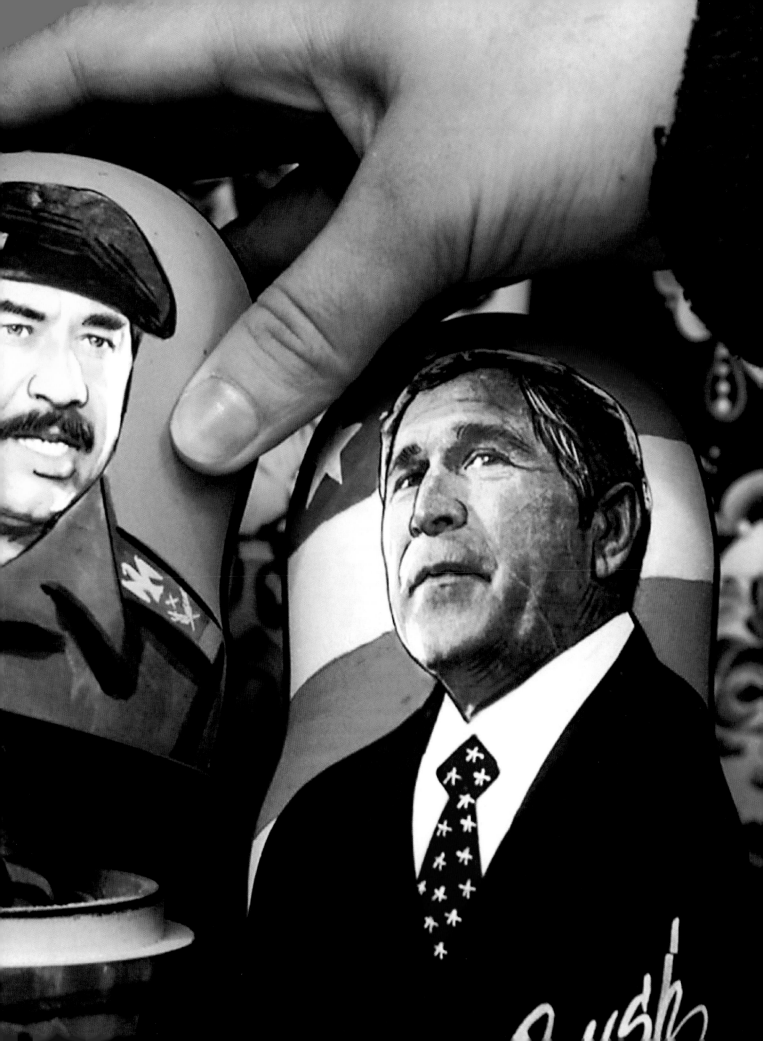

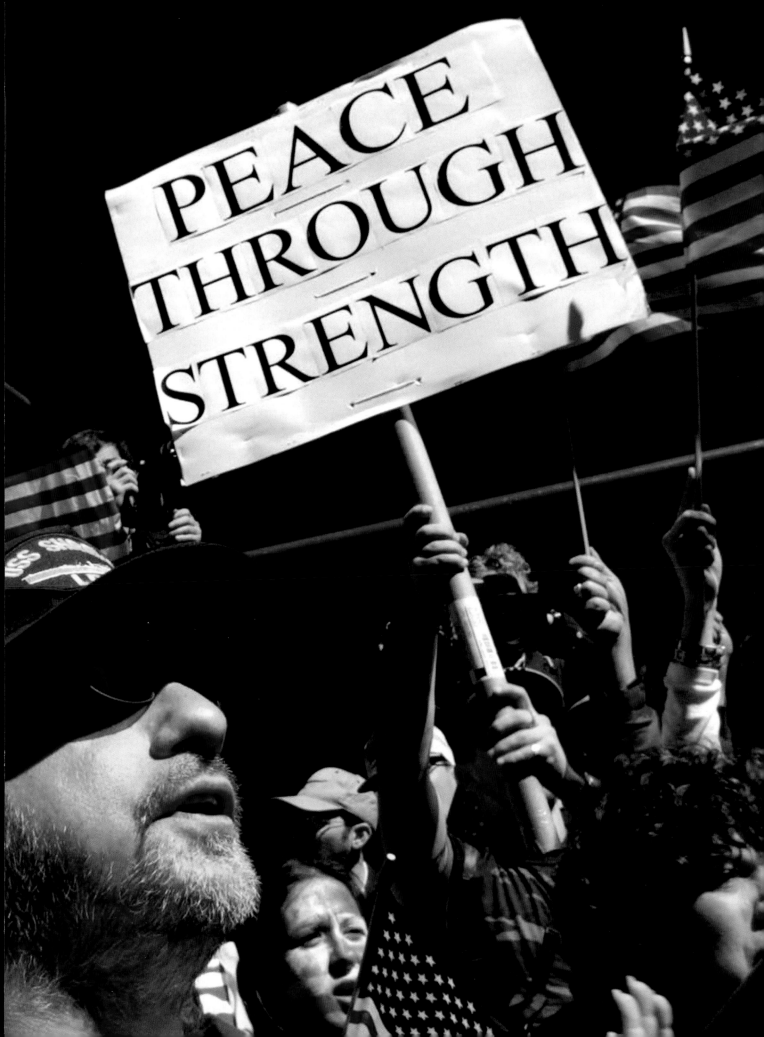

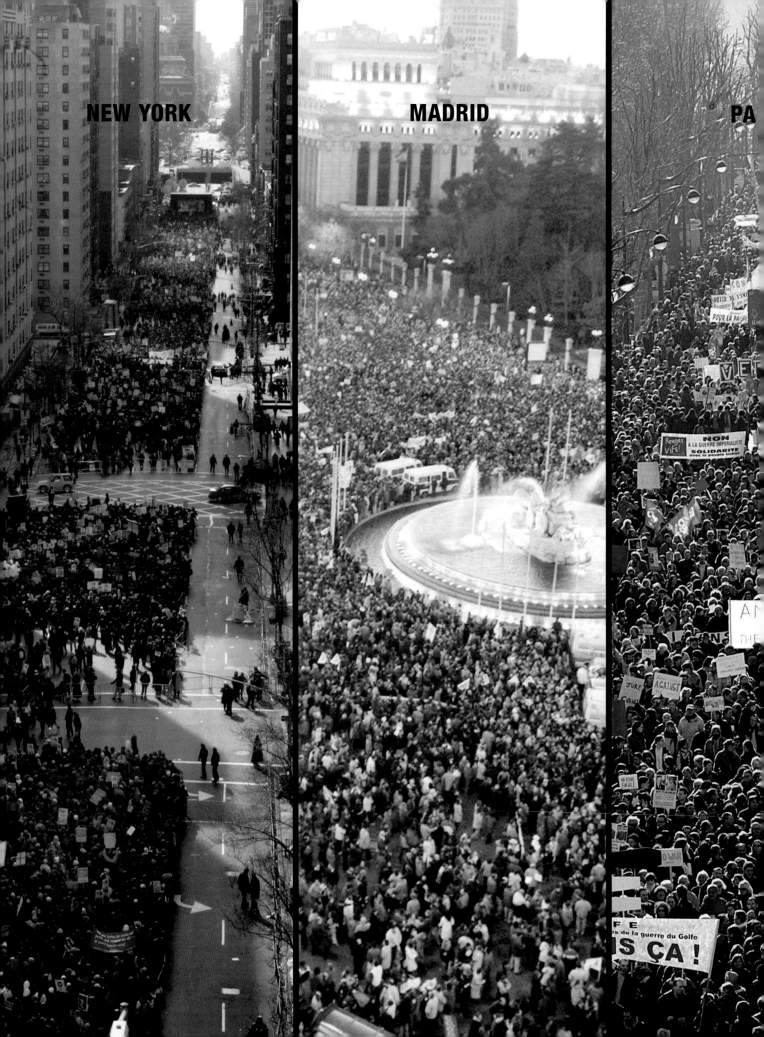

NEW YORK

MADRID

PA

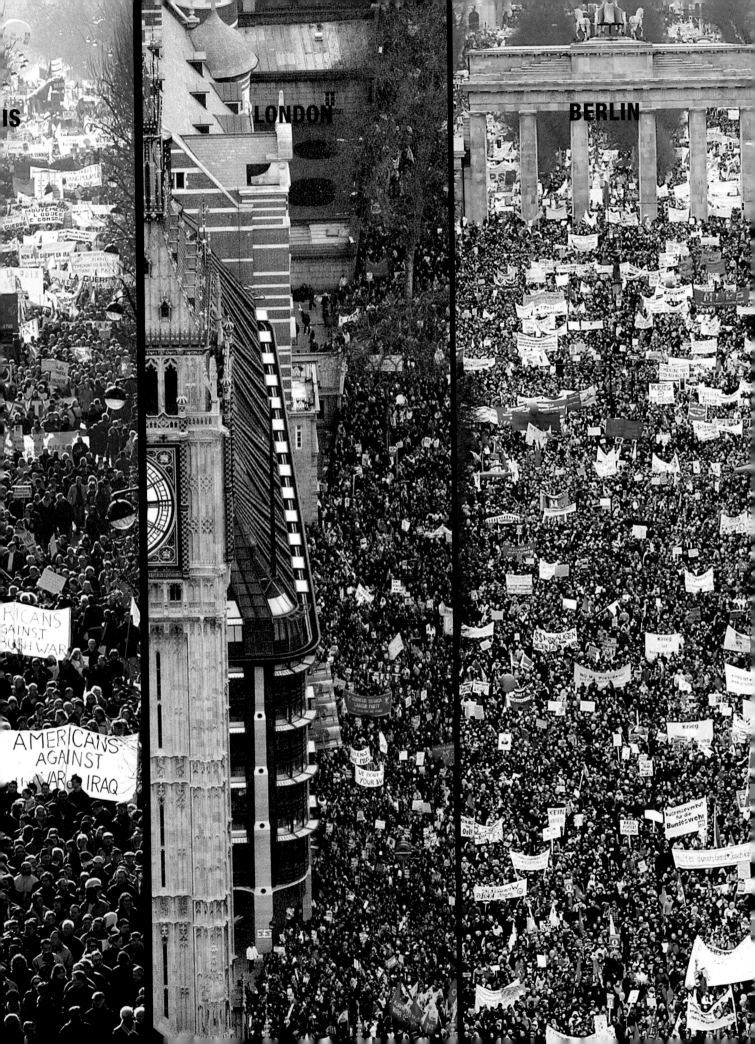

IS

LONDON

BERLIN

AMERICANS AGAINST BUSH WAR

AMERICANS AGAINST the WAR on IRAQ

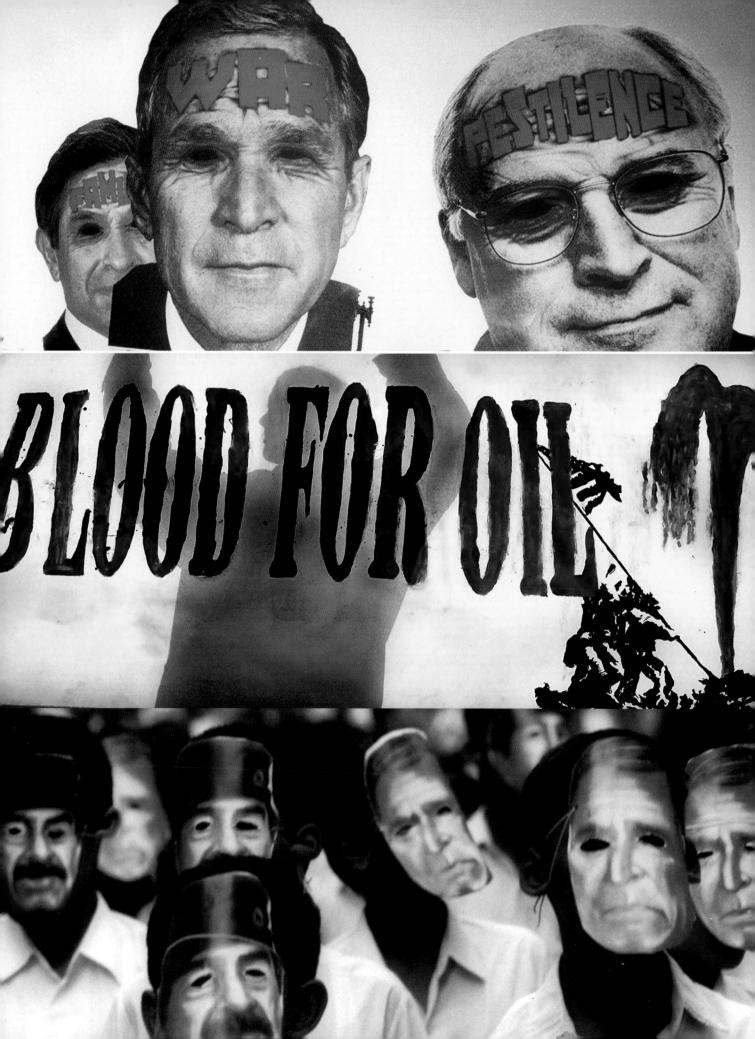

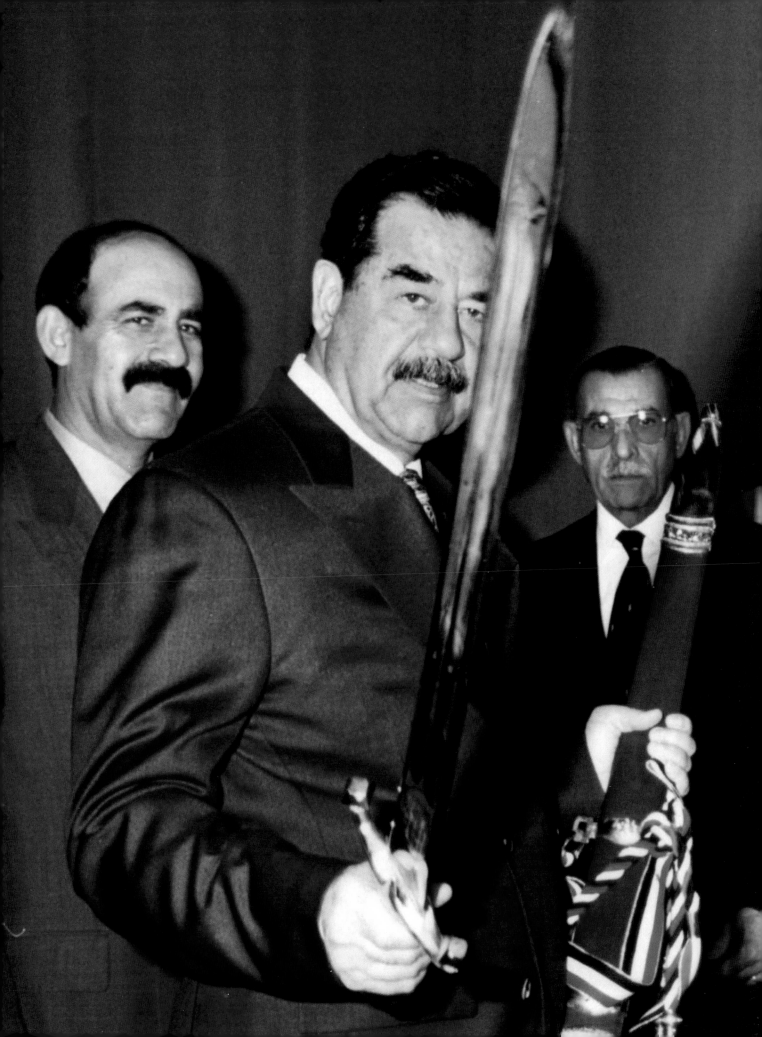

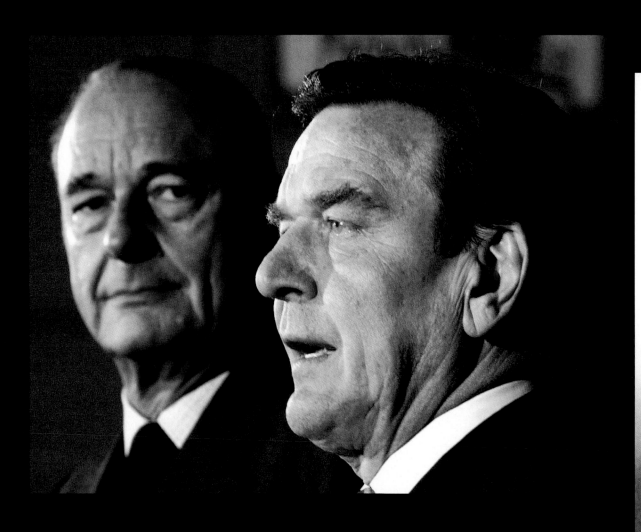

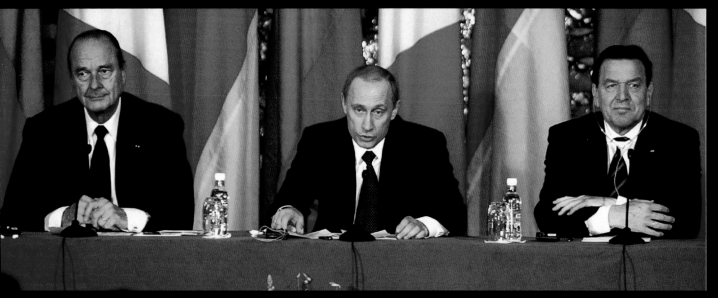

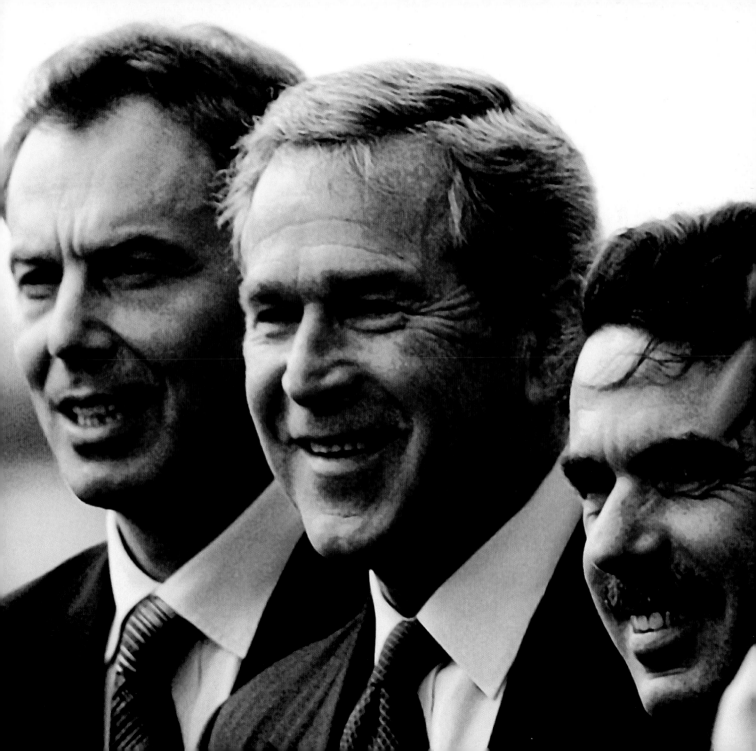

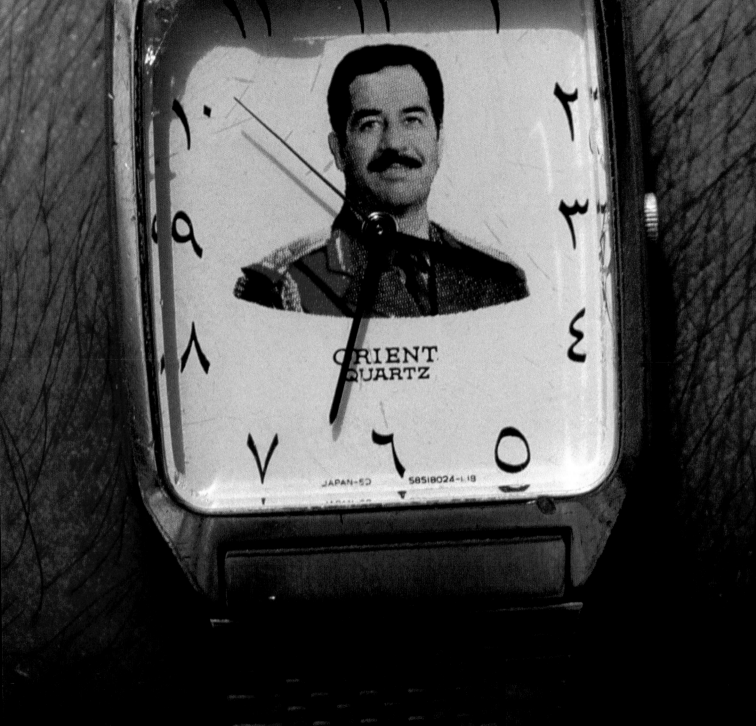

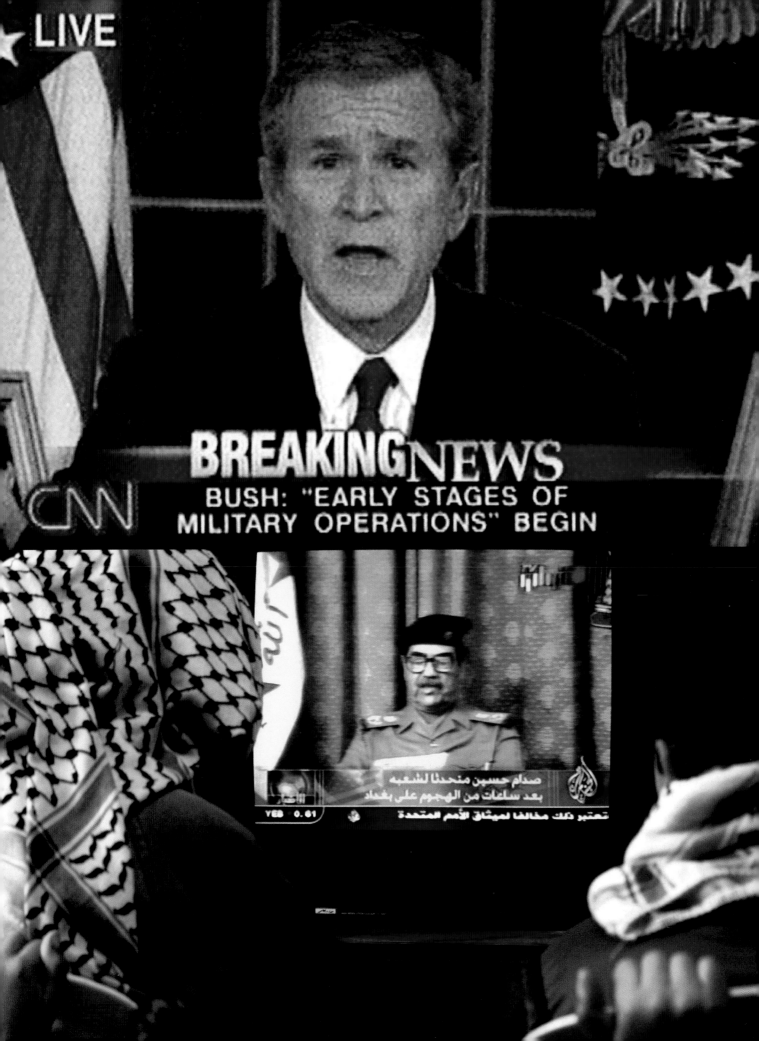

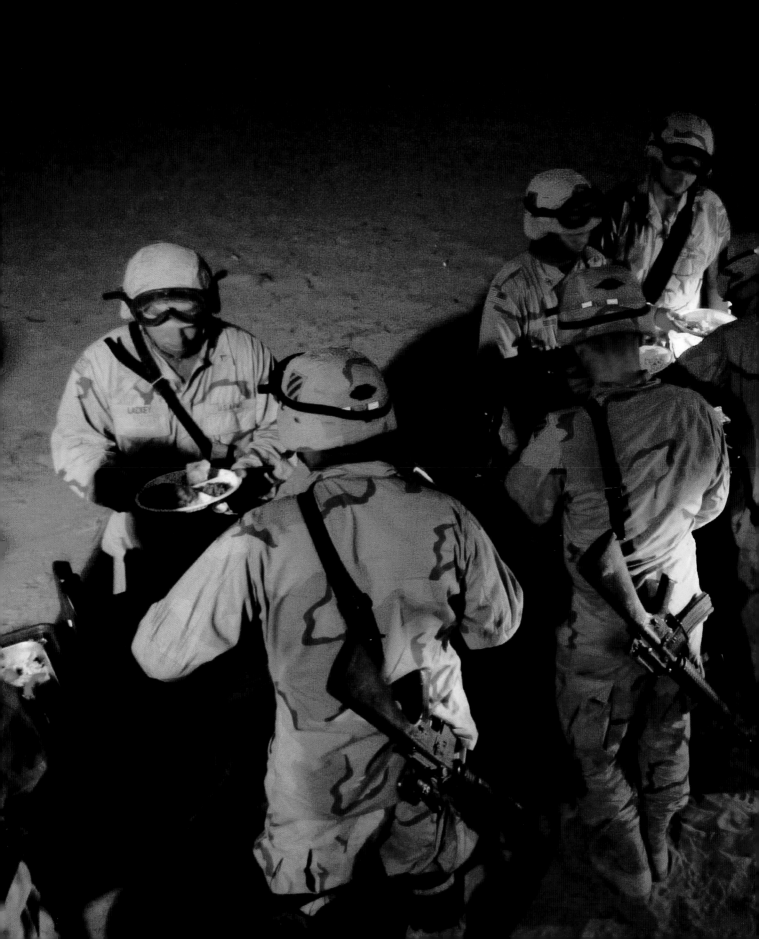

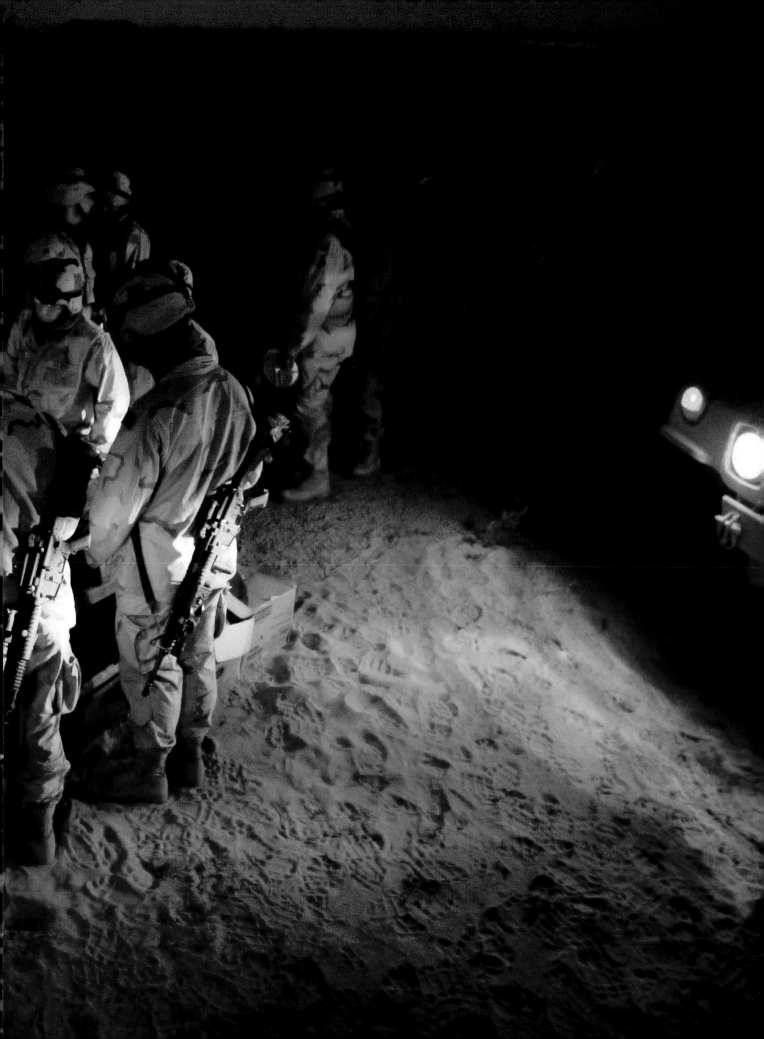

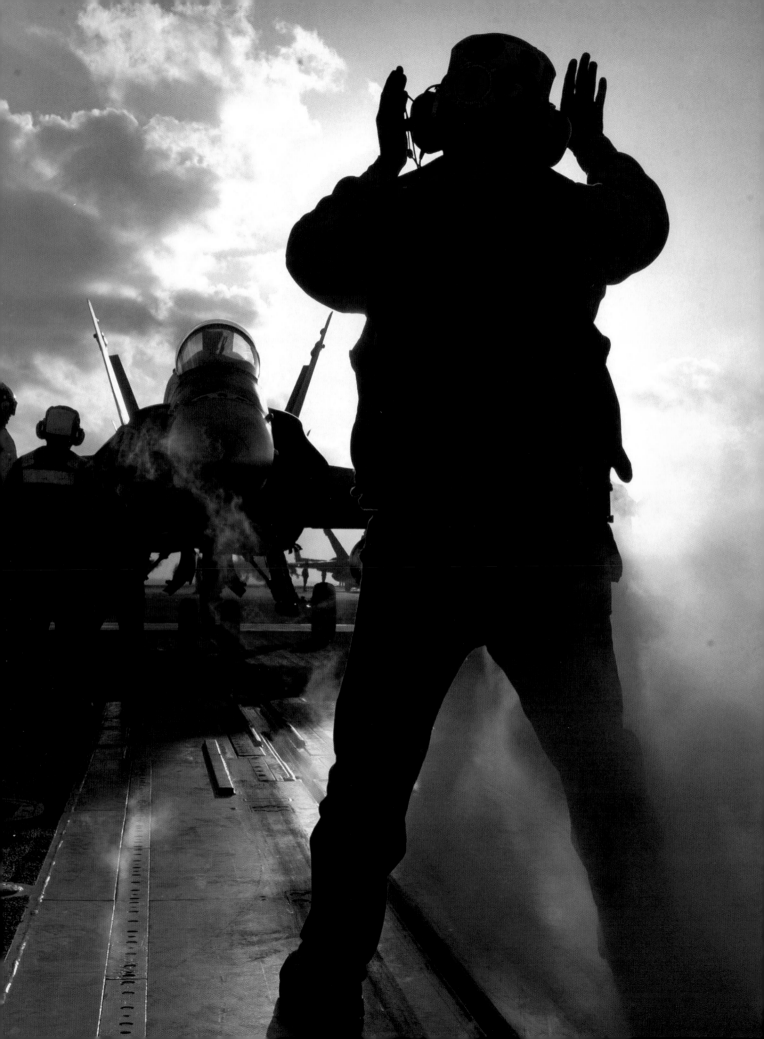

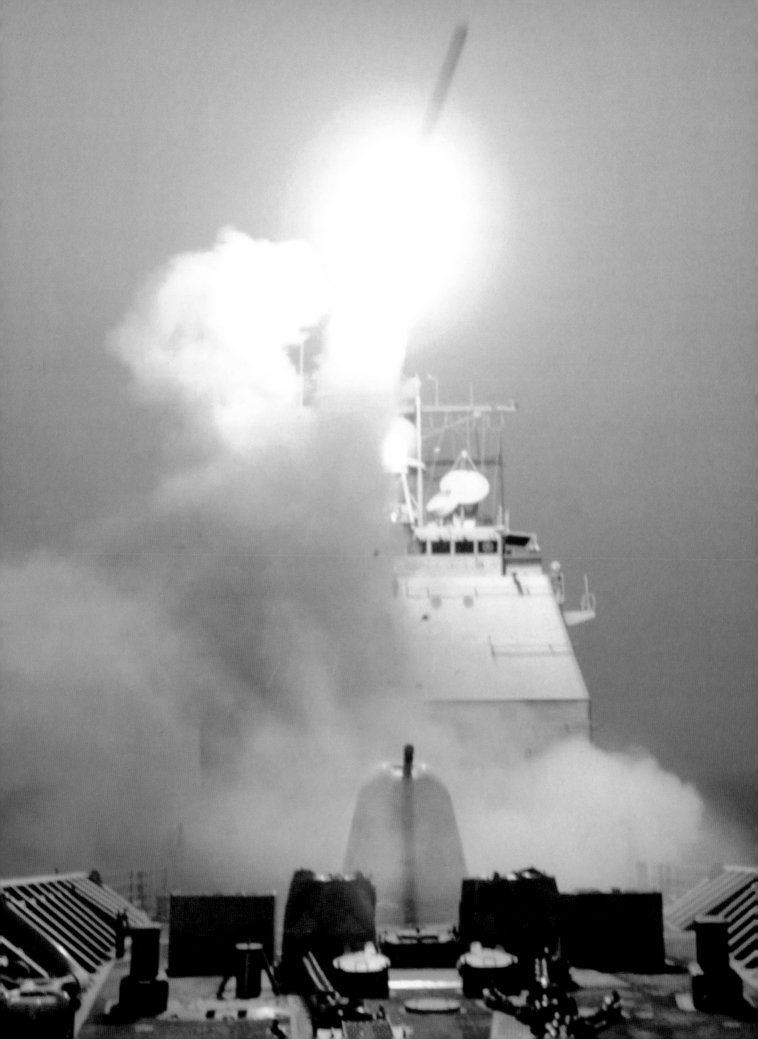

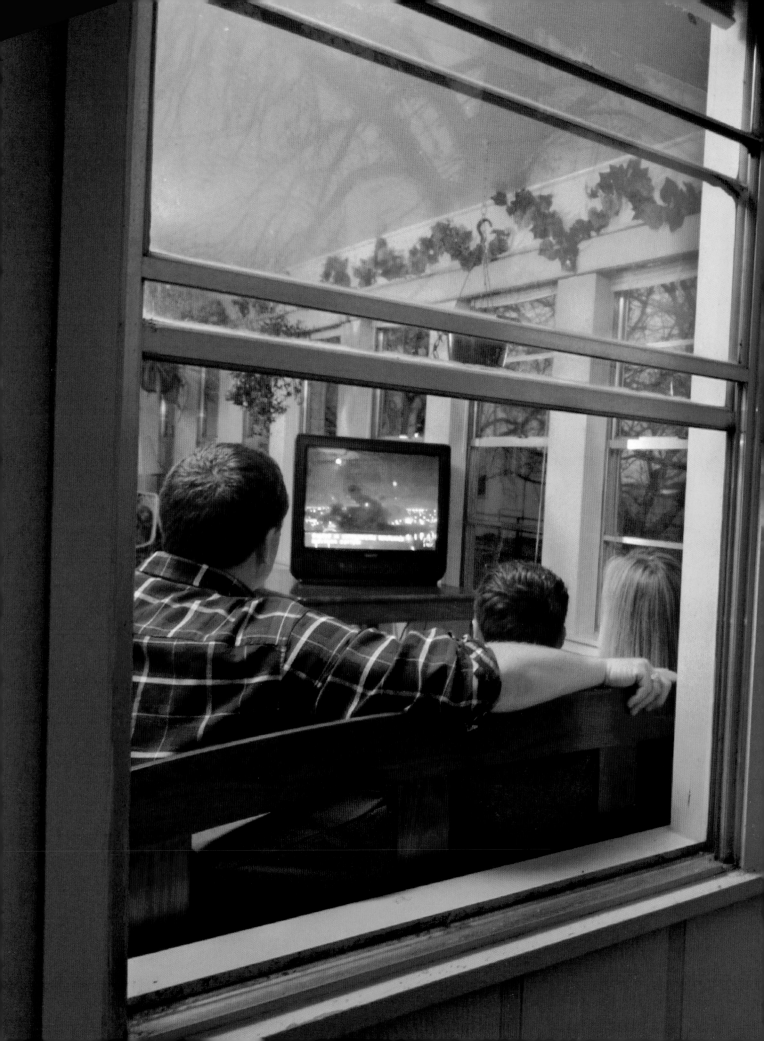

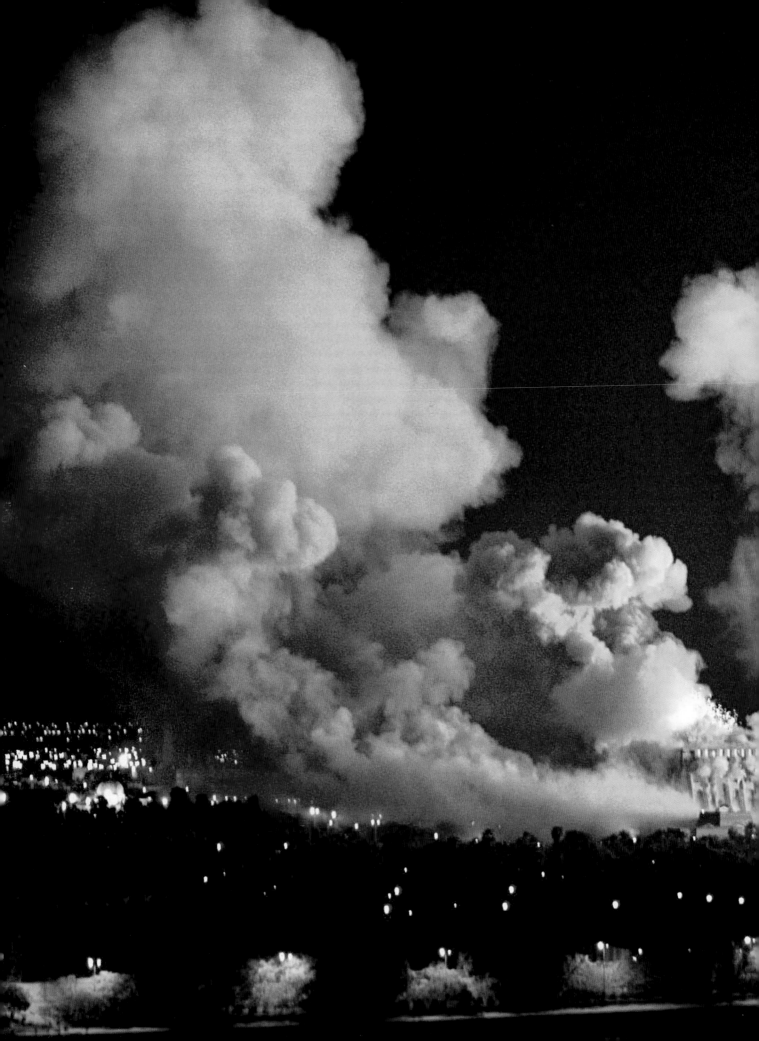

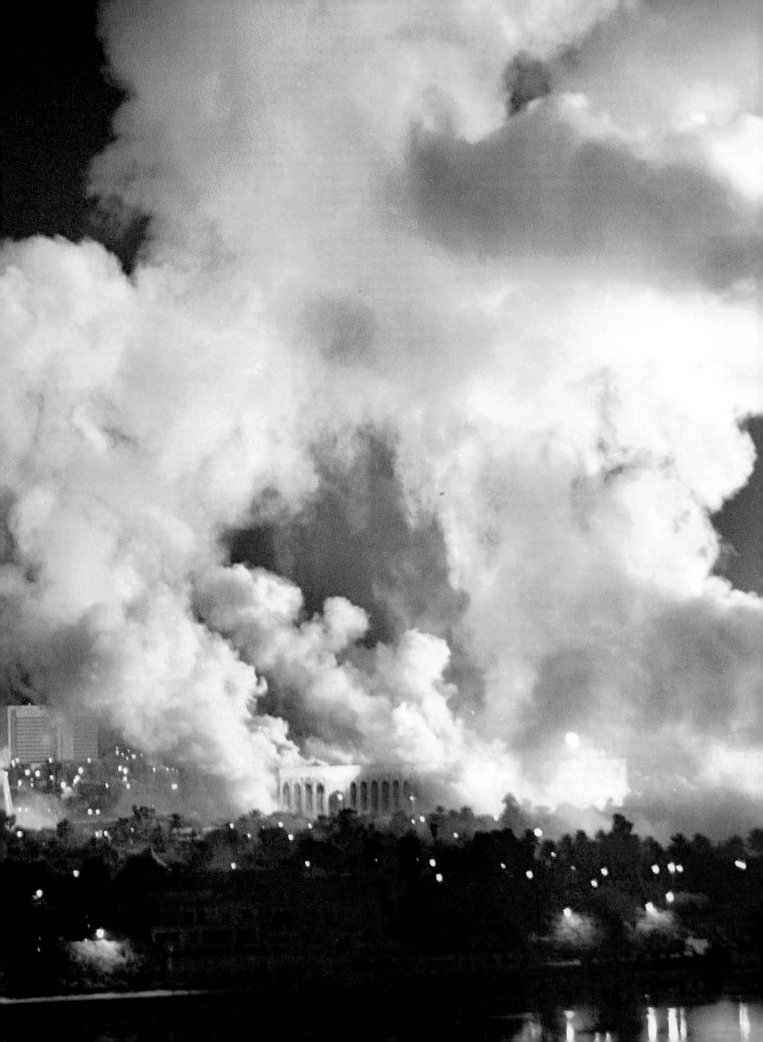

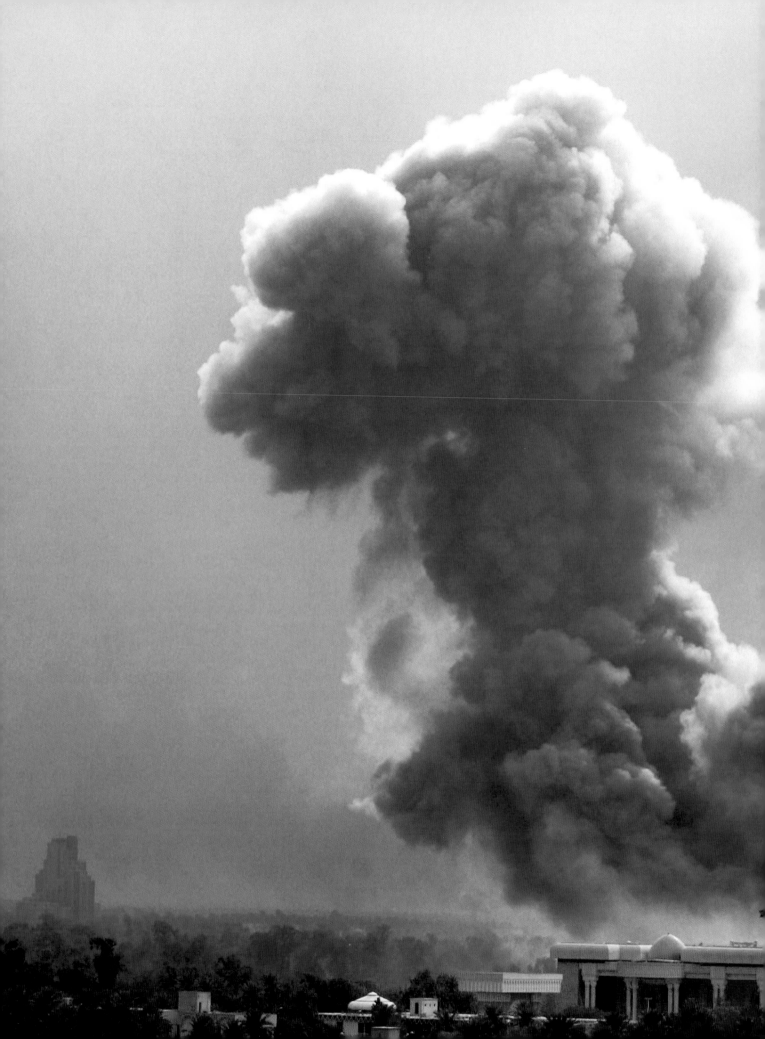

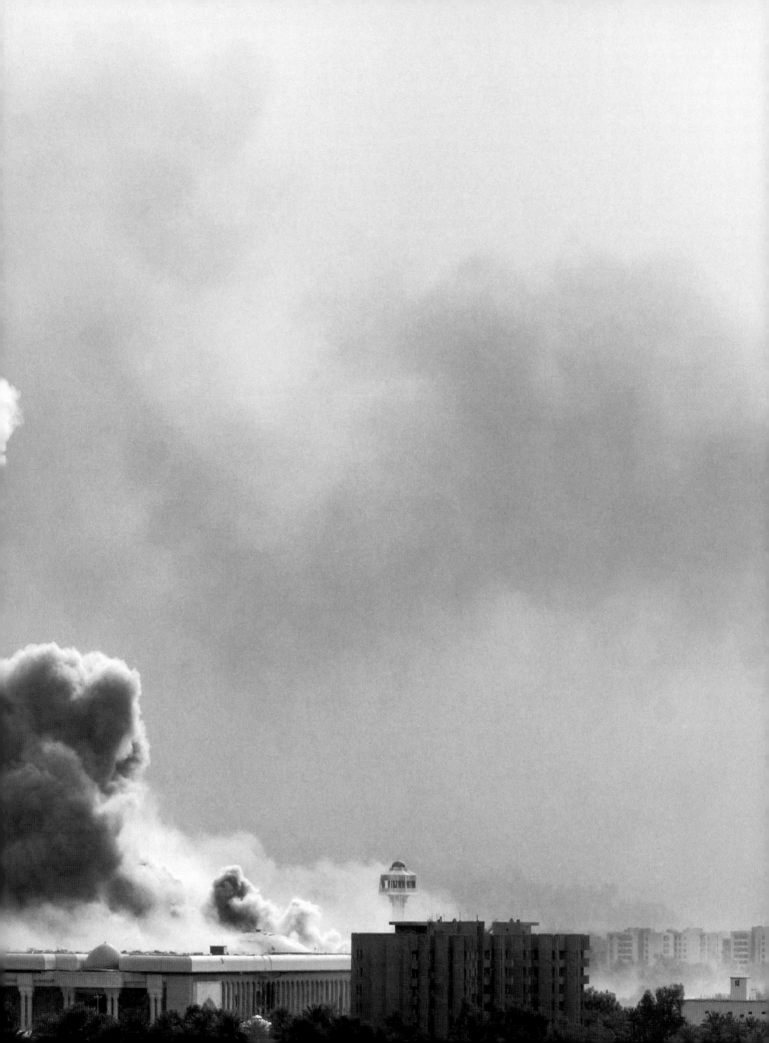

WAR

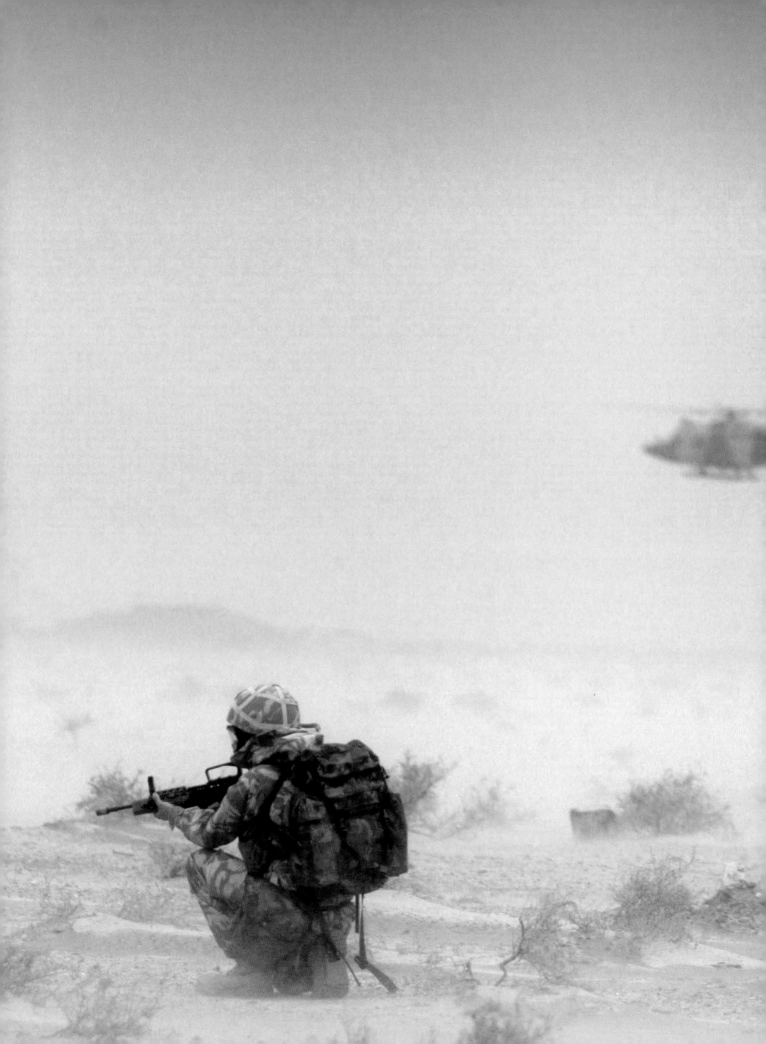

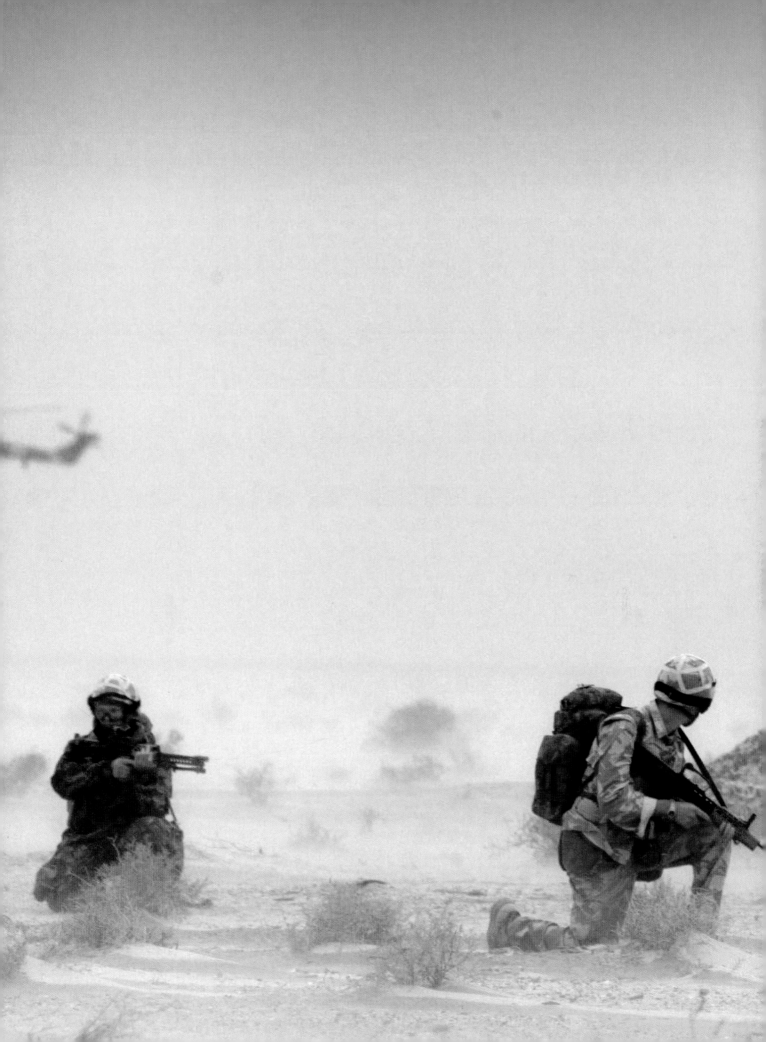

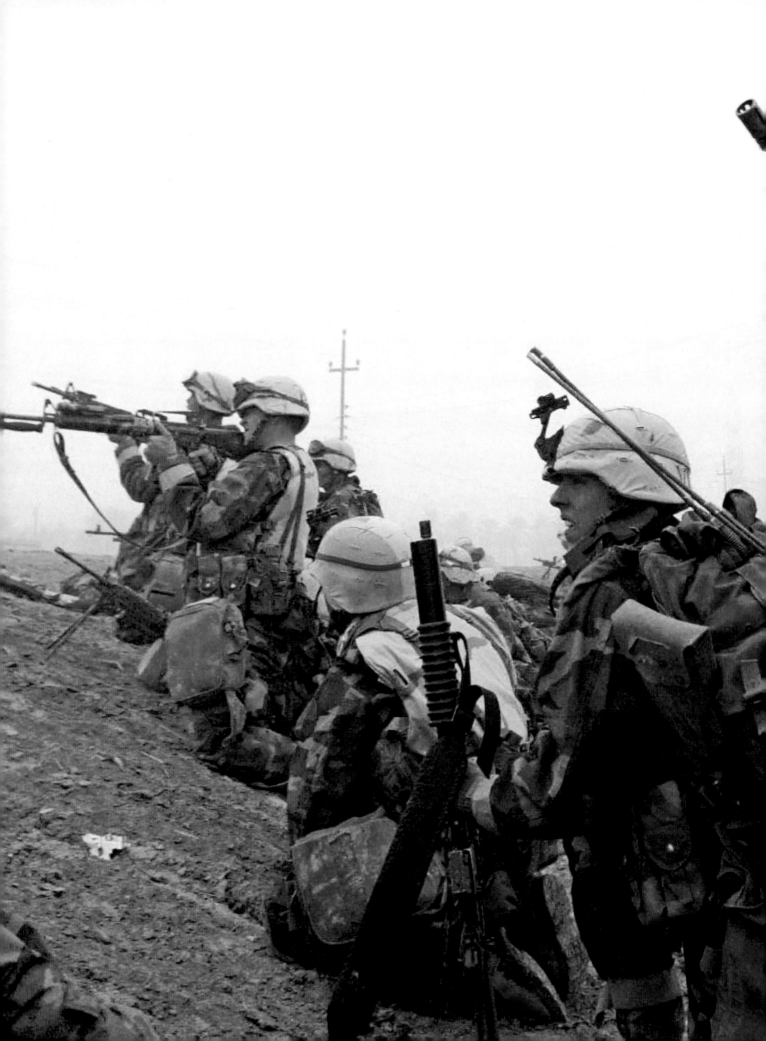

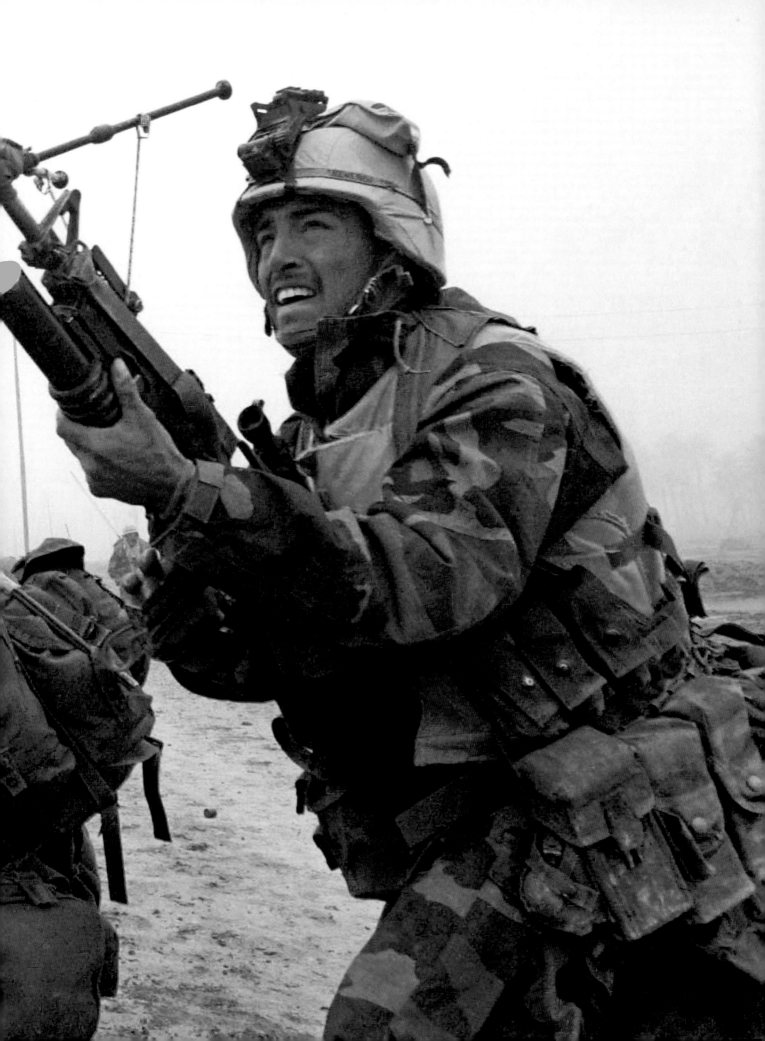

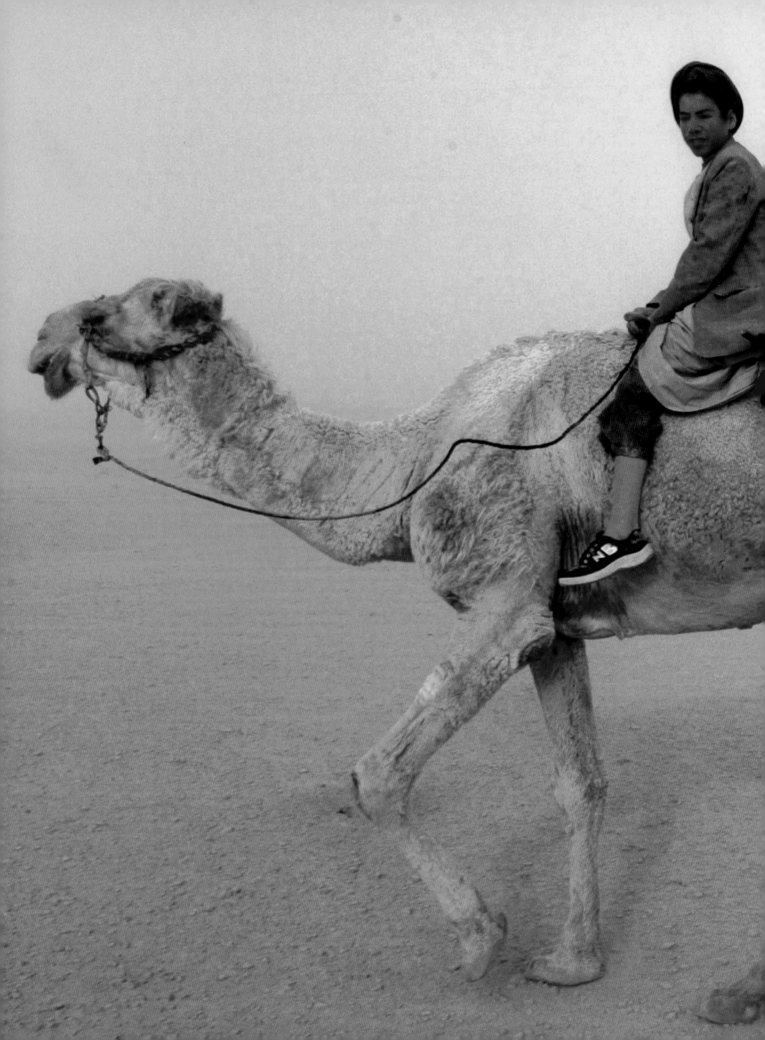

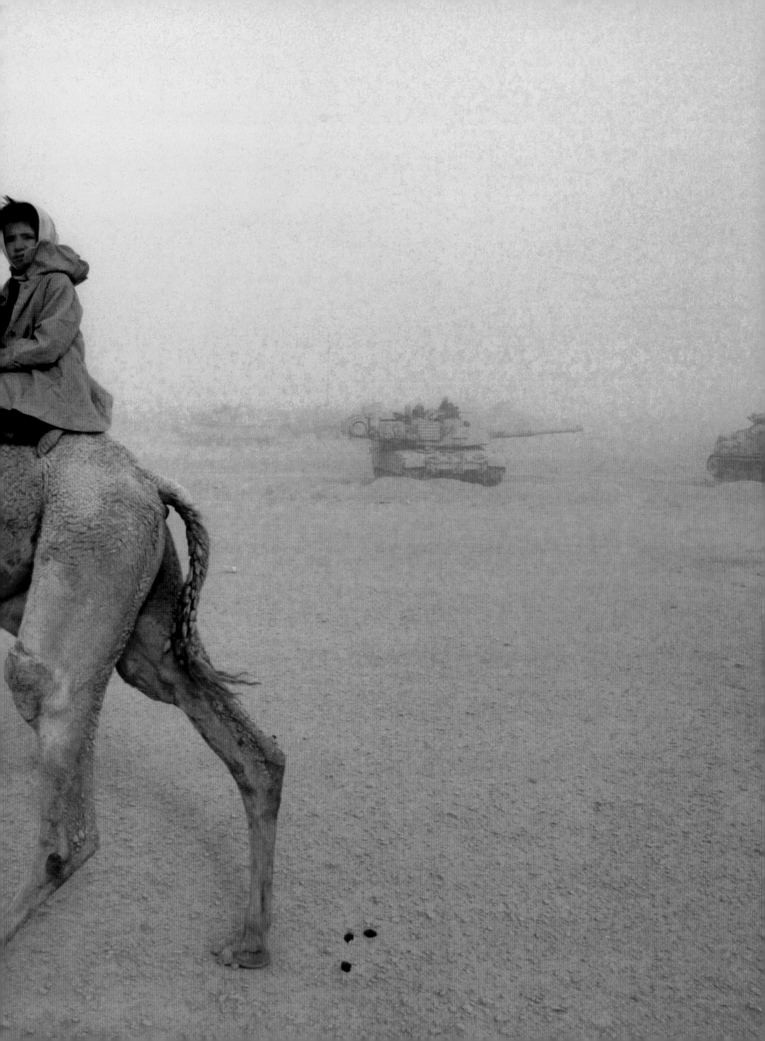

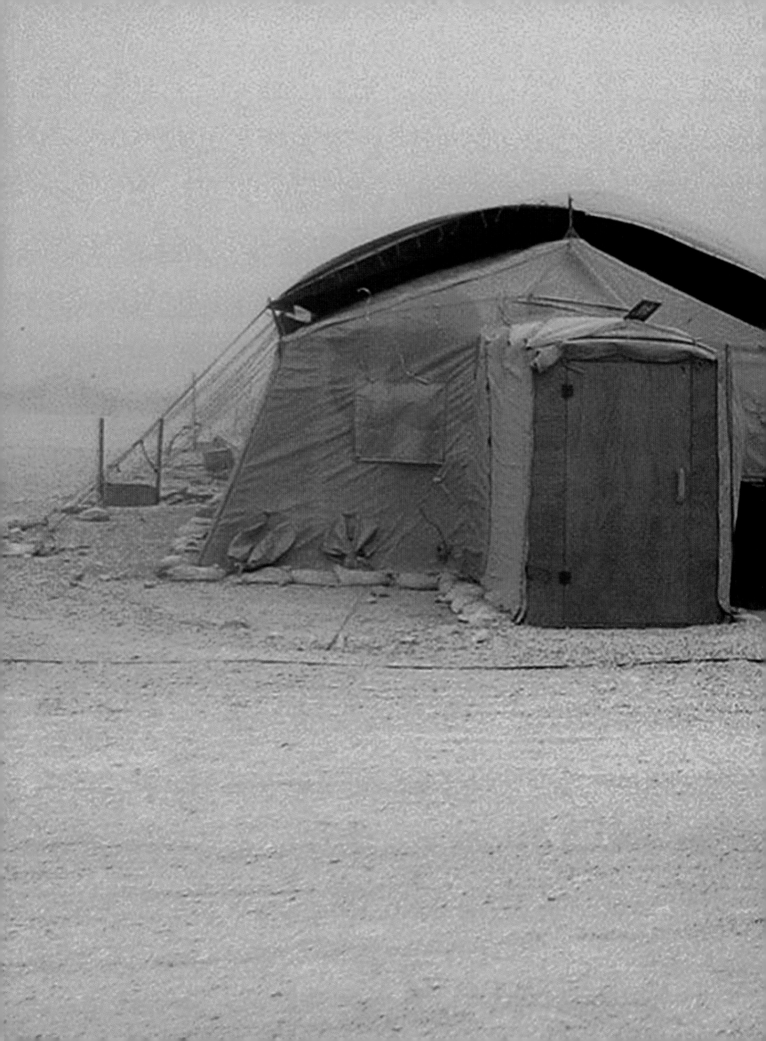

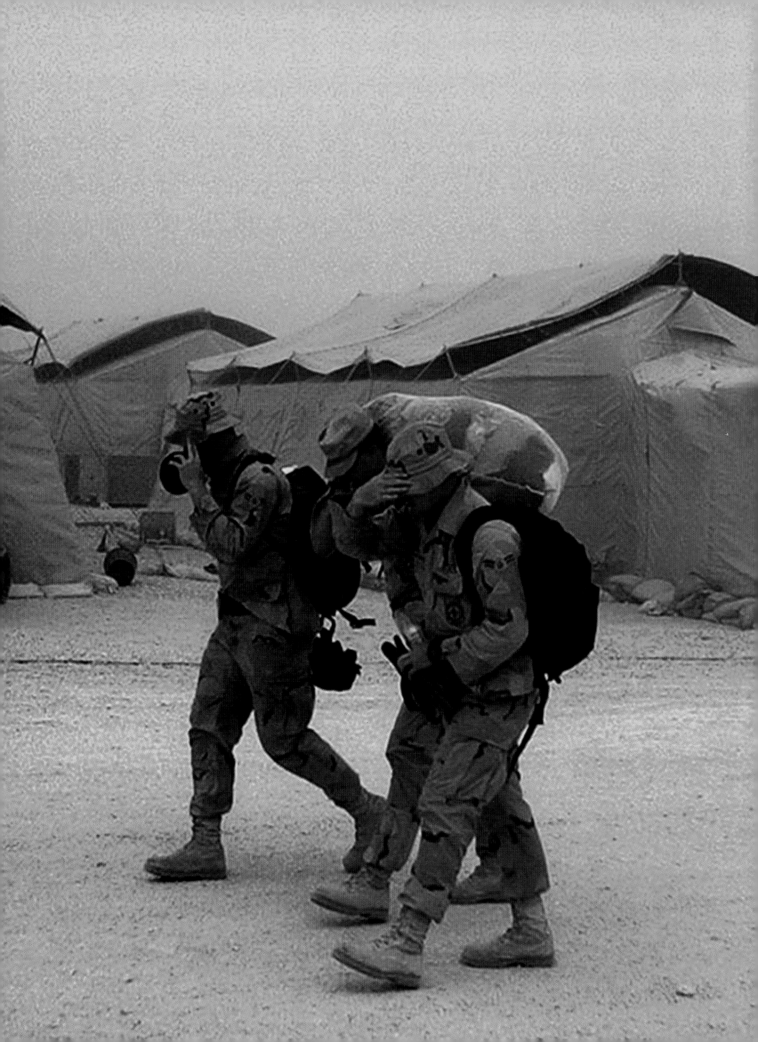

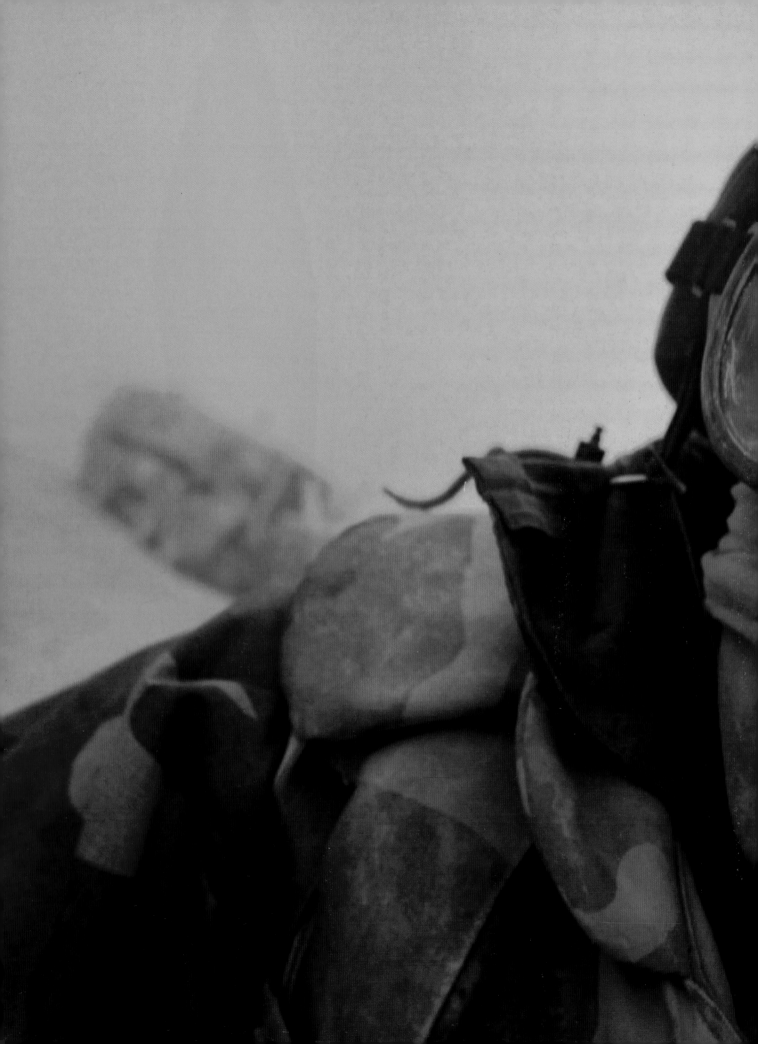

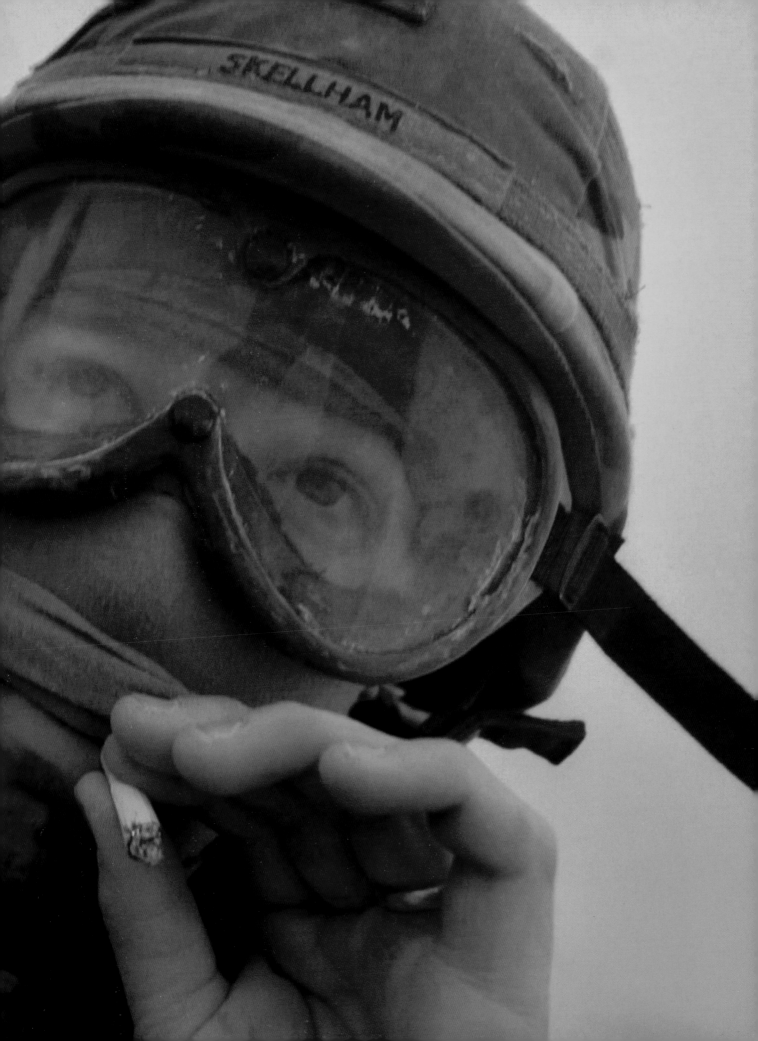

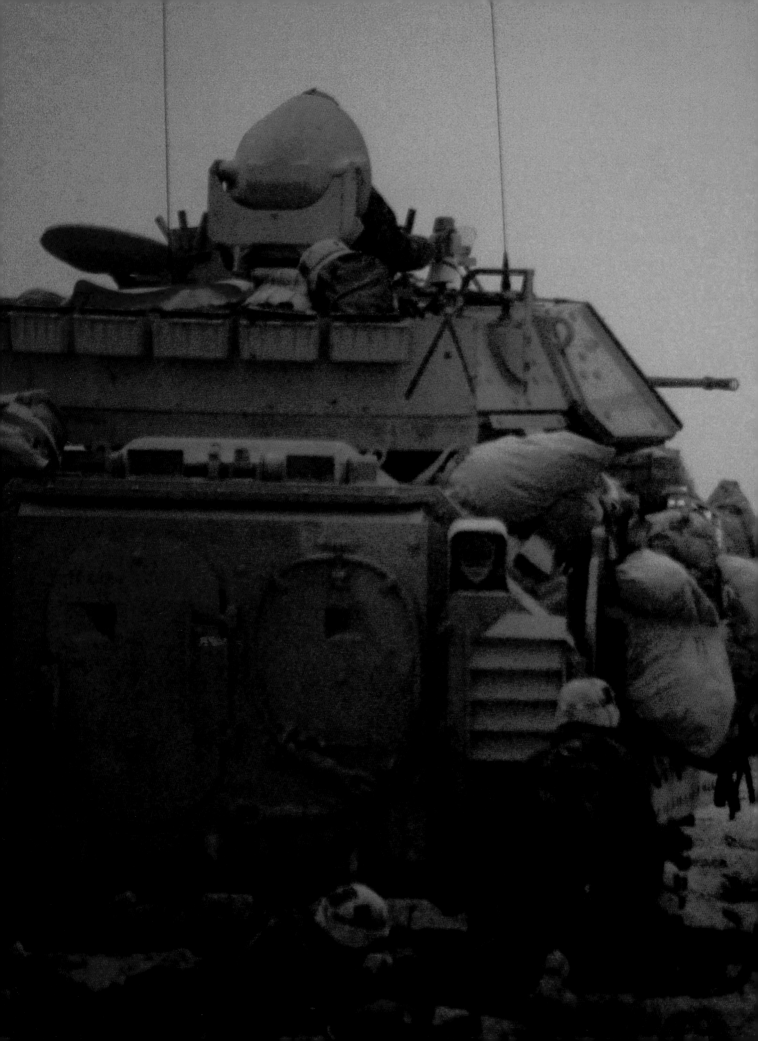

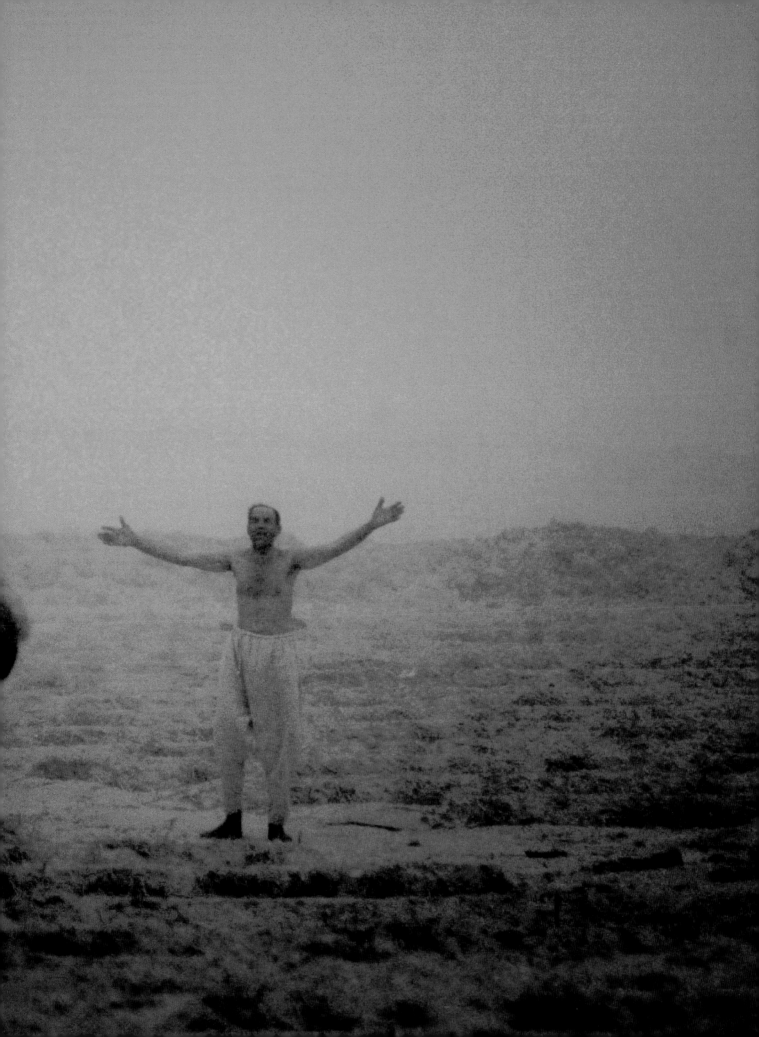

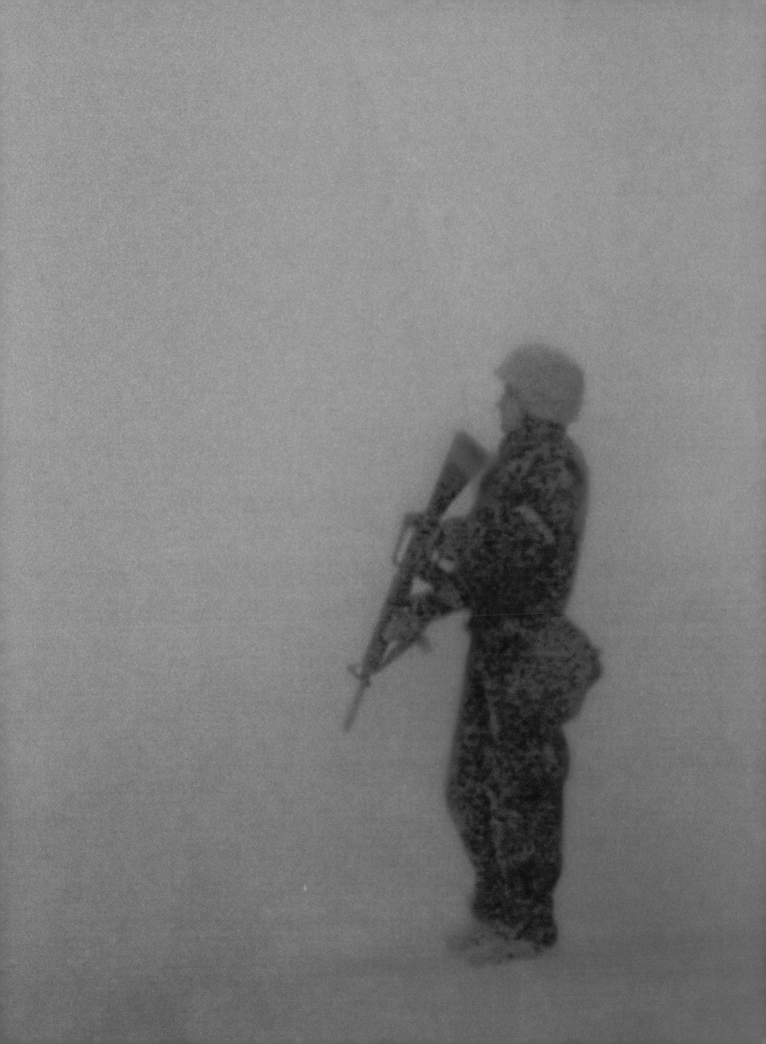

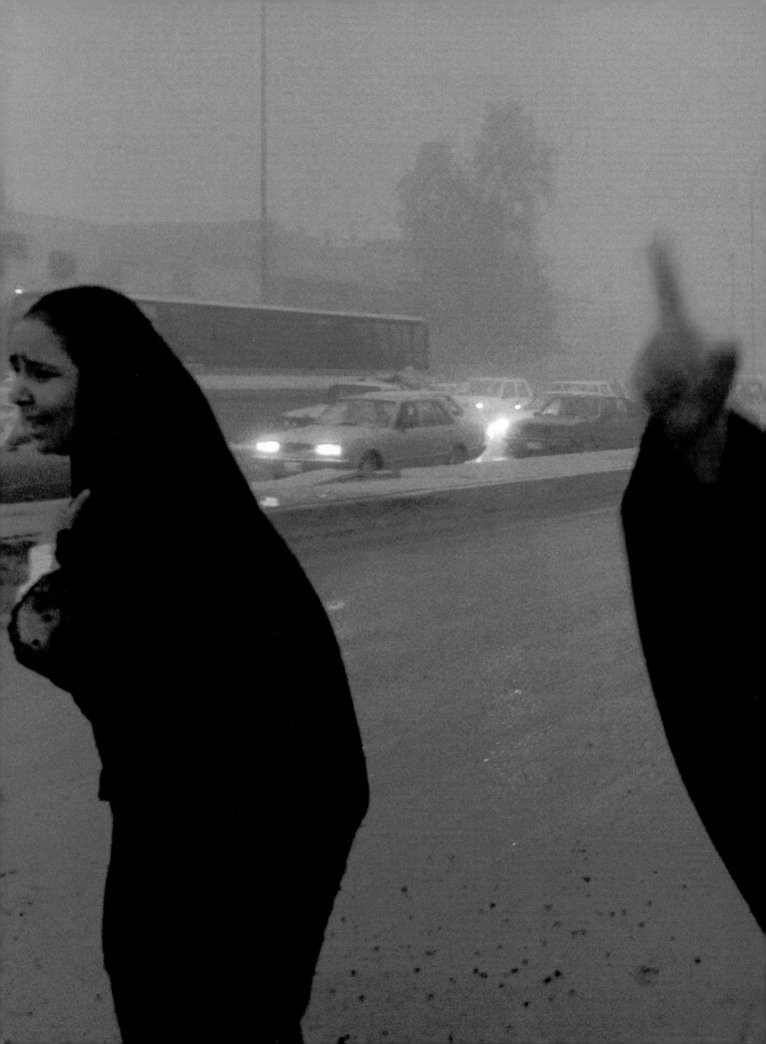

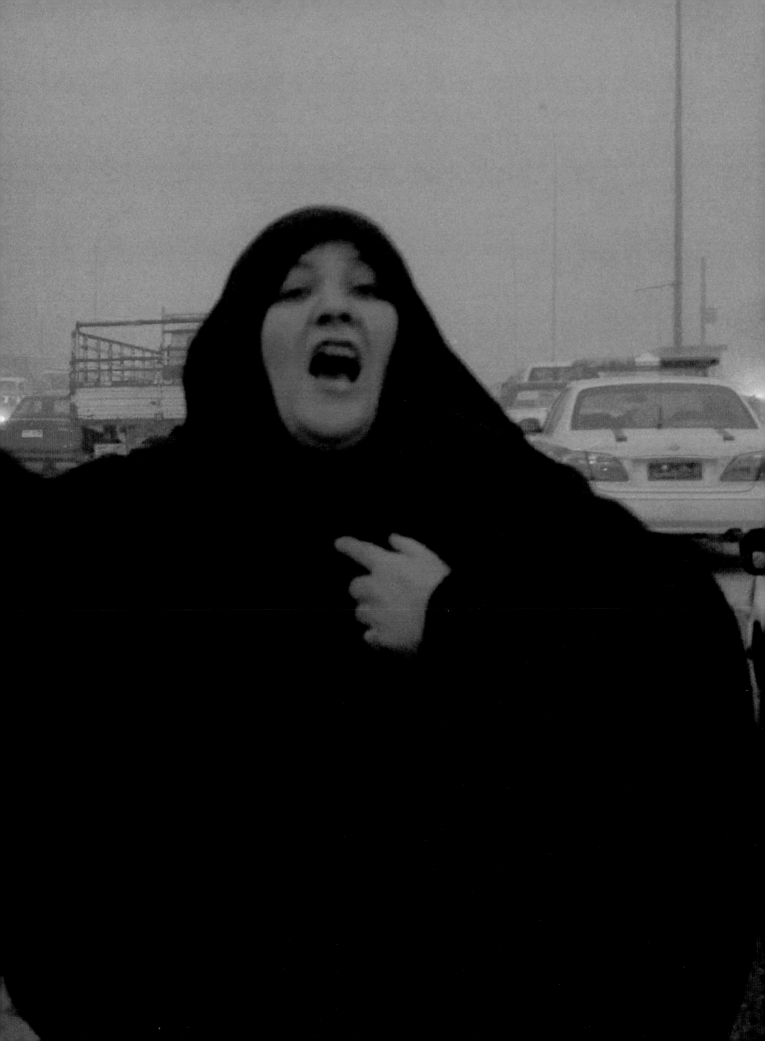

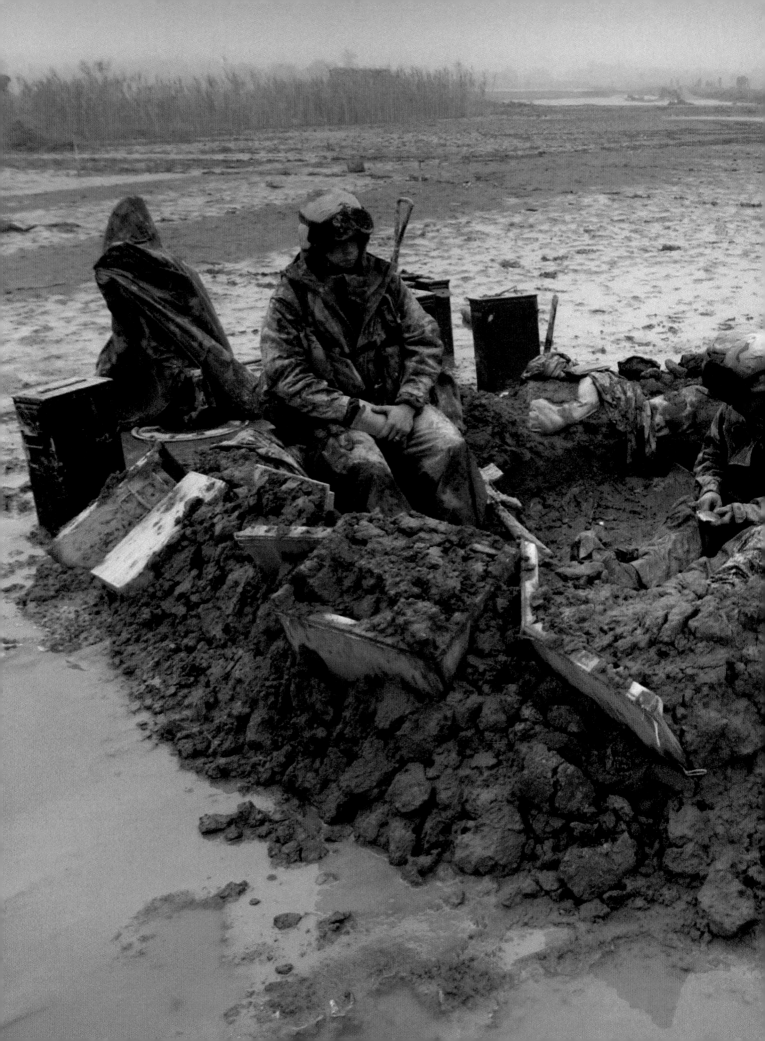

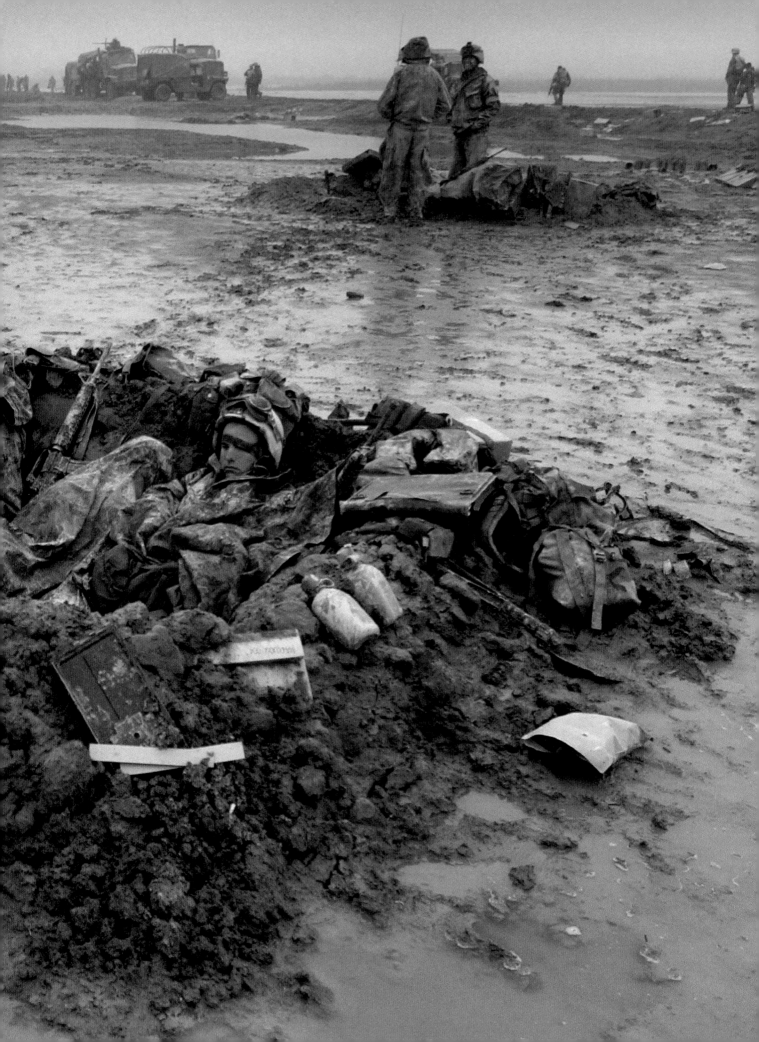

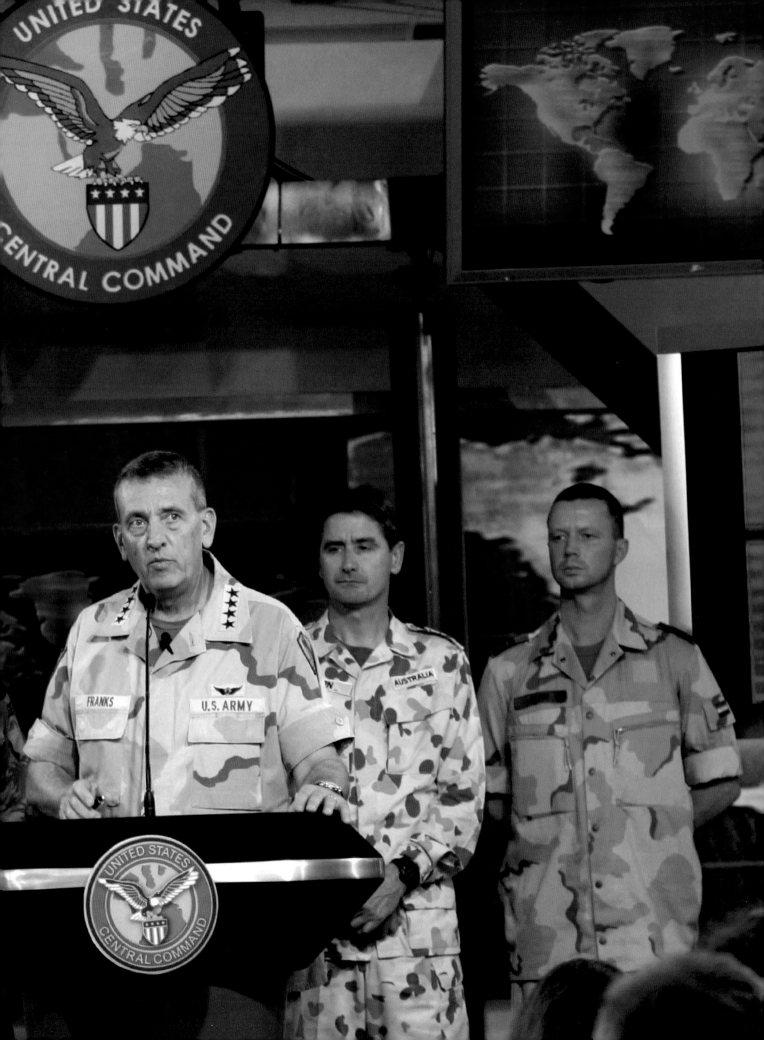

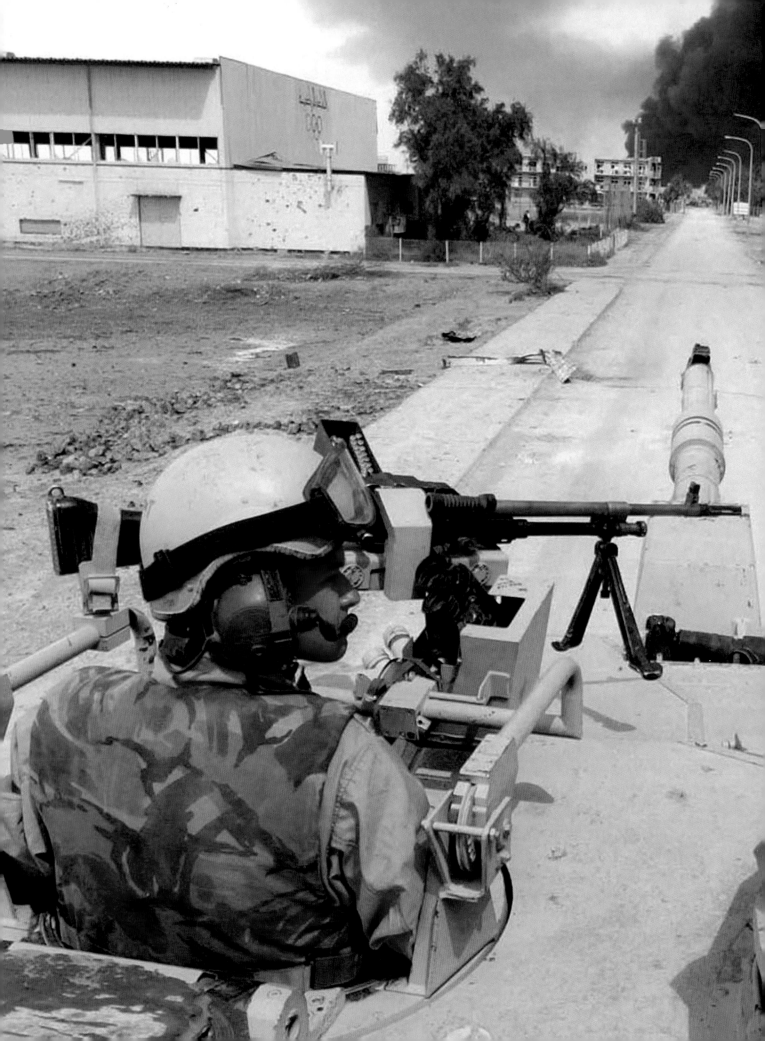

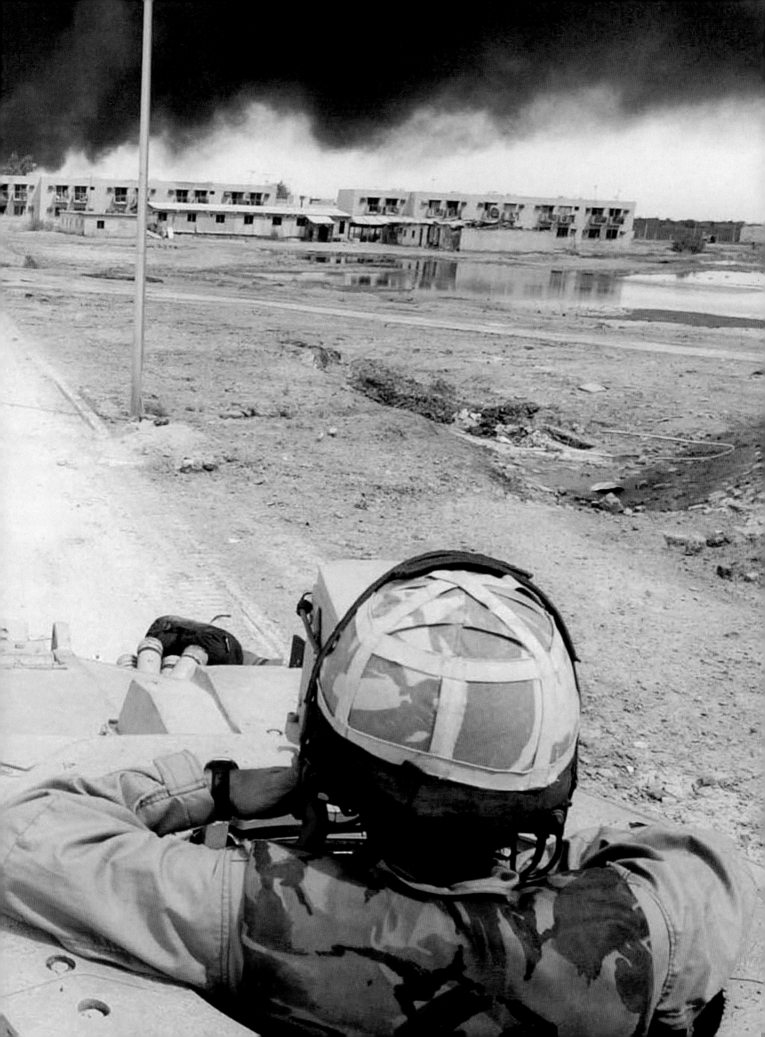

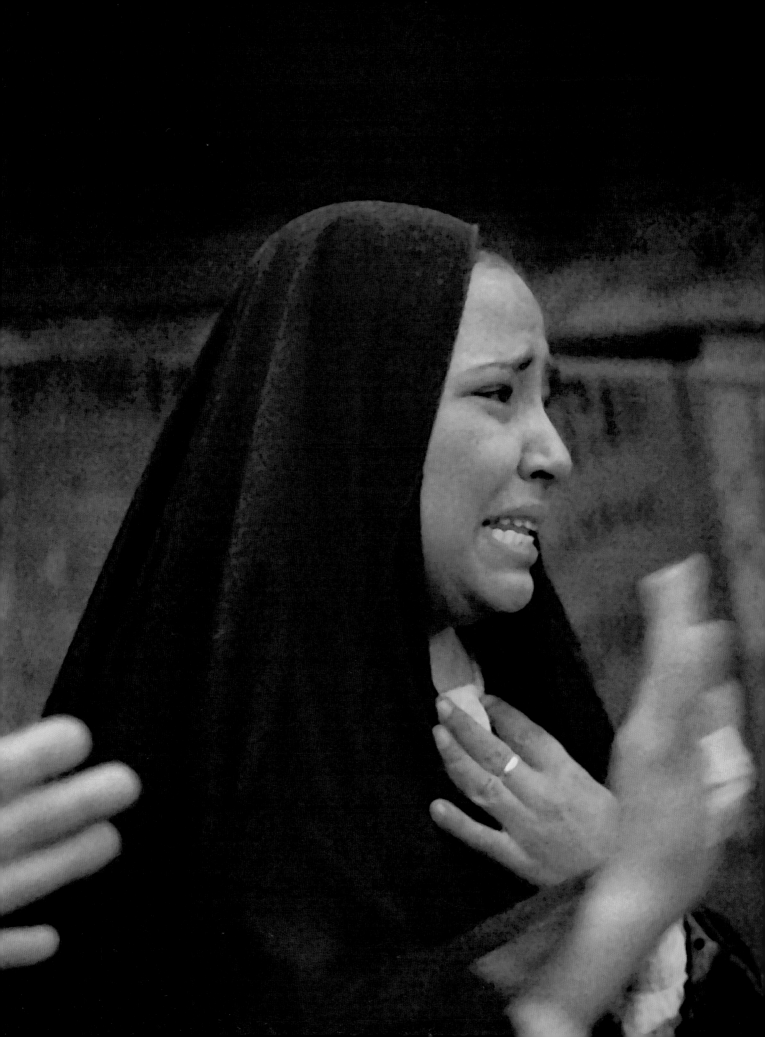

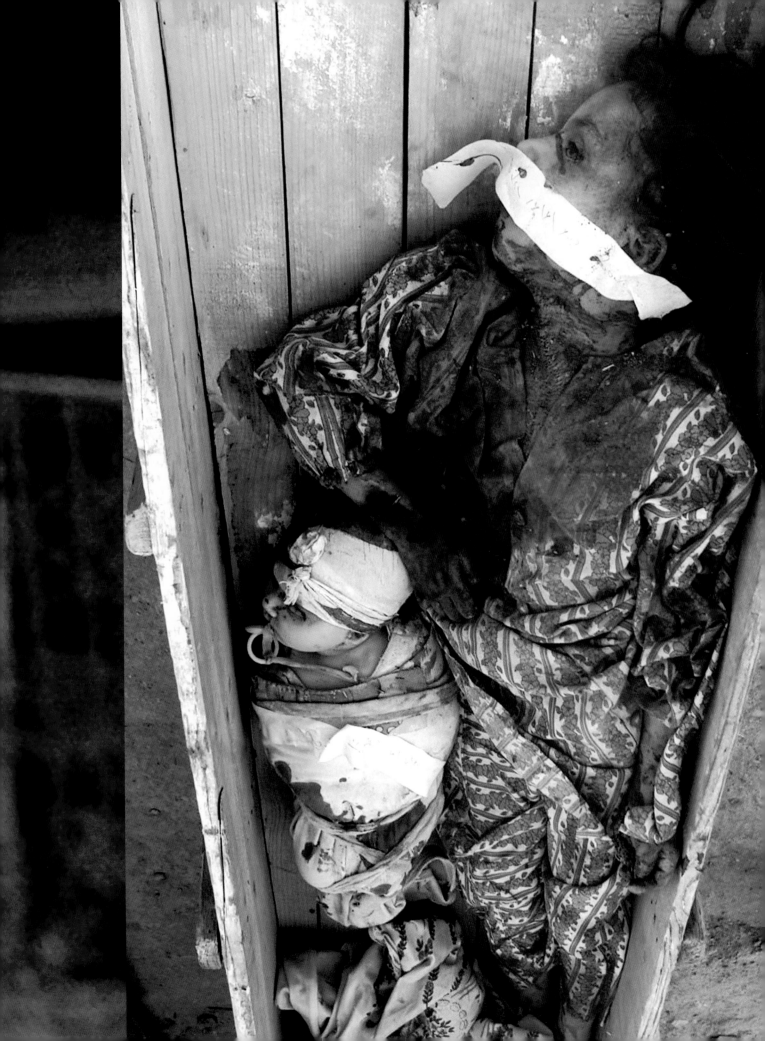

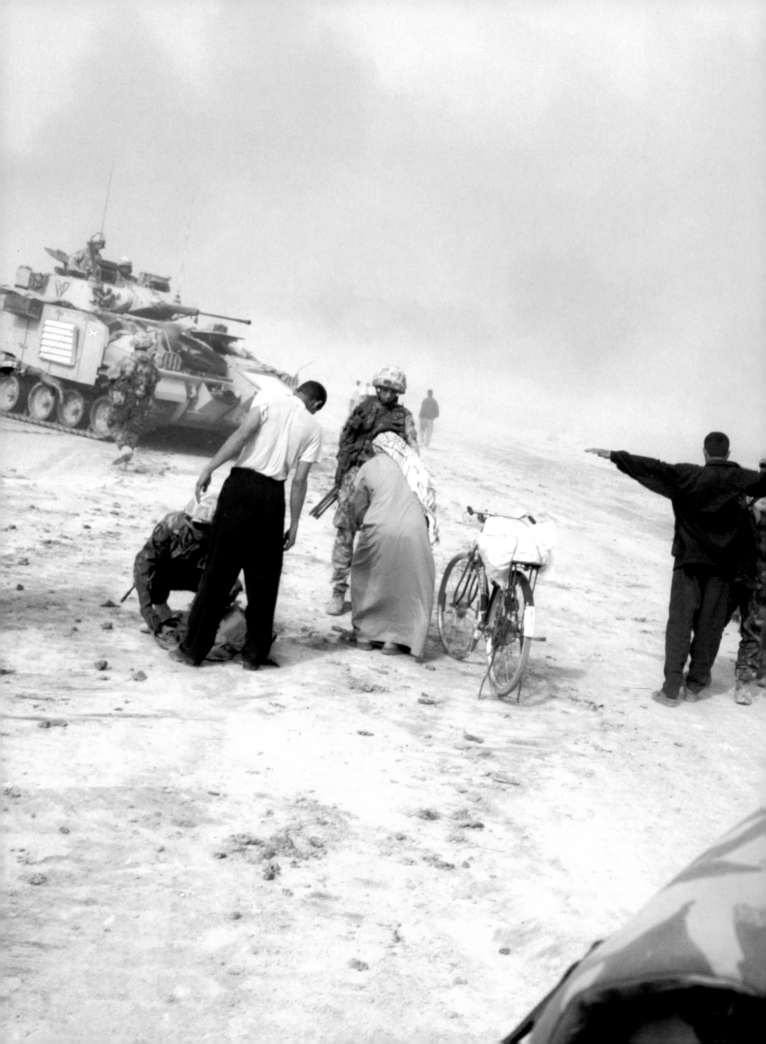

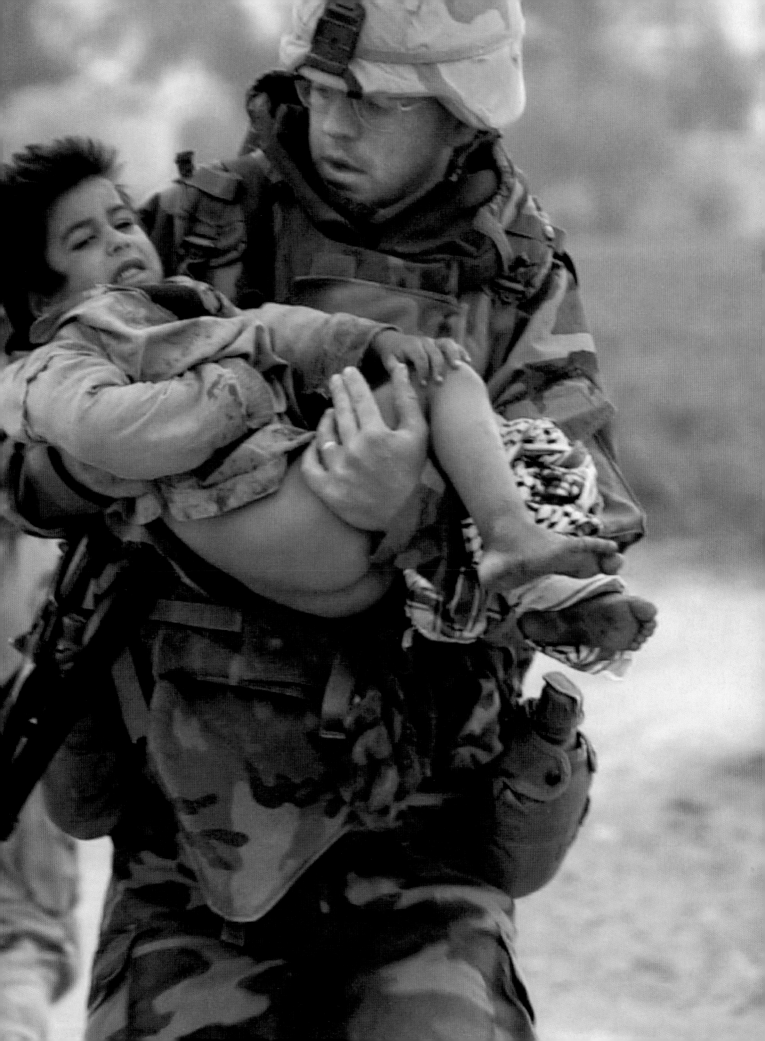

تسقط امريكا

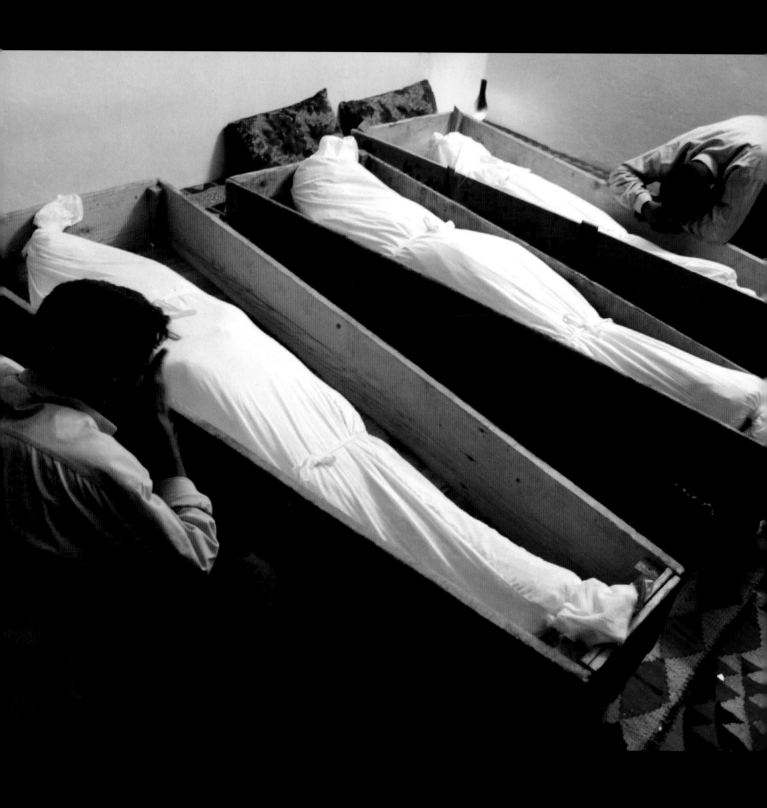

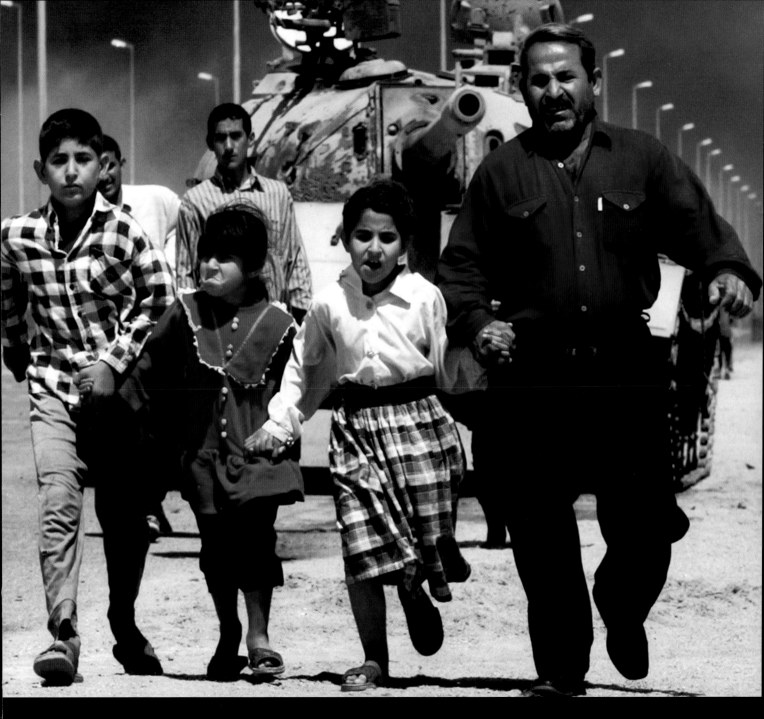

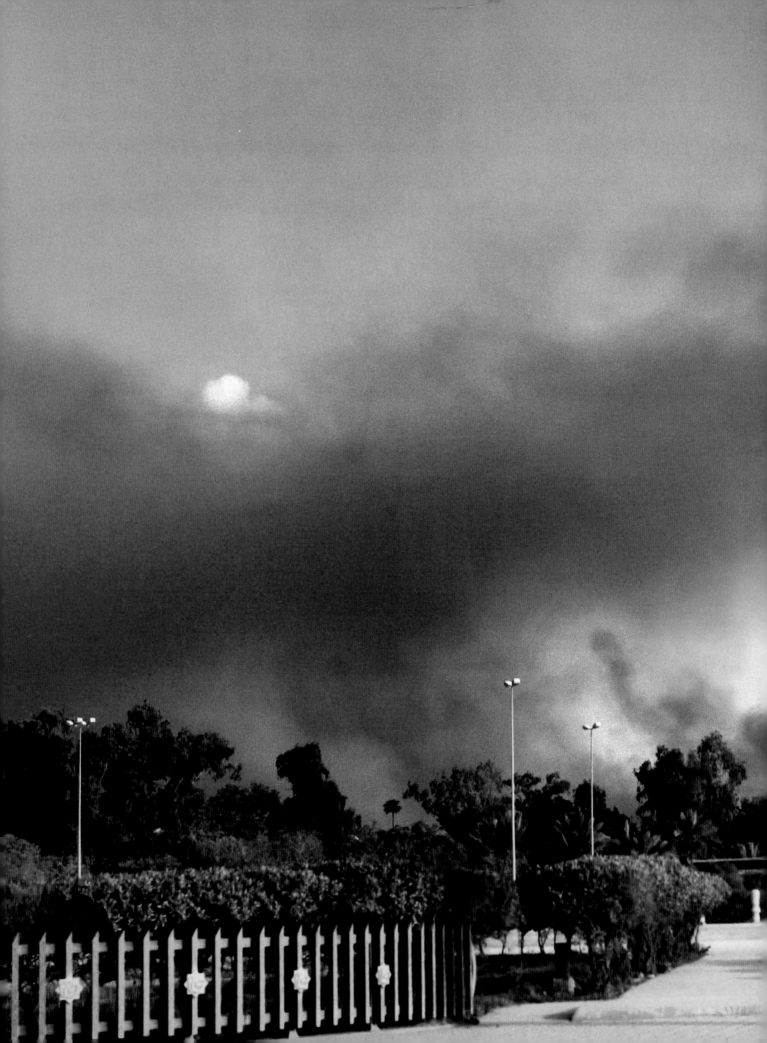

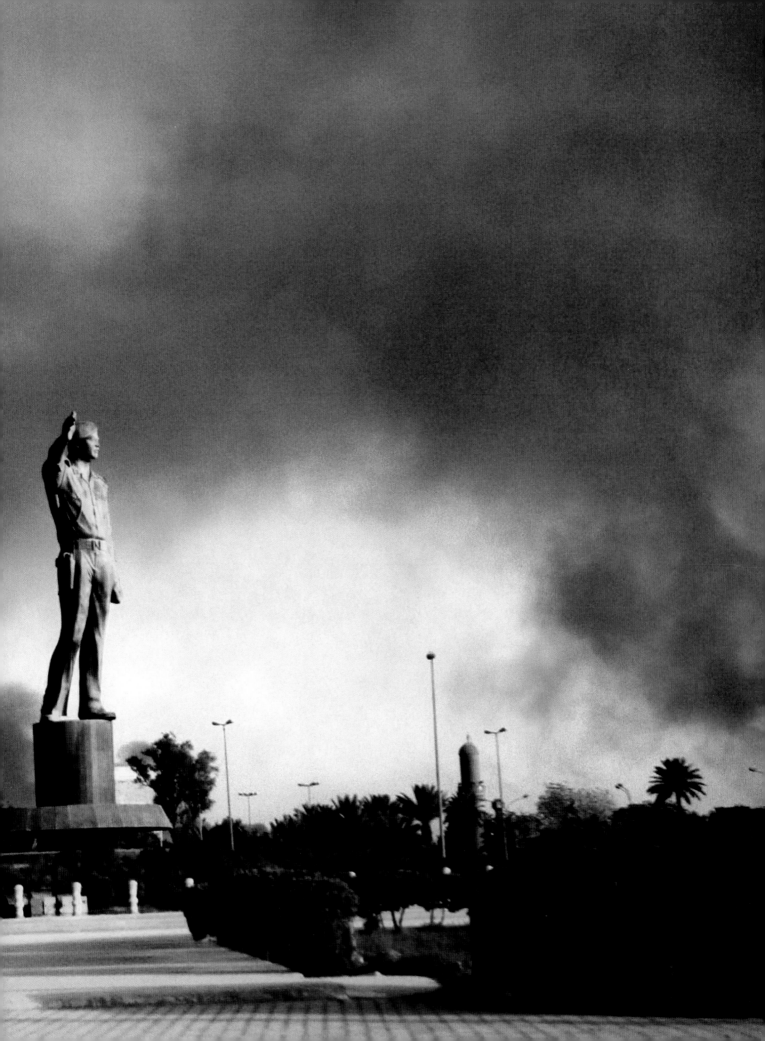

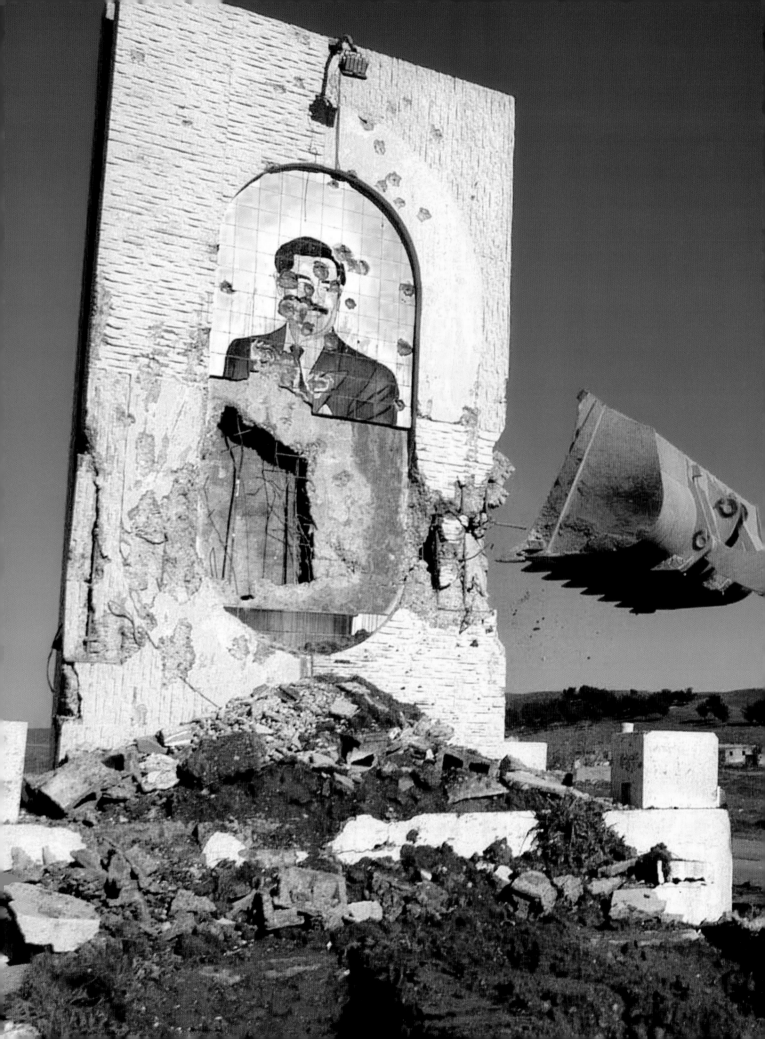

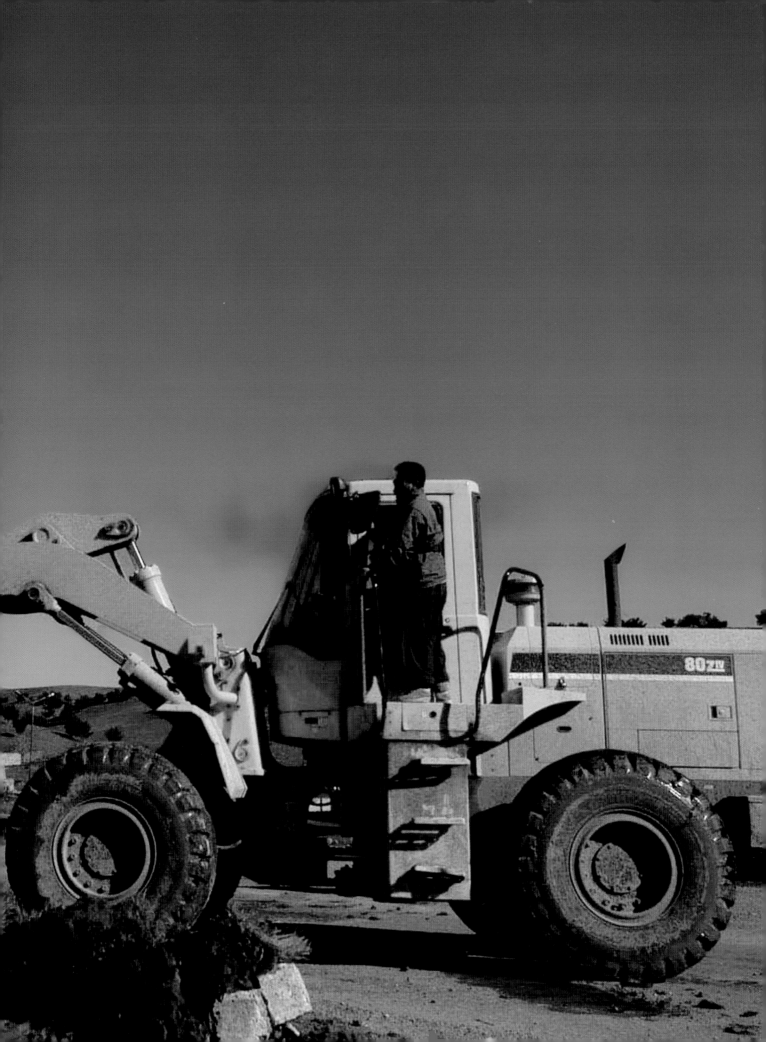

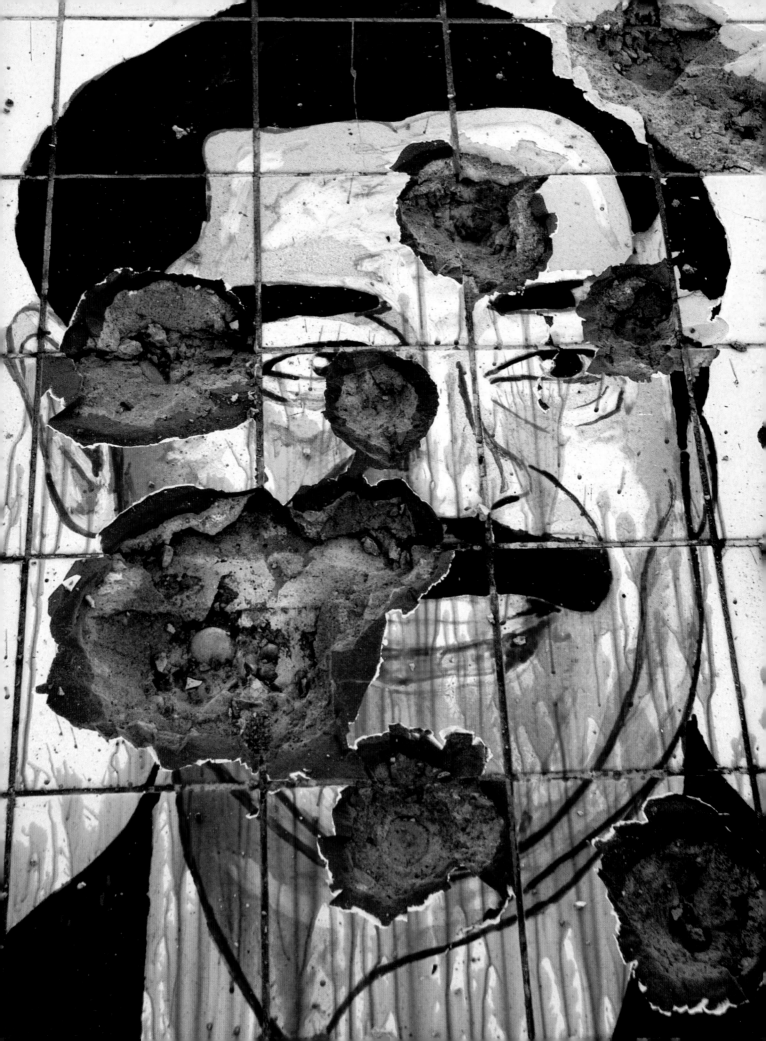

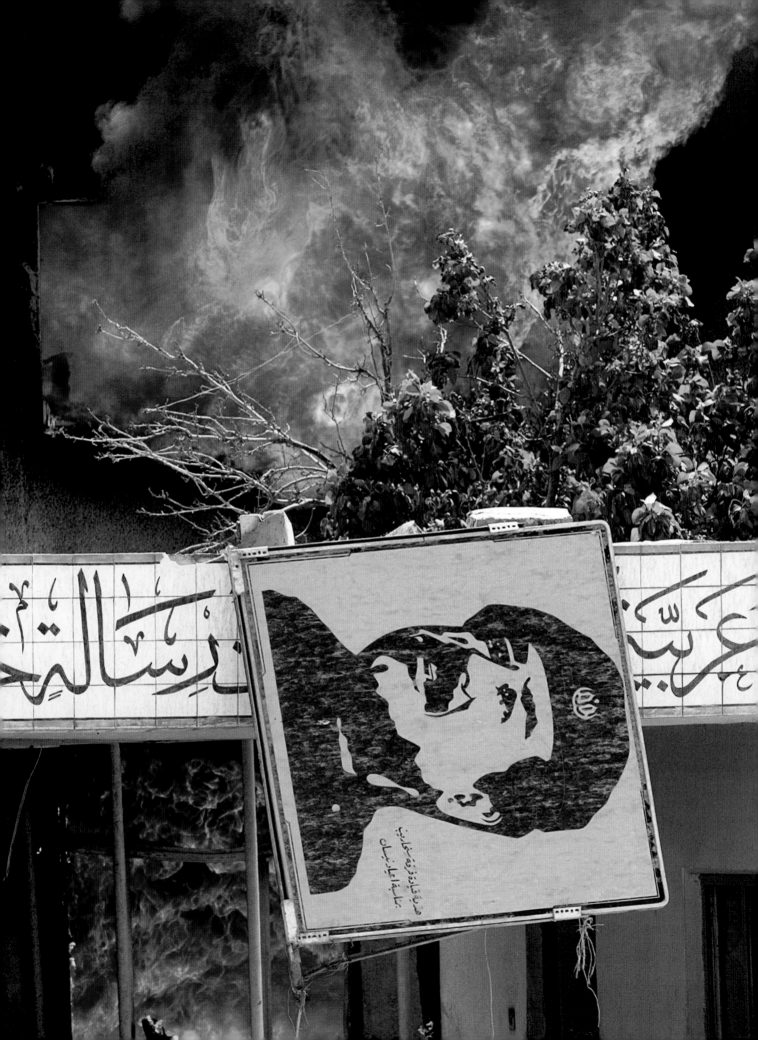

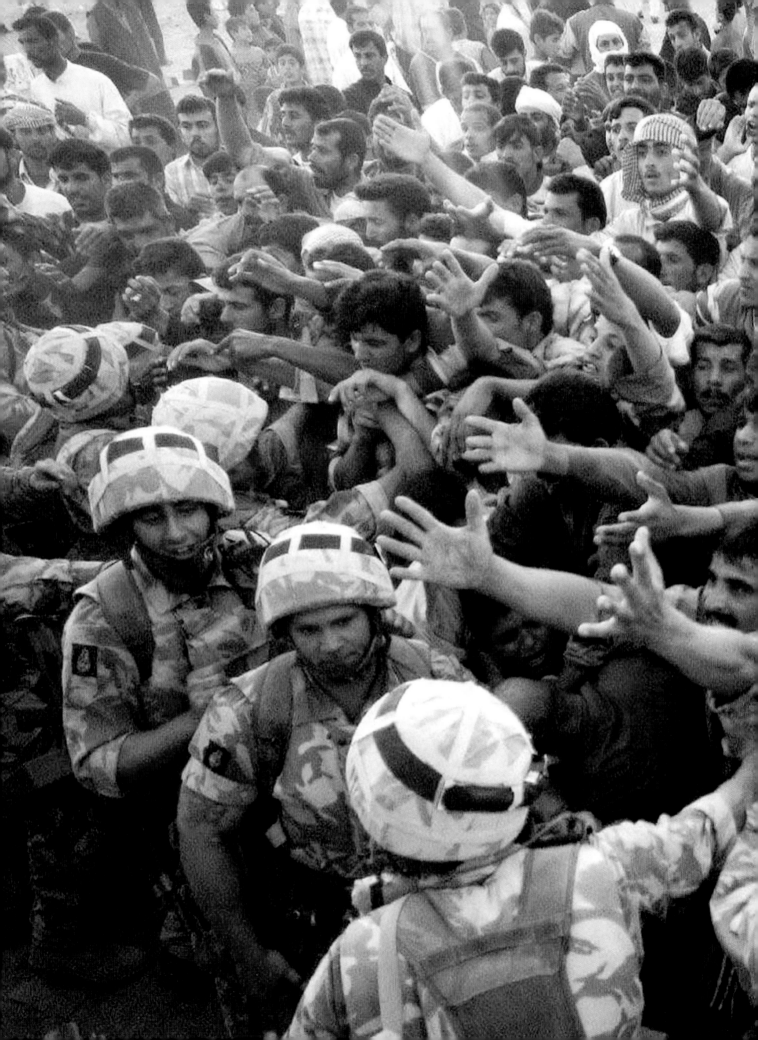

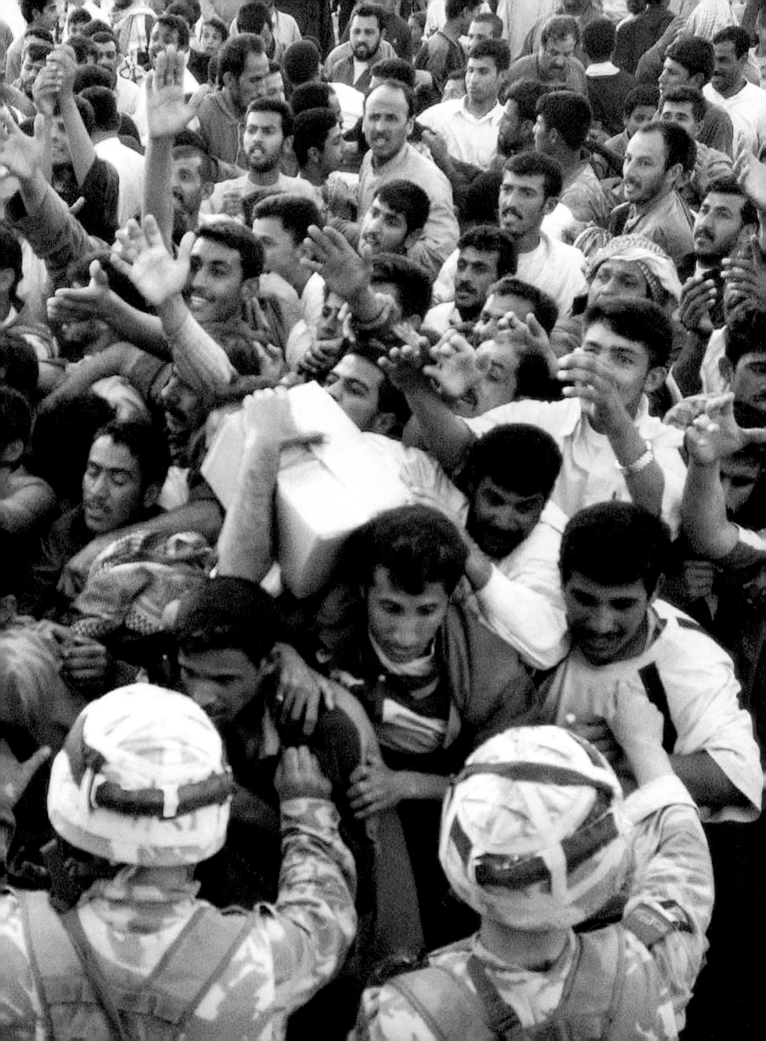

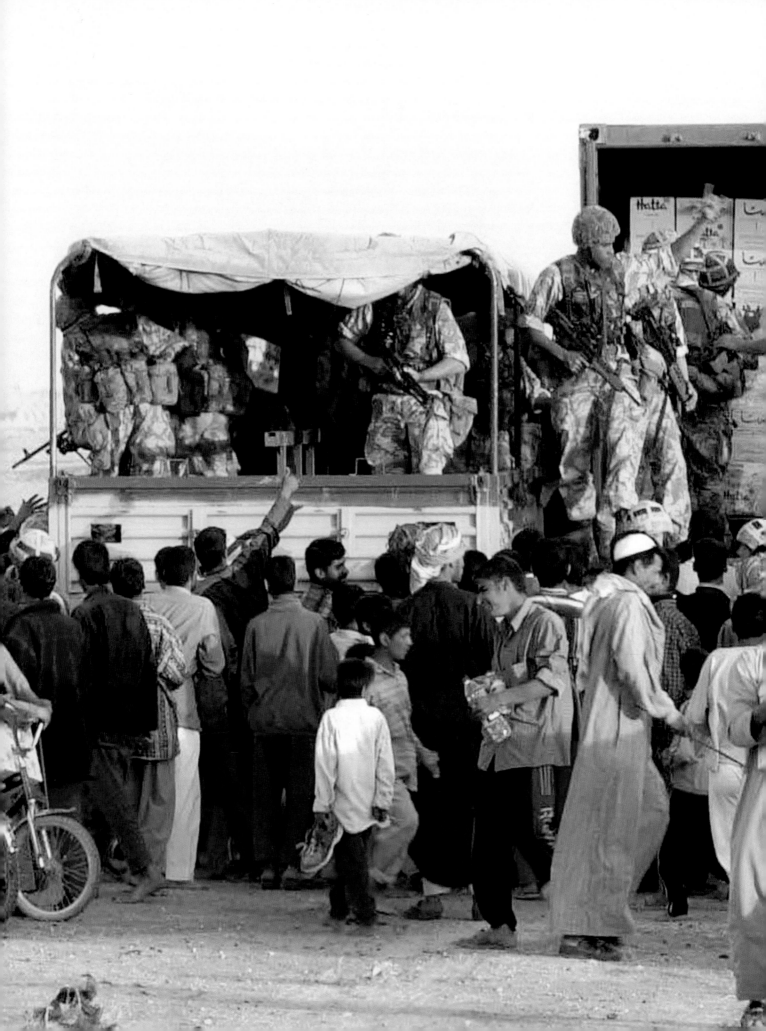

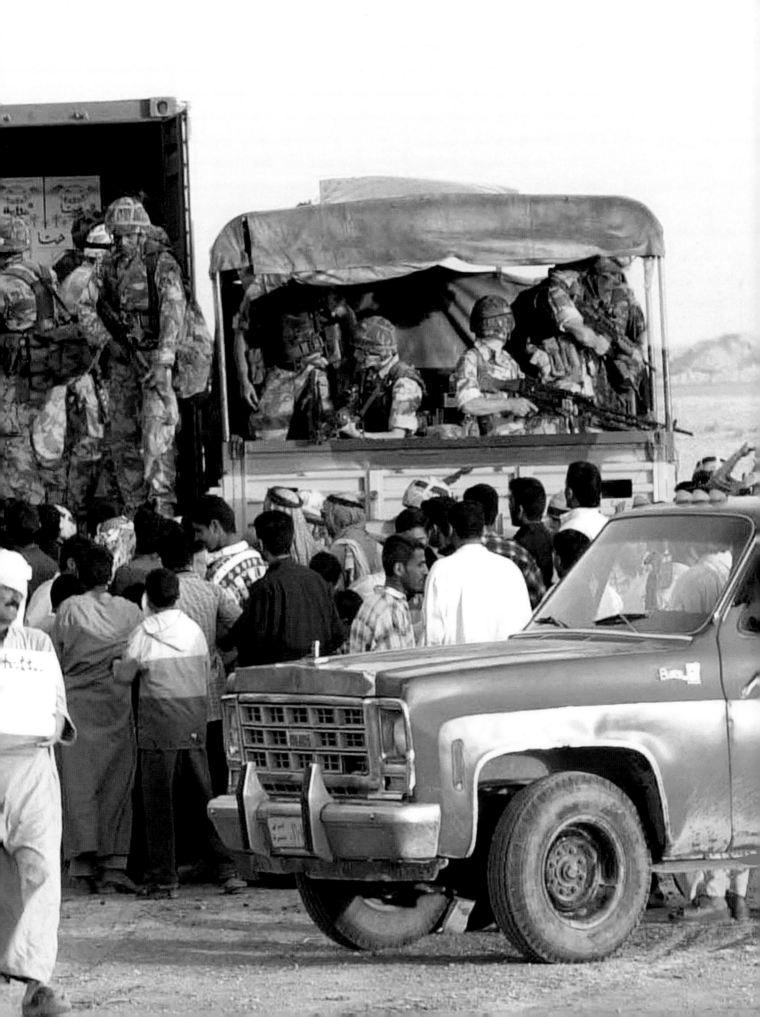

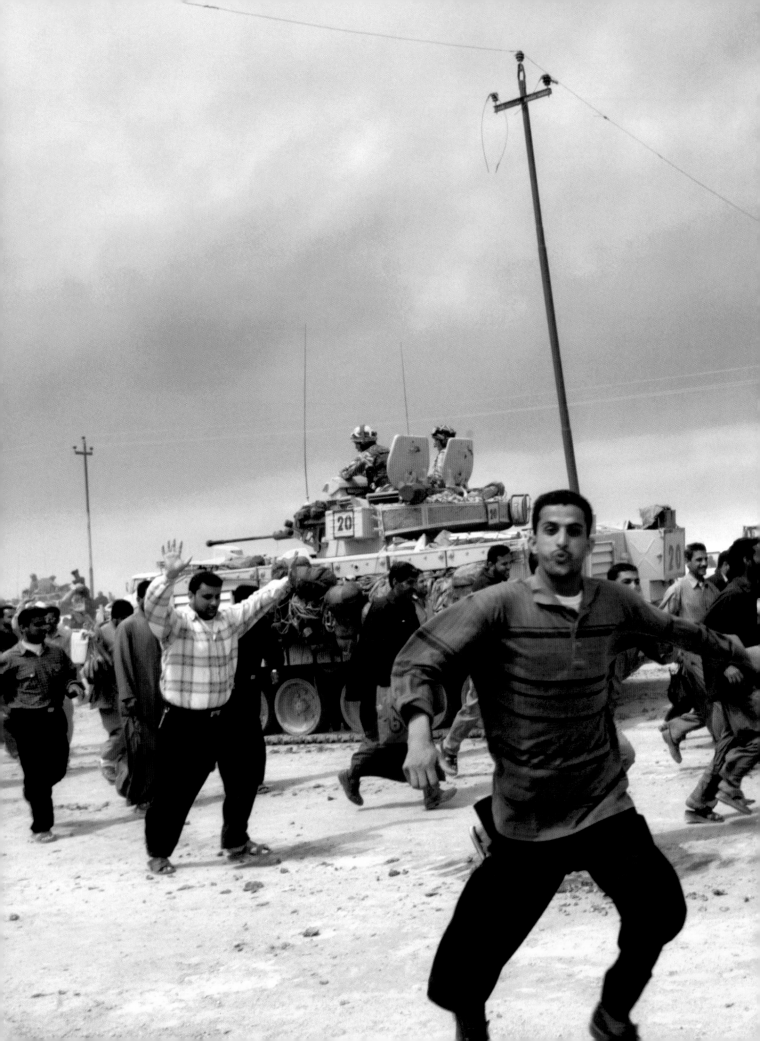

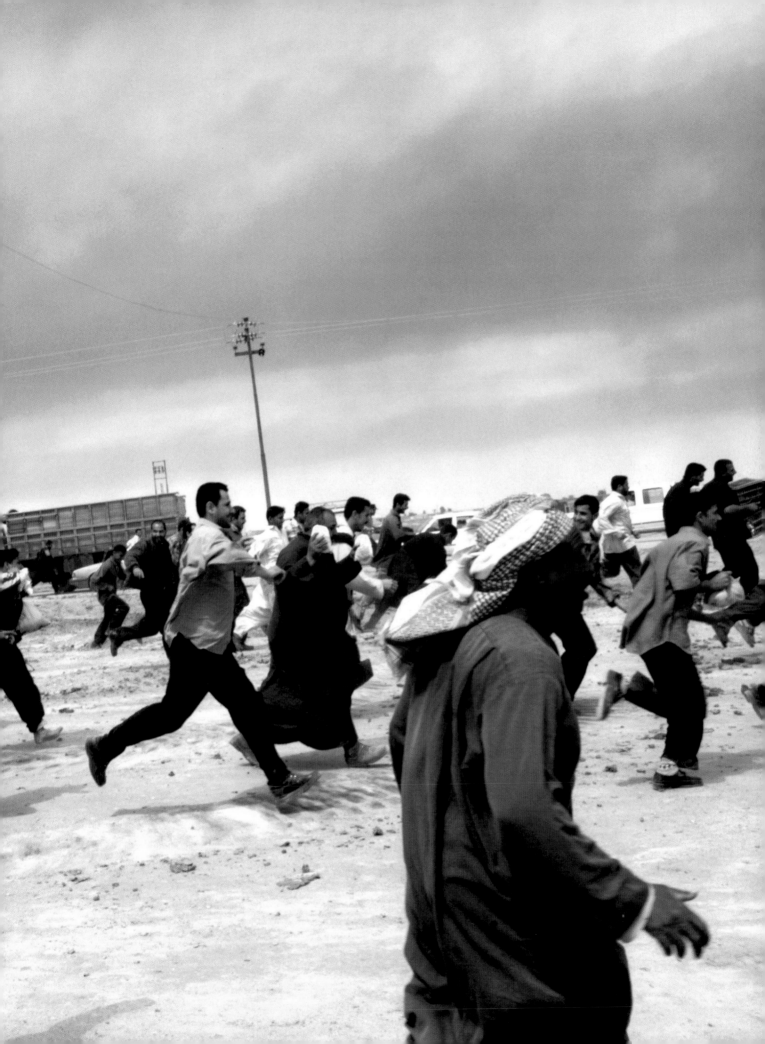

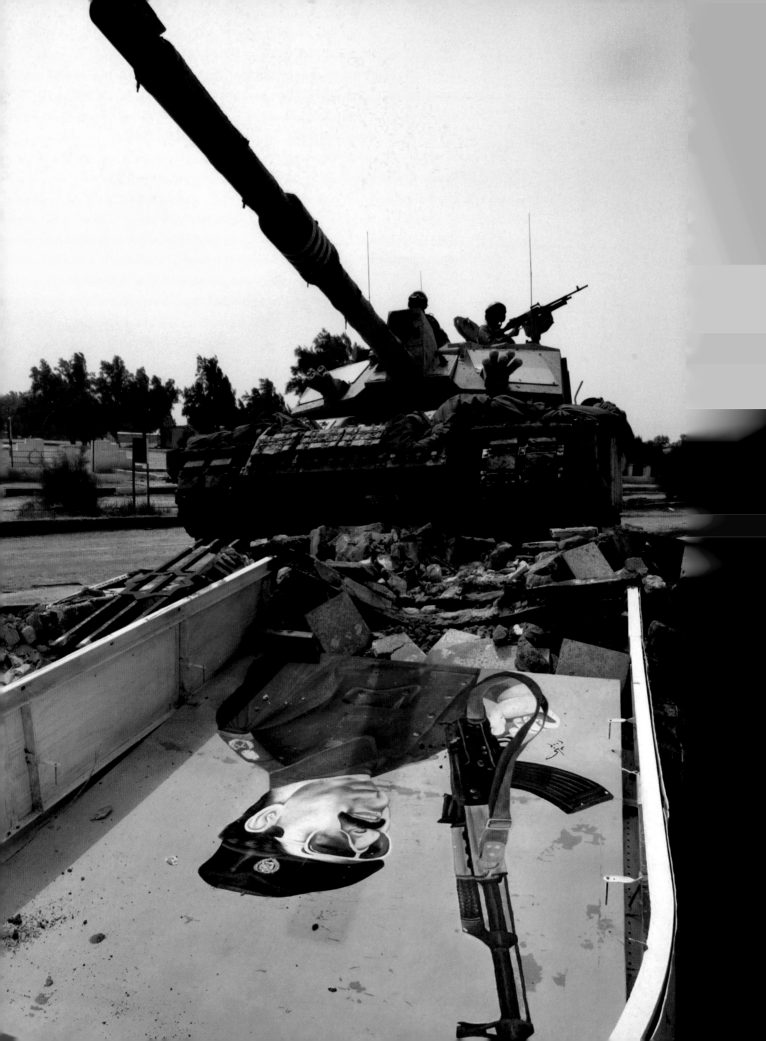

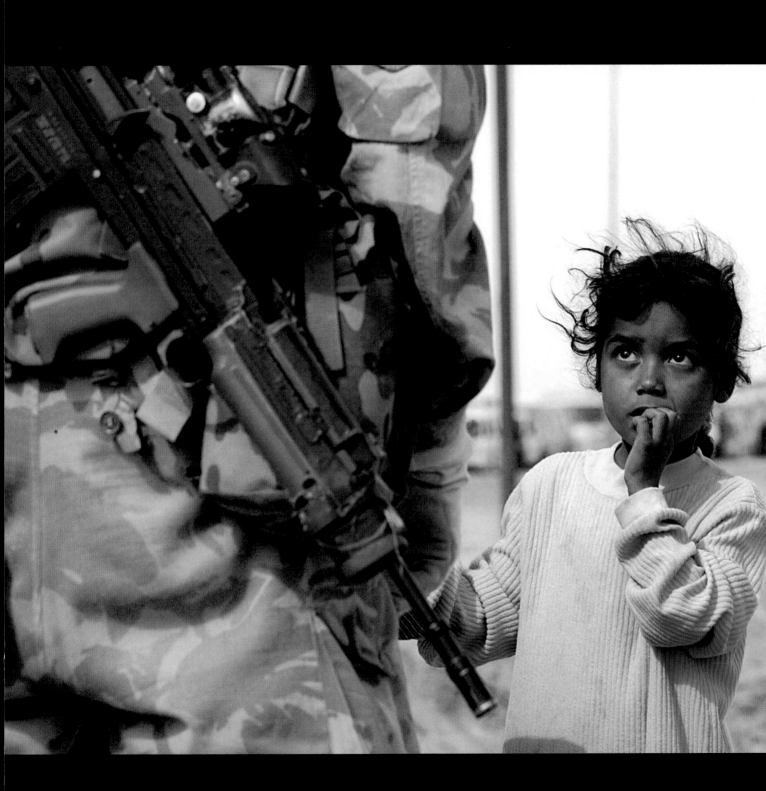

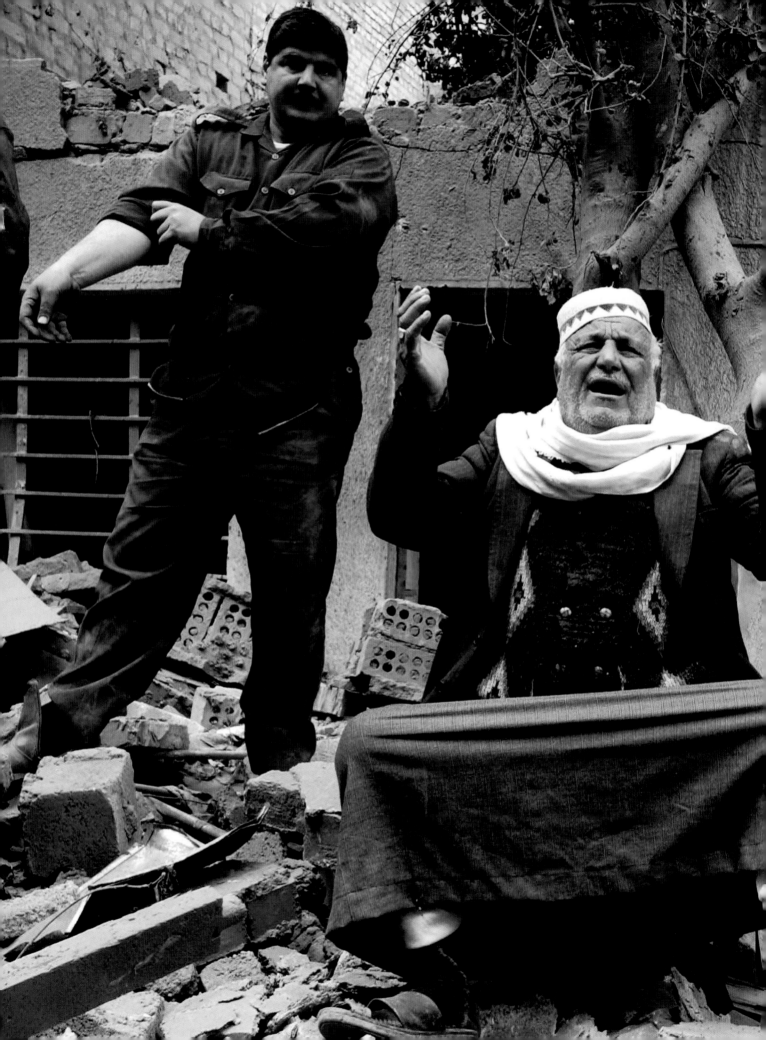

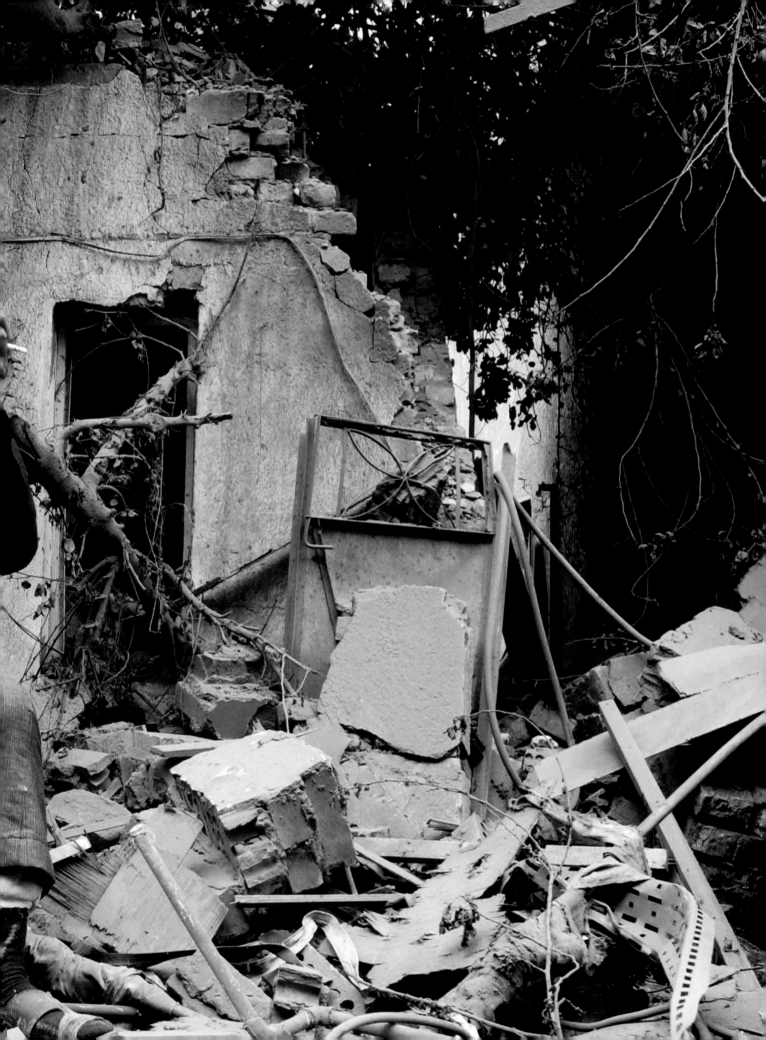

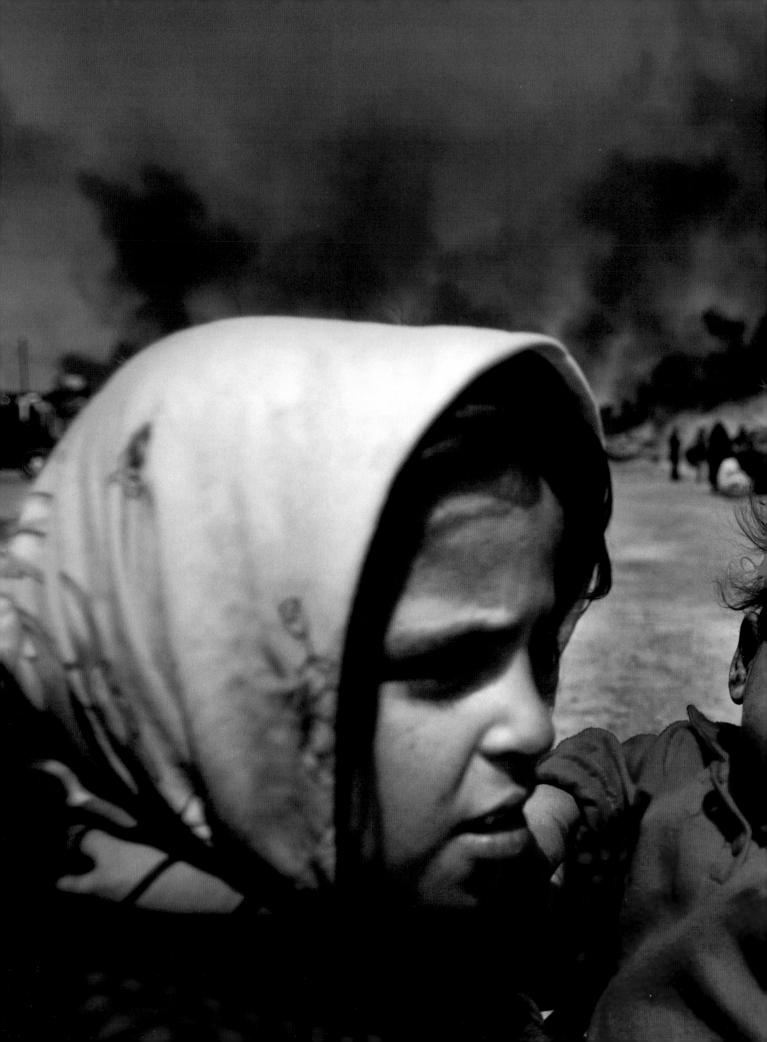

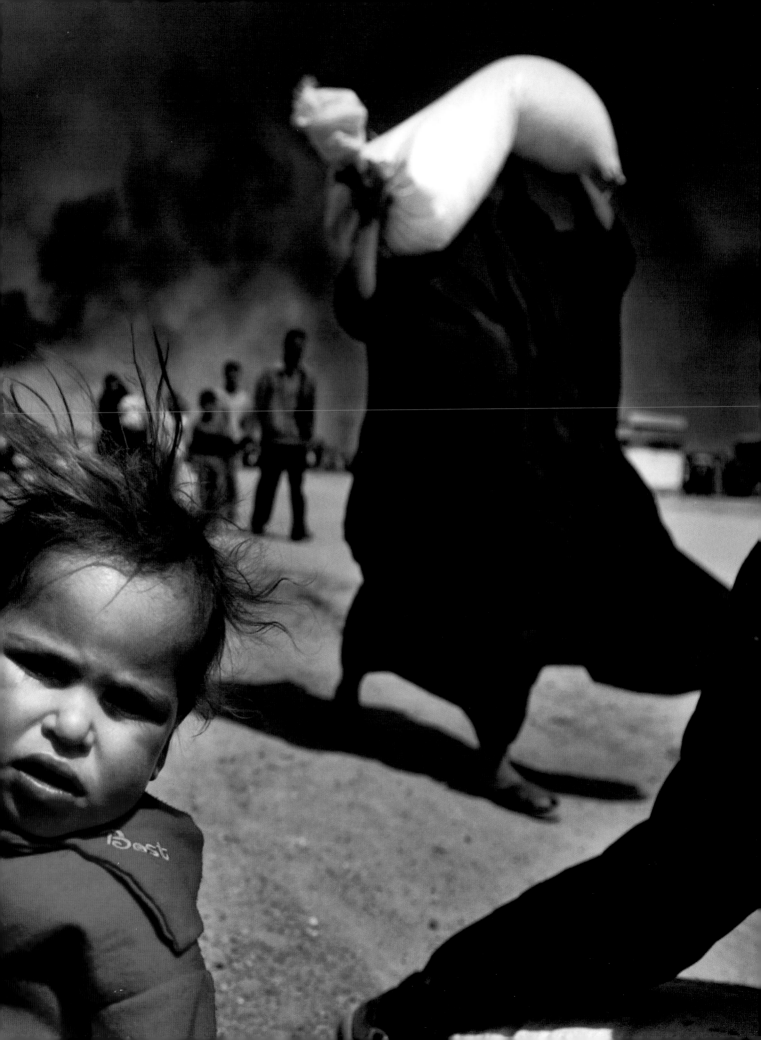

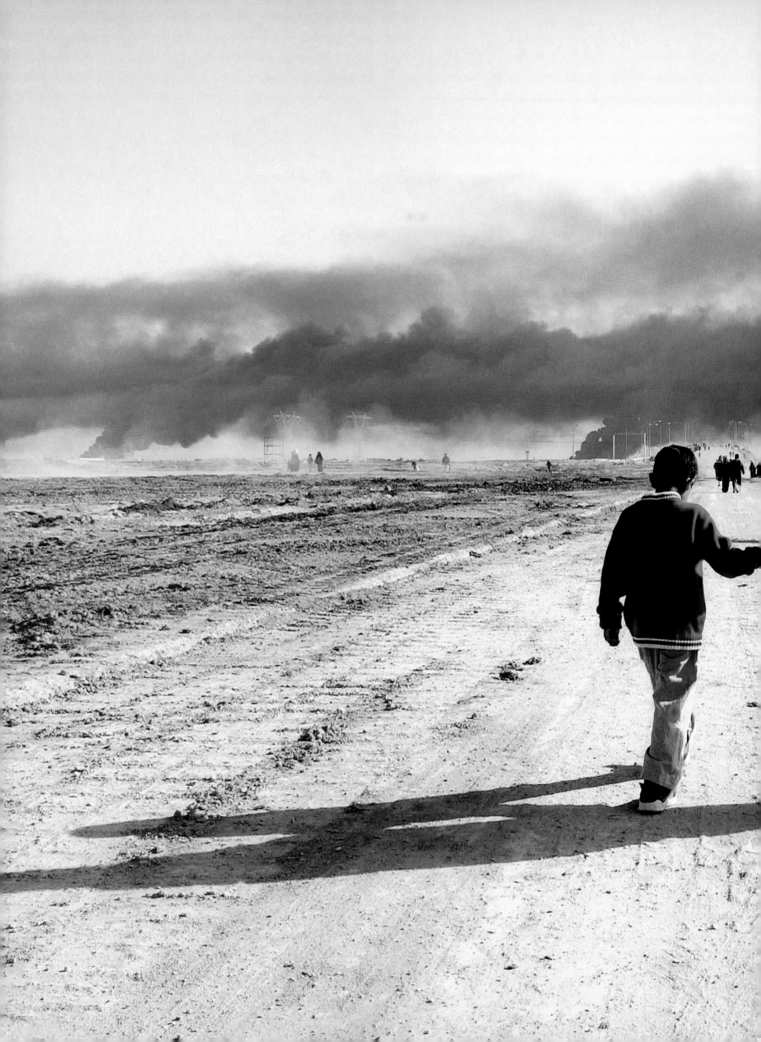

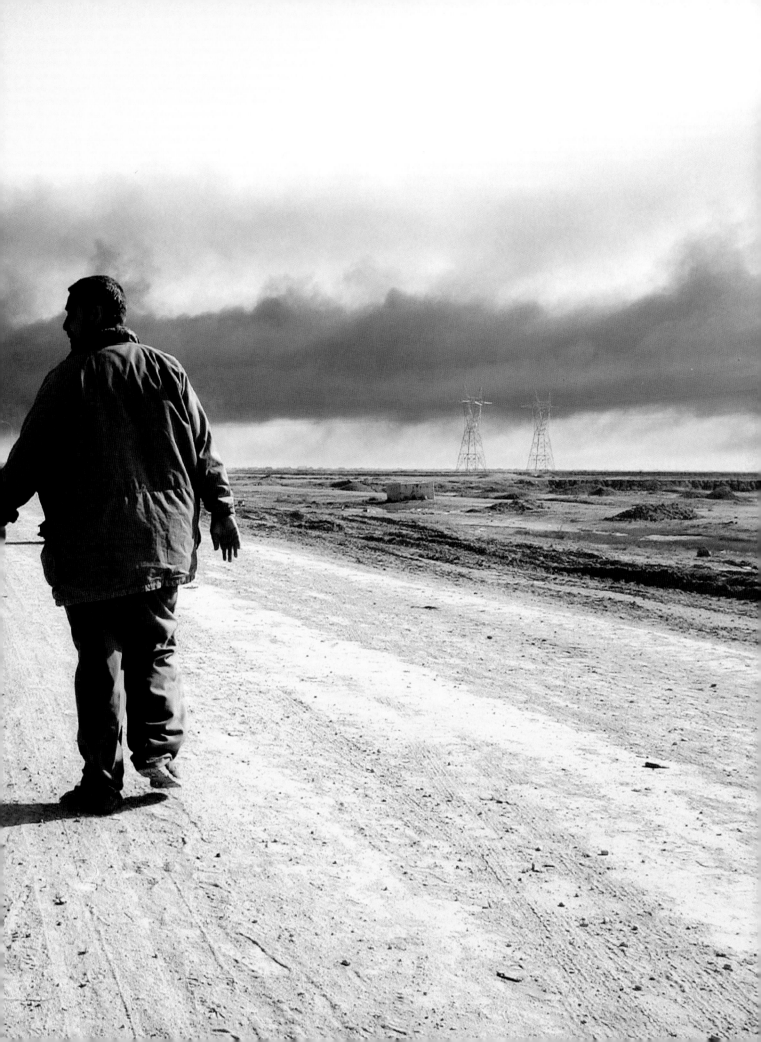

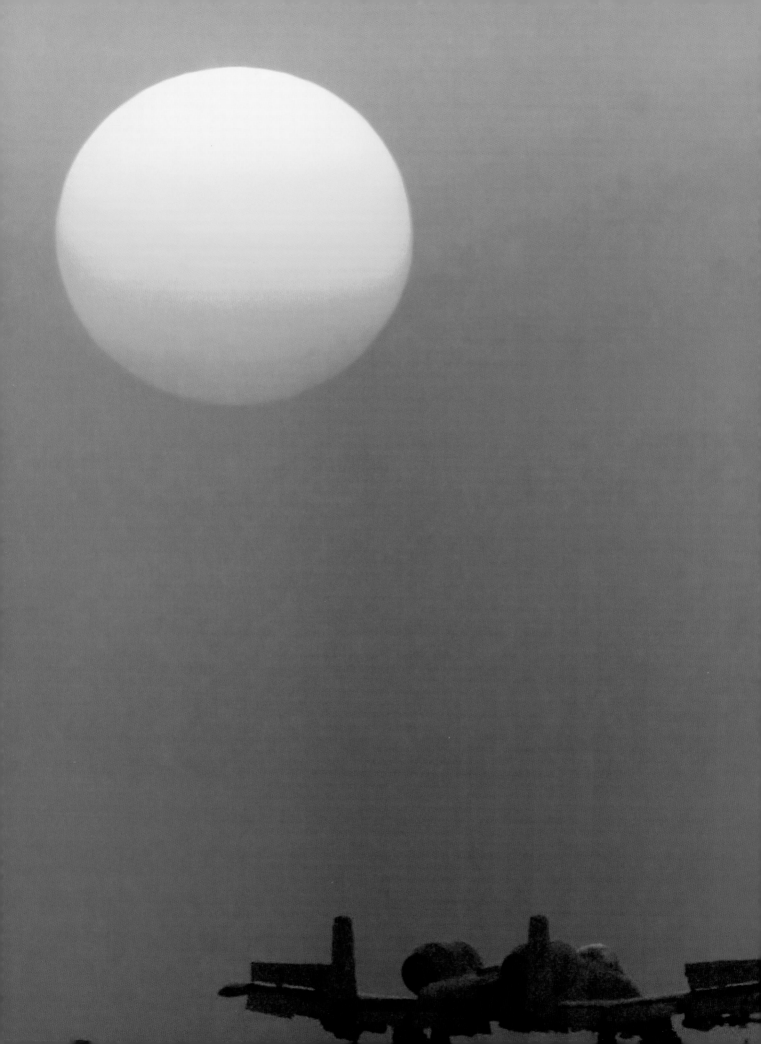

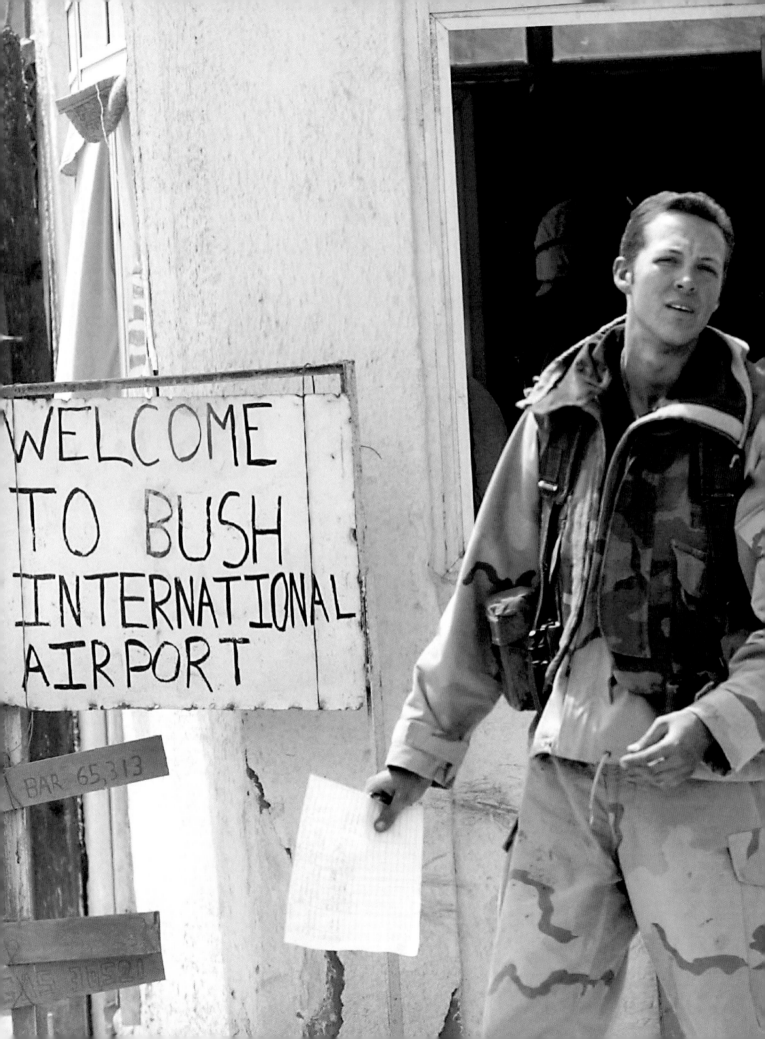

WELCOME
TO BUSH
INTERNATIONAL
AIRPORT

BAR 65,313

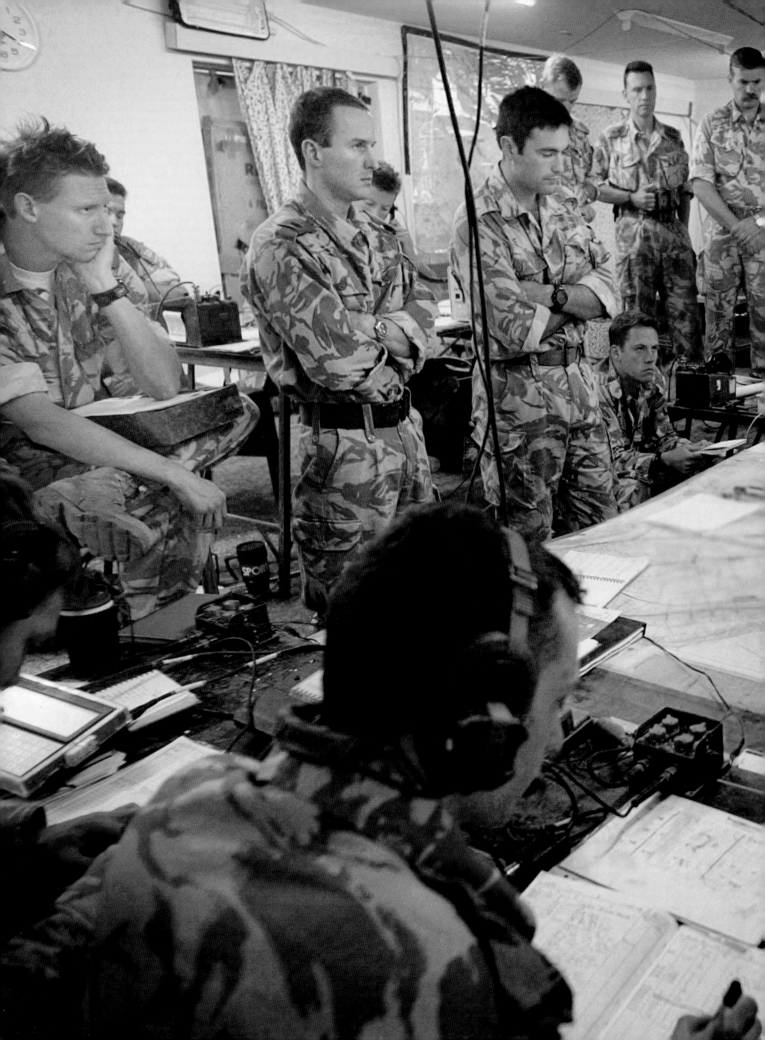

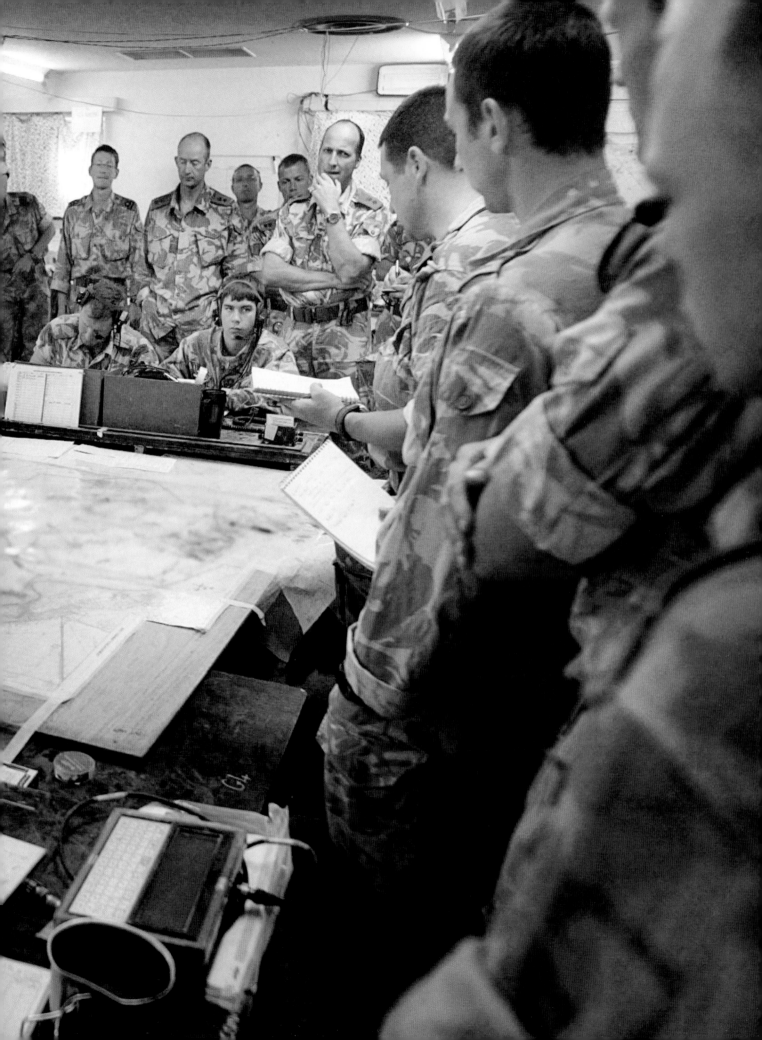

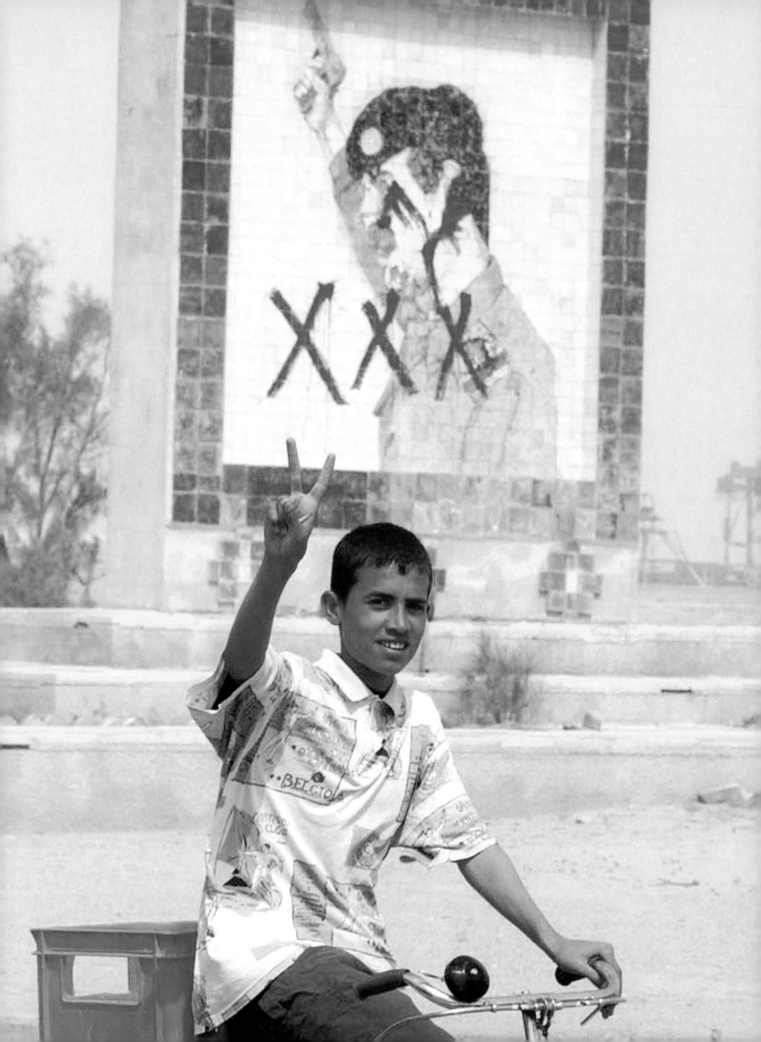

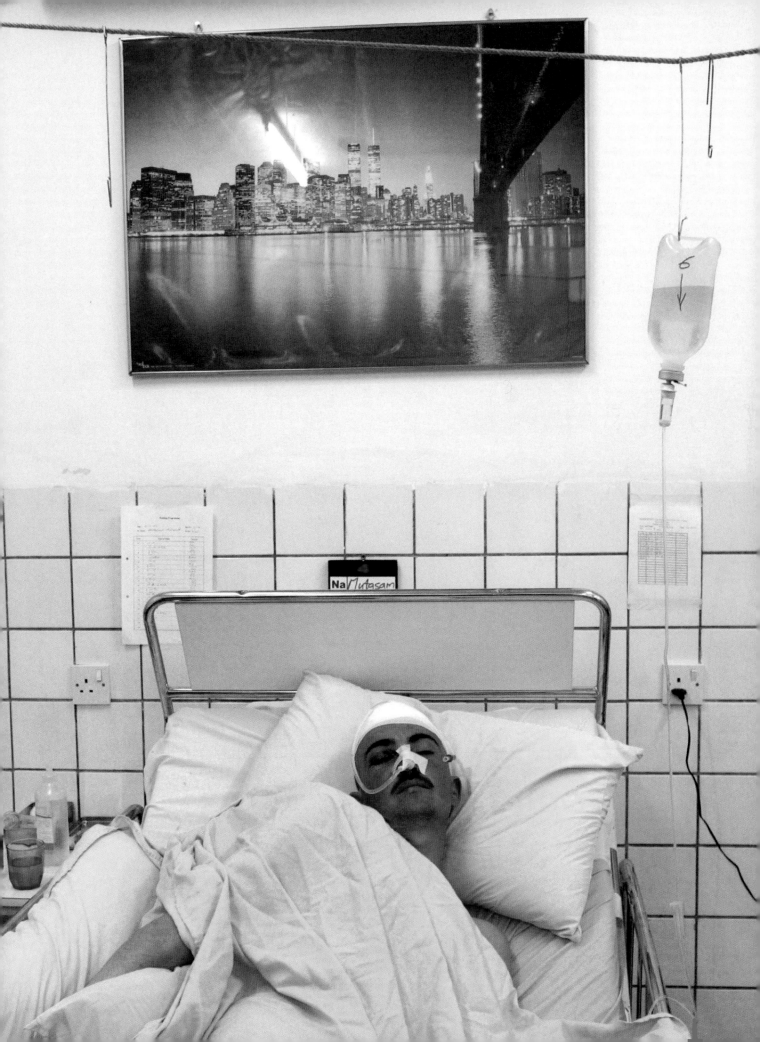

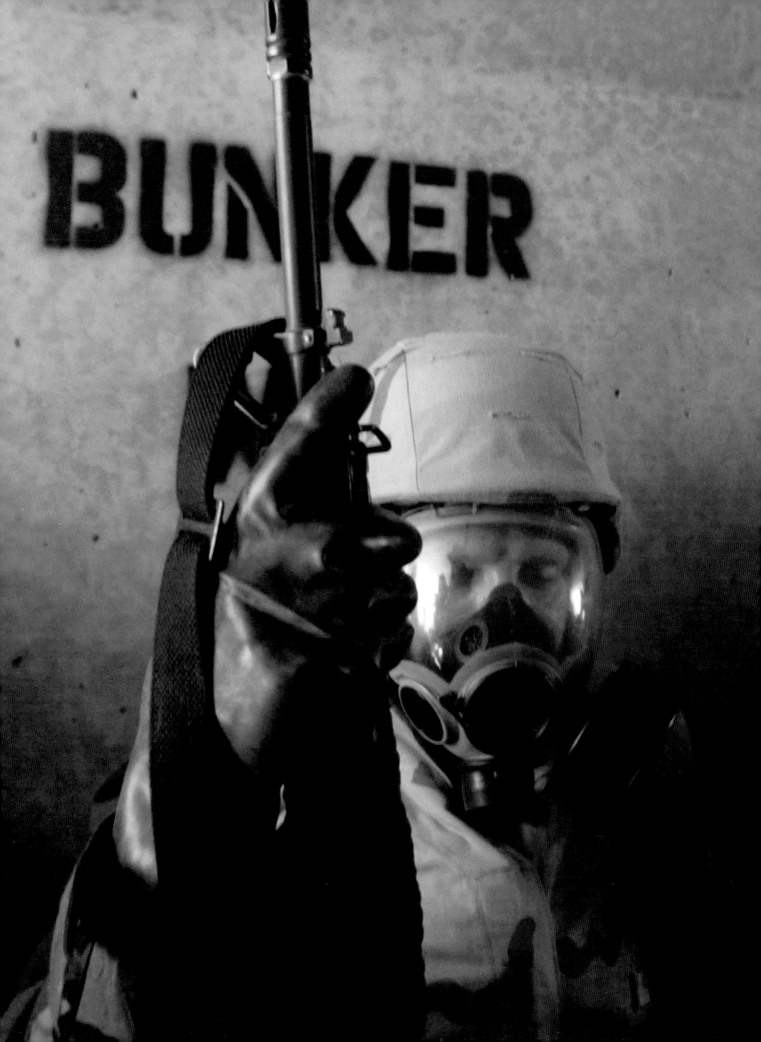

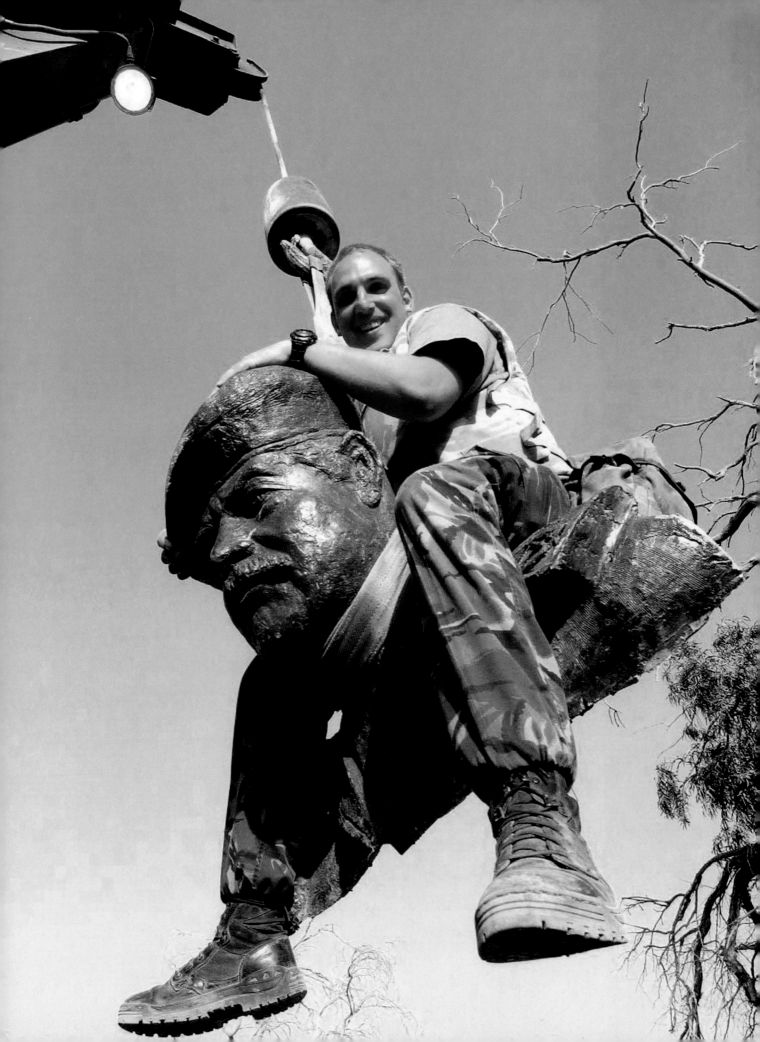

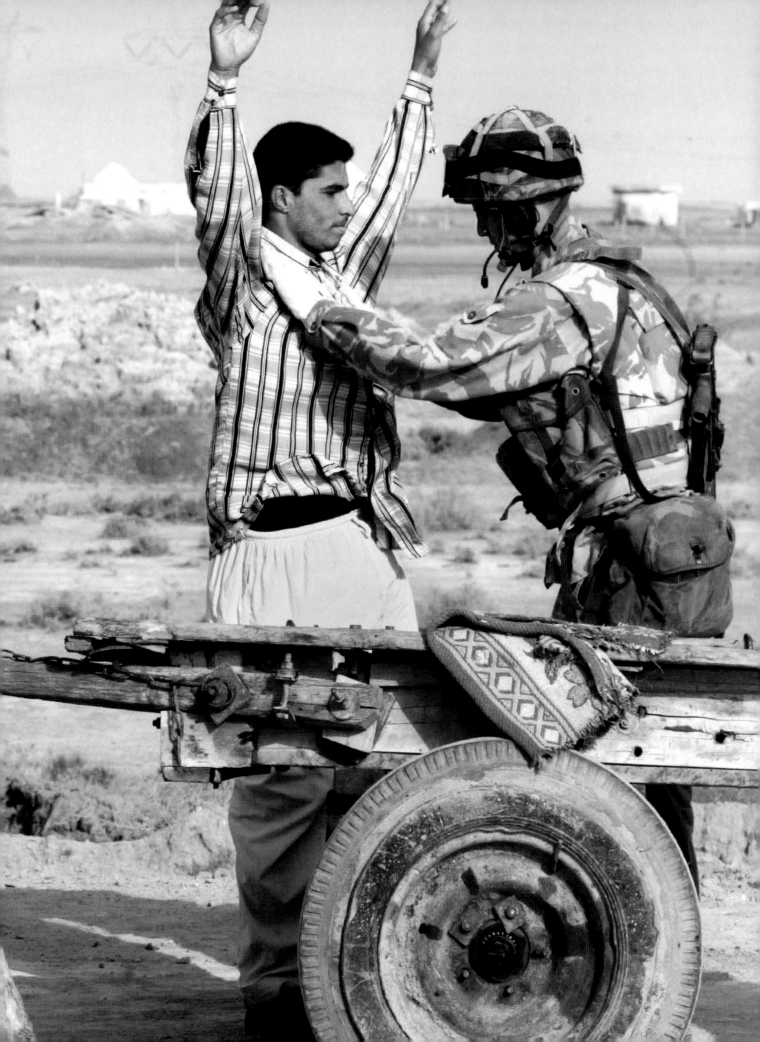

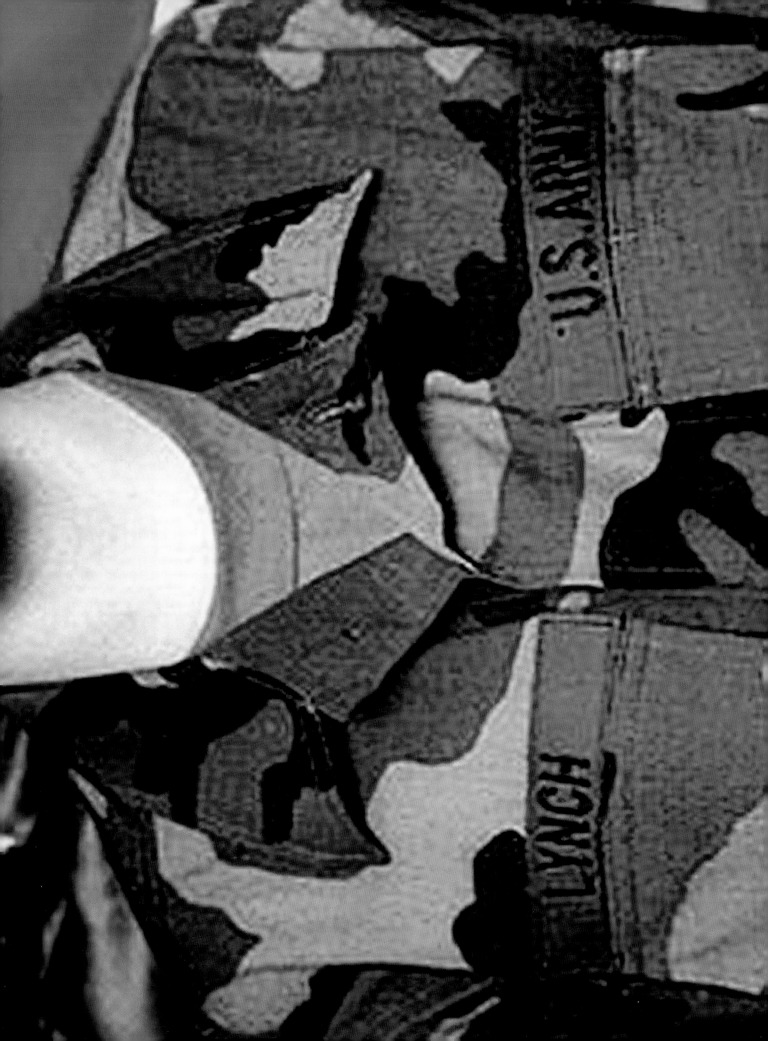

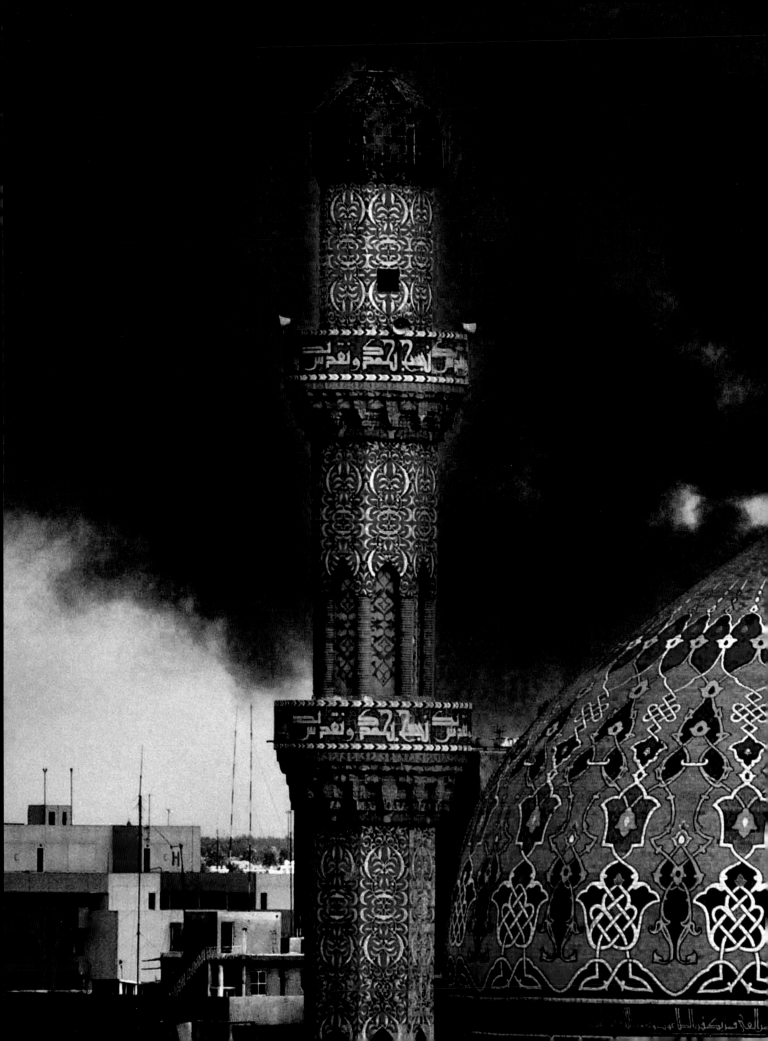

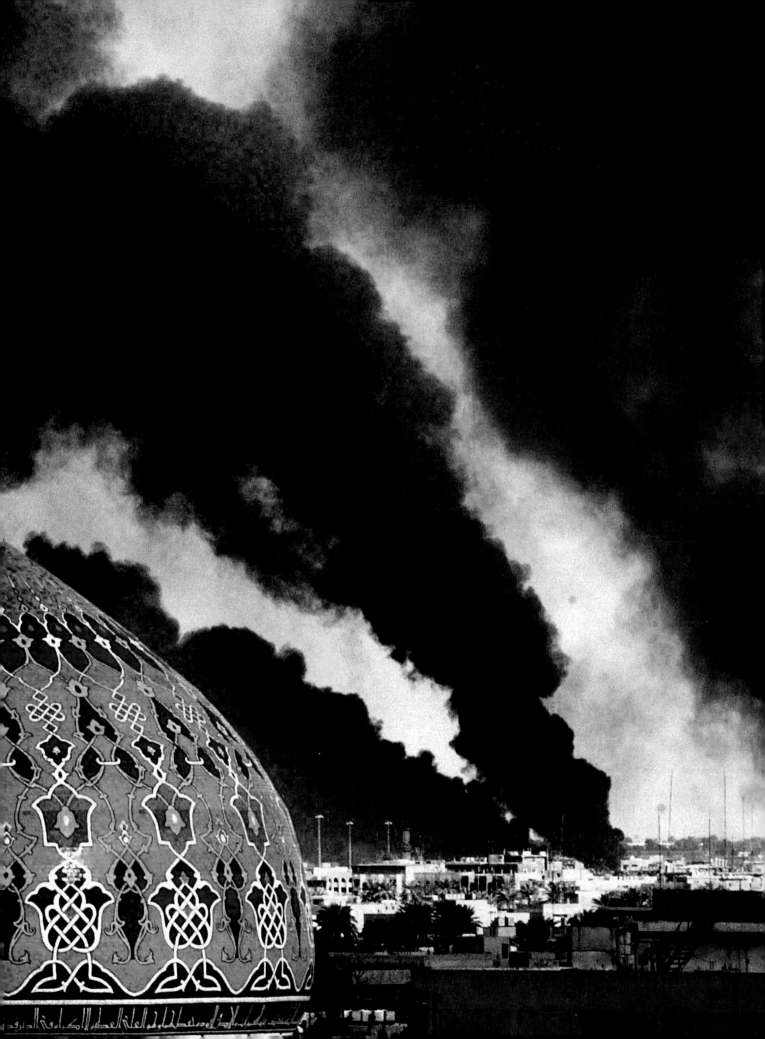

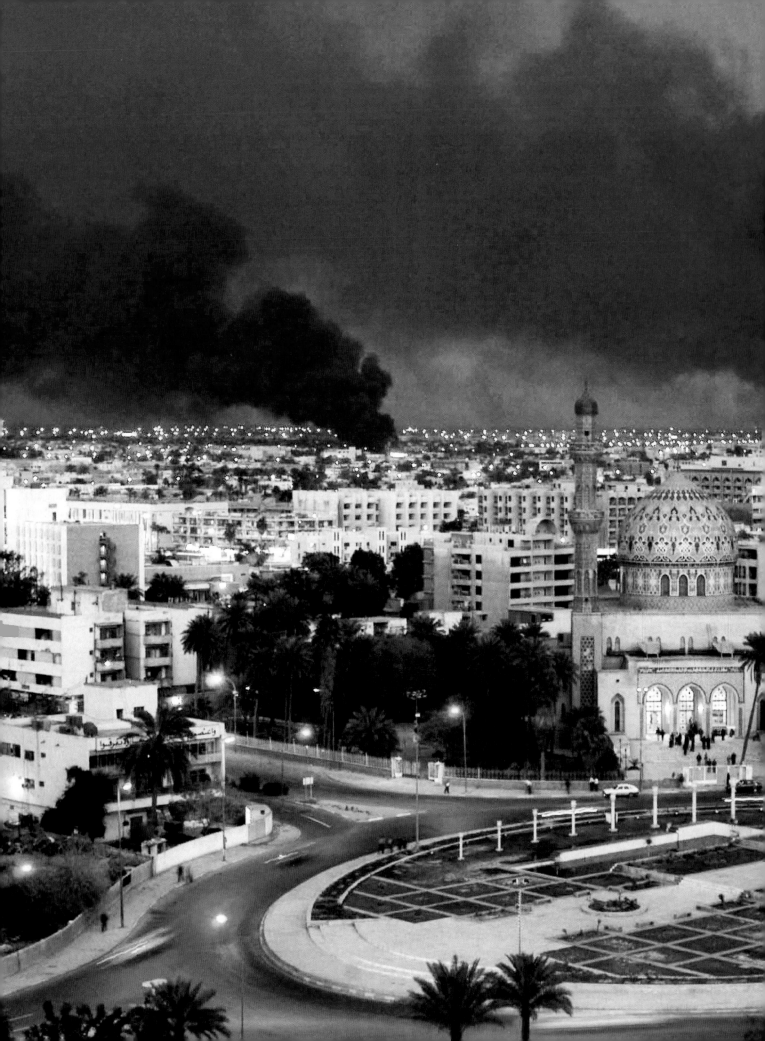

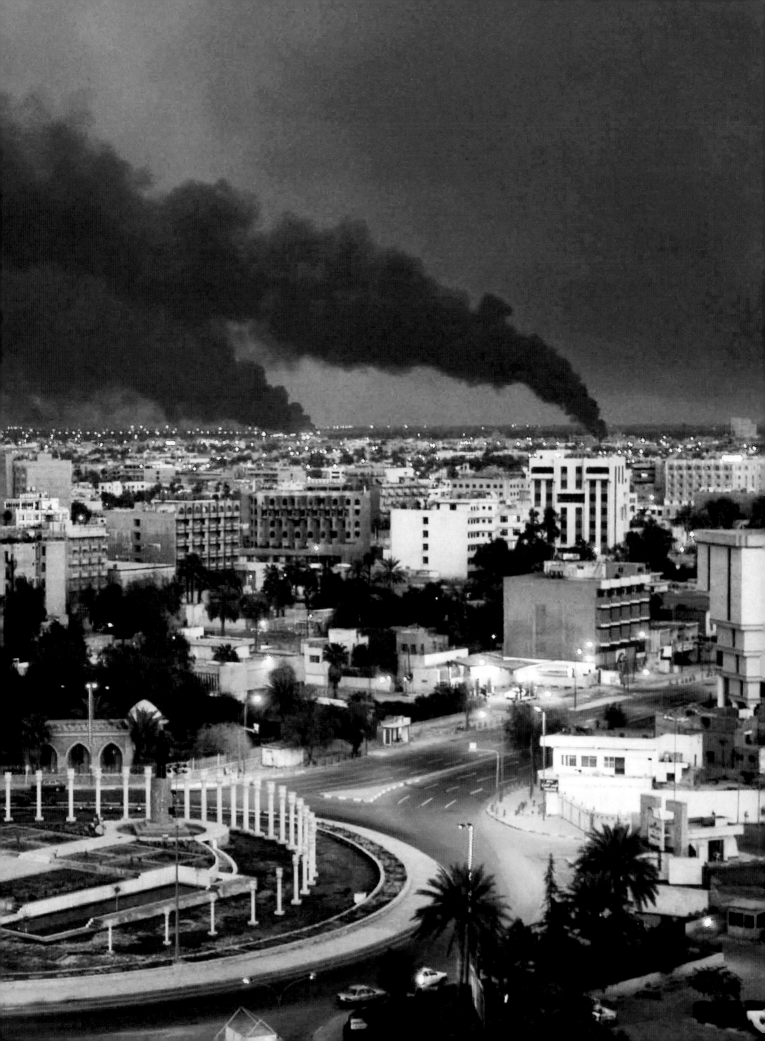

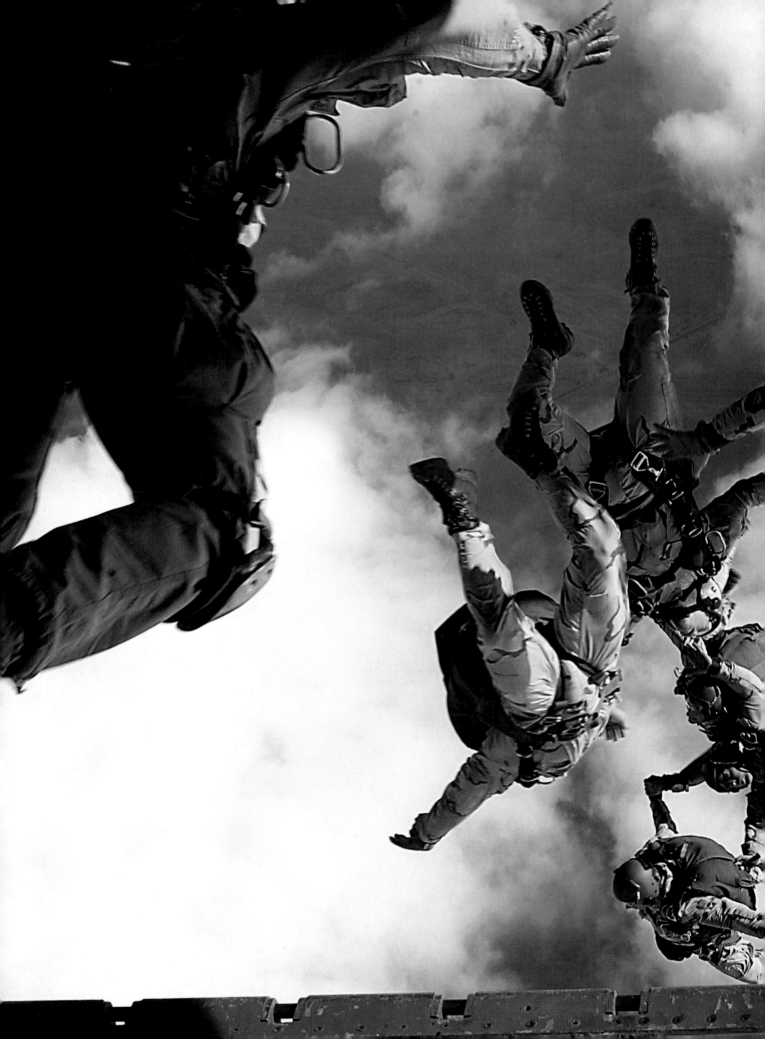

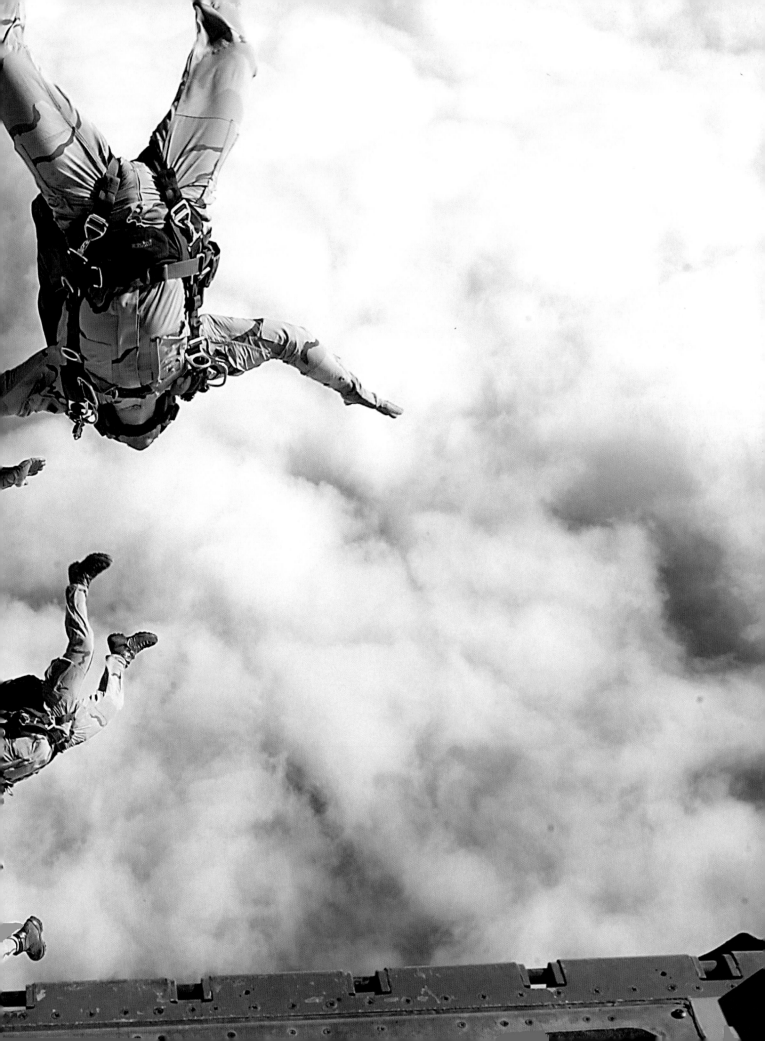

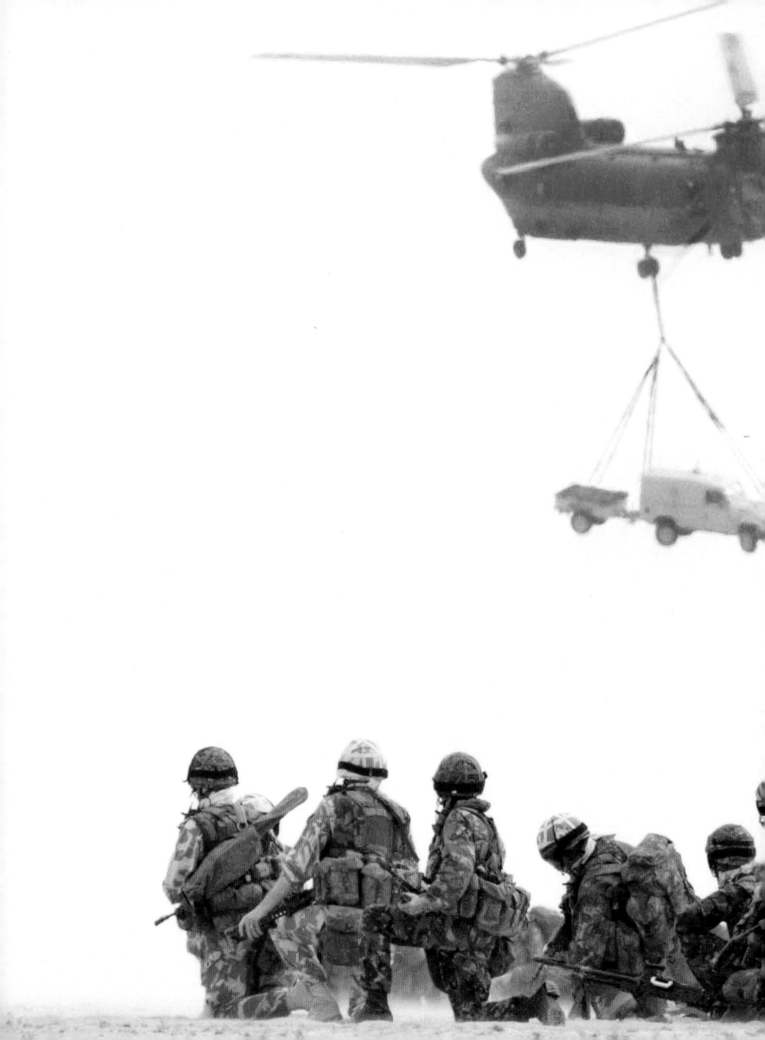

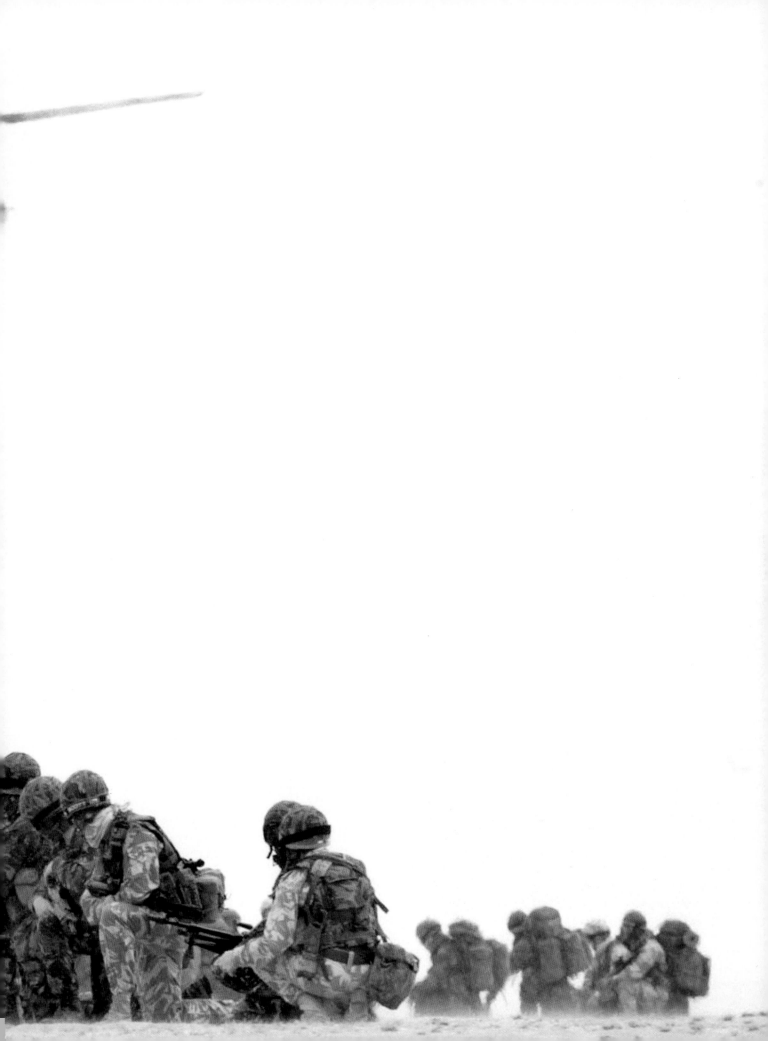

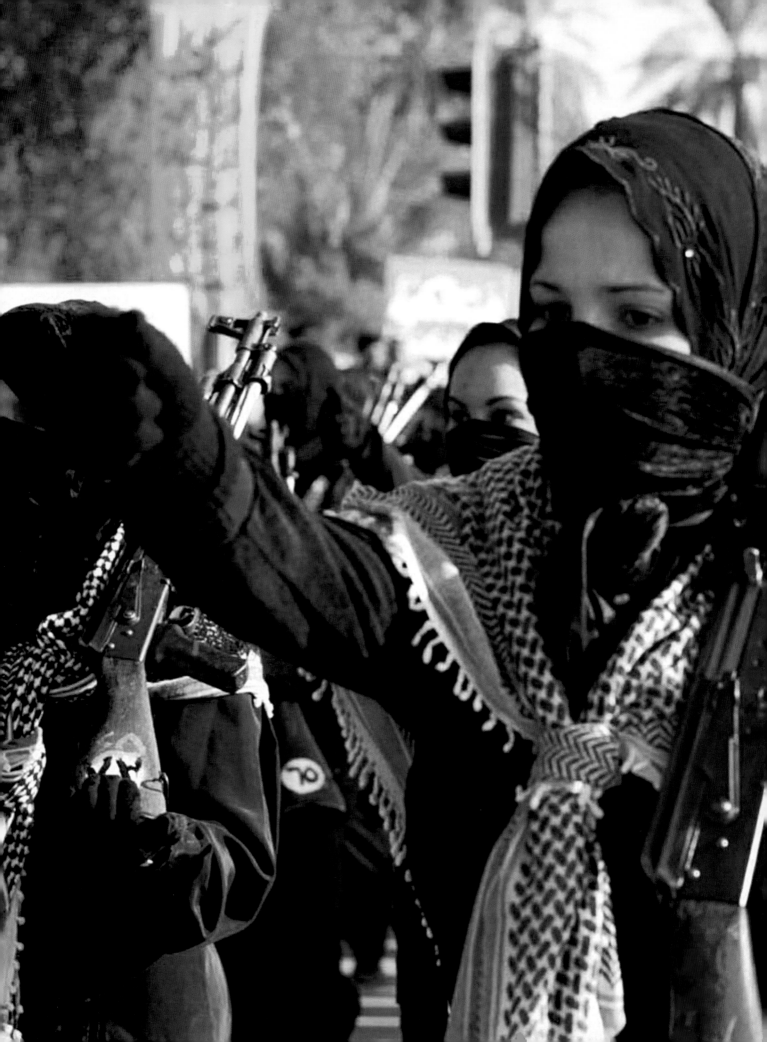

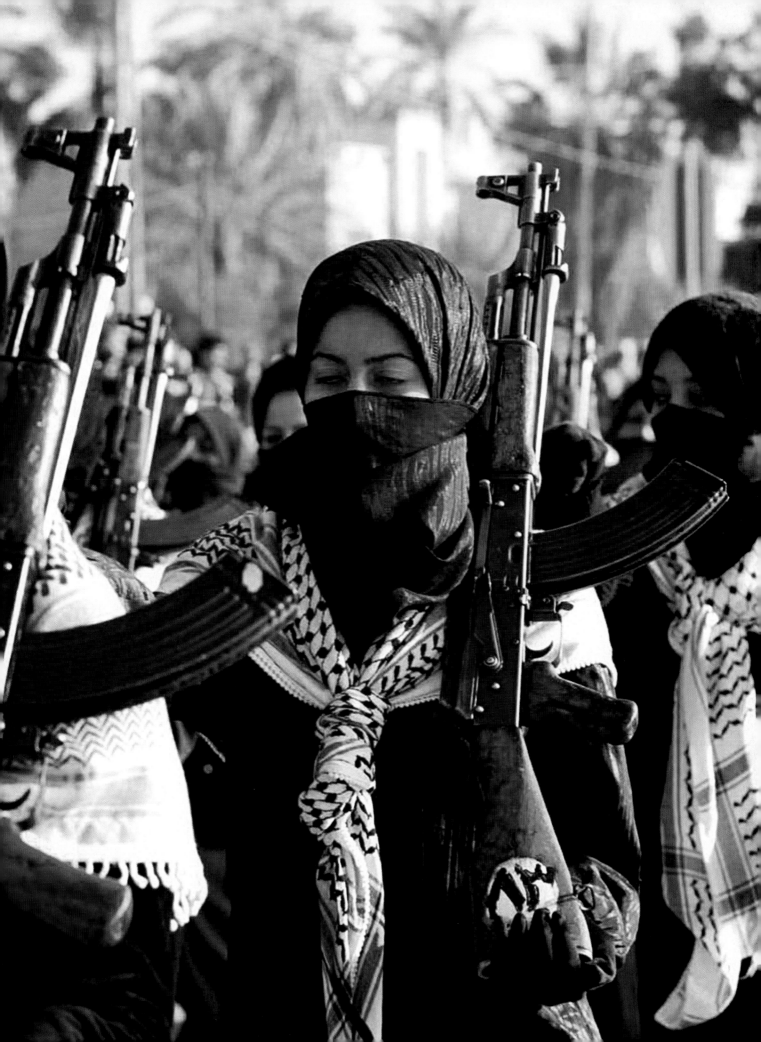

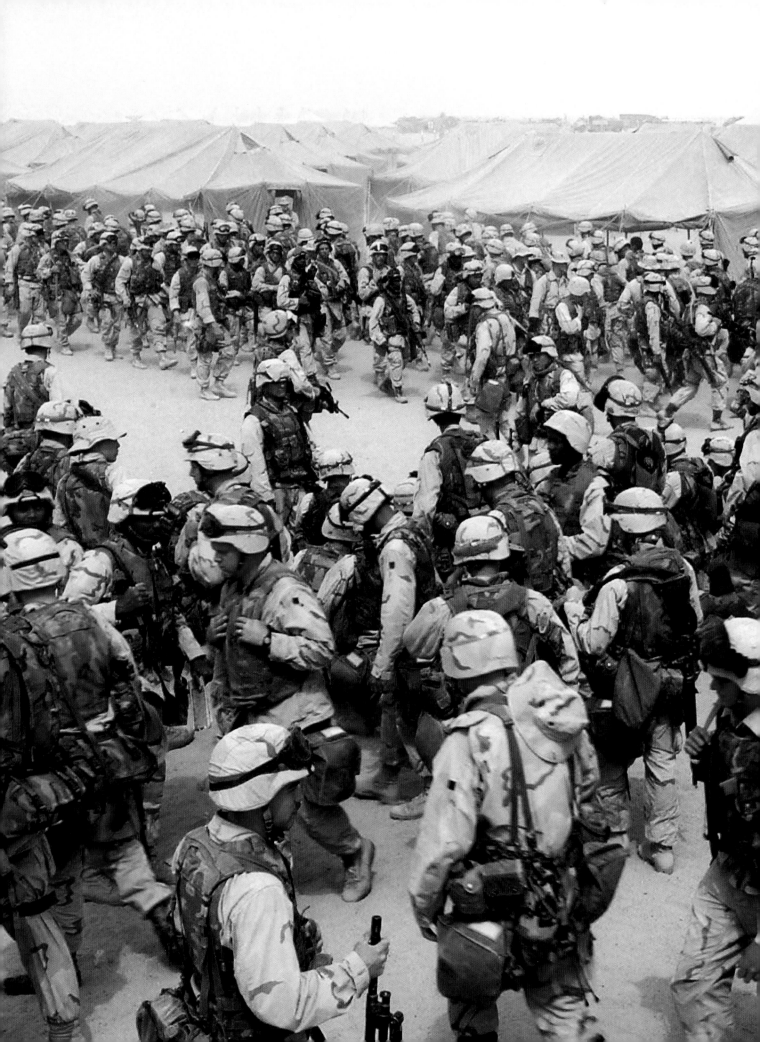

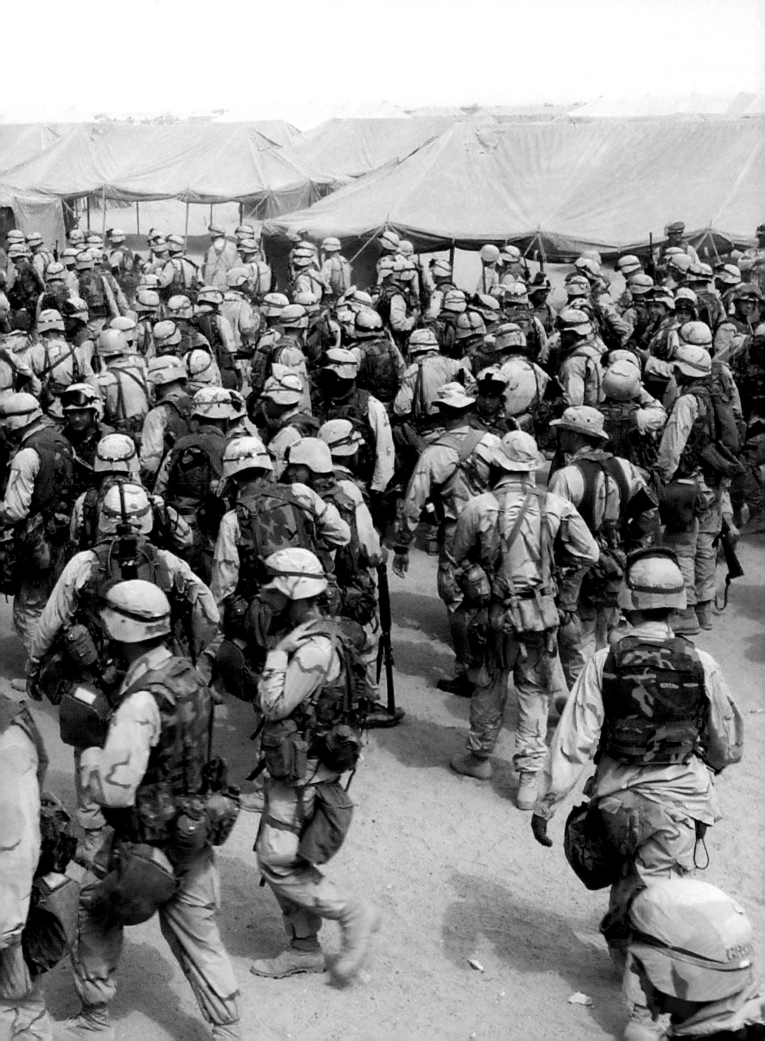

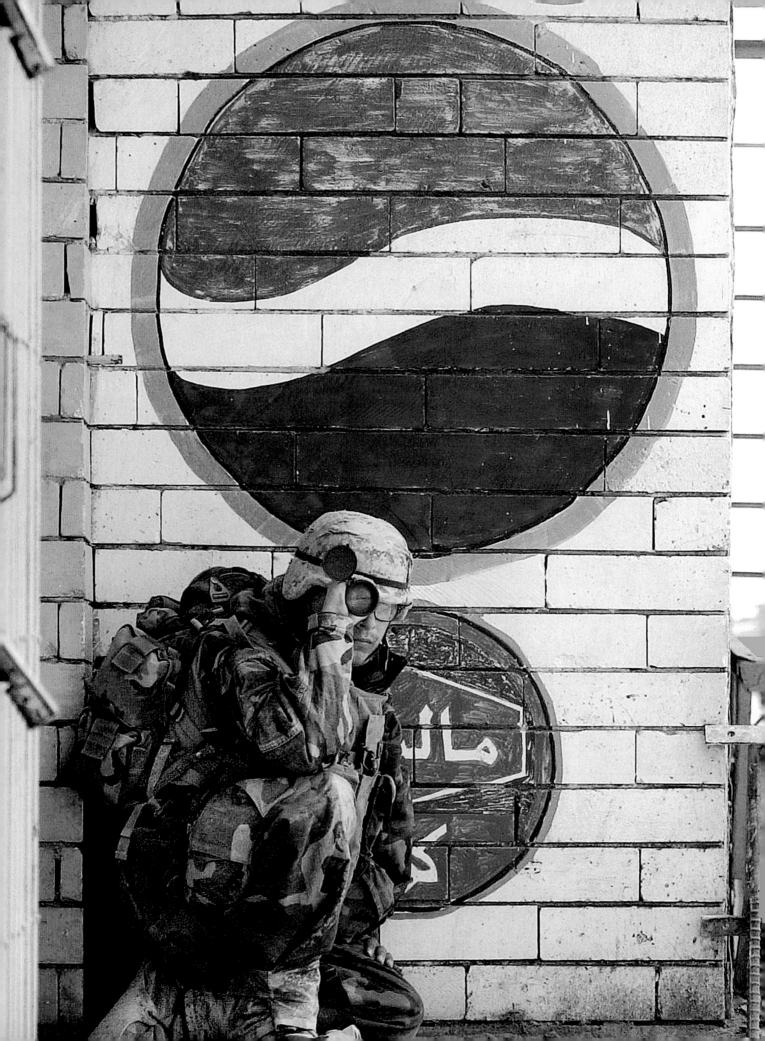

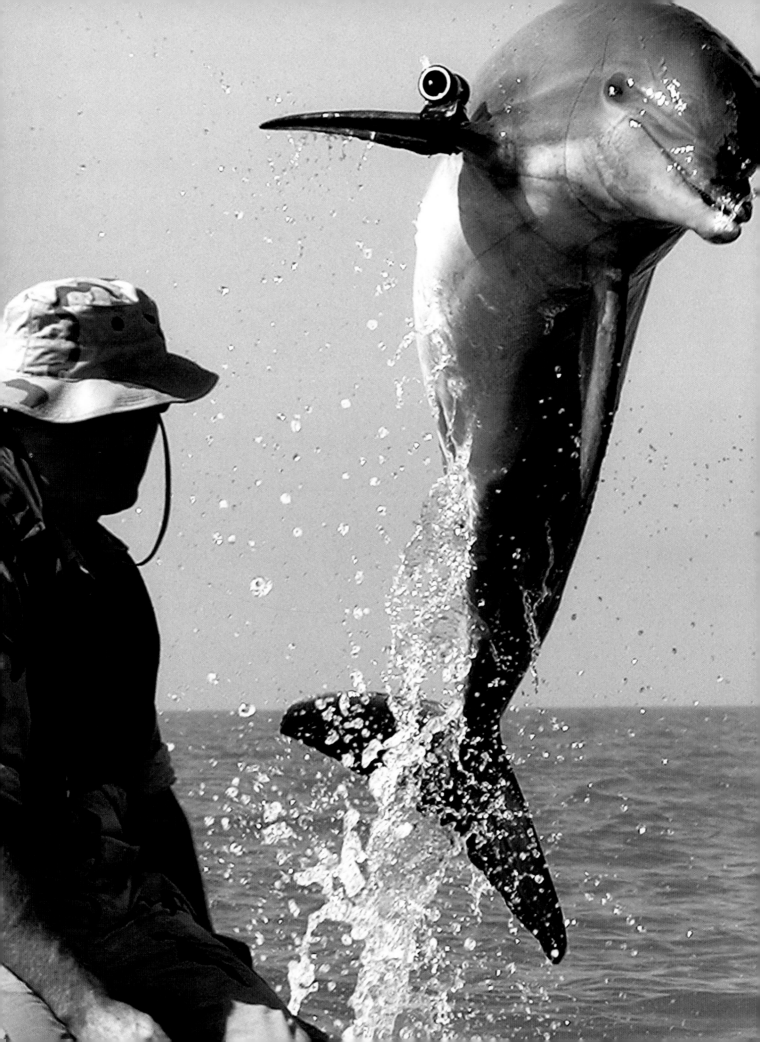

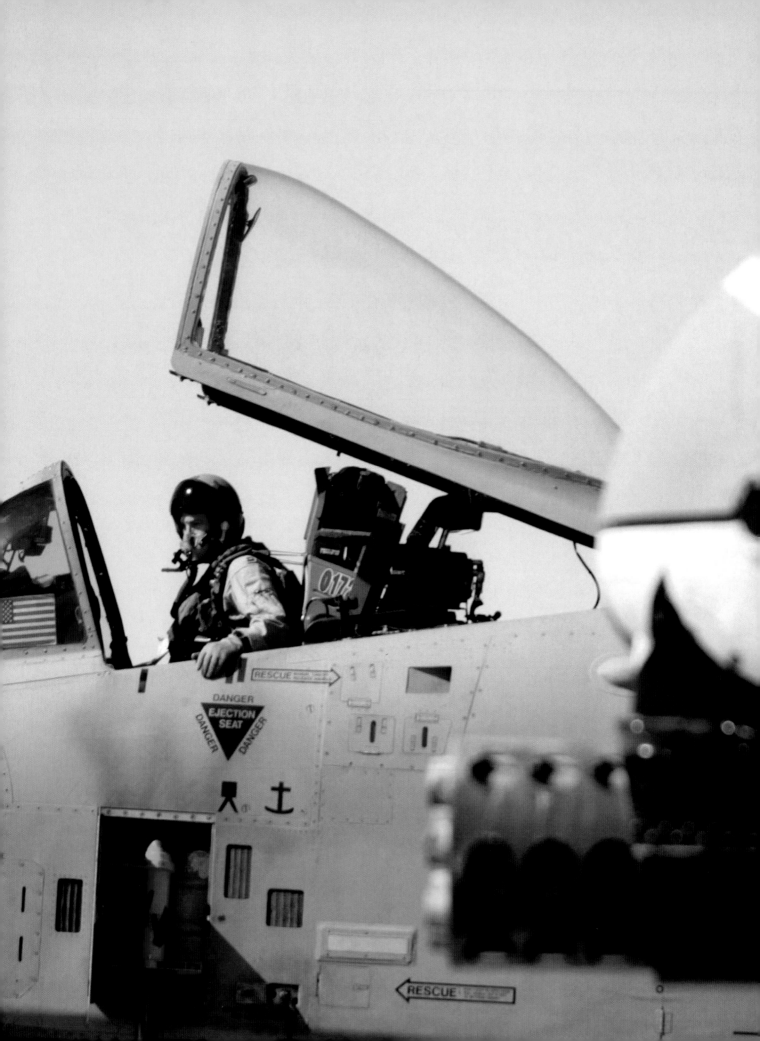

SECURITY HEA[D]

PRE STRIKE

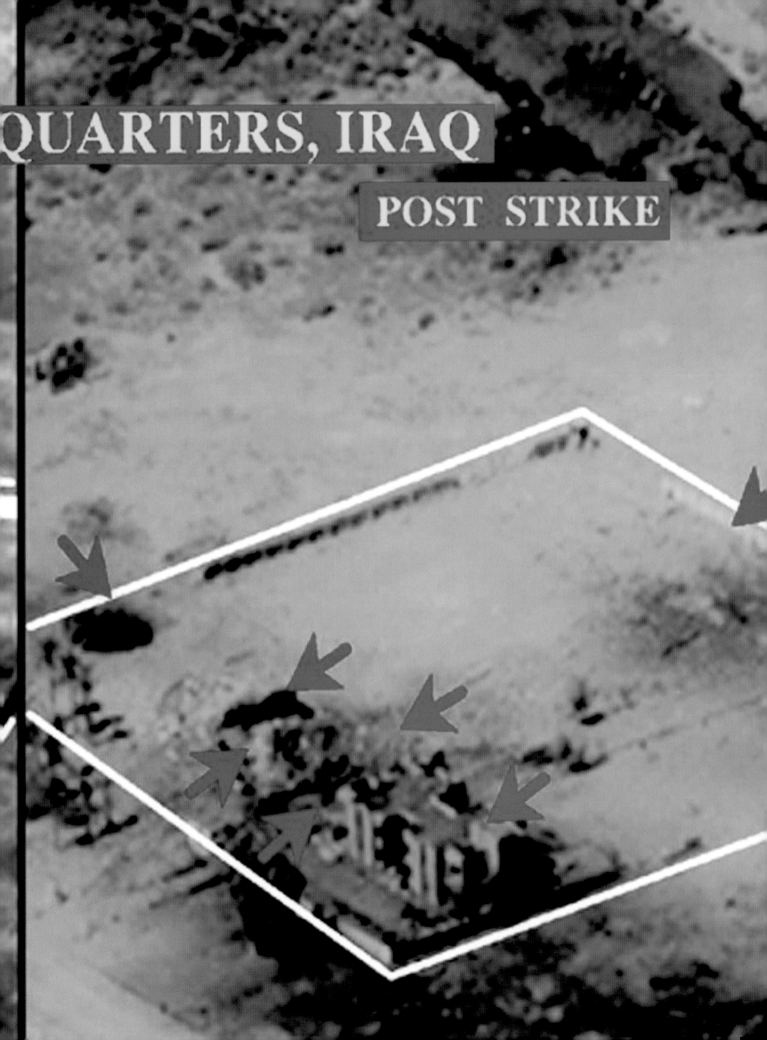

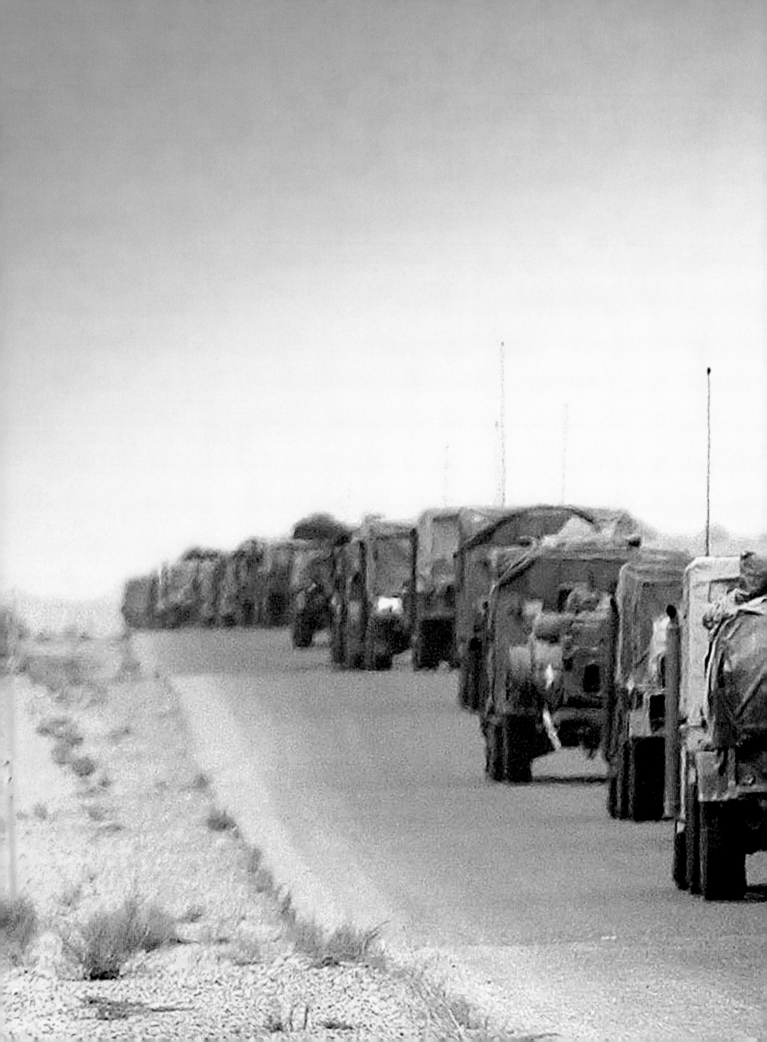

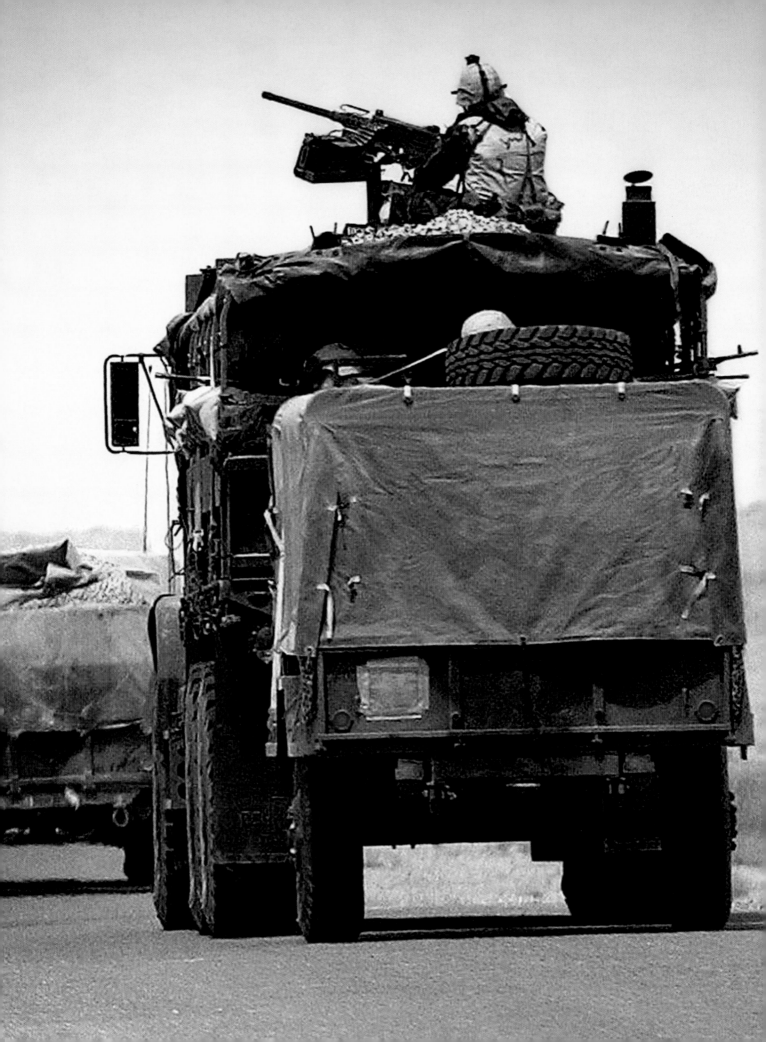

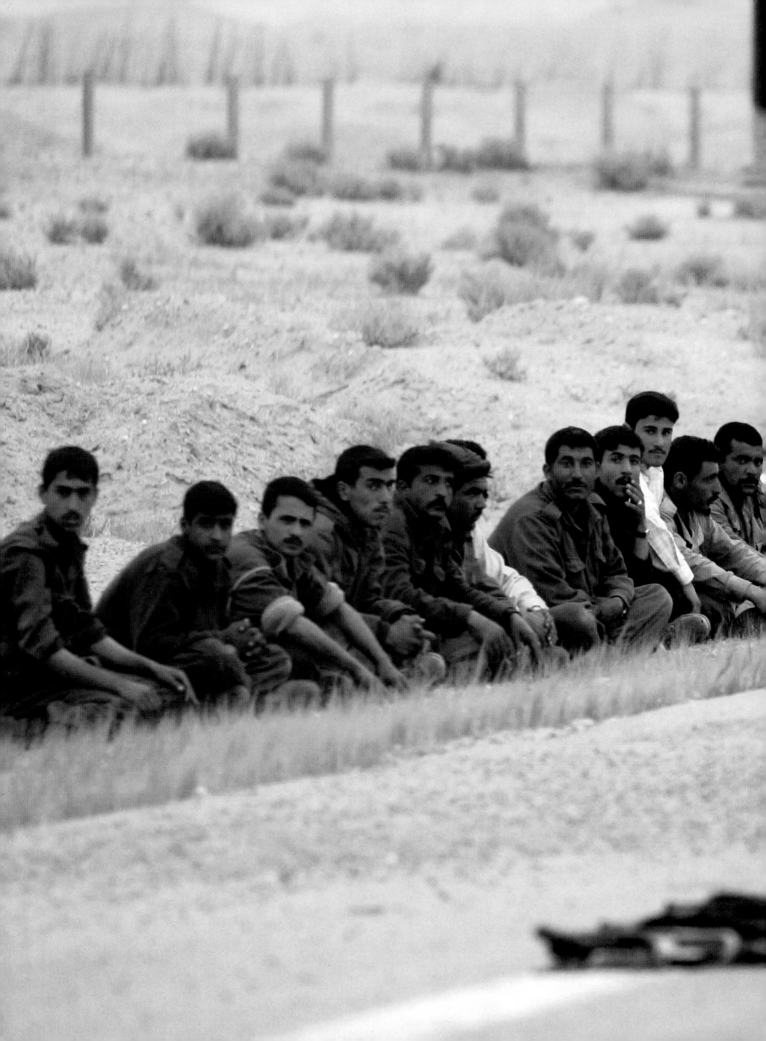

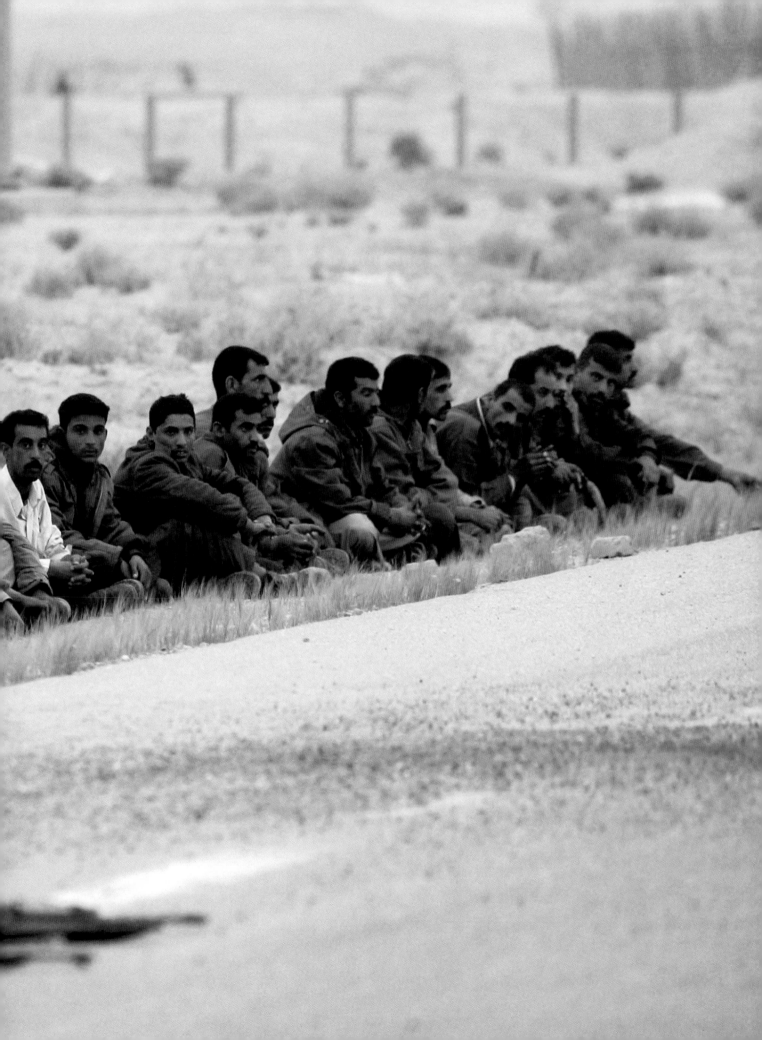

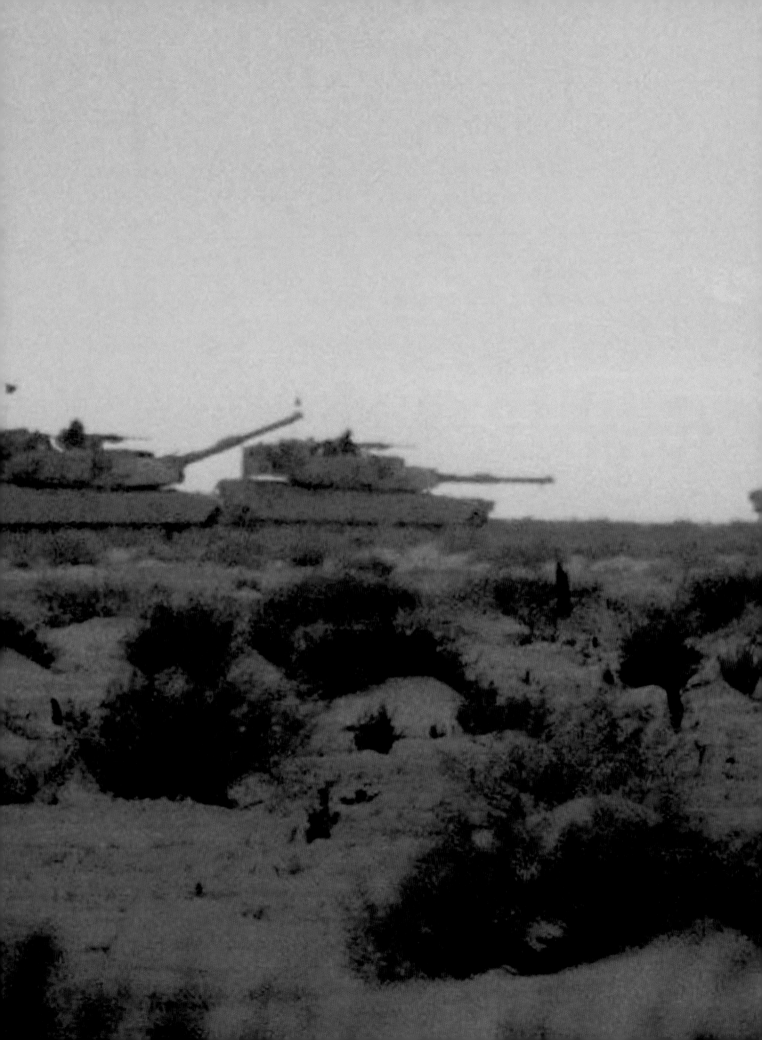

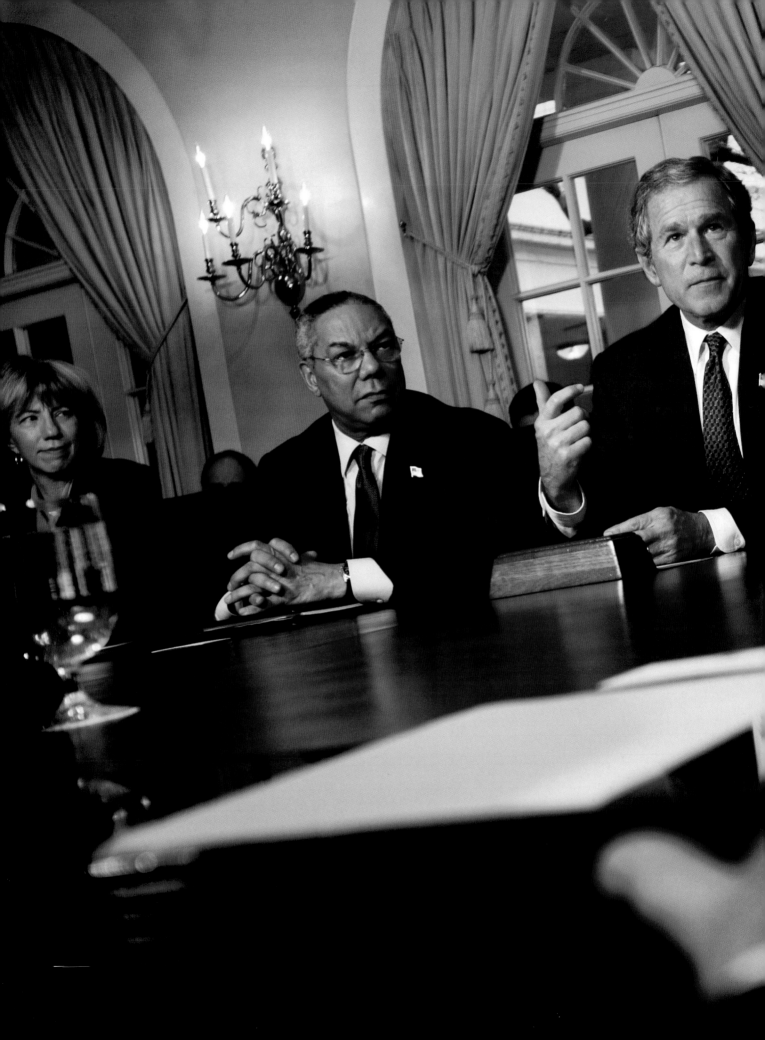

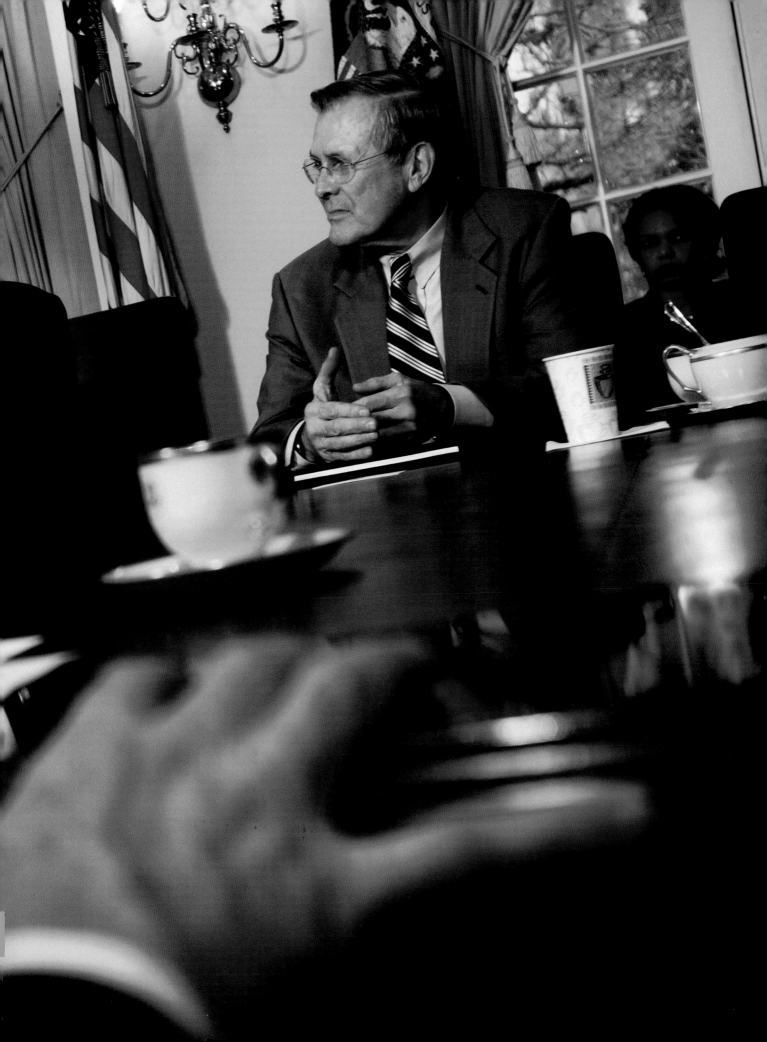

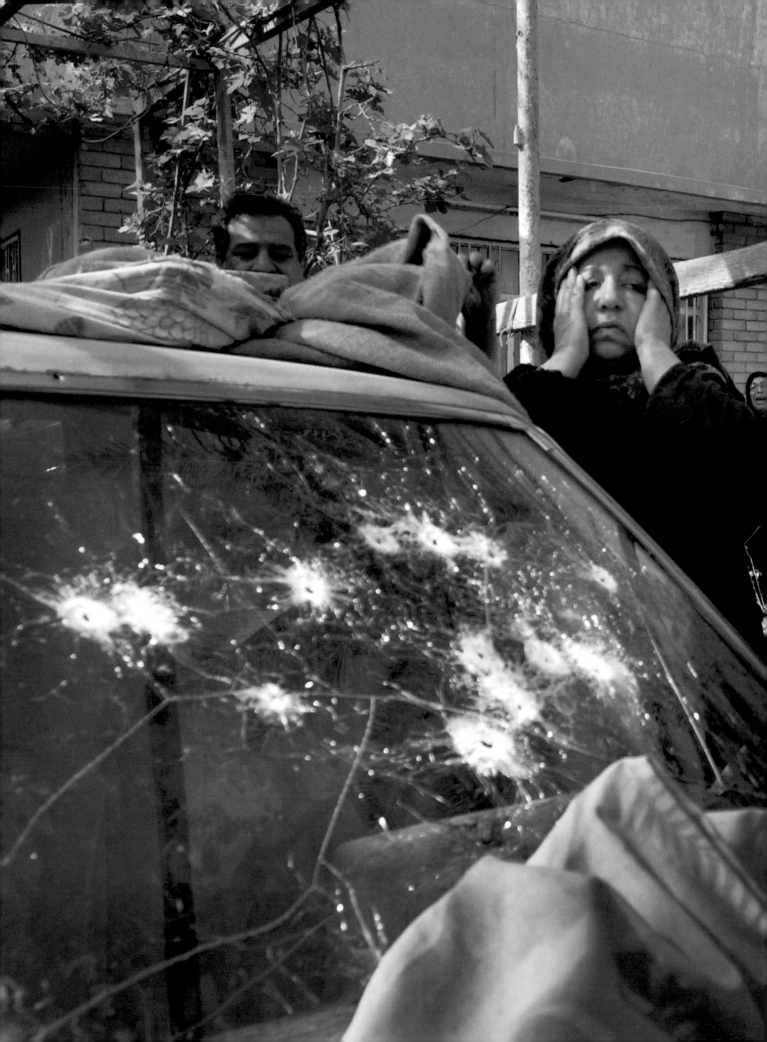

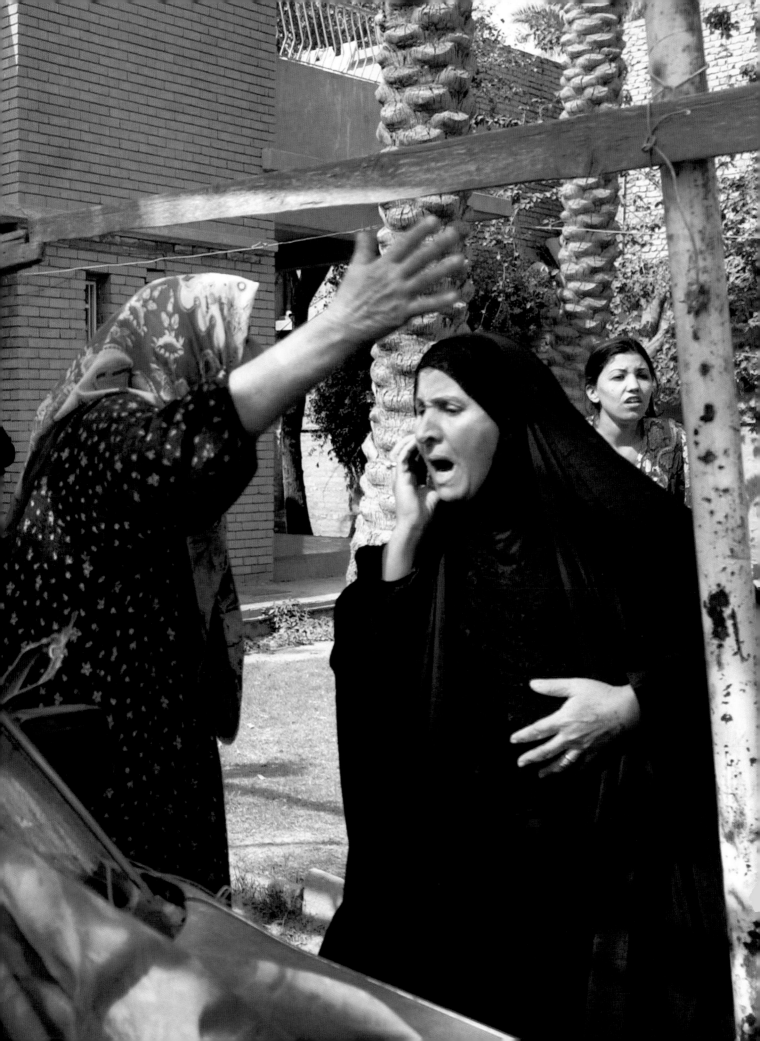

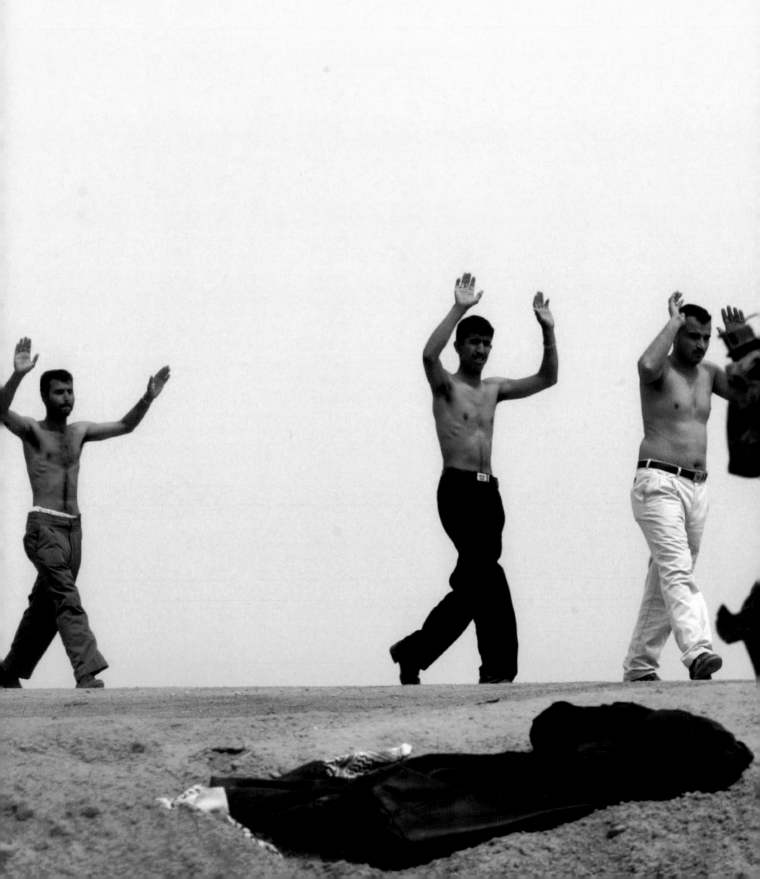

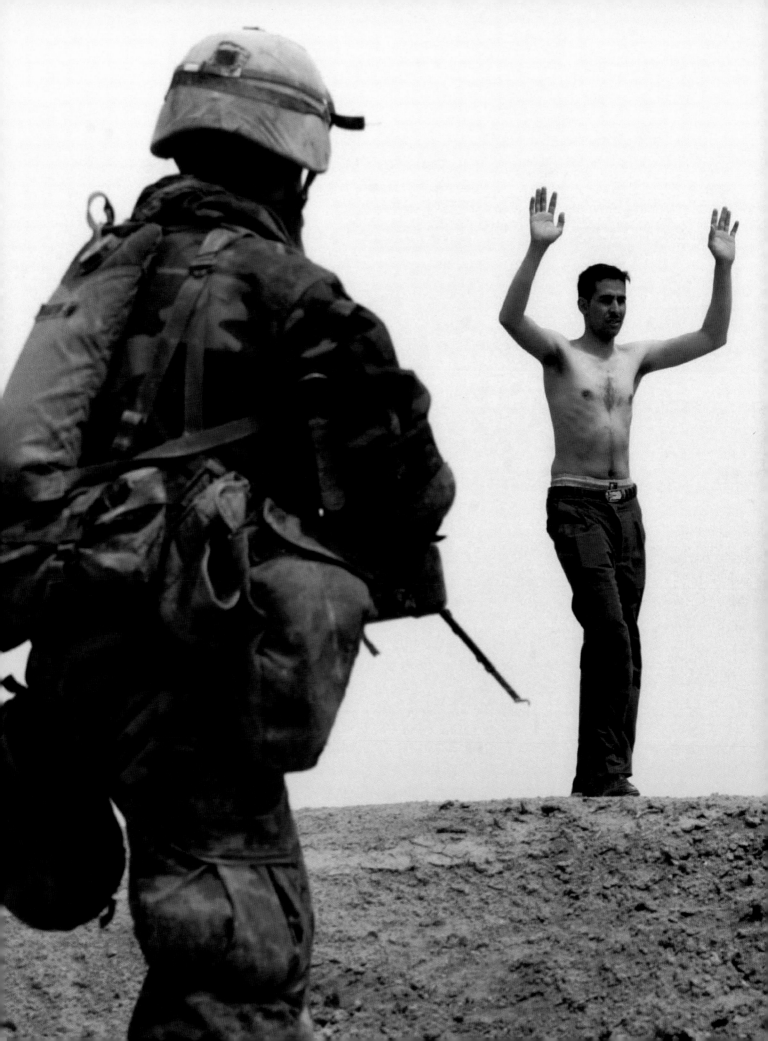

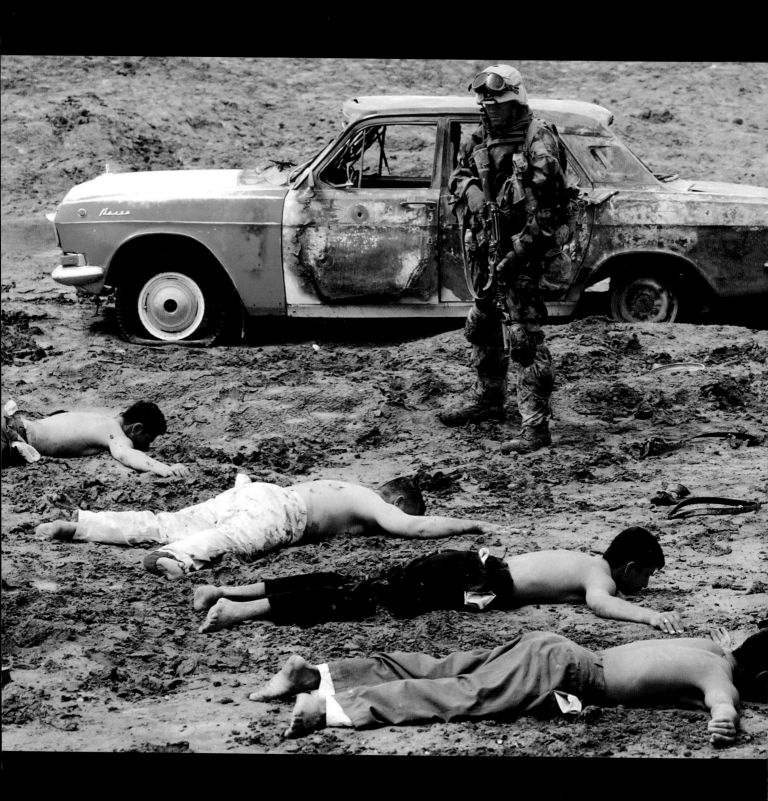

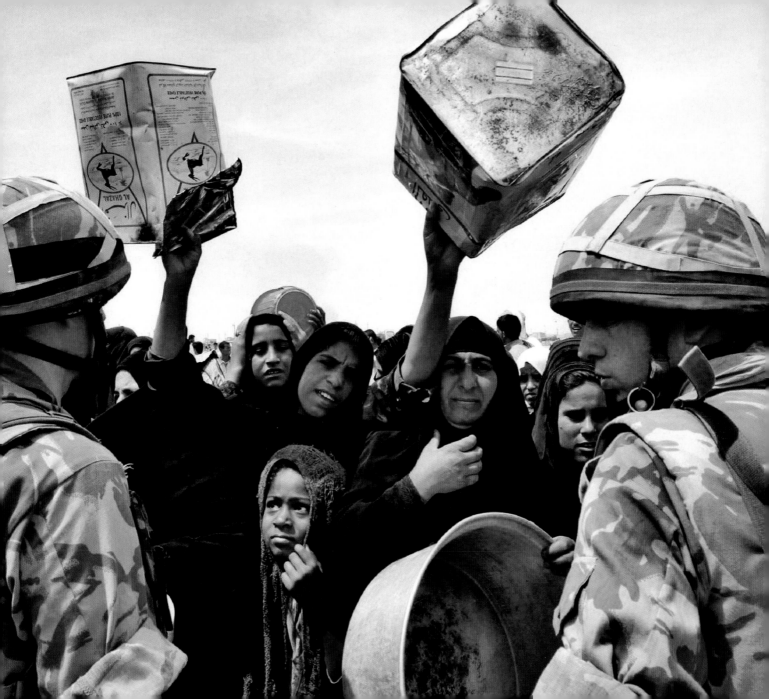

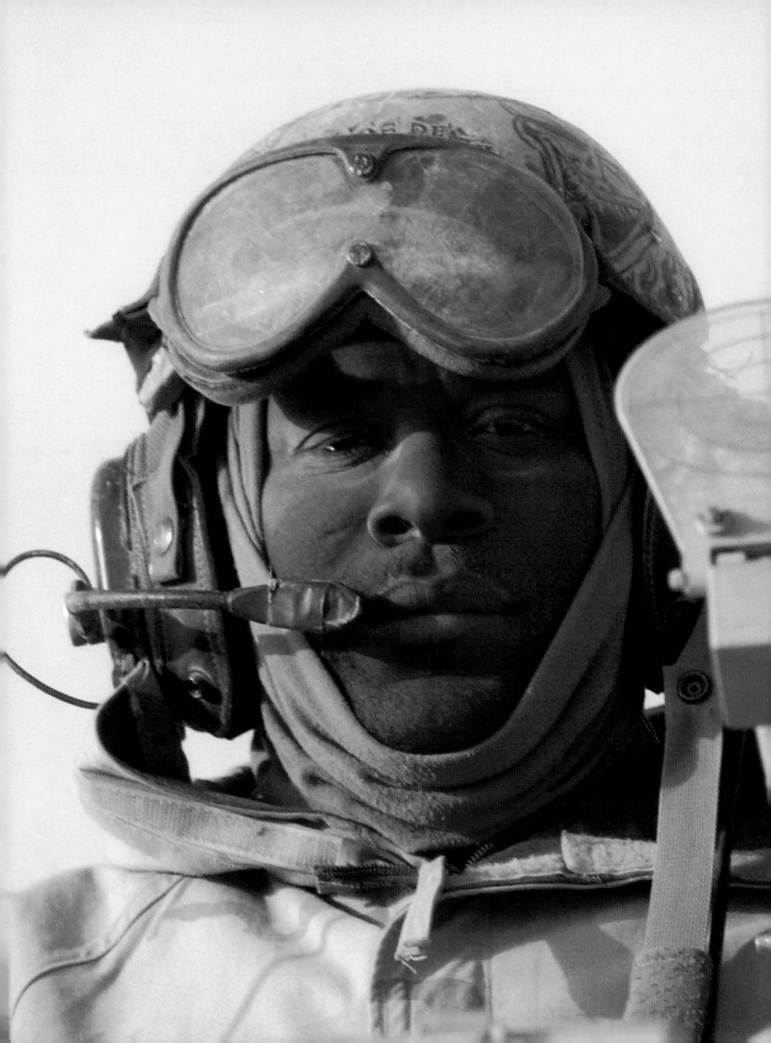

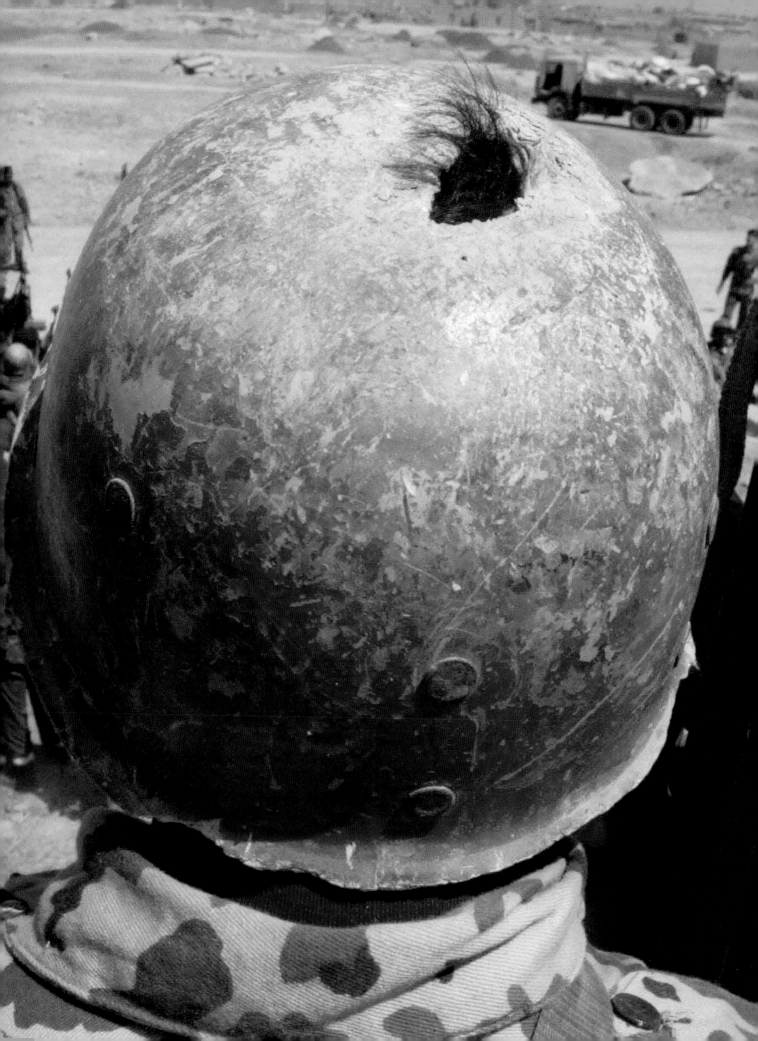

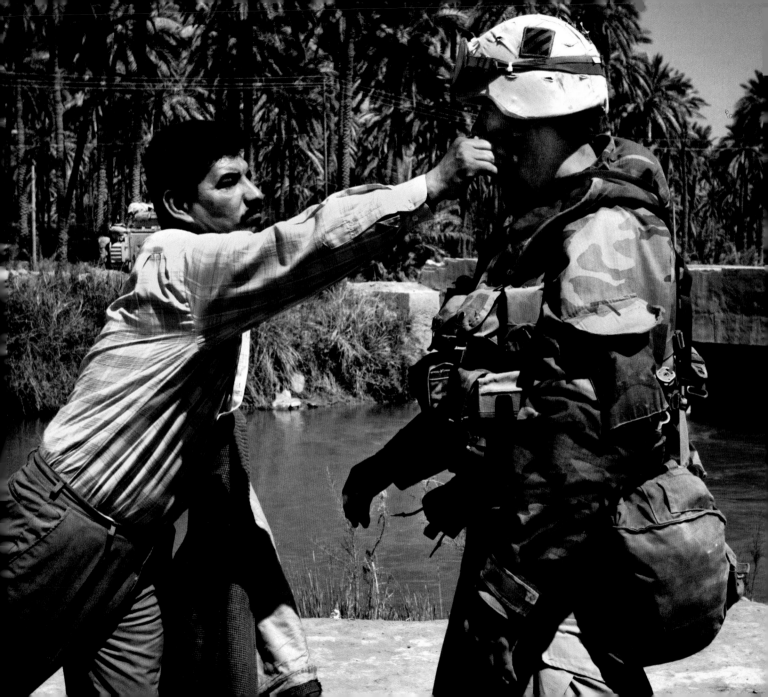

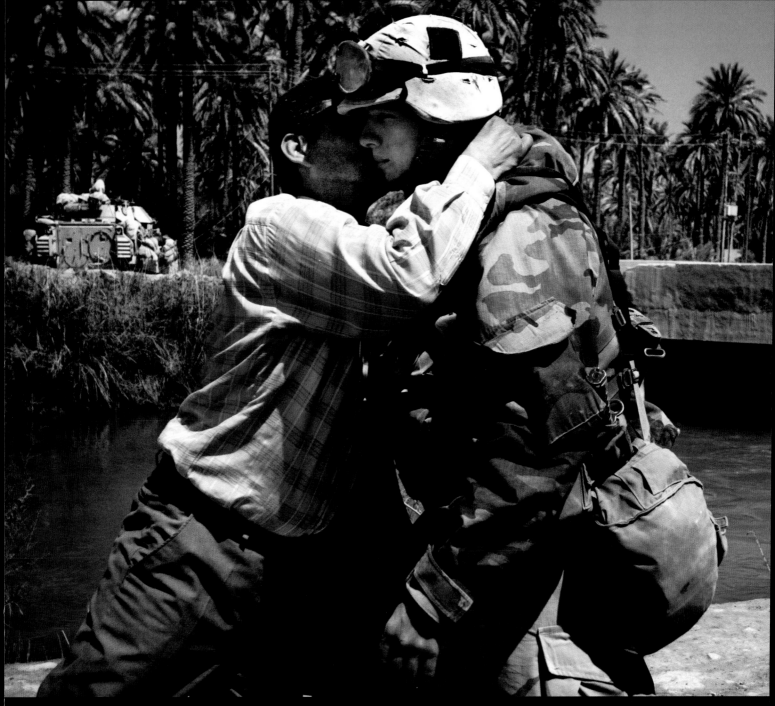

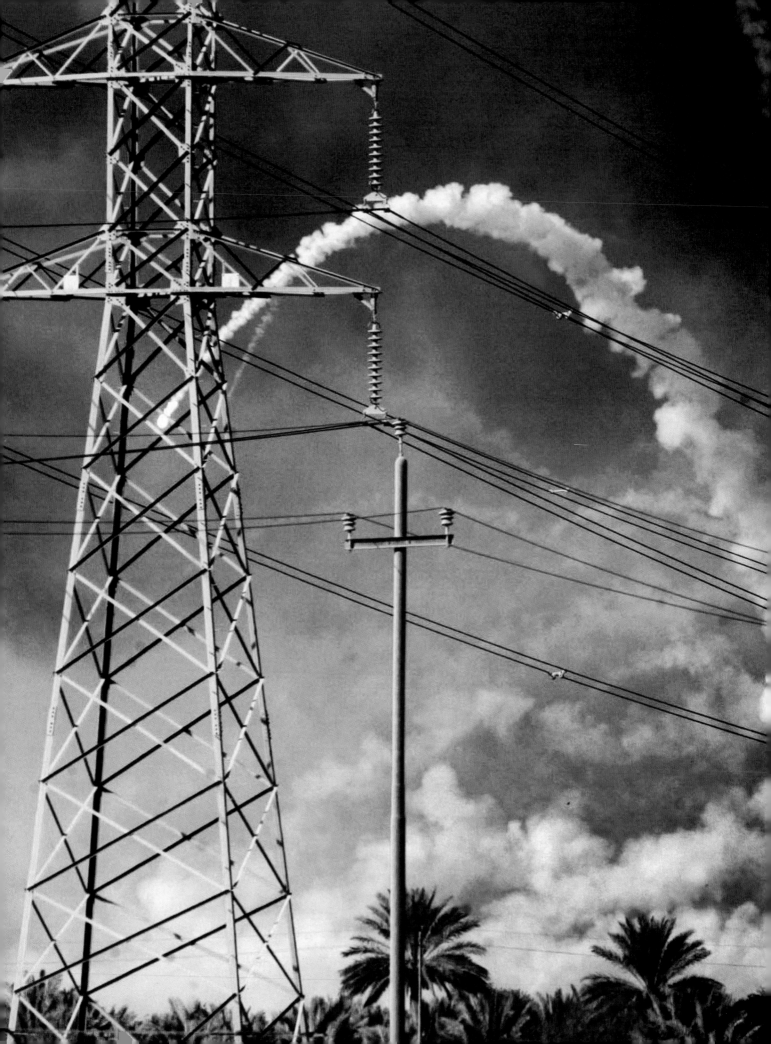

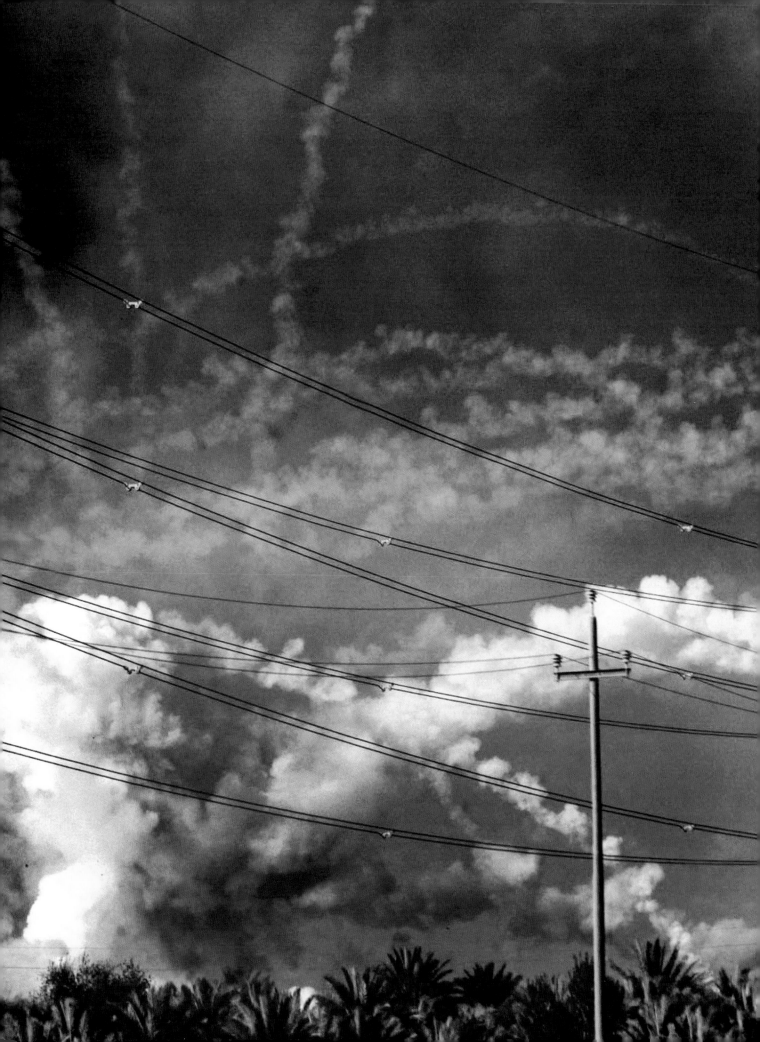

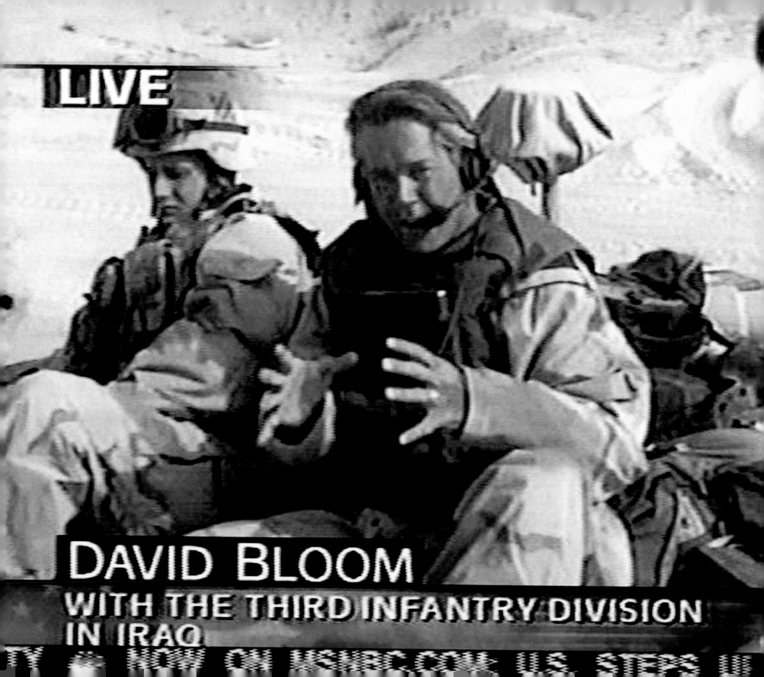

LIVE

DAVID BLOOM
WITH THE THIRD INFANTRY DIVISION
IN IRAQ

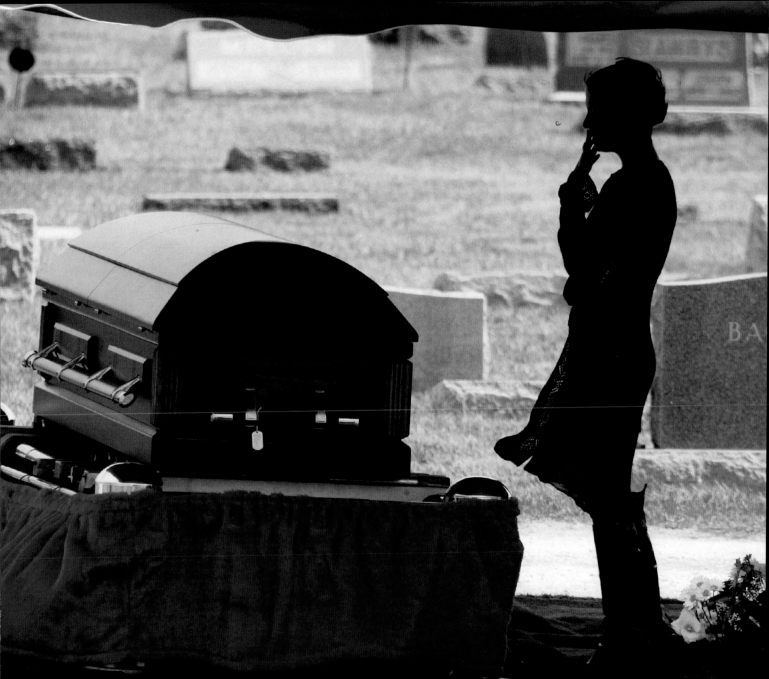

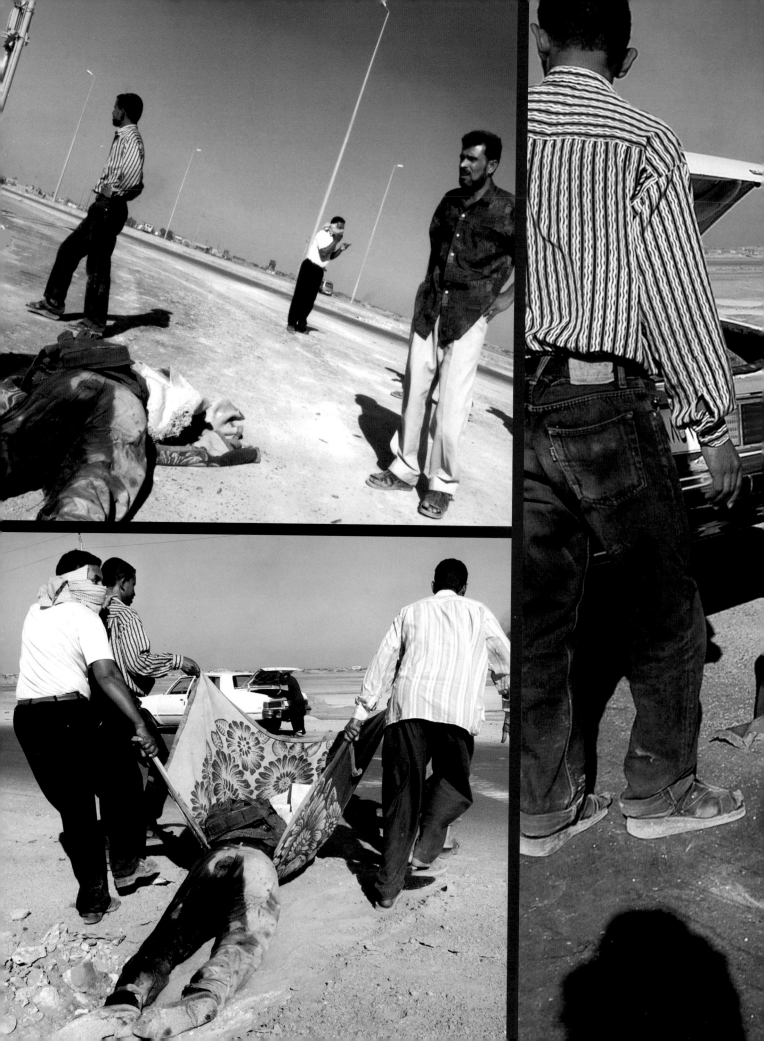

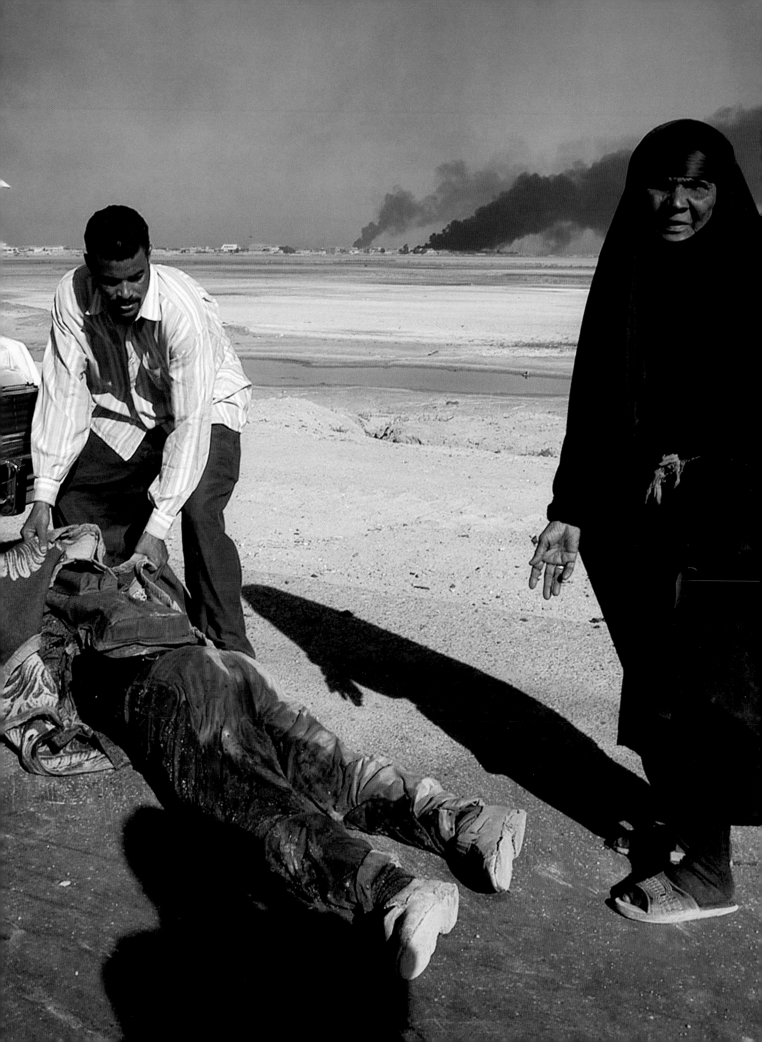

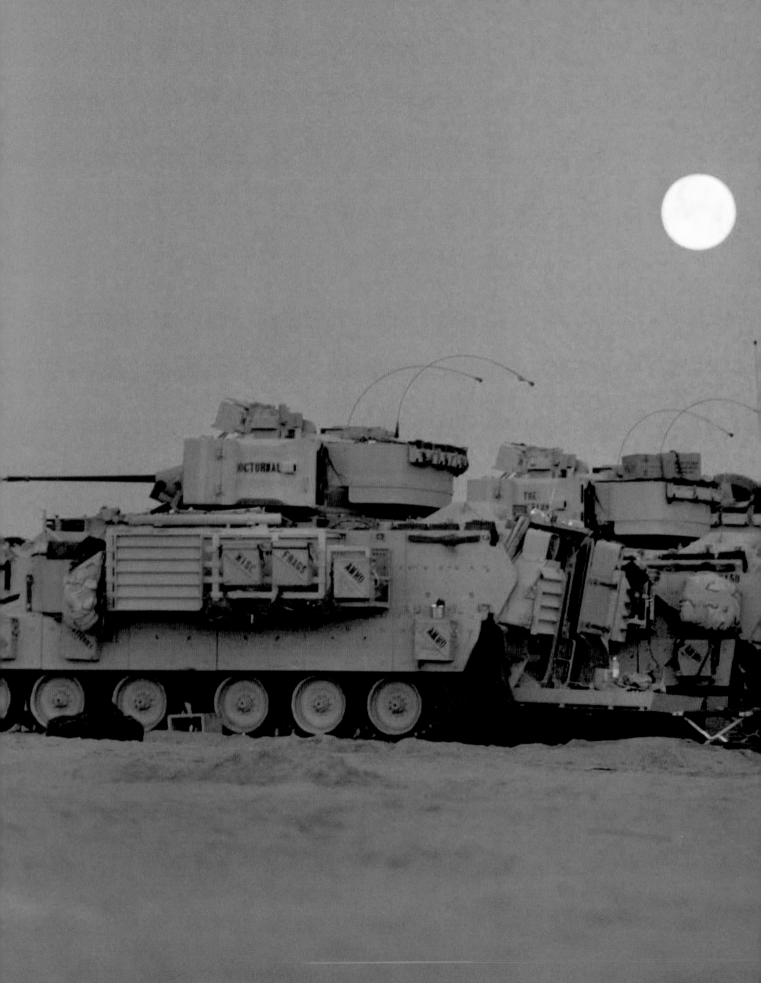

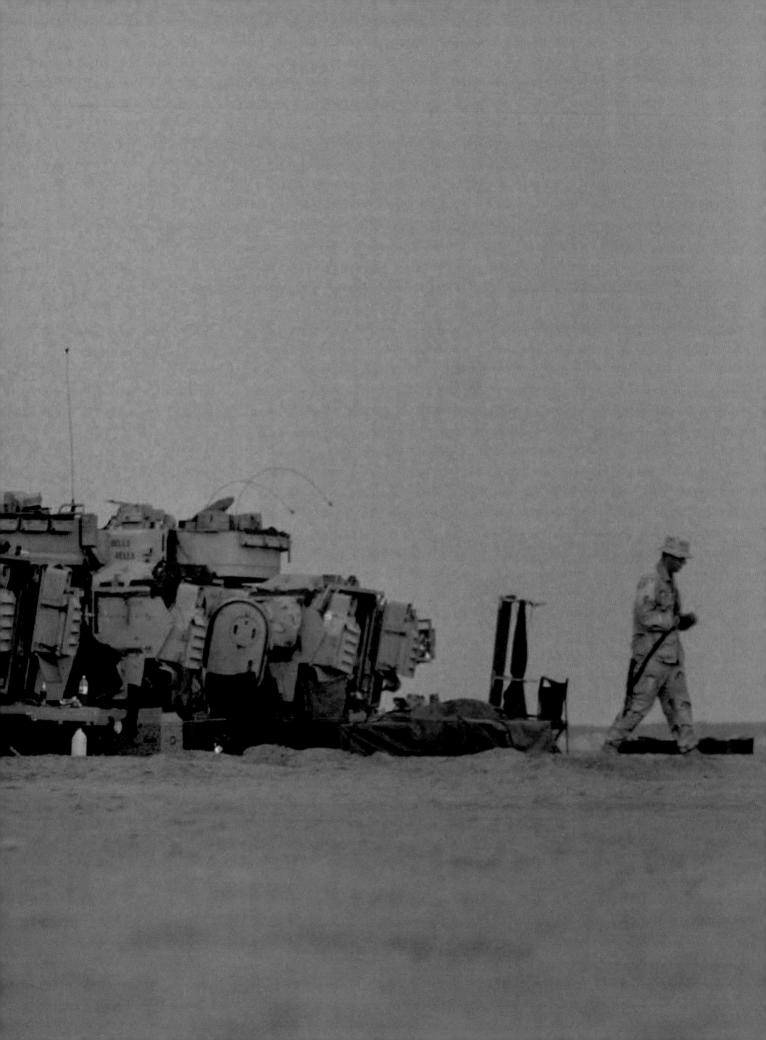

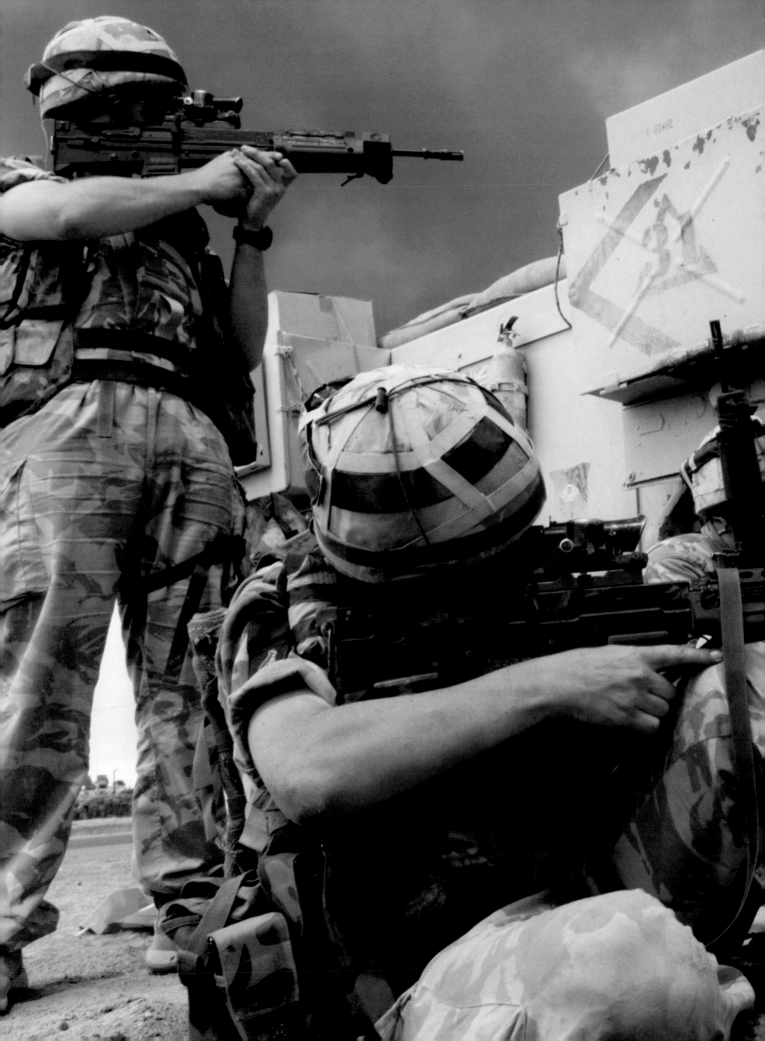

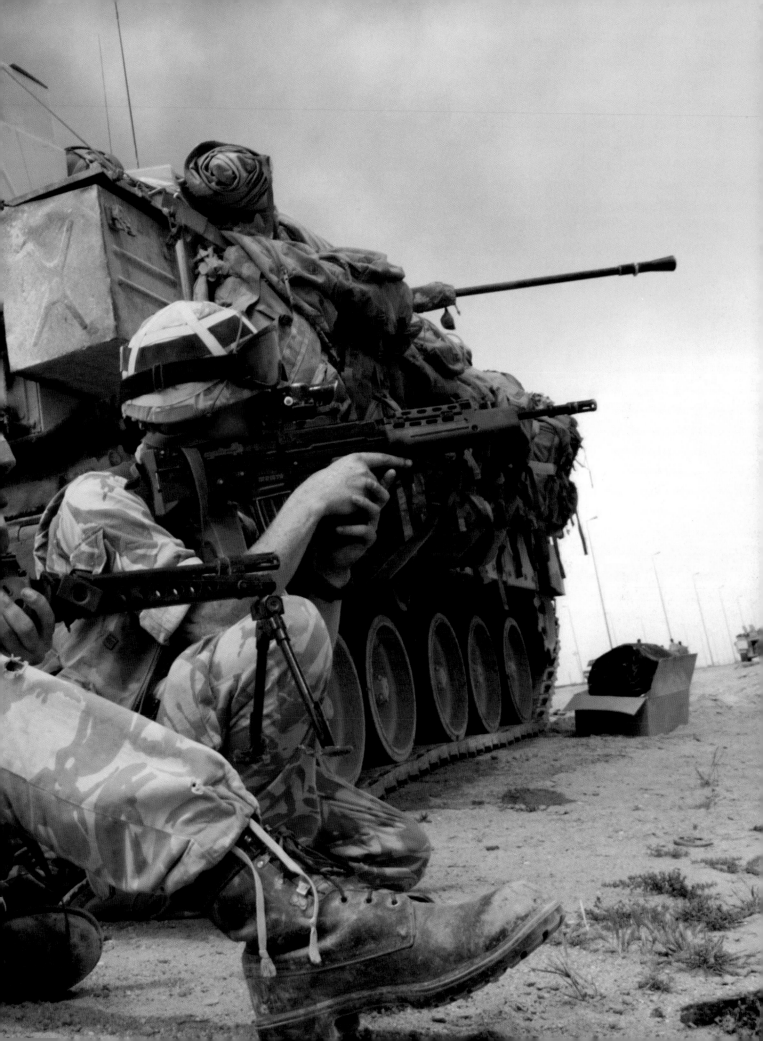

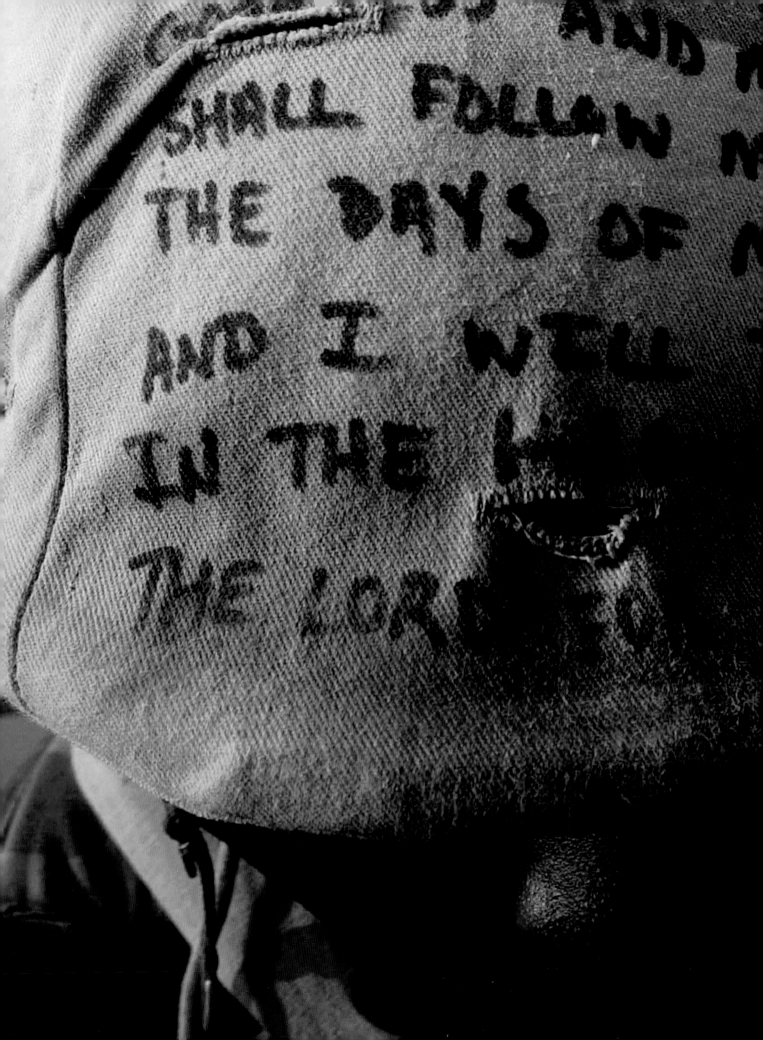

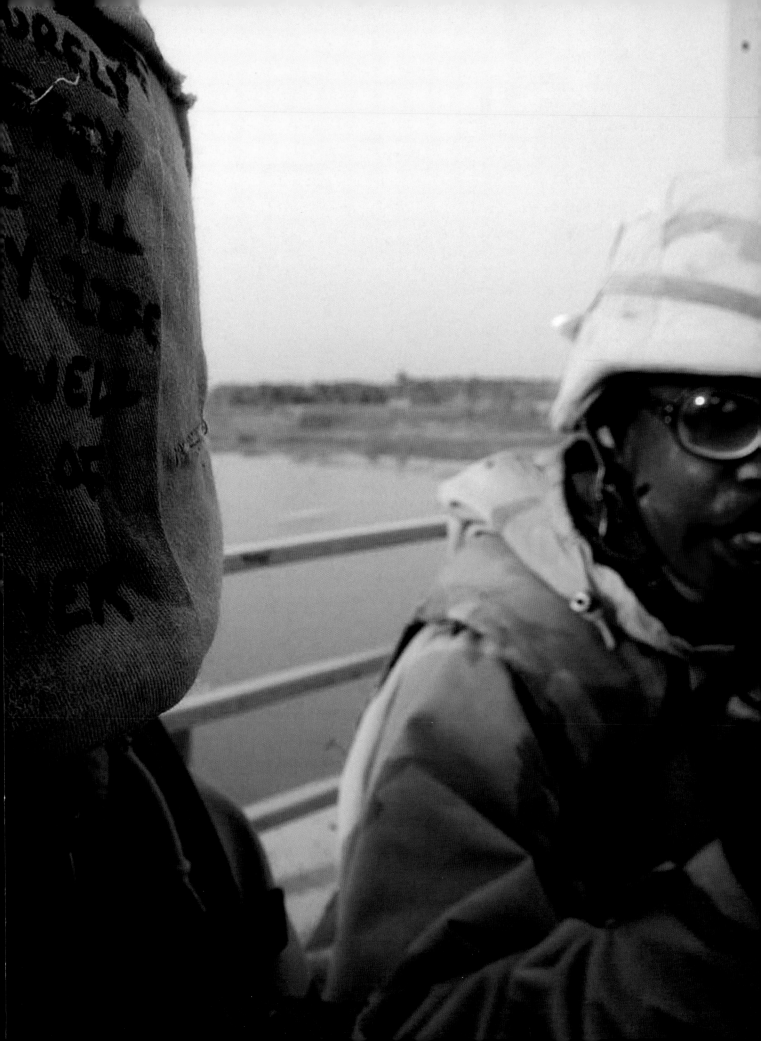

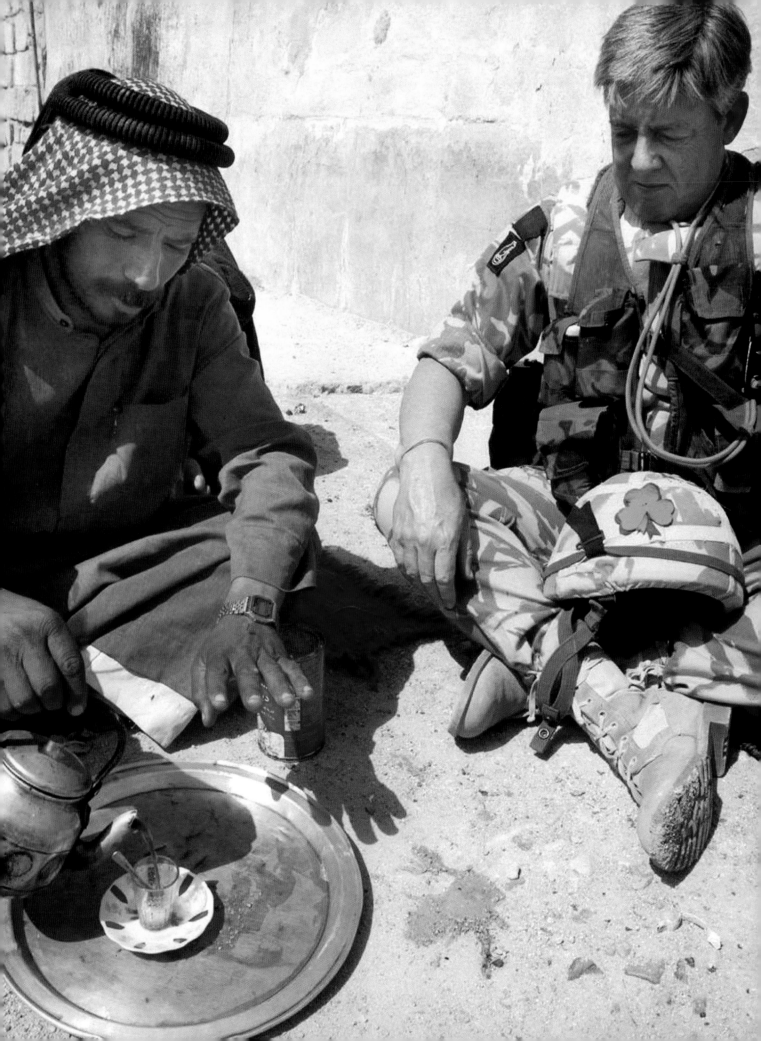

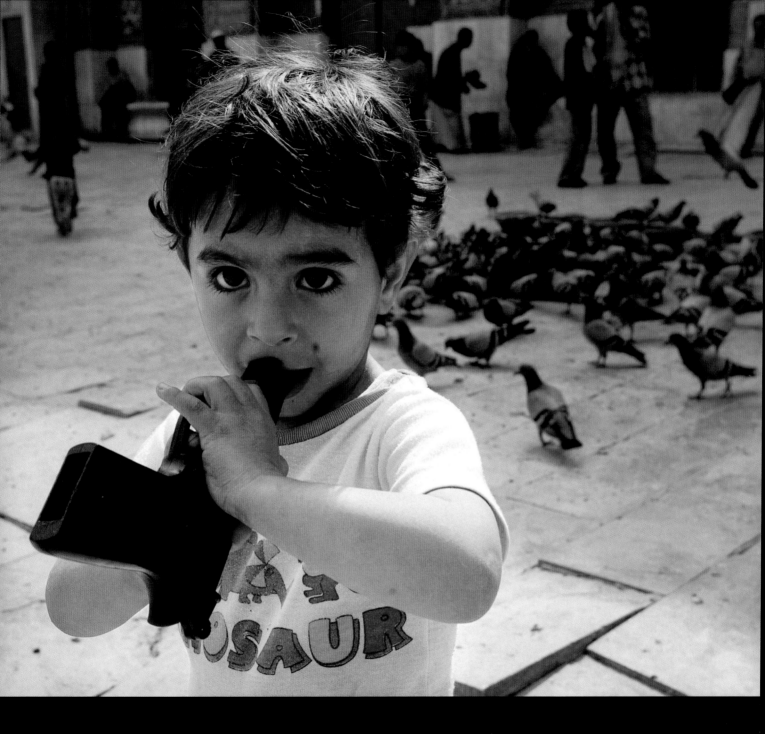

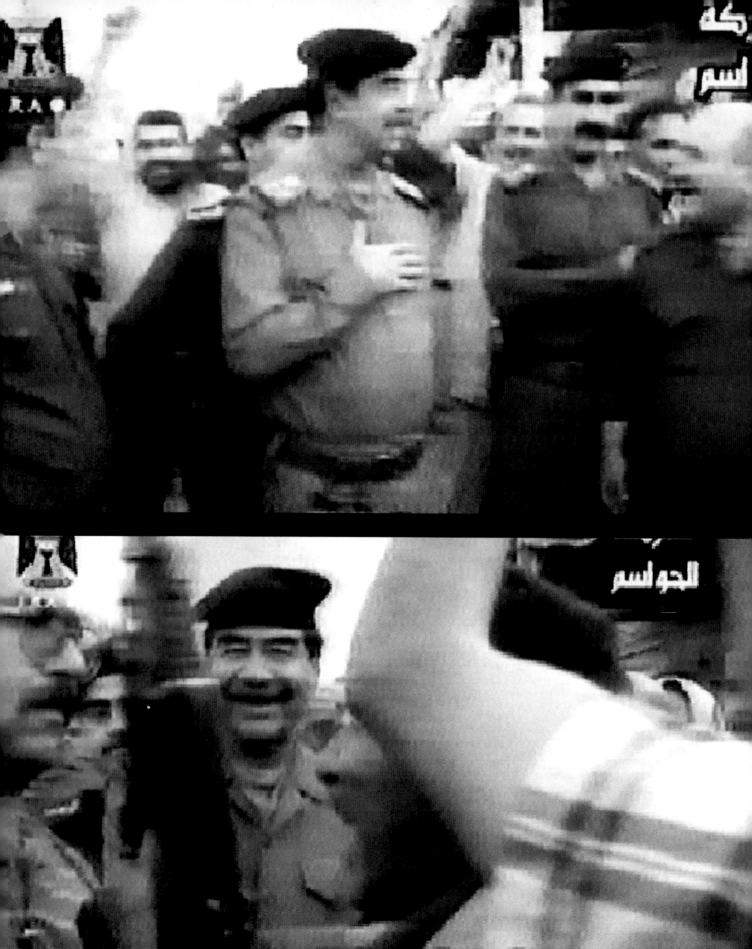

السيد الرئيس القائد صدام حسين
يتفقد عدداً من مناطق مدينة بغداد

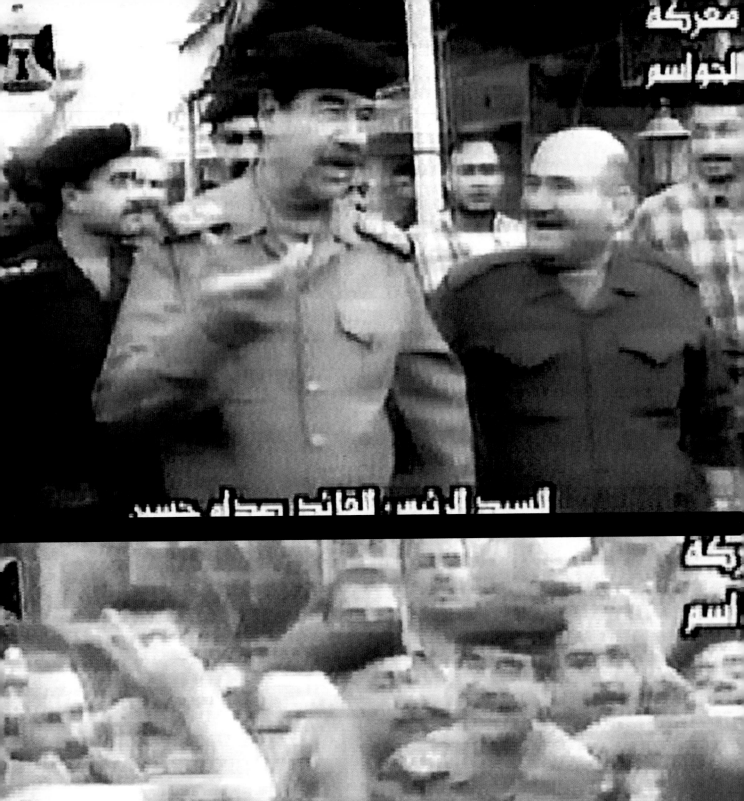

السيد الرئيس القائد صدام حسين

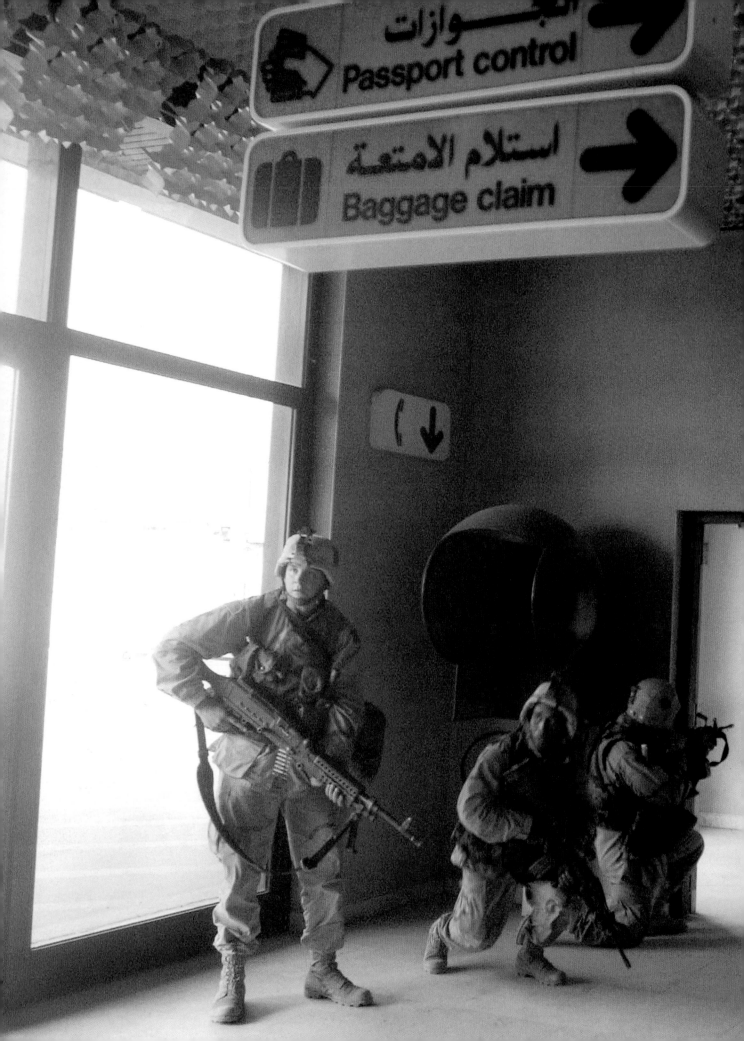

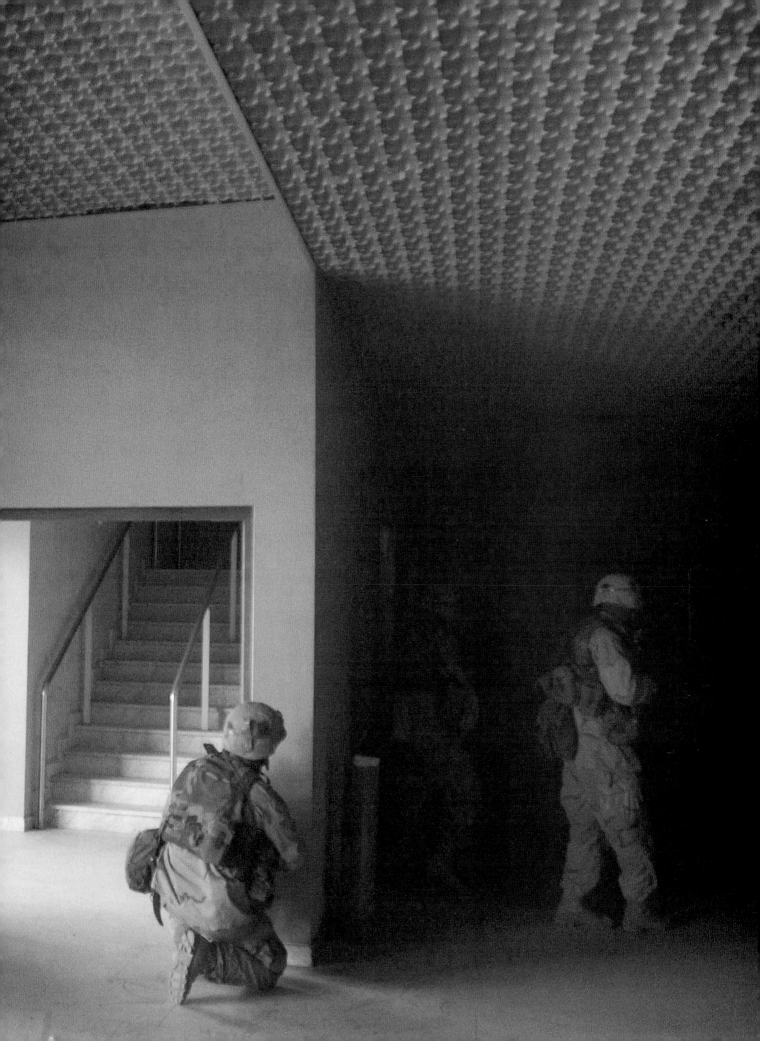

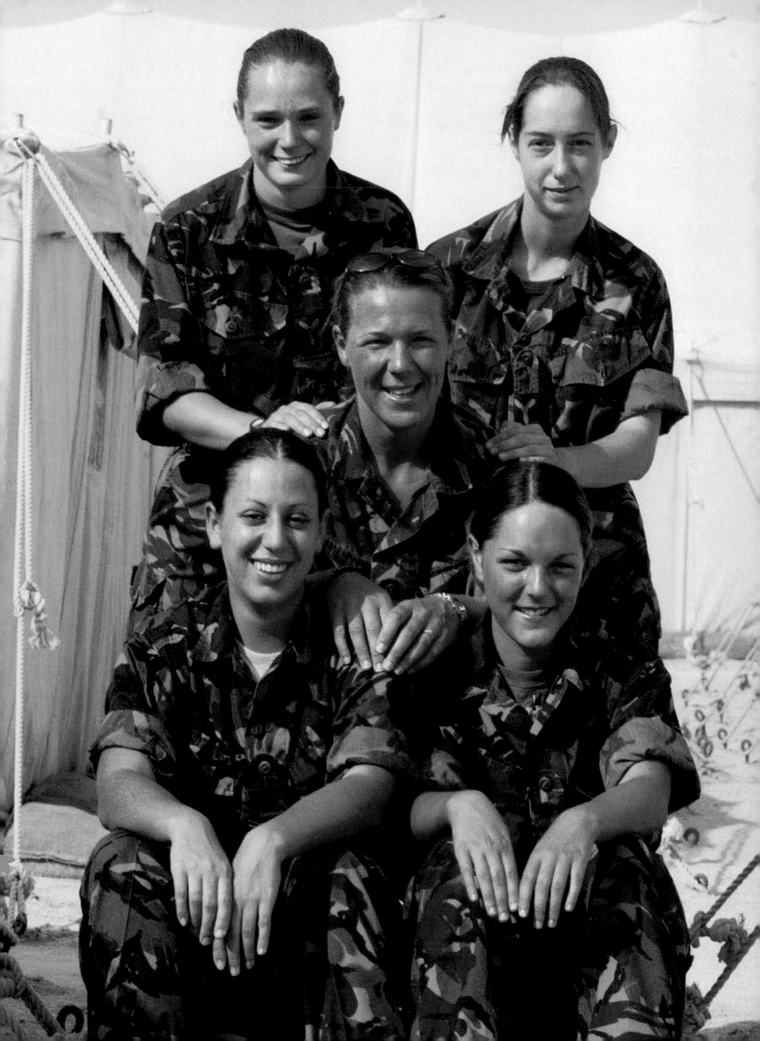

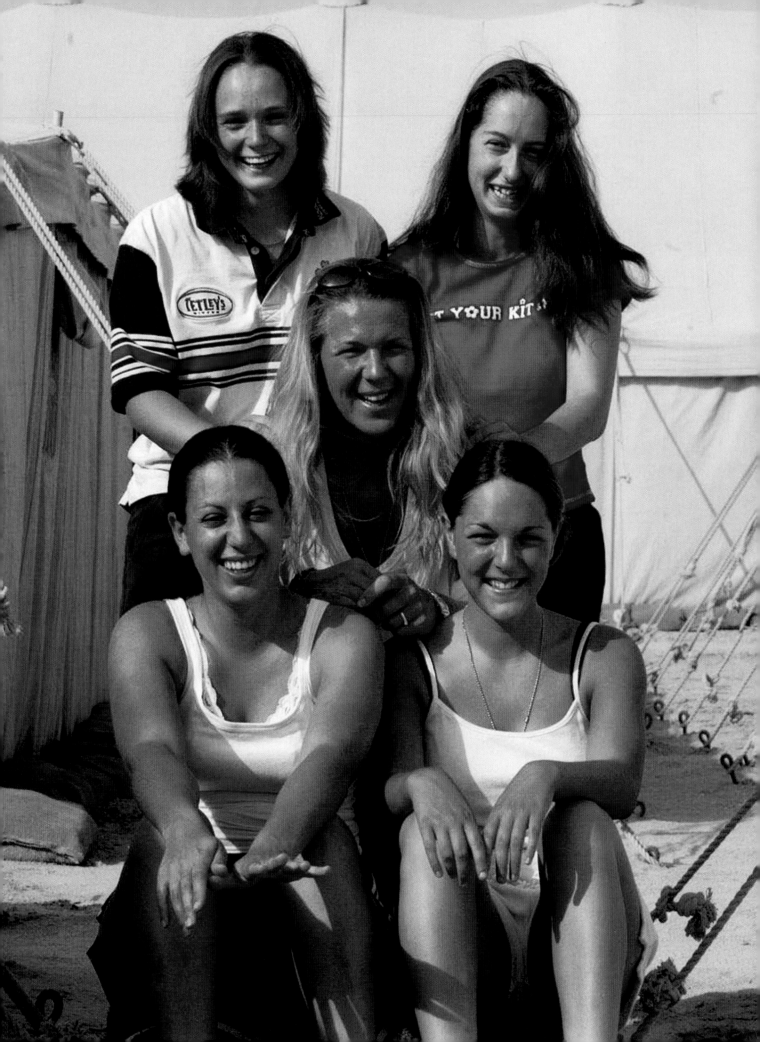

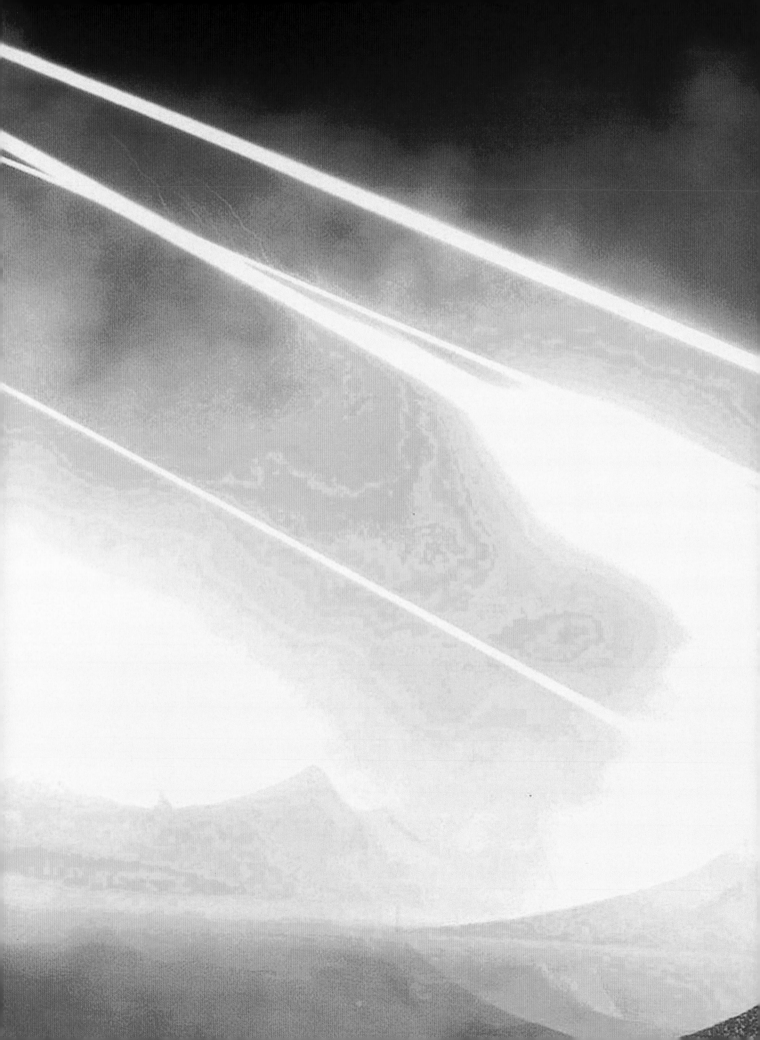

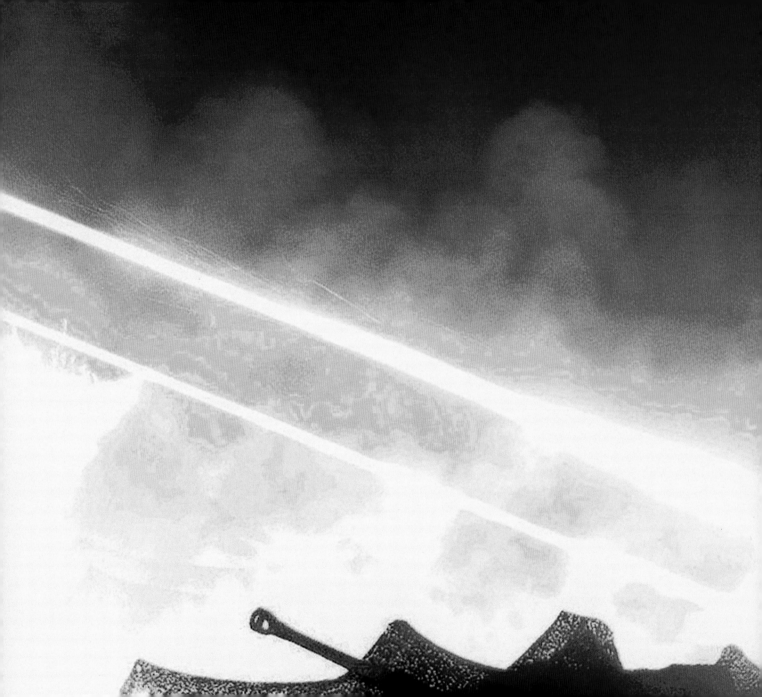

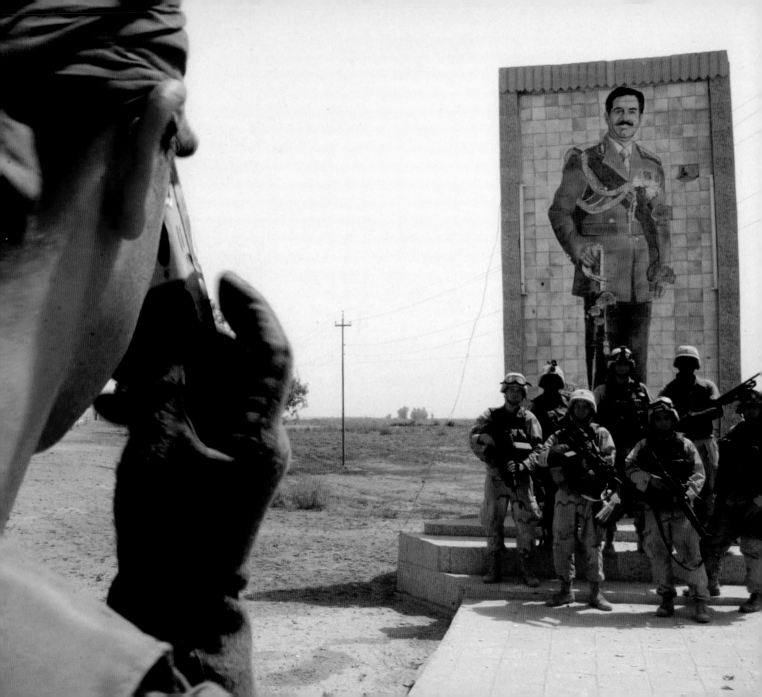

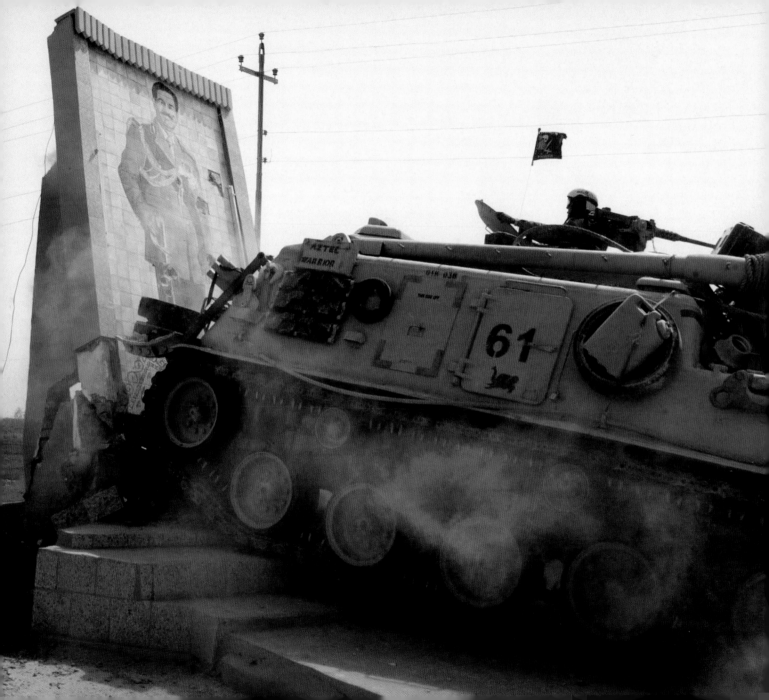

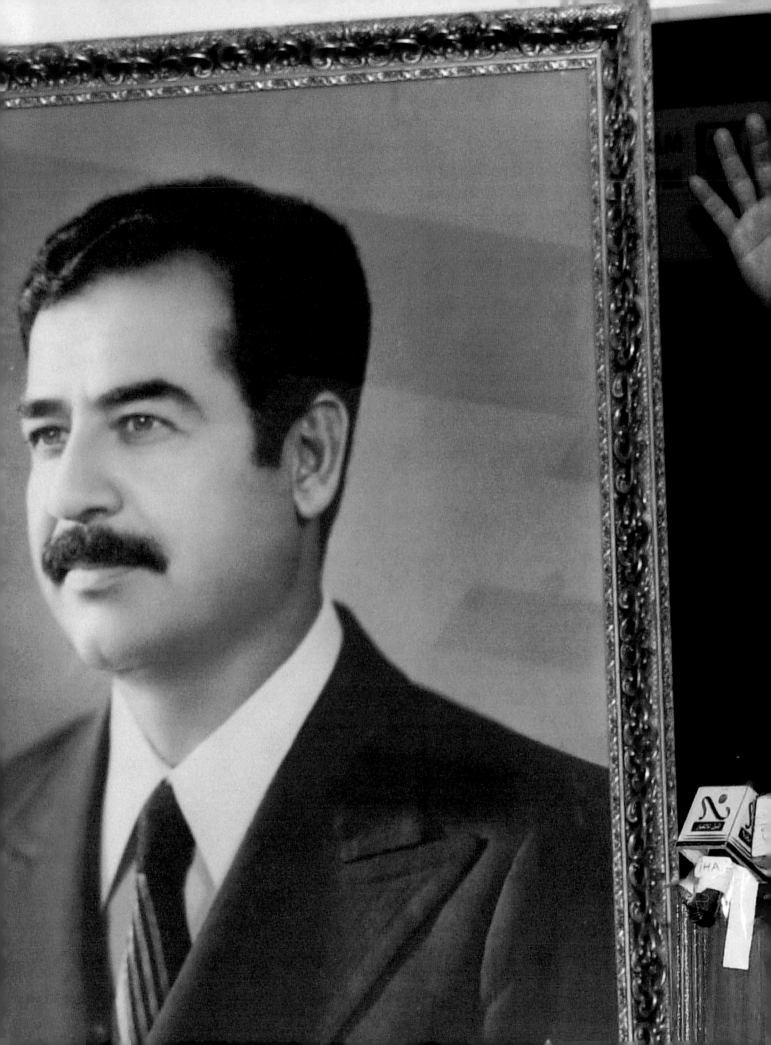

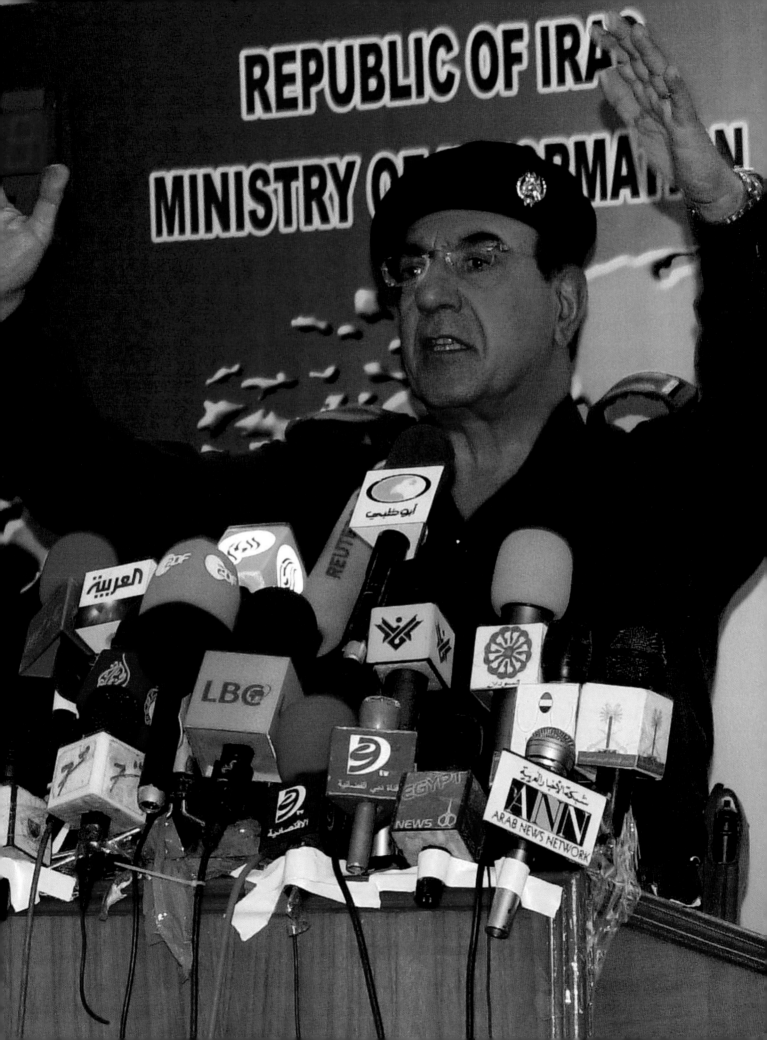

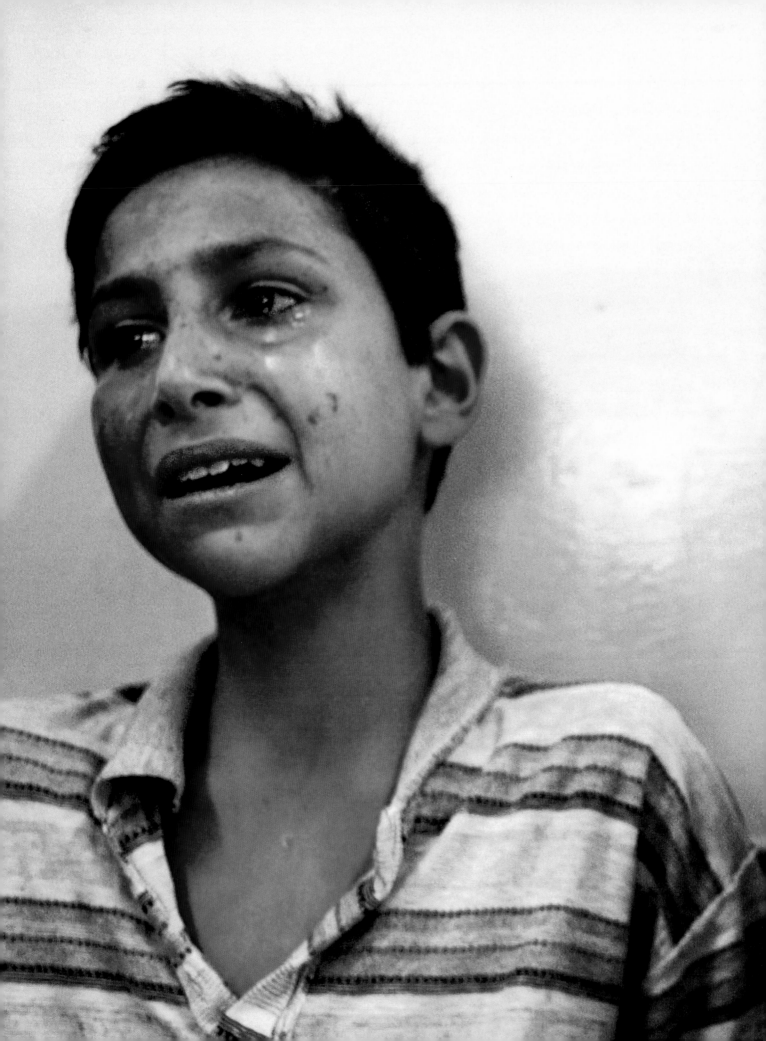

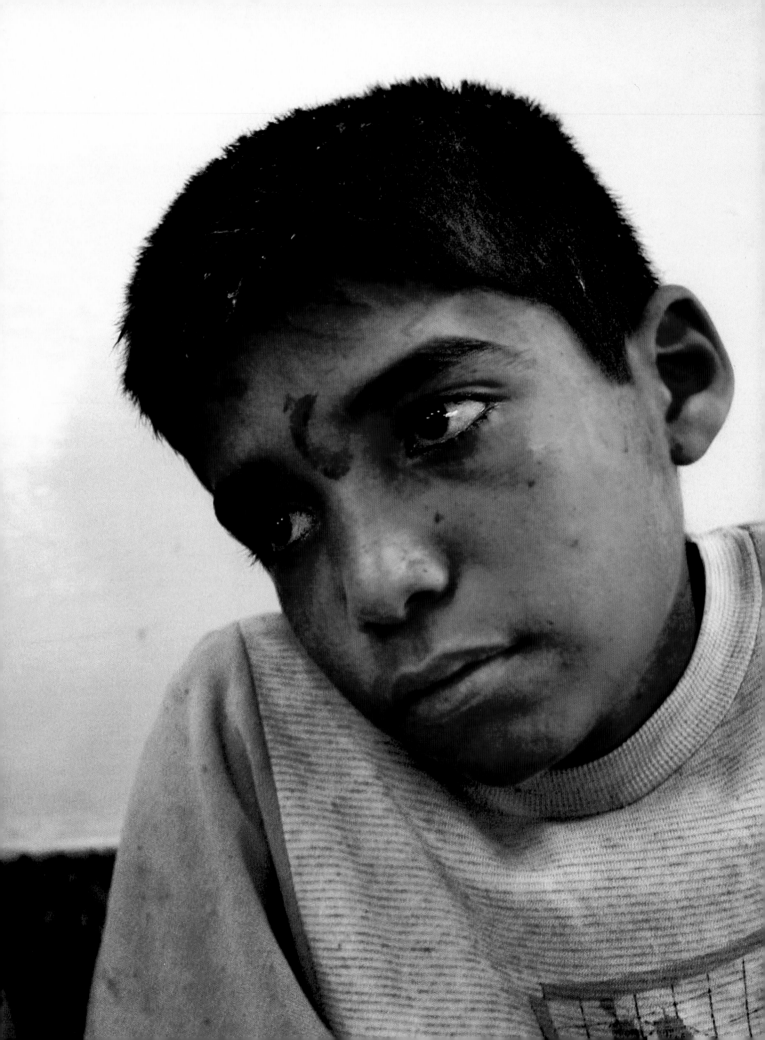

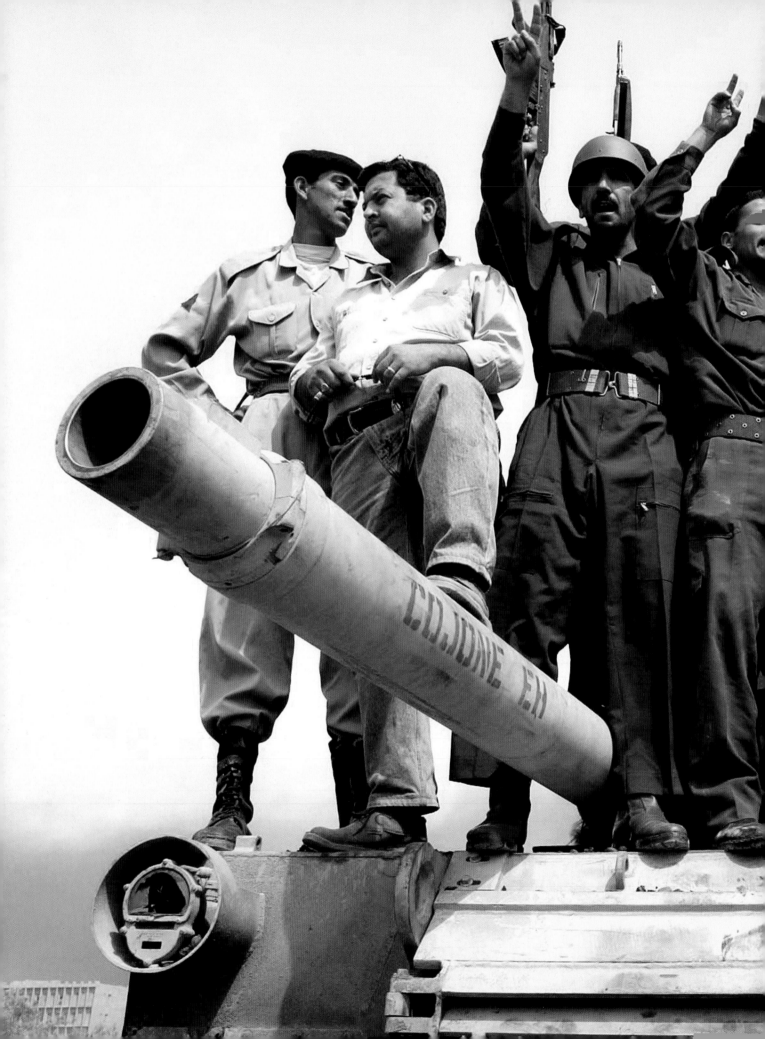

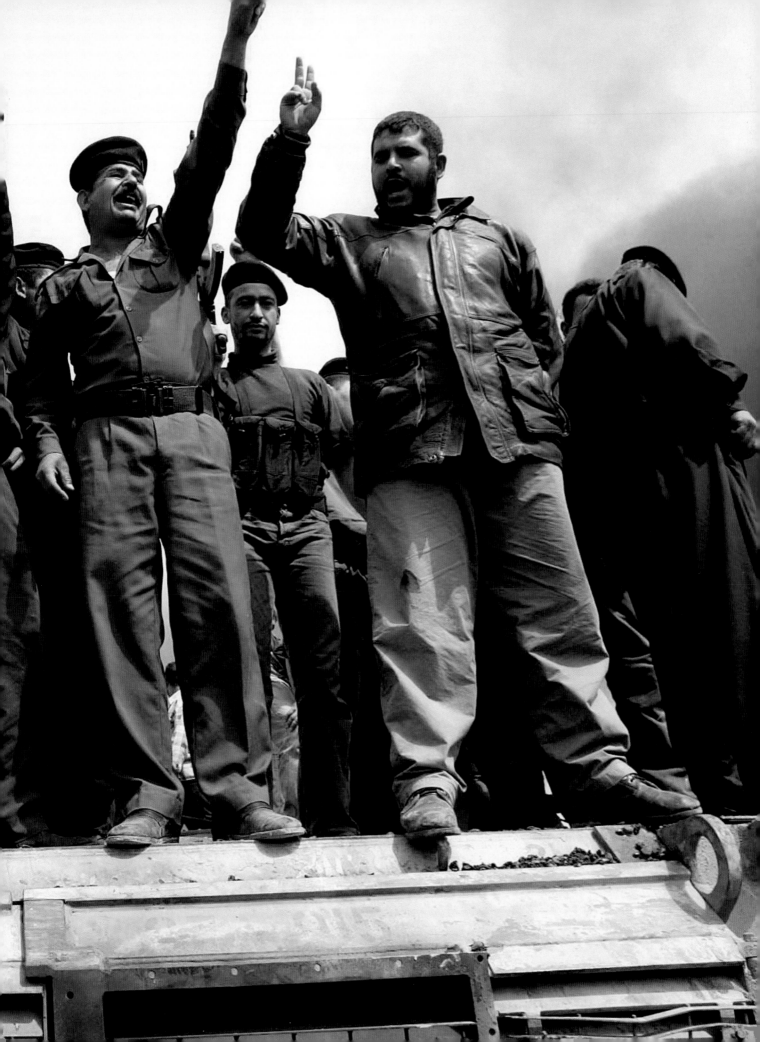

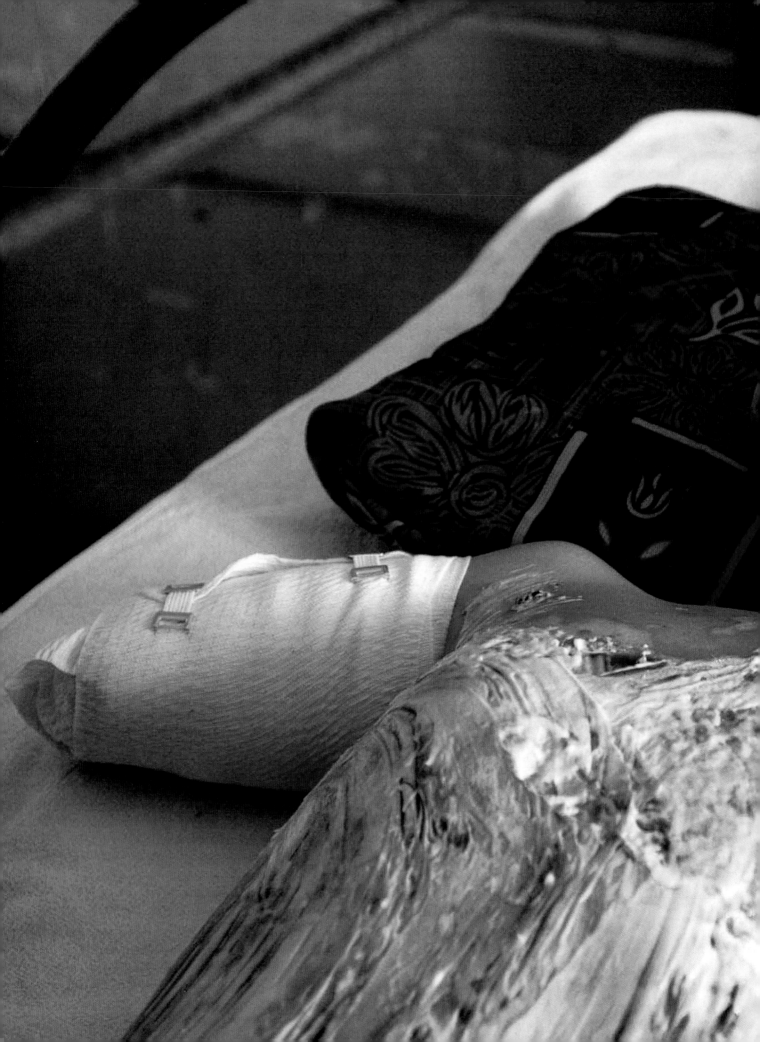

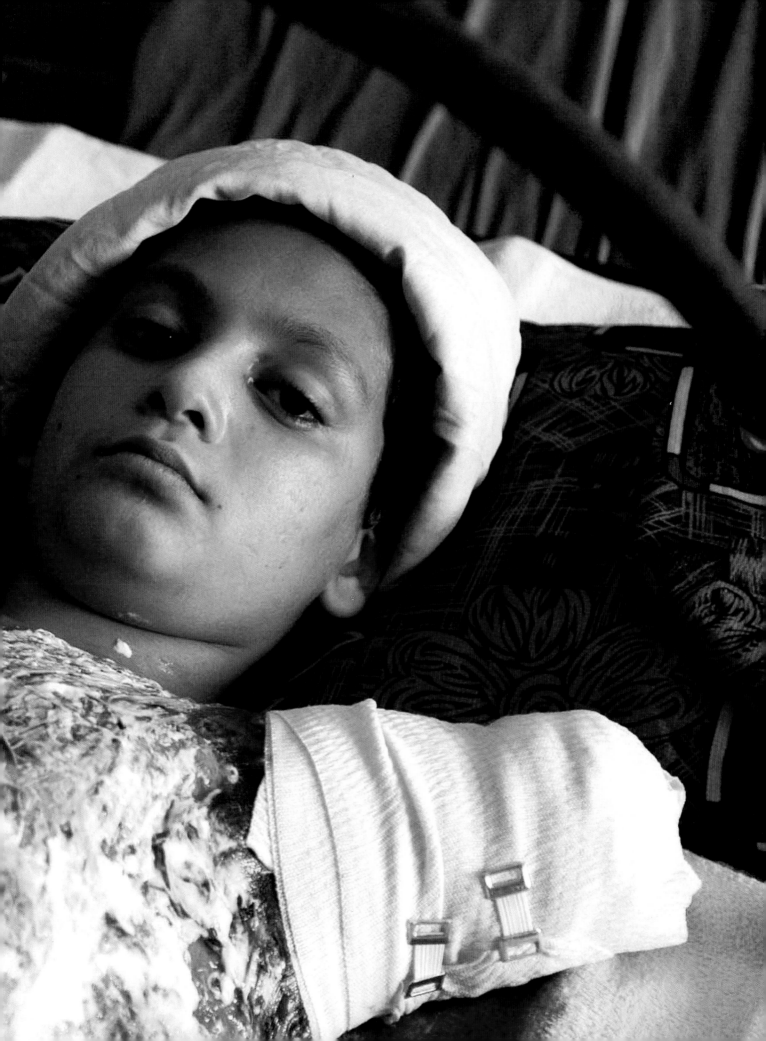

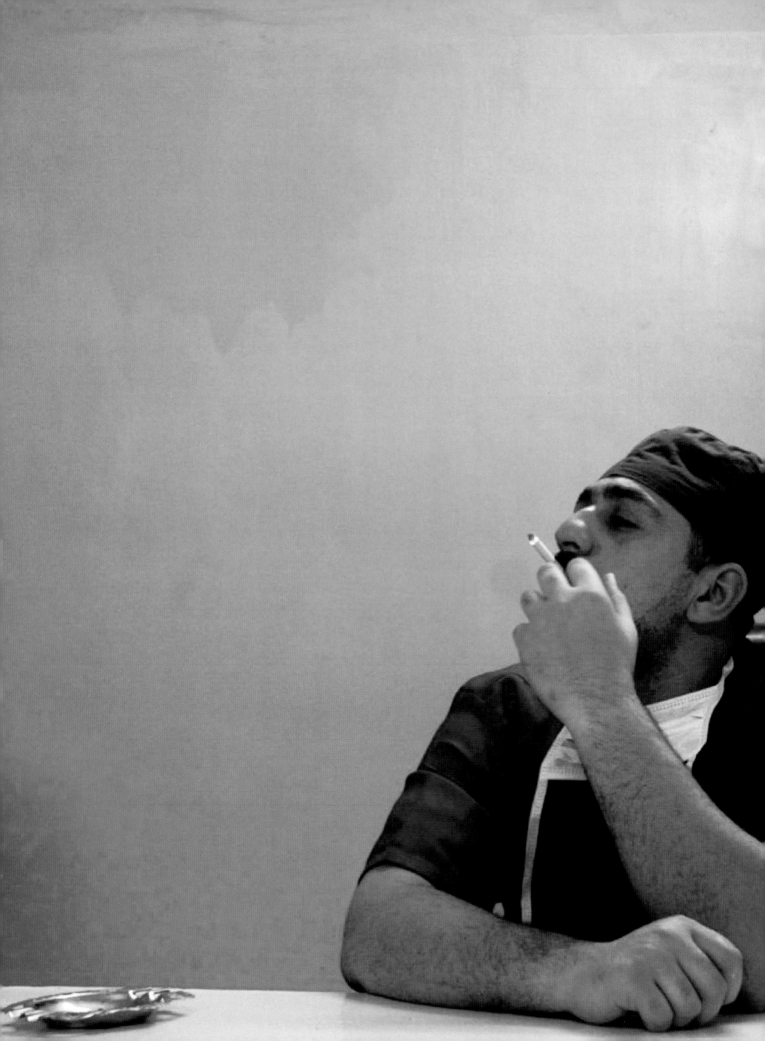

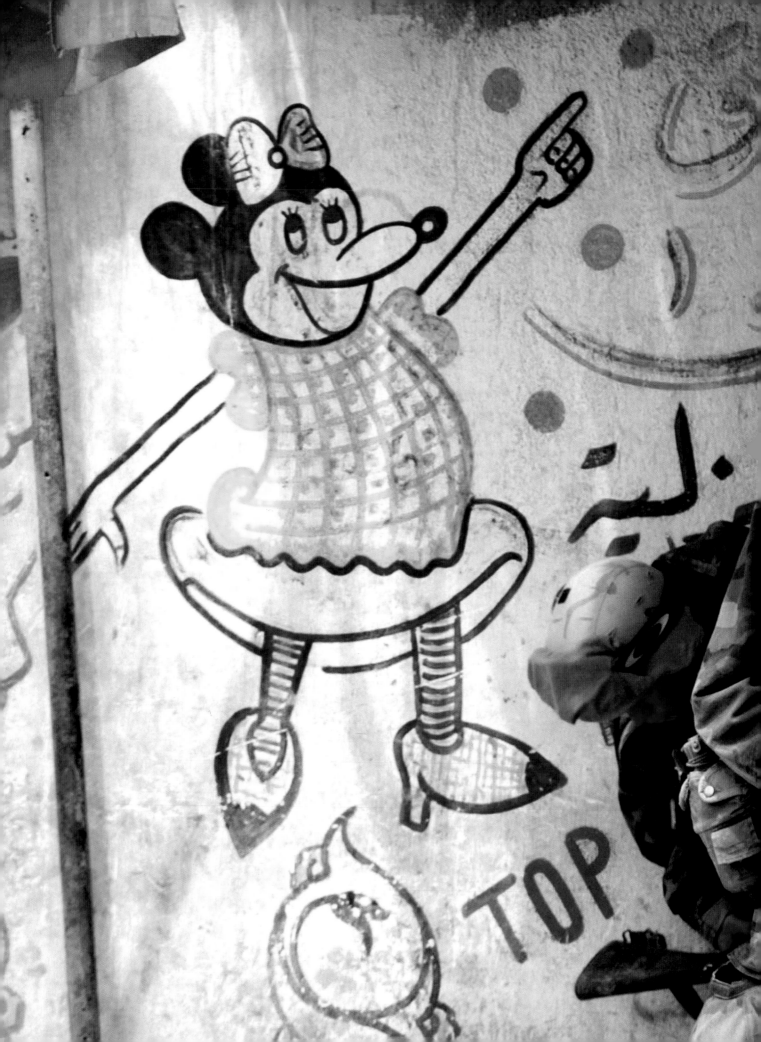

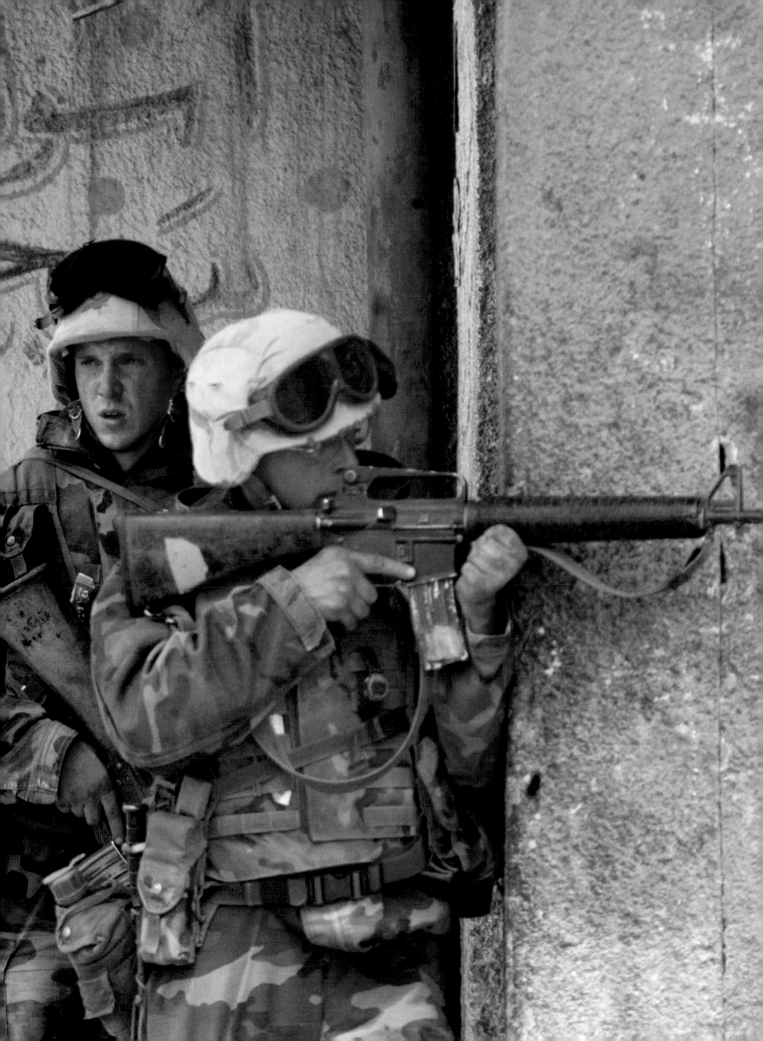

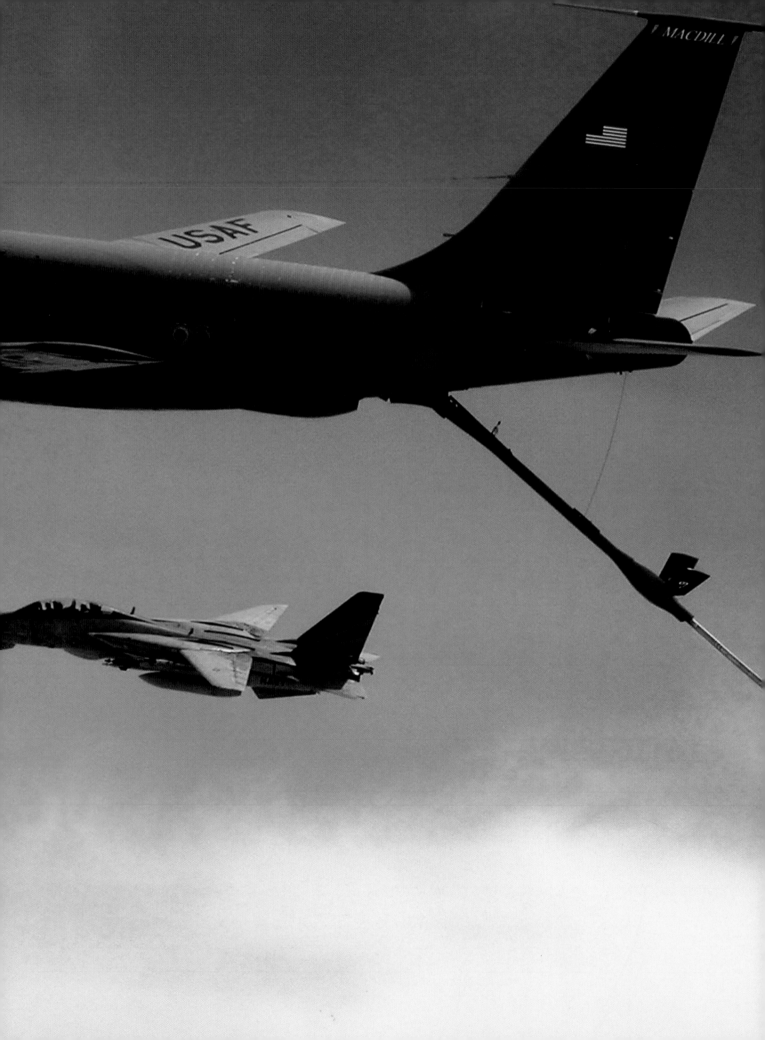

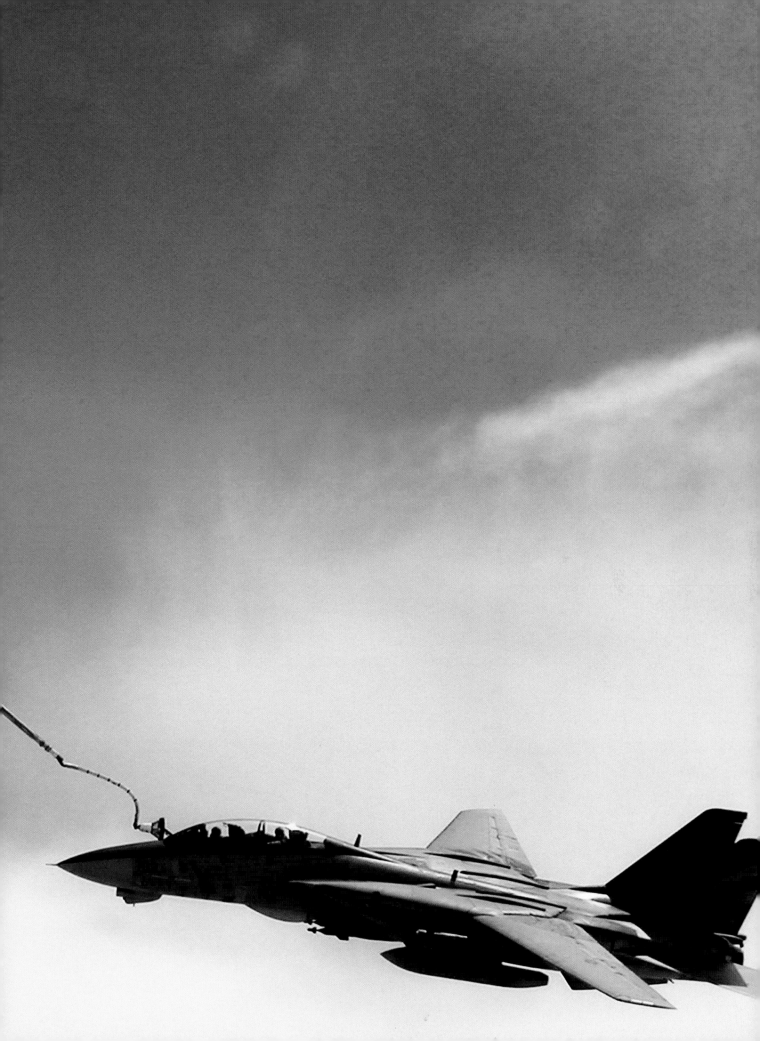

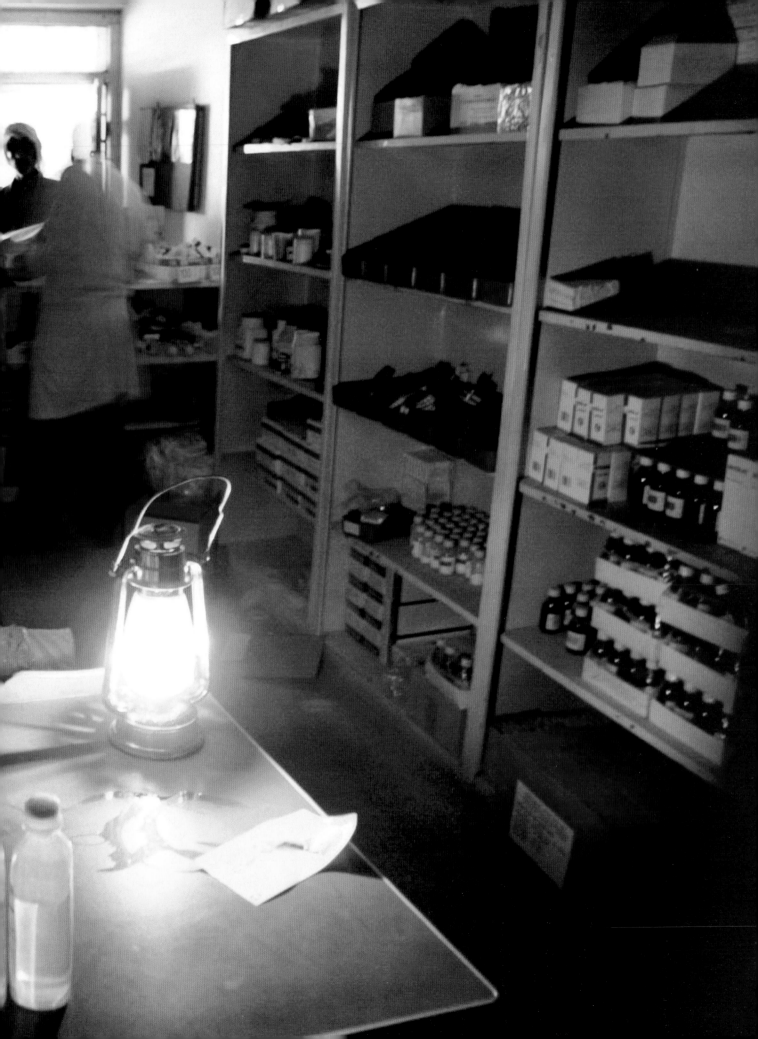

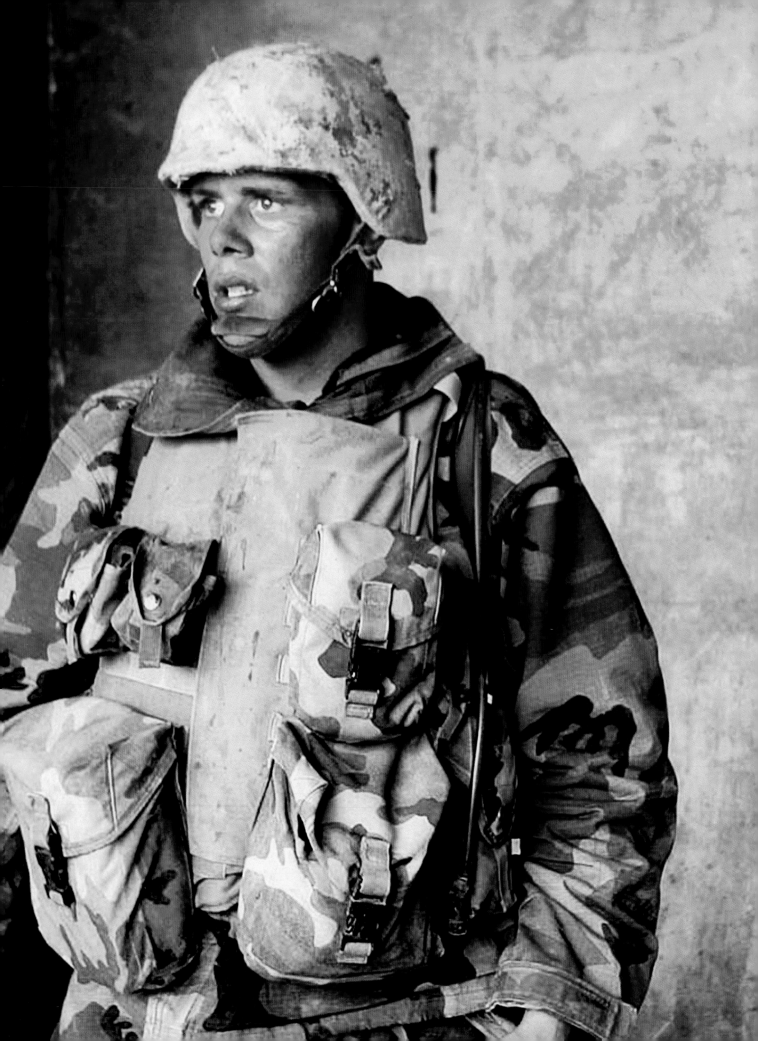

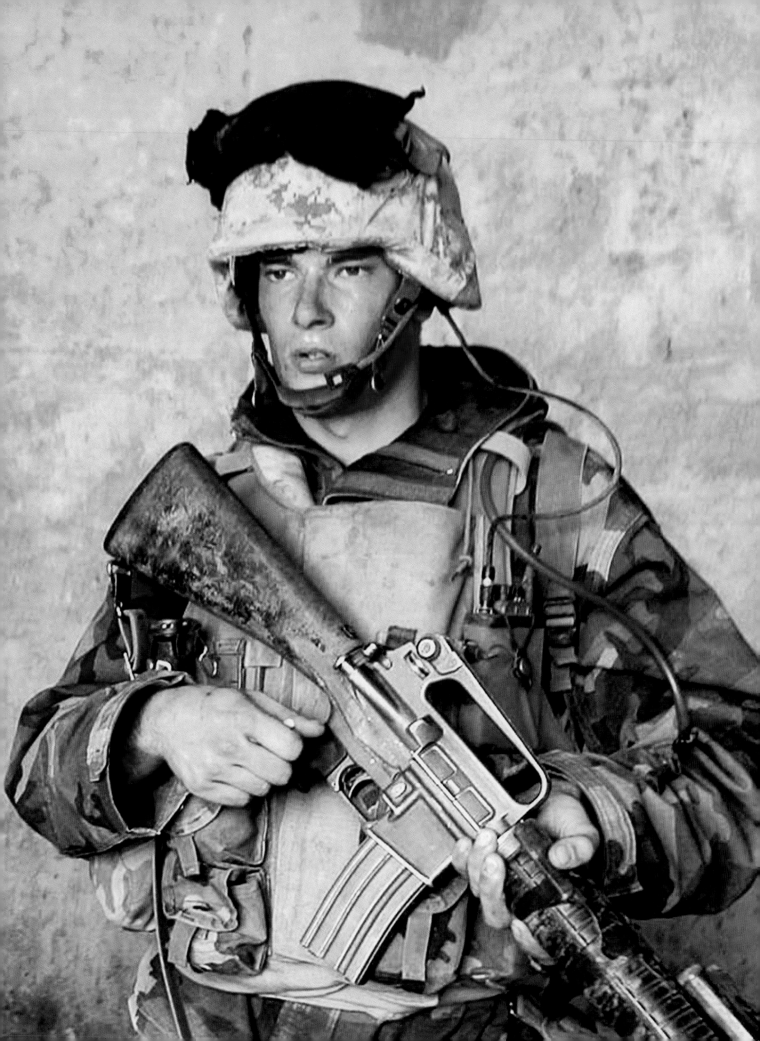

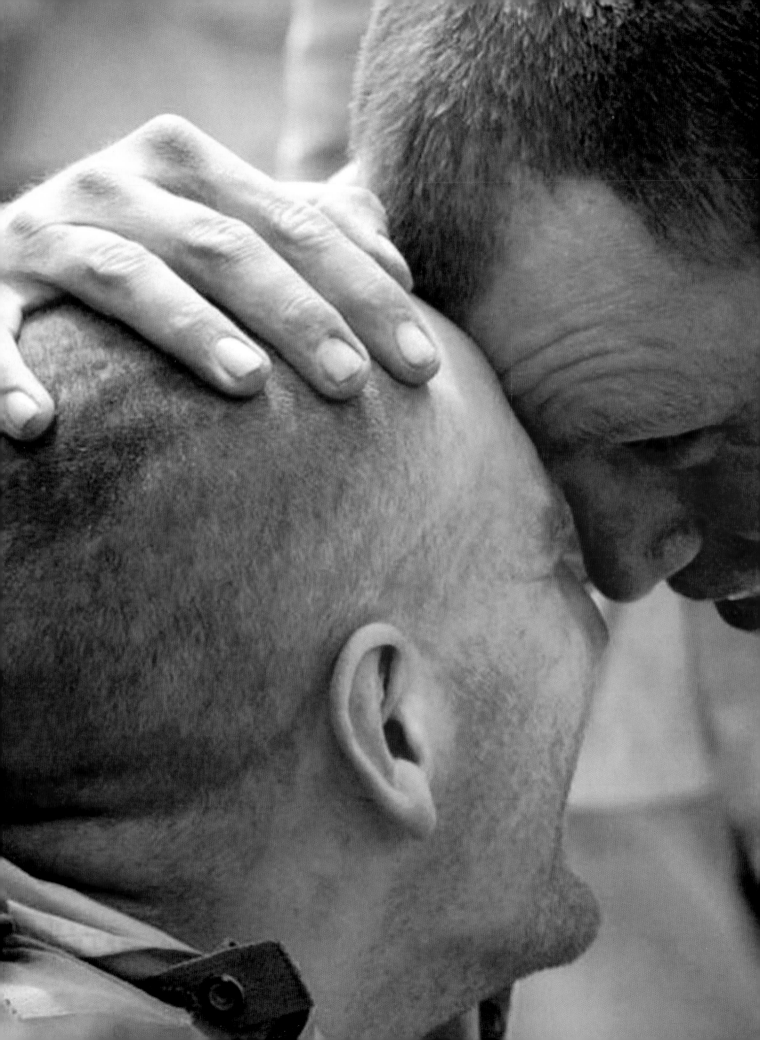

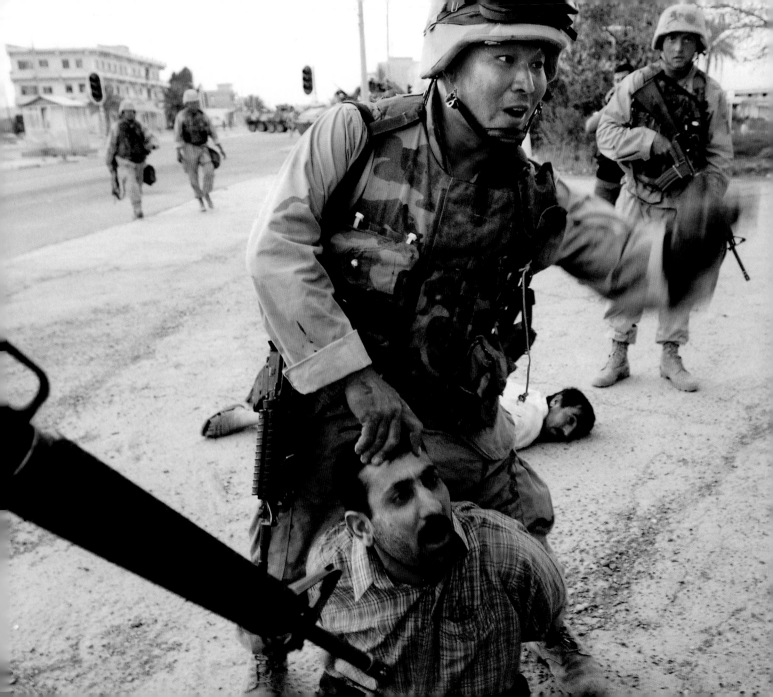

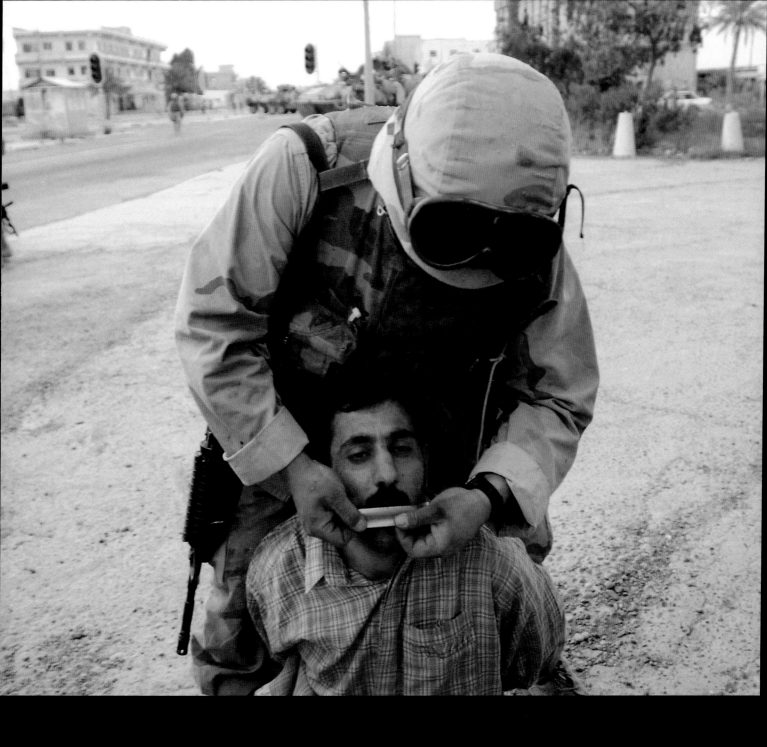

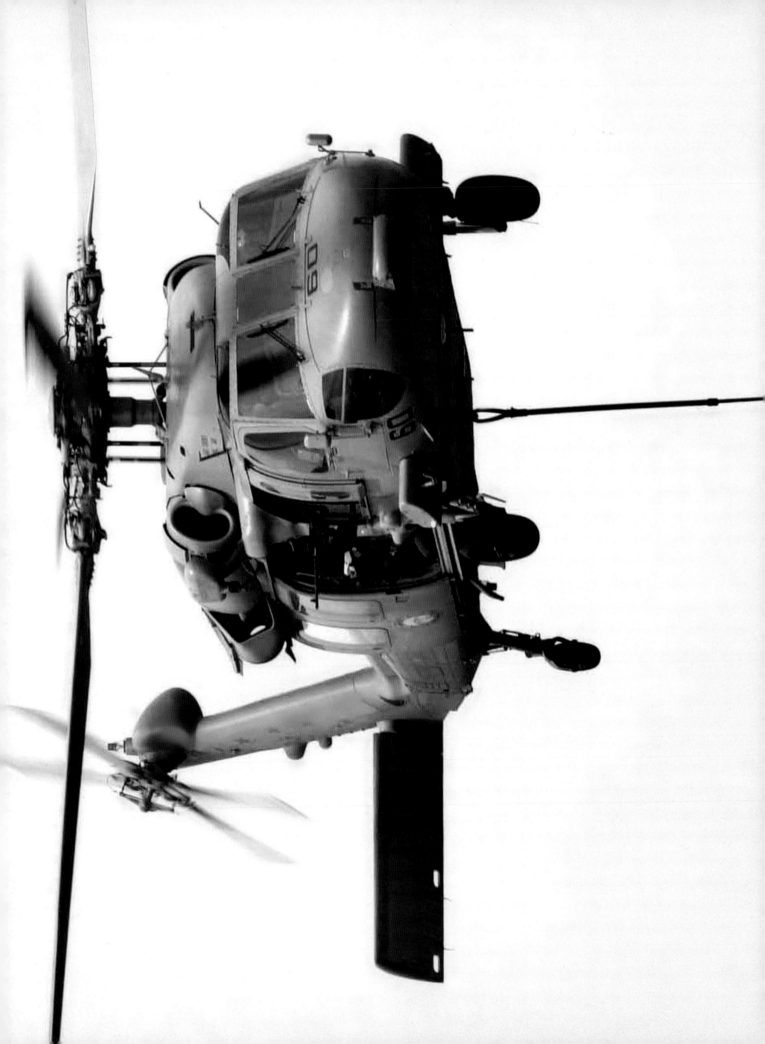

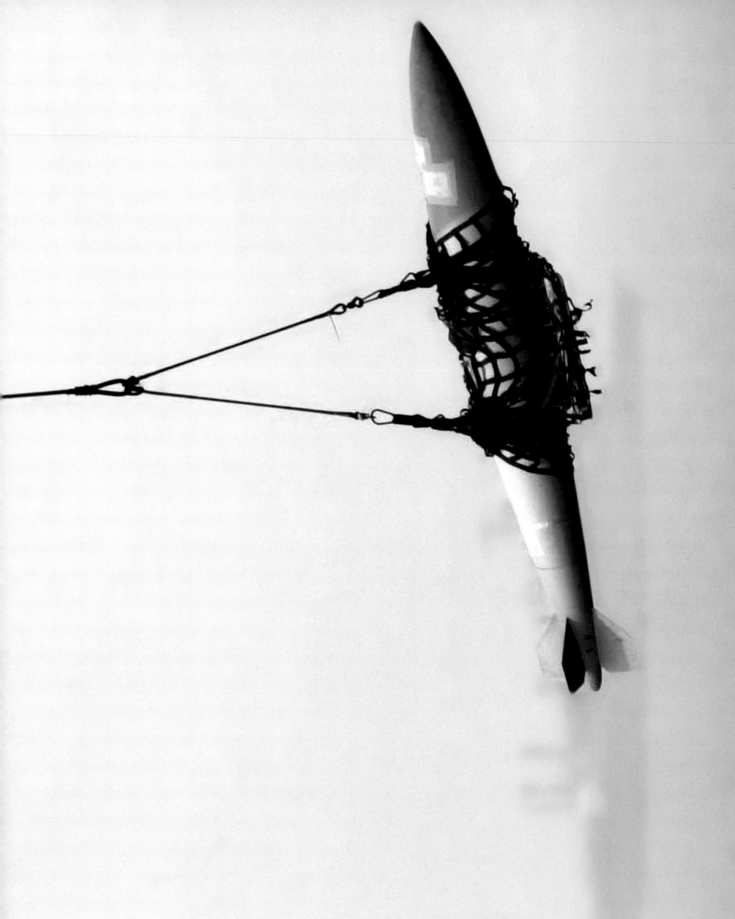

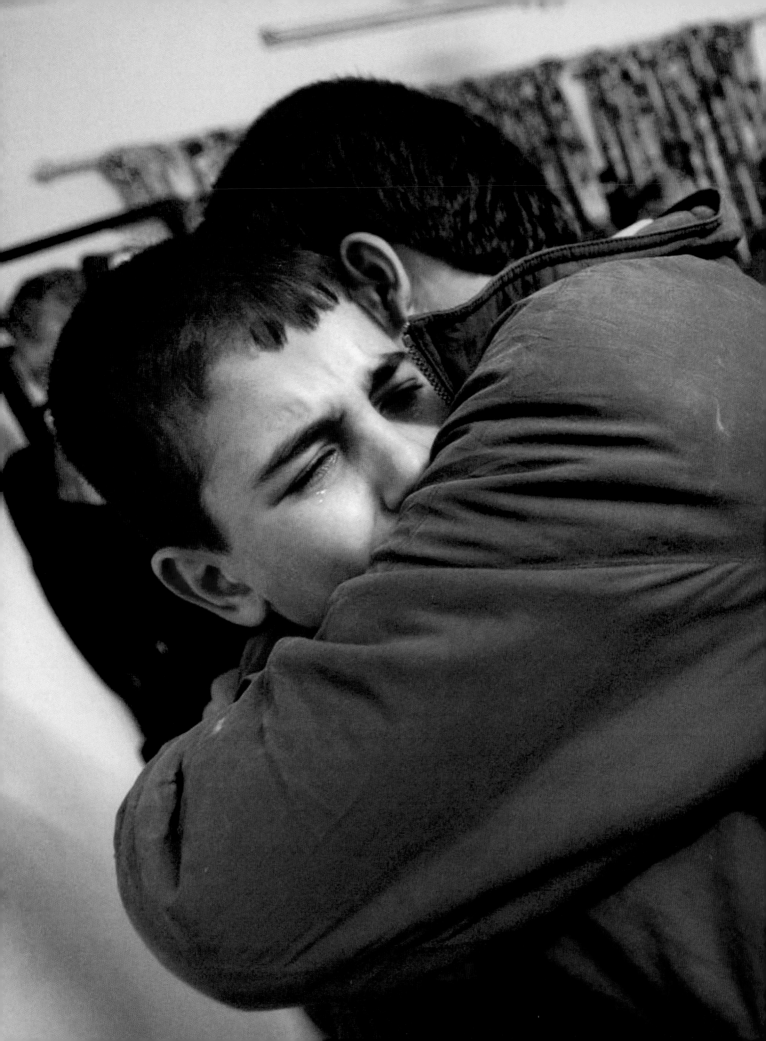

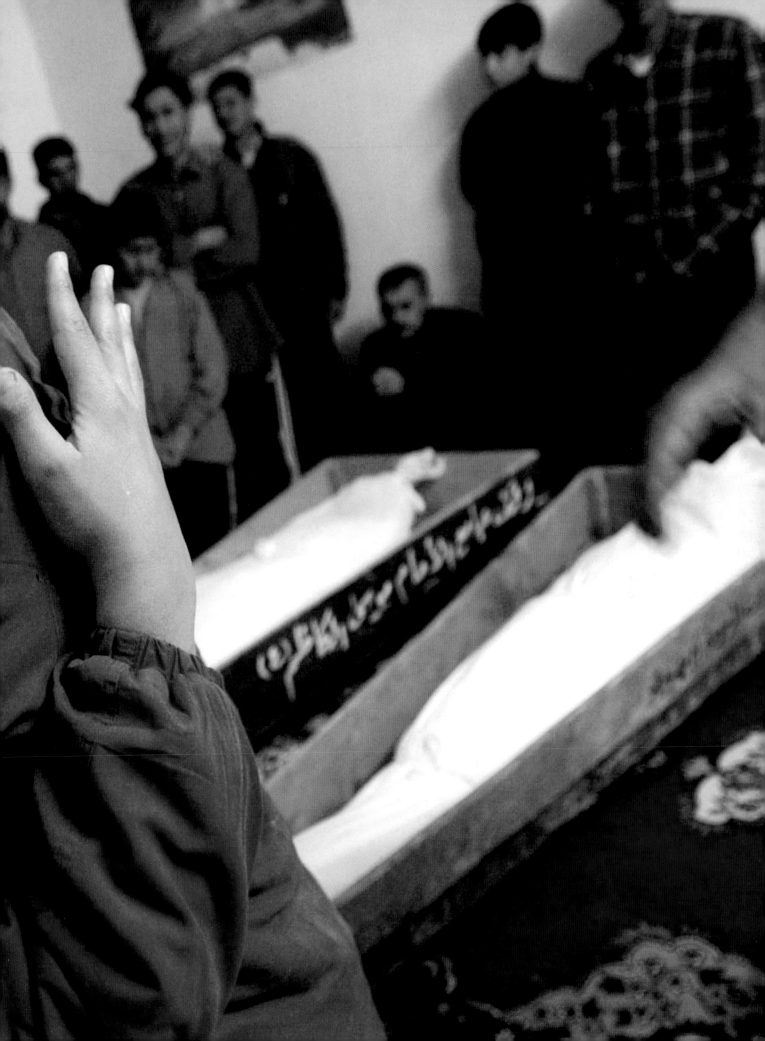

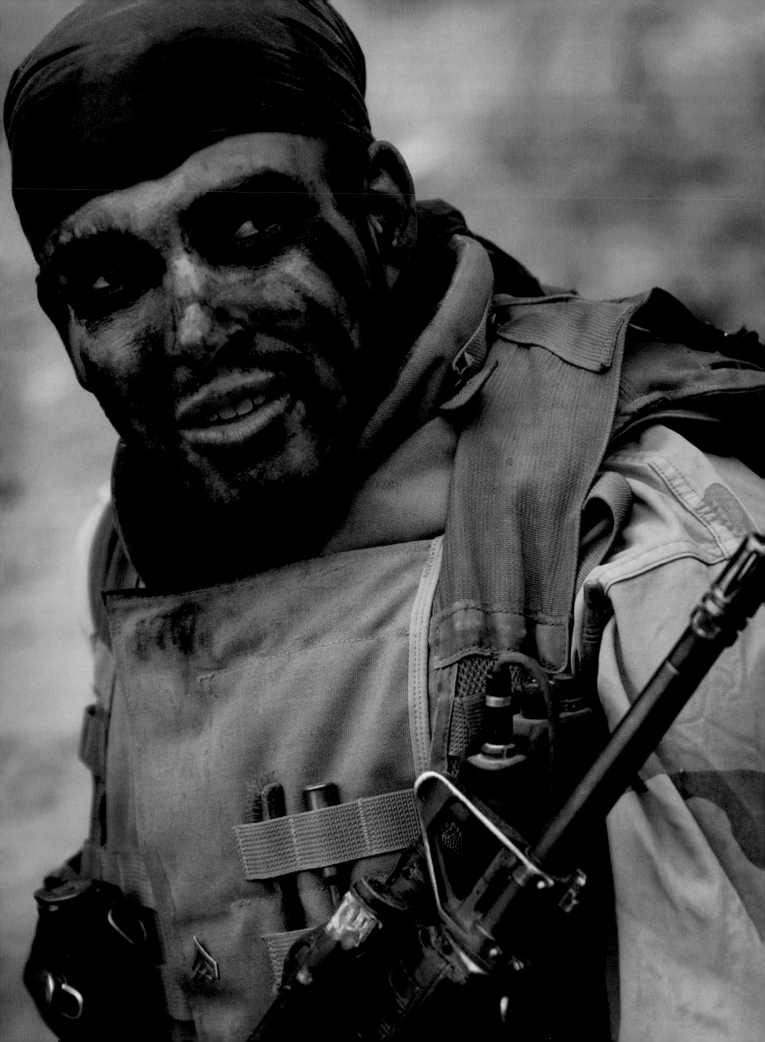

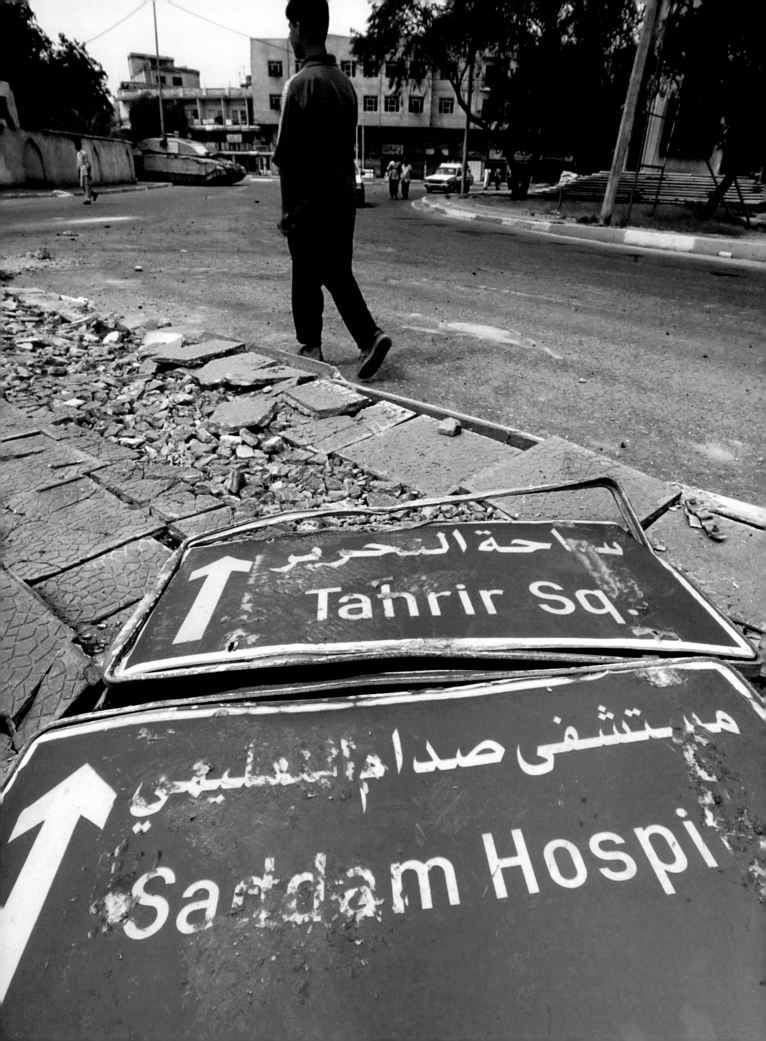

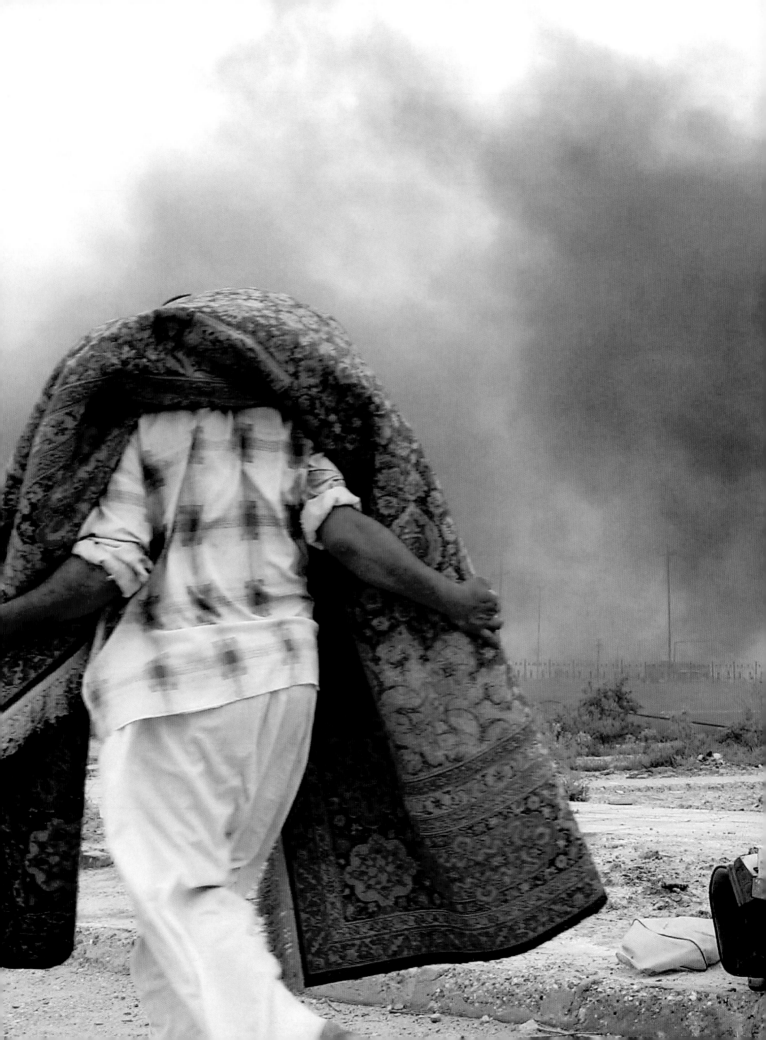

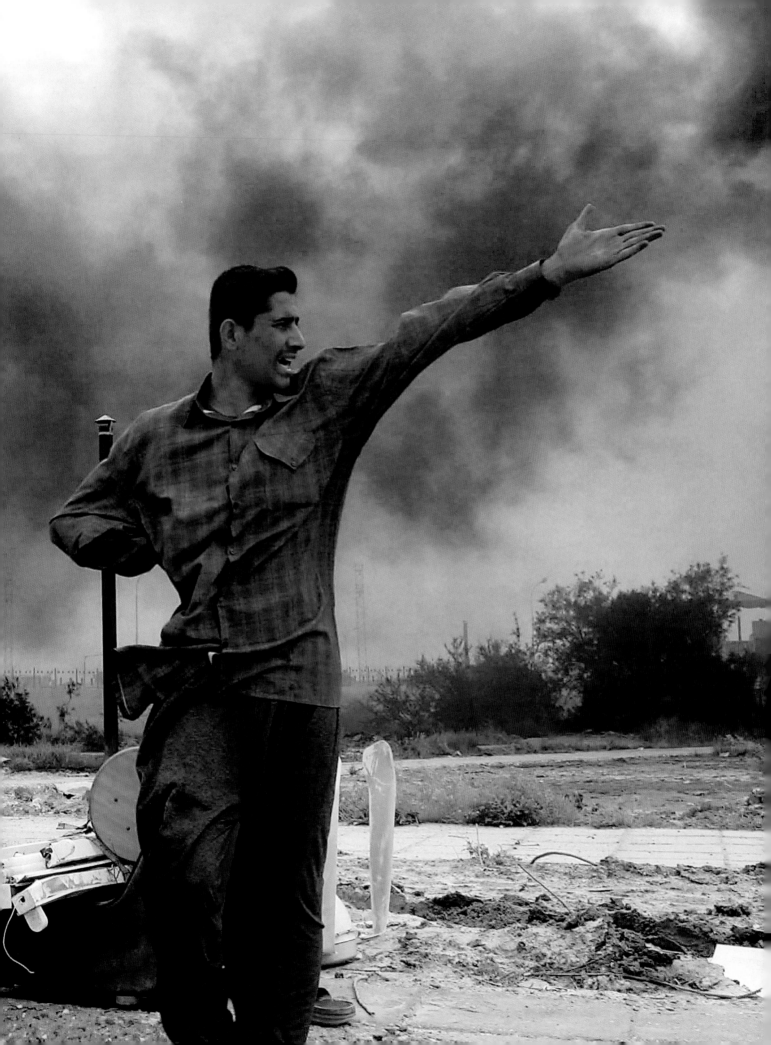

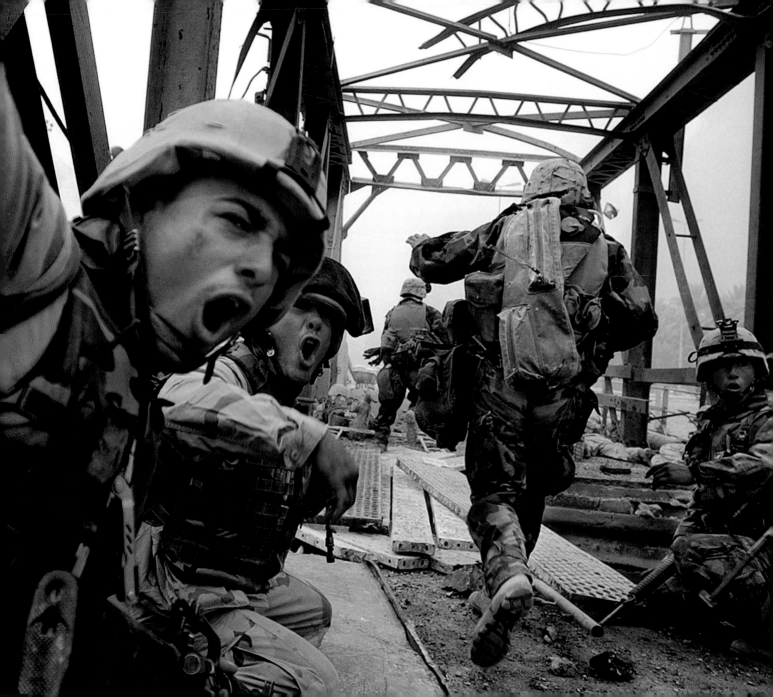

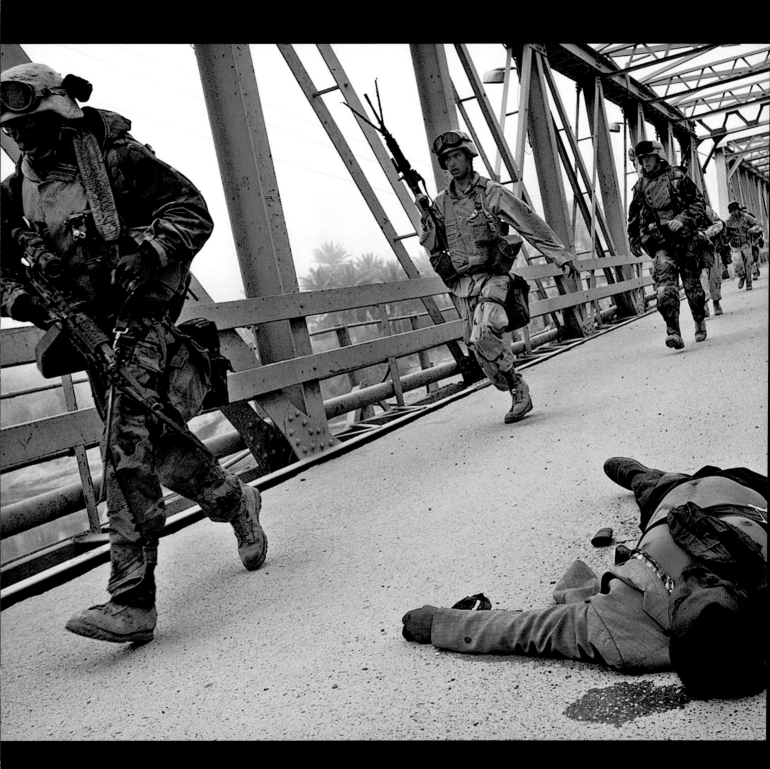

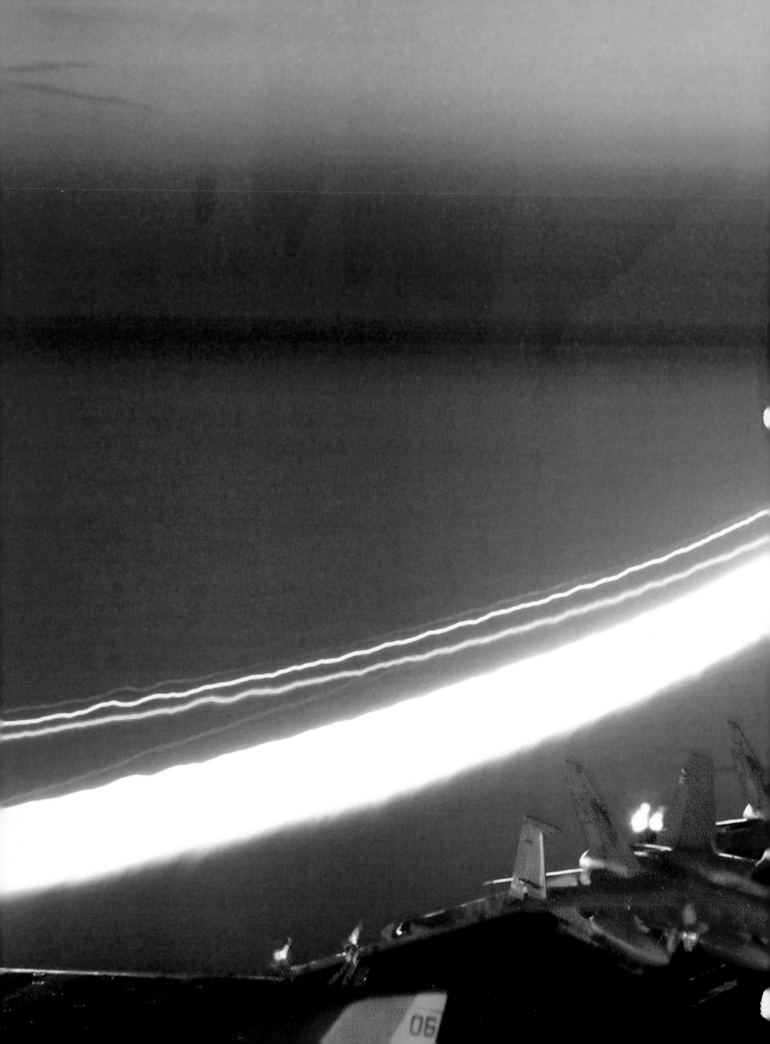

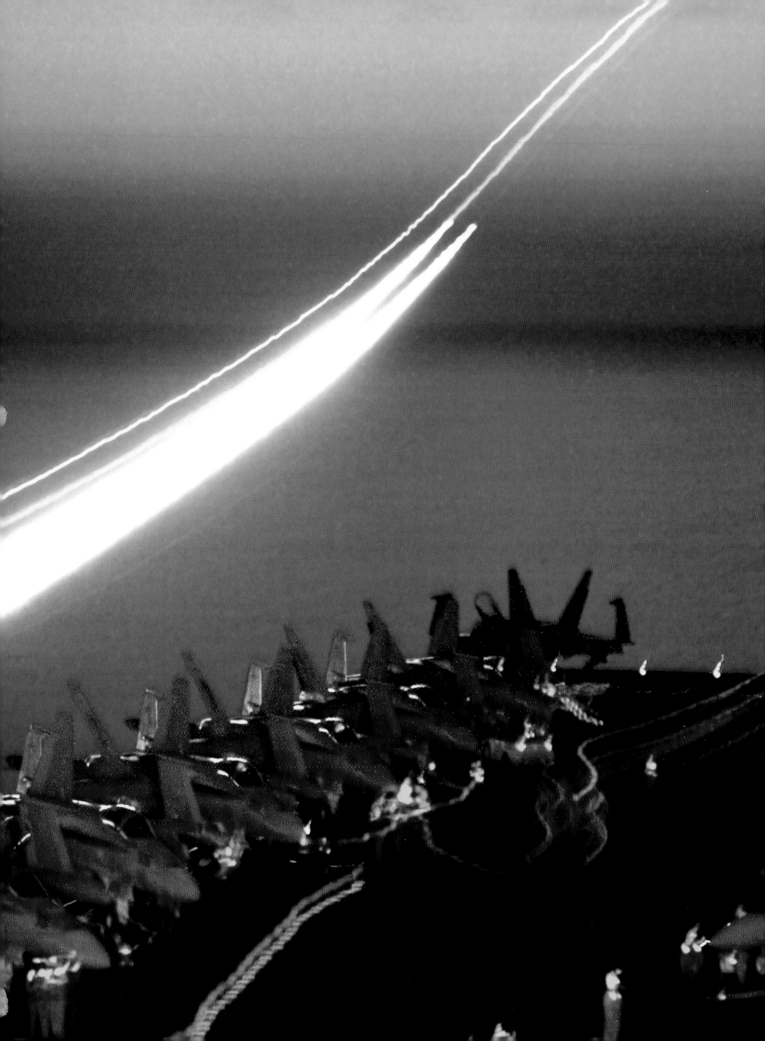

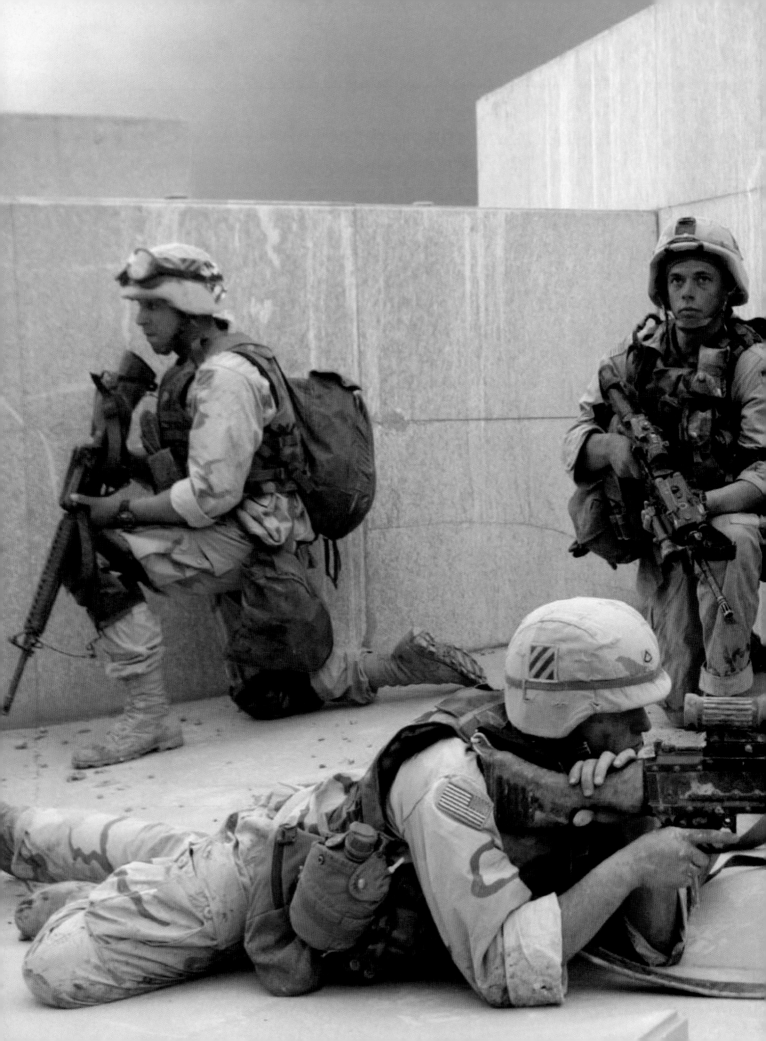

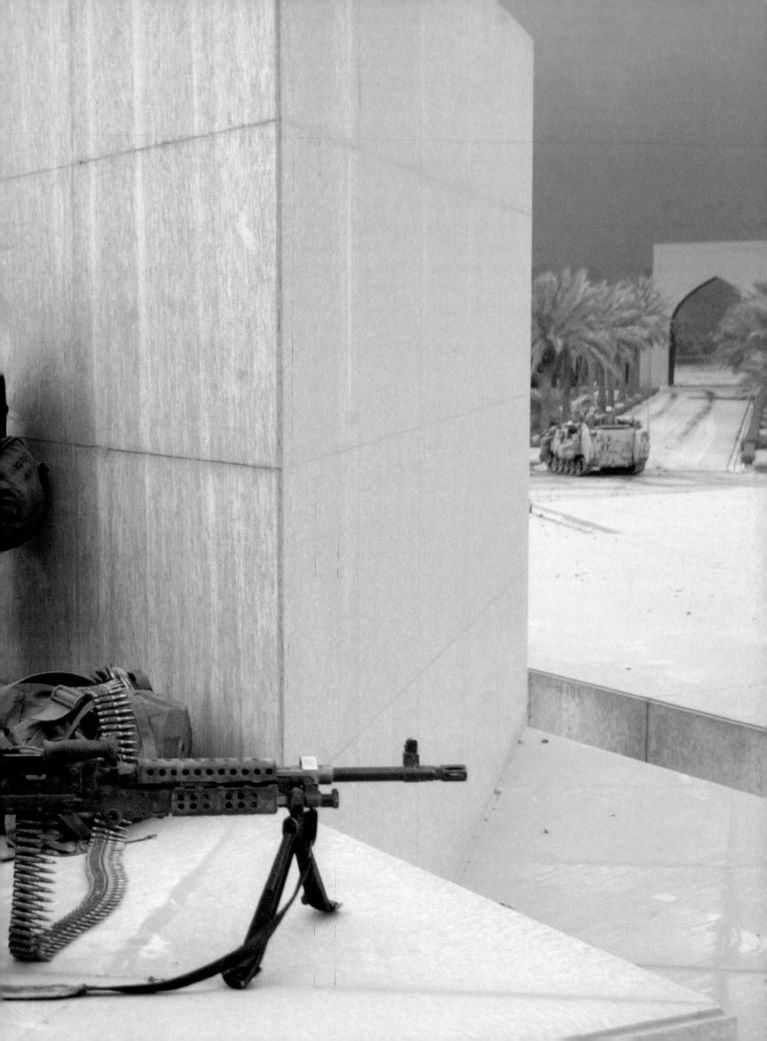

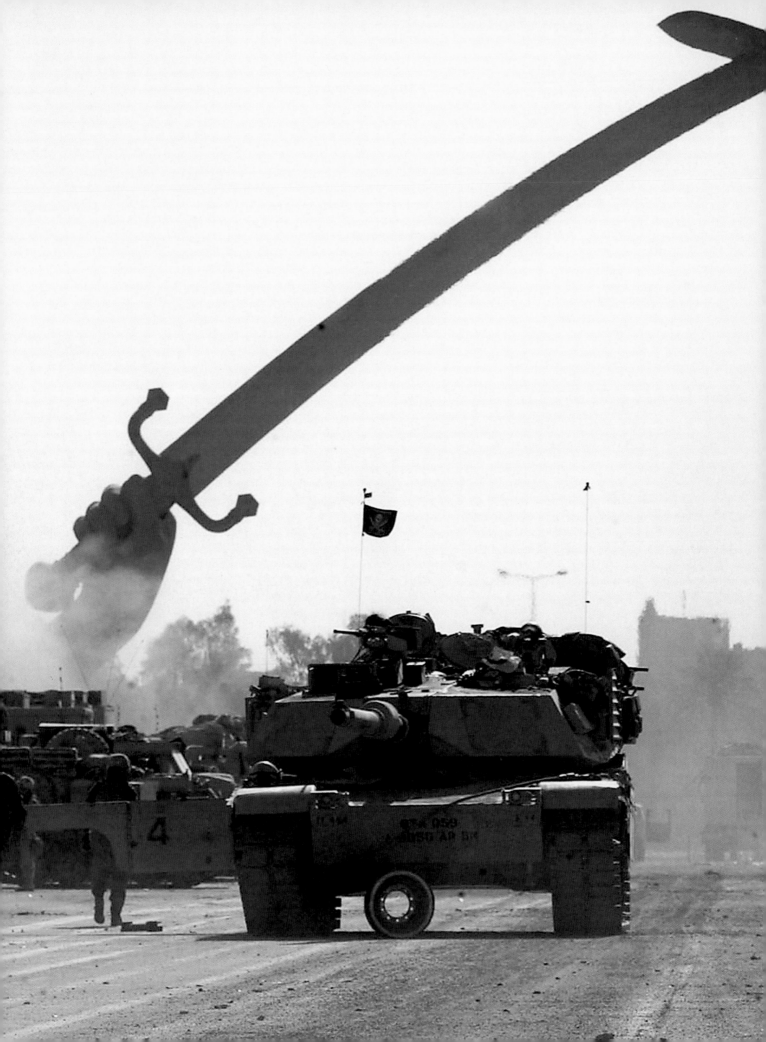

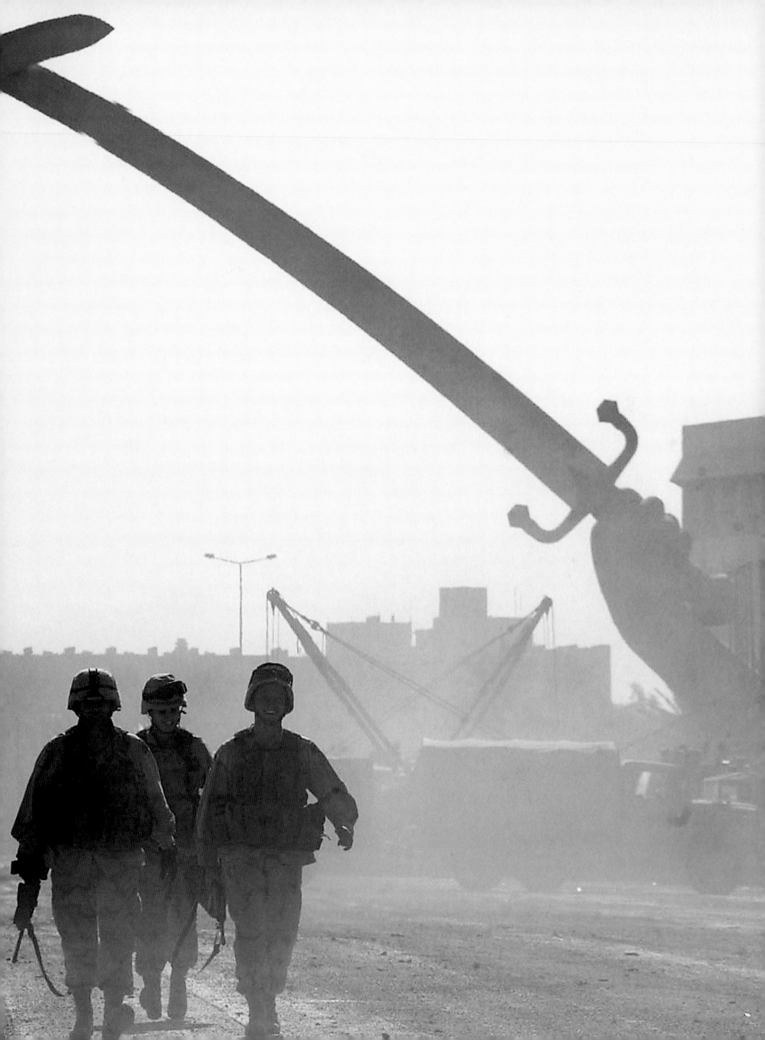

SADDAM HUSSEIN'S
ART & PHOTO ALBUM

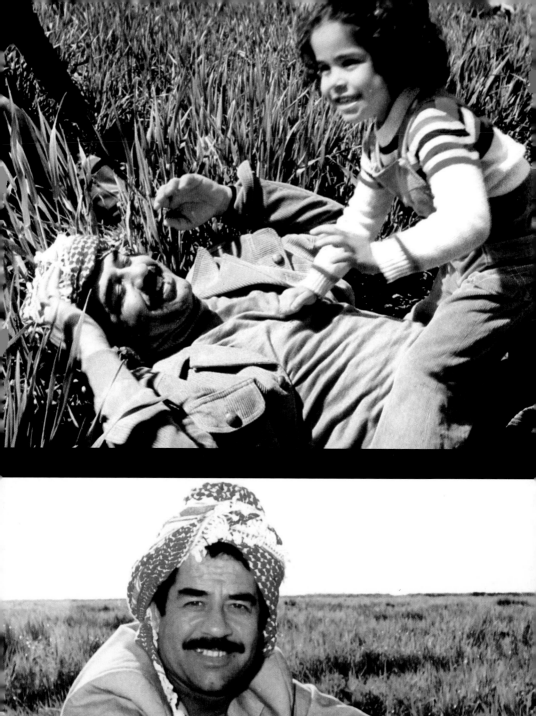
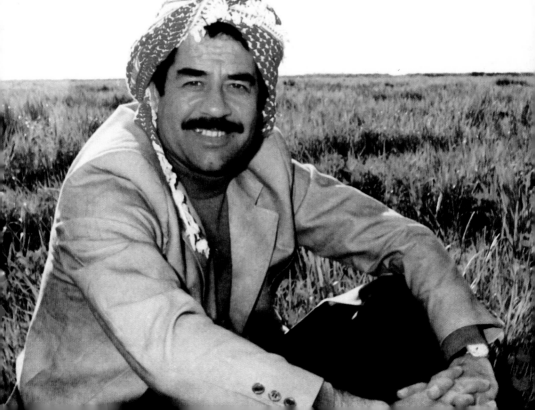

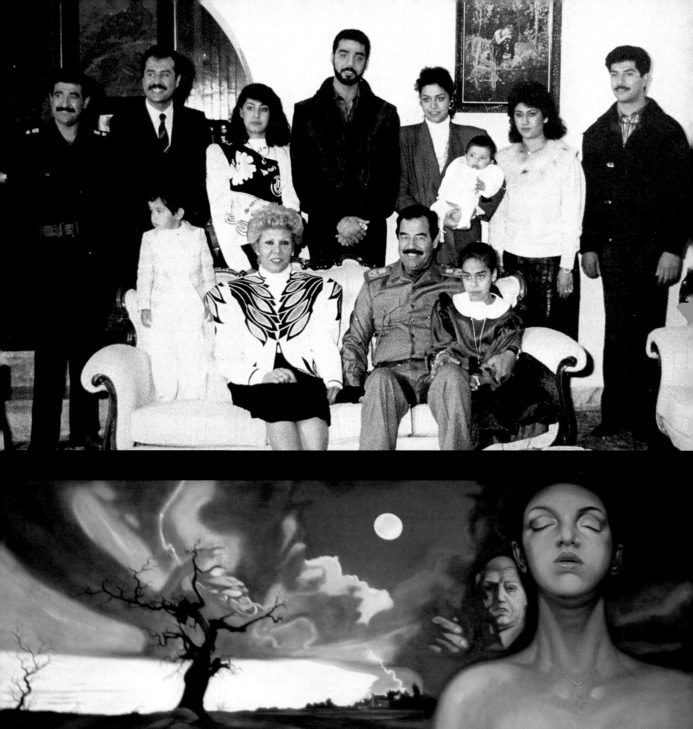

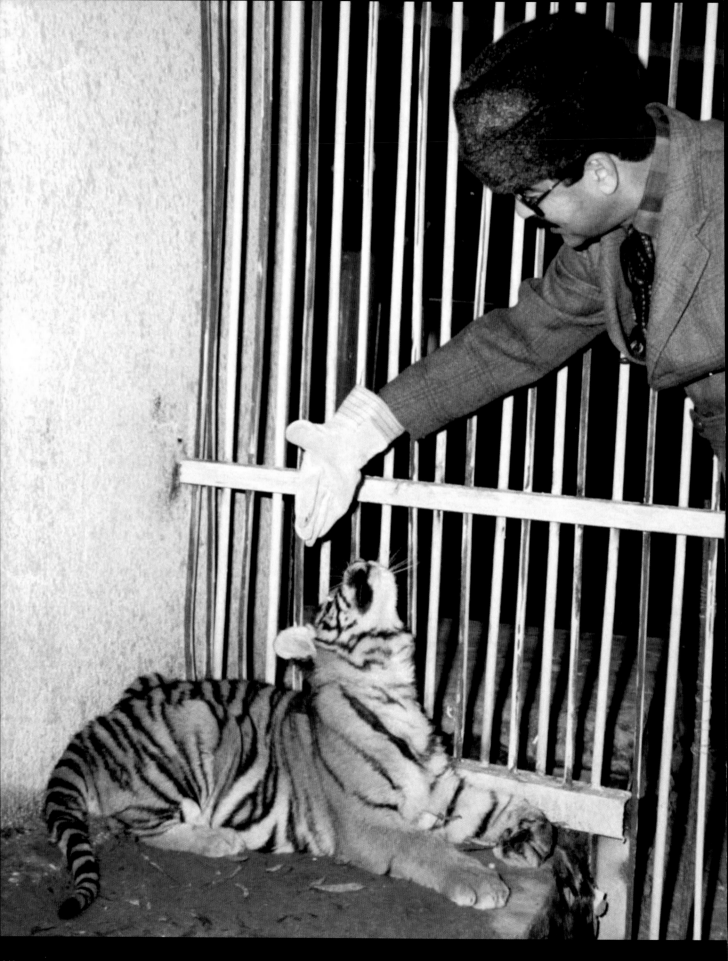

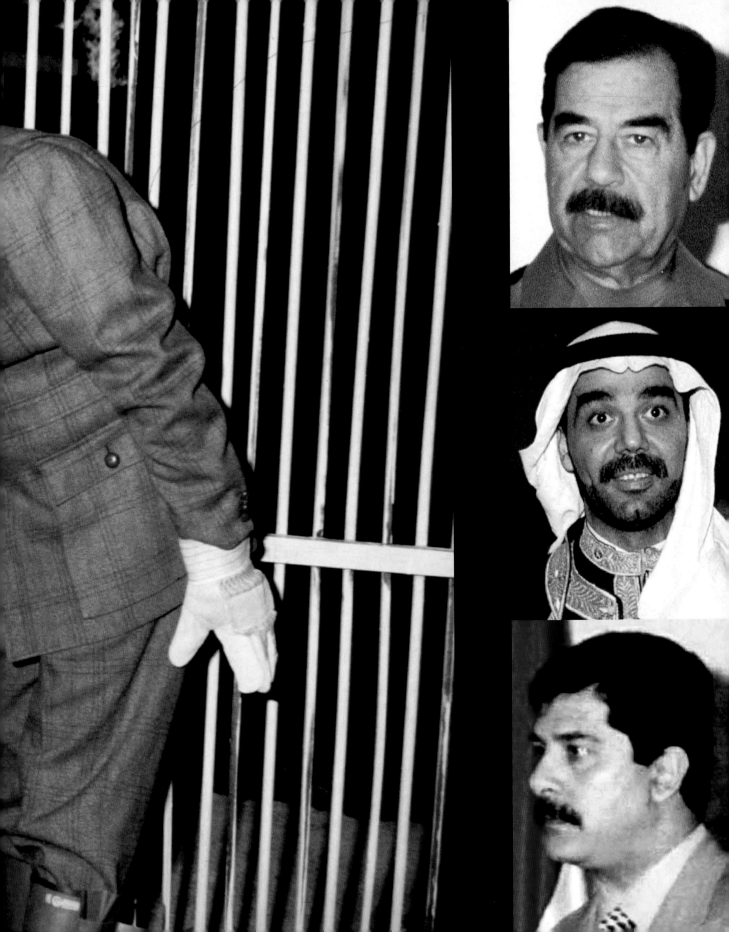

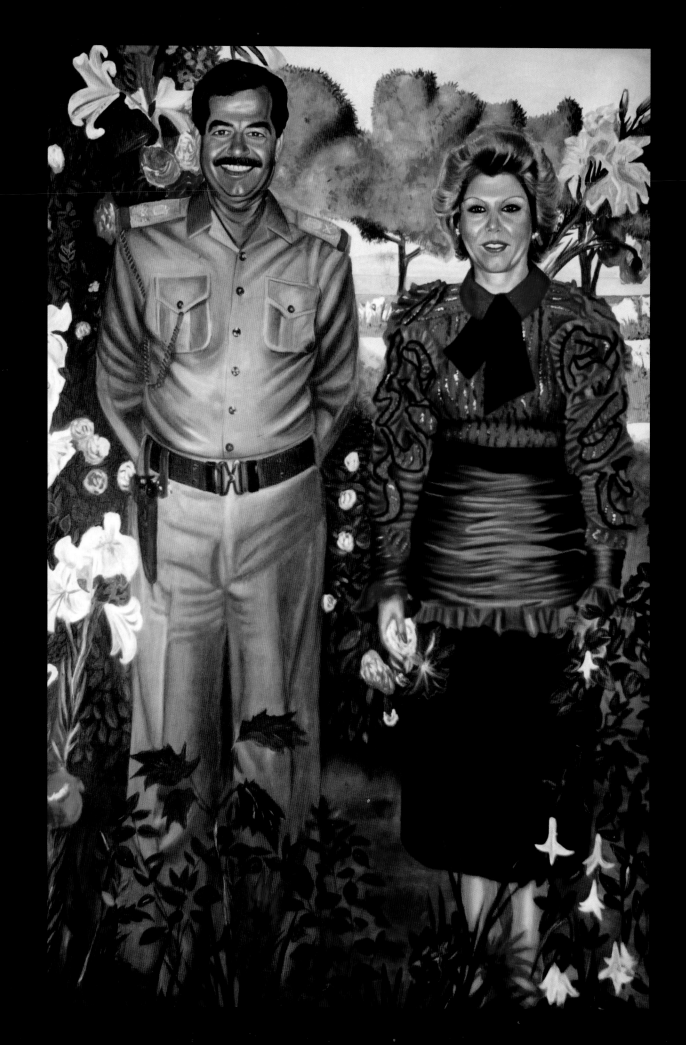

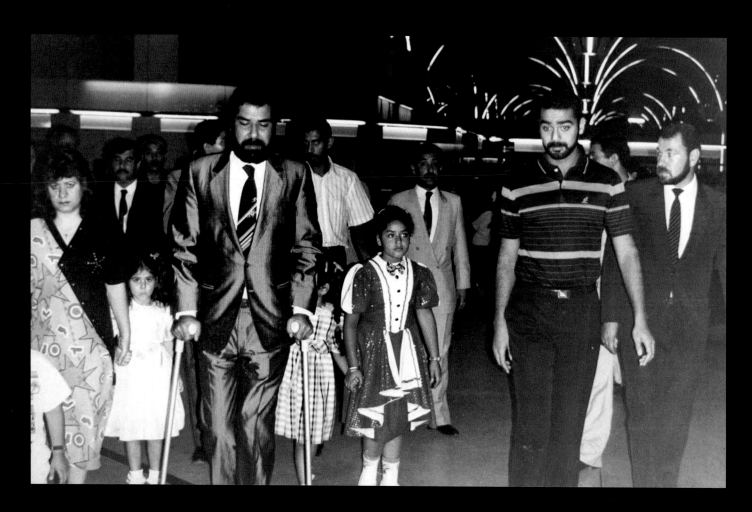

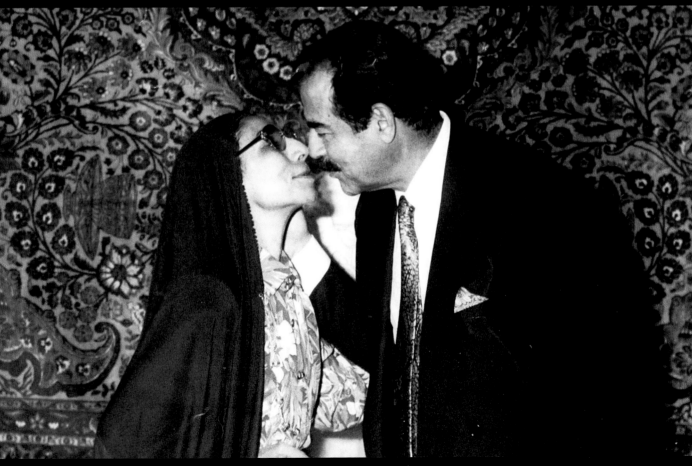

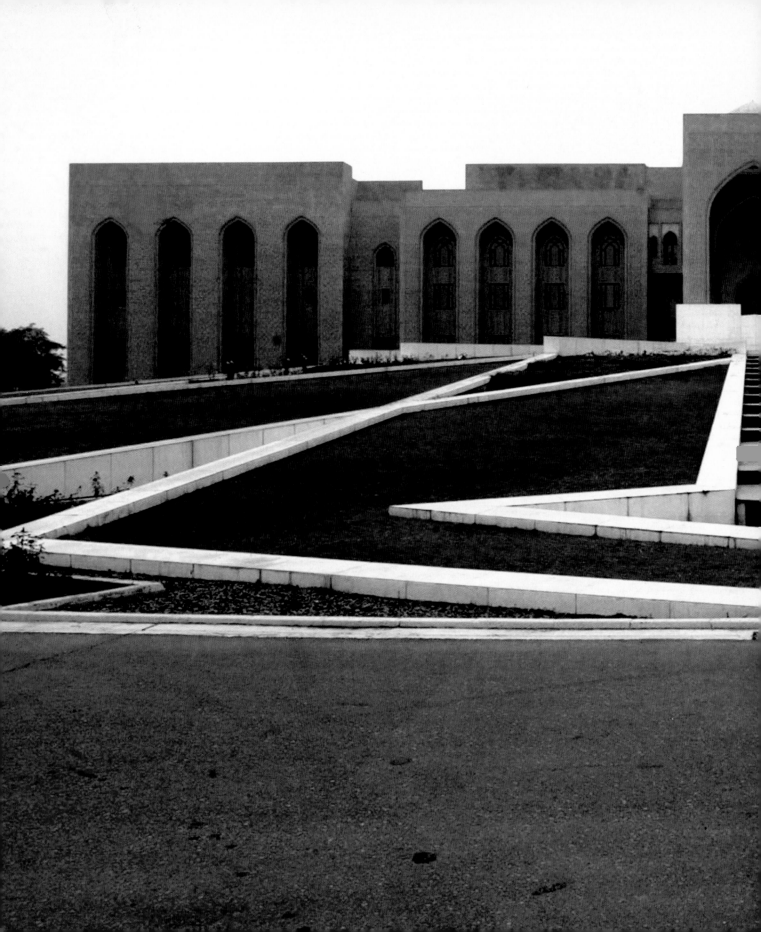

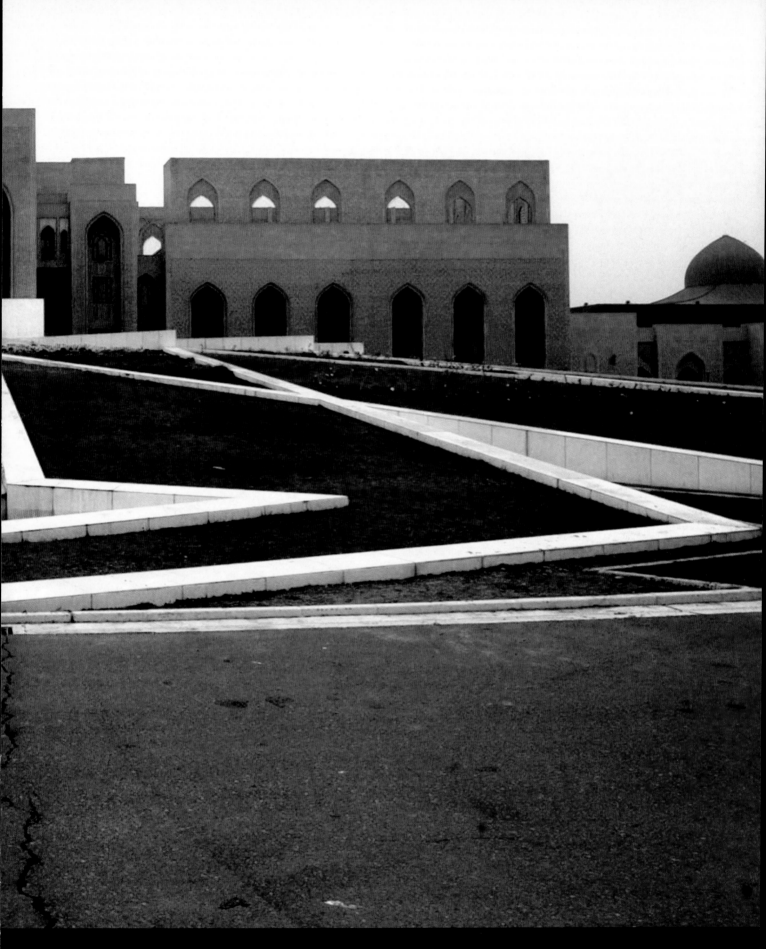

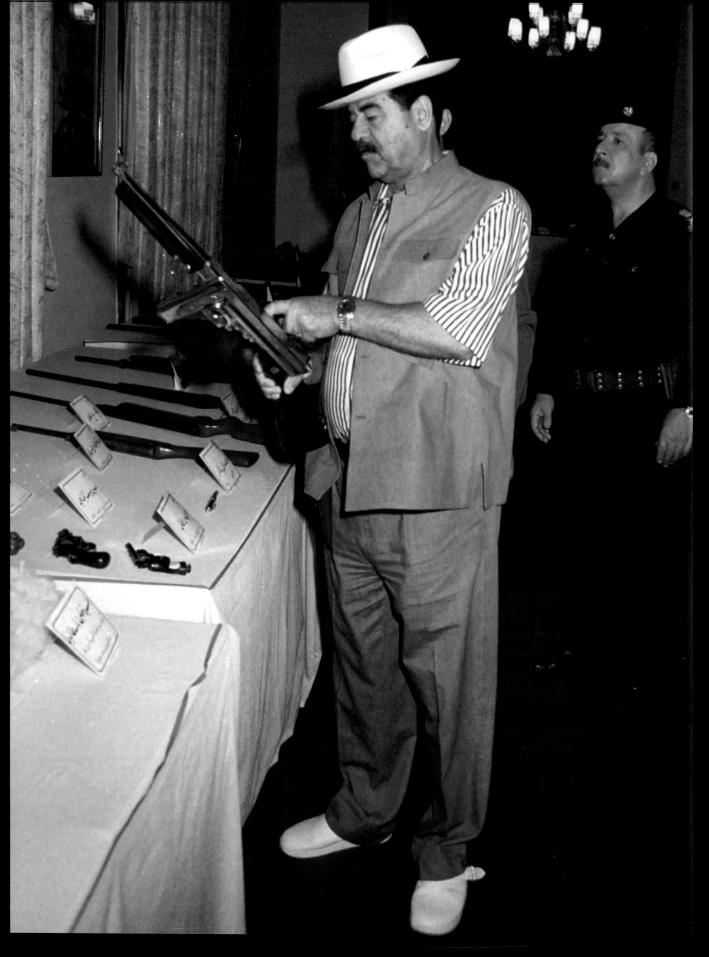

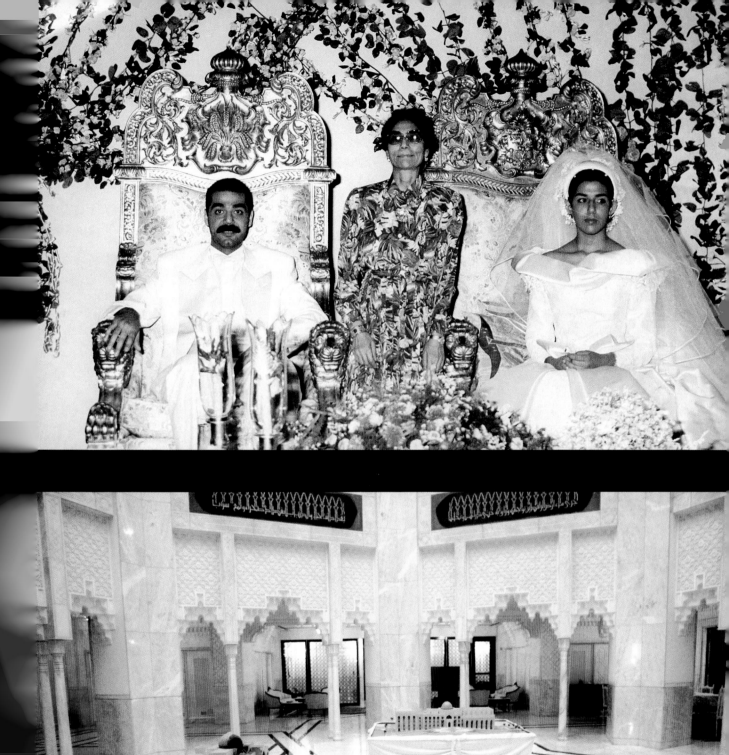

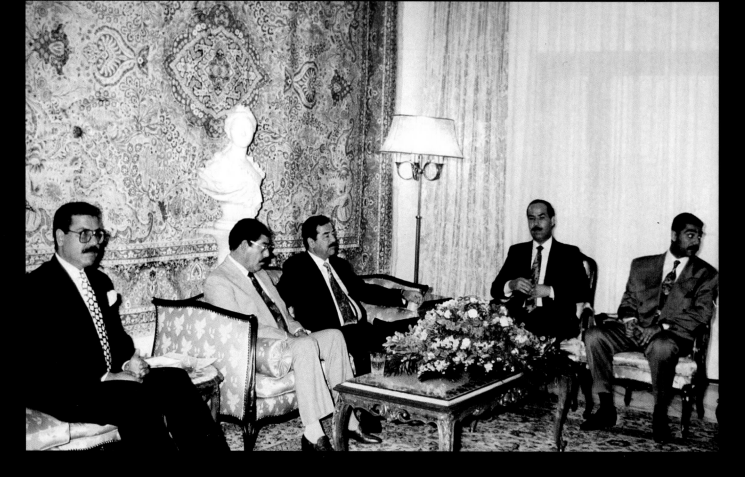

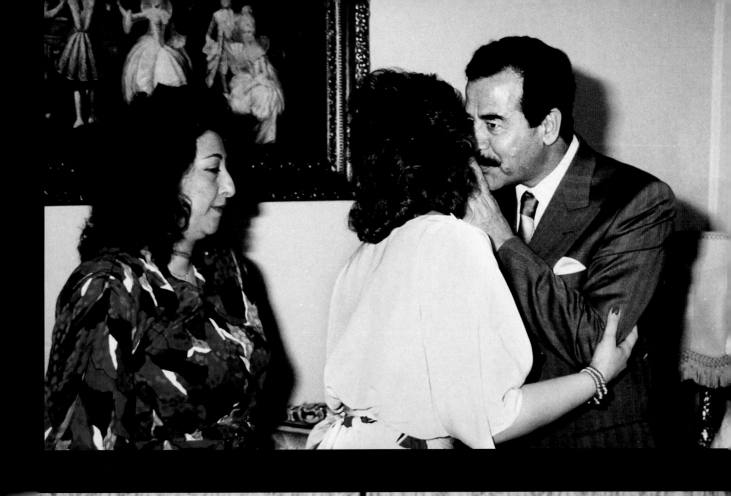

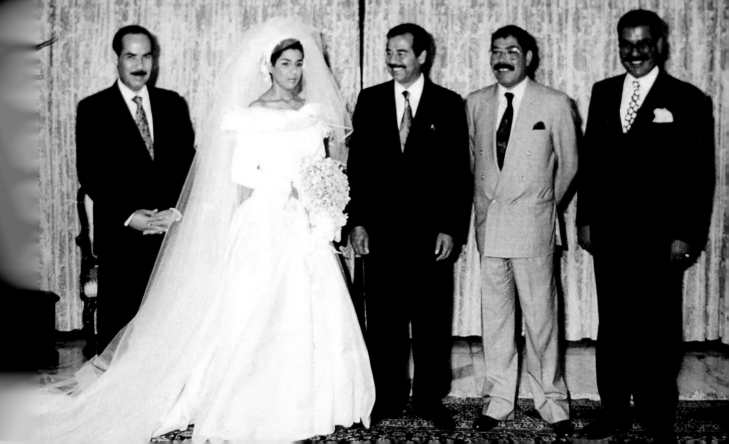

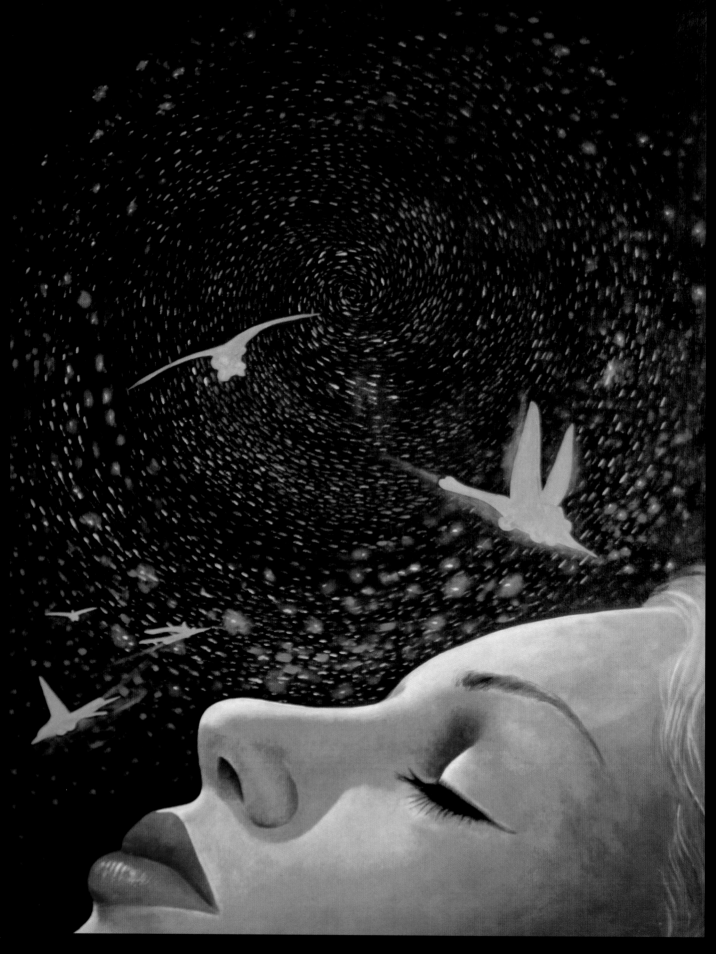

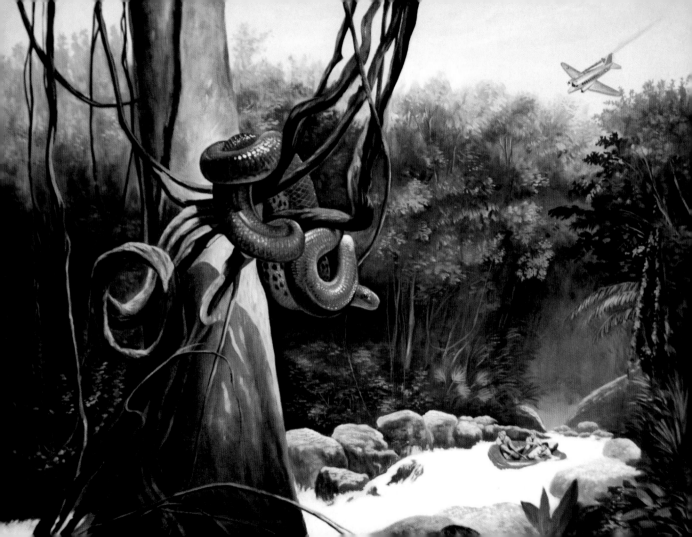

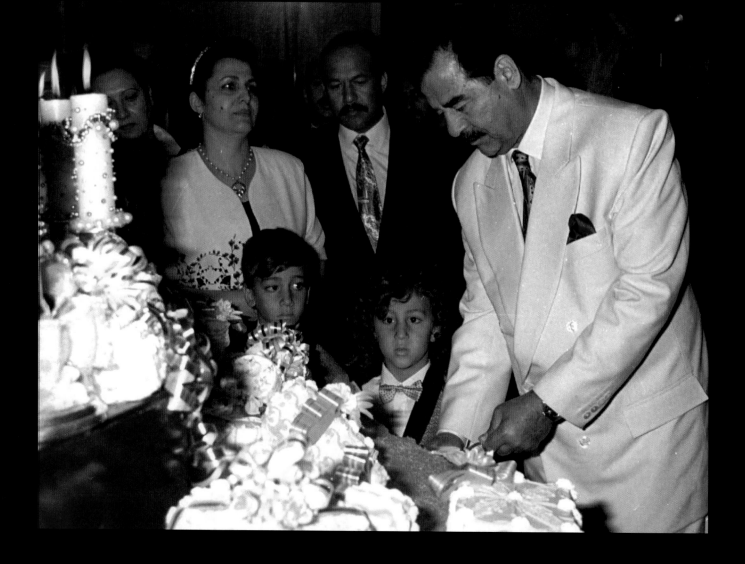

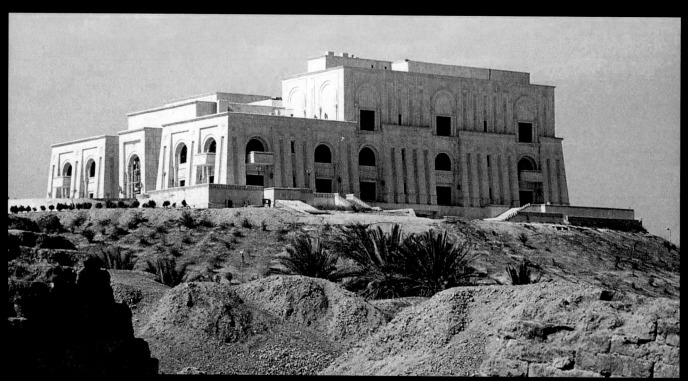

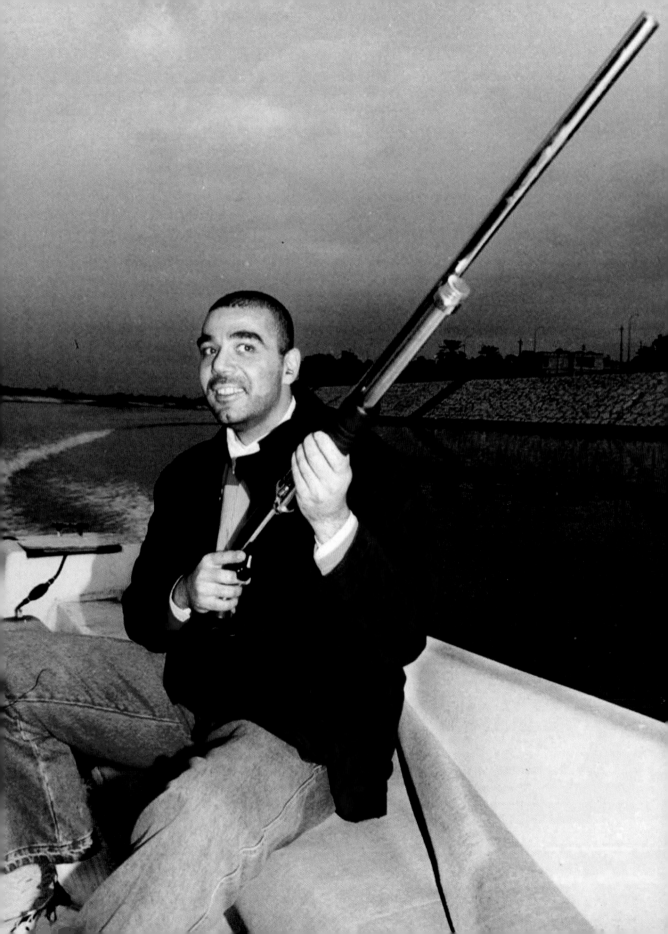

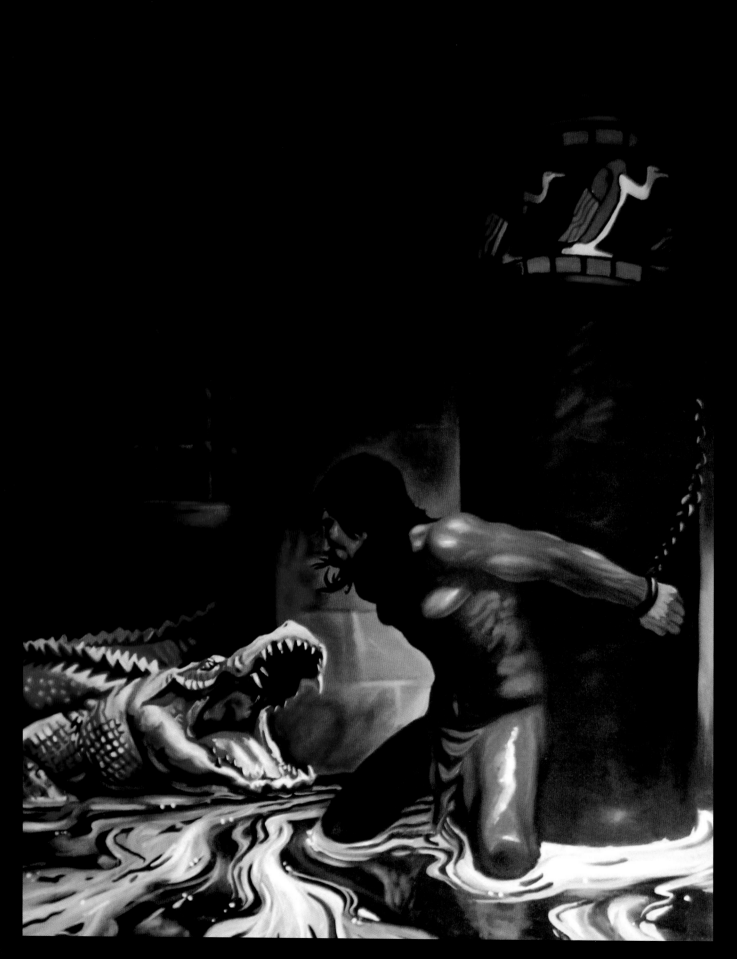

THE FALL OF BAGHDAD

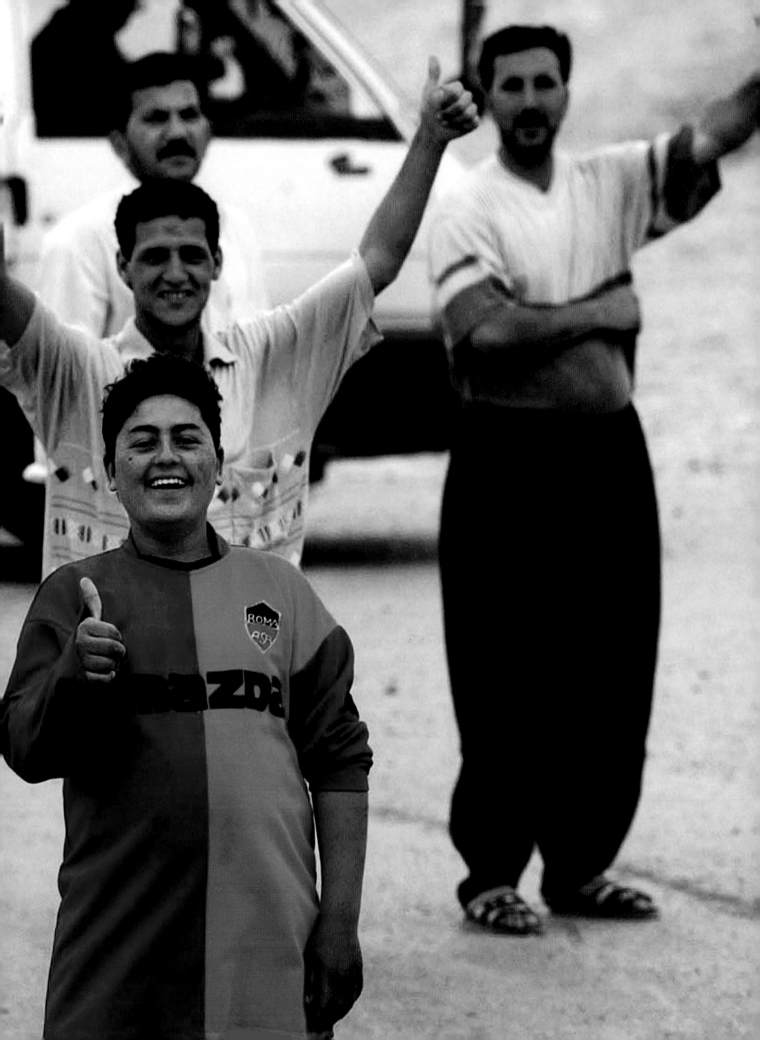

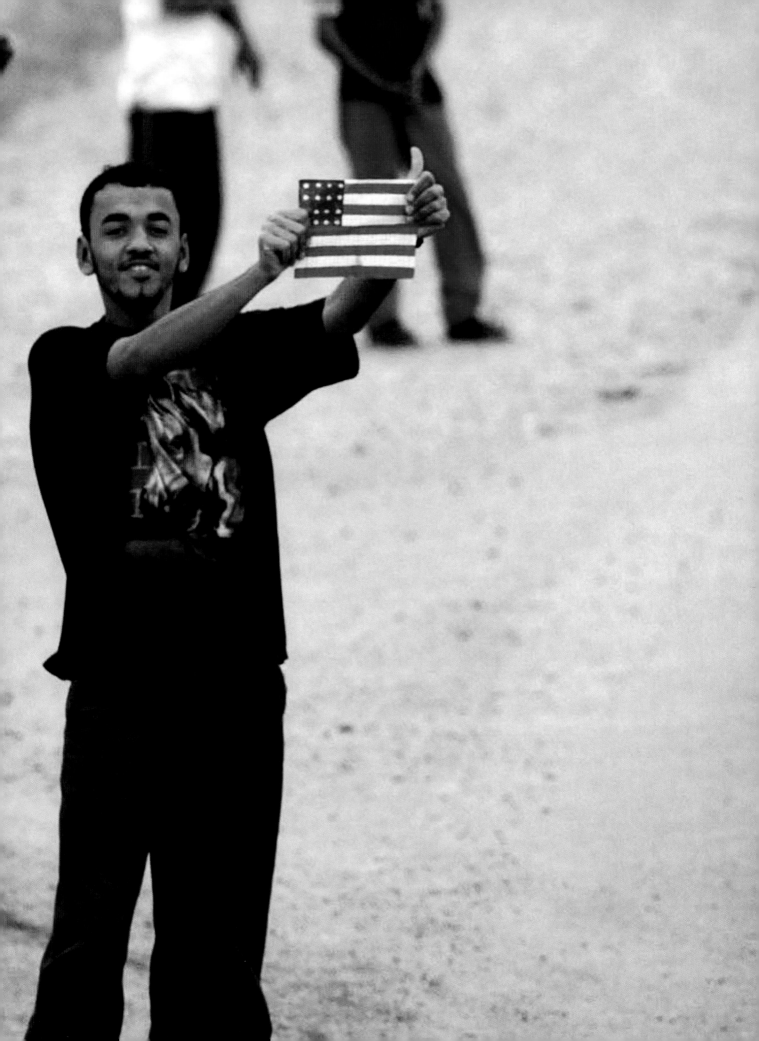

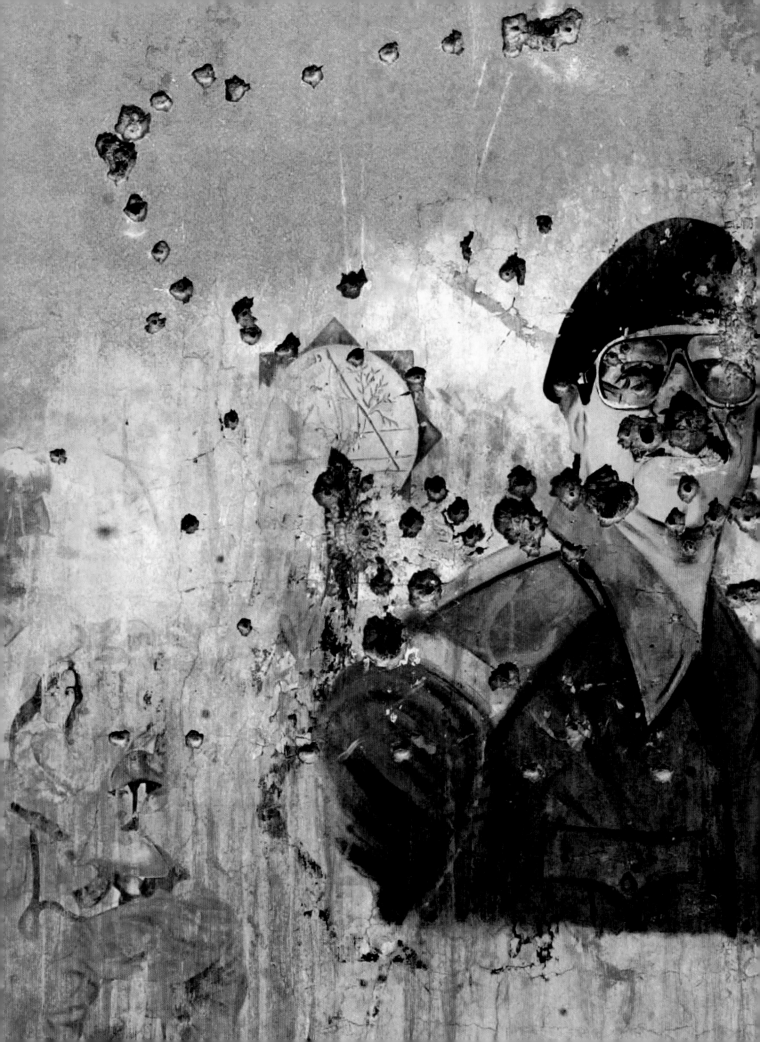

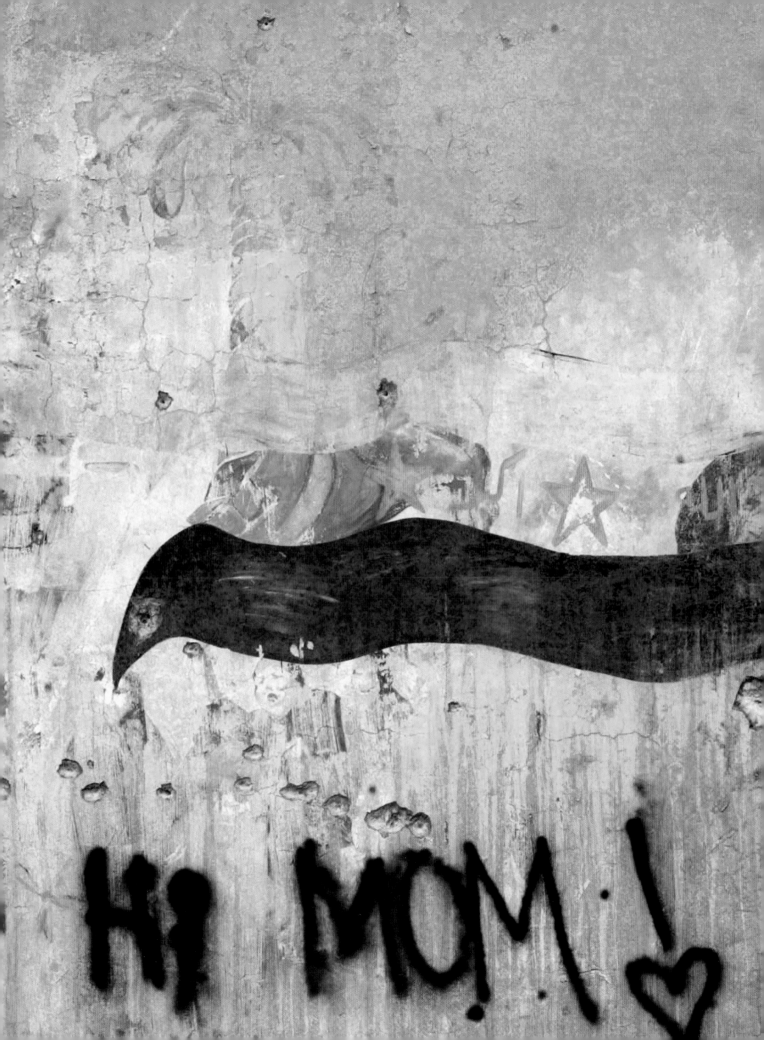

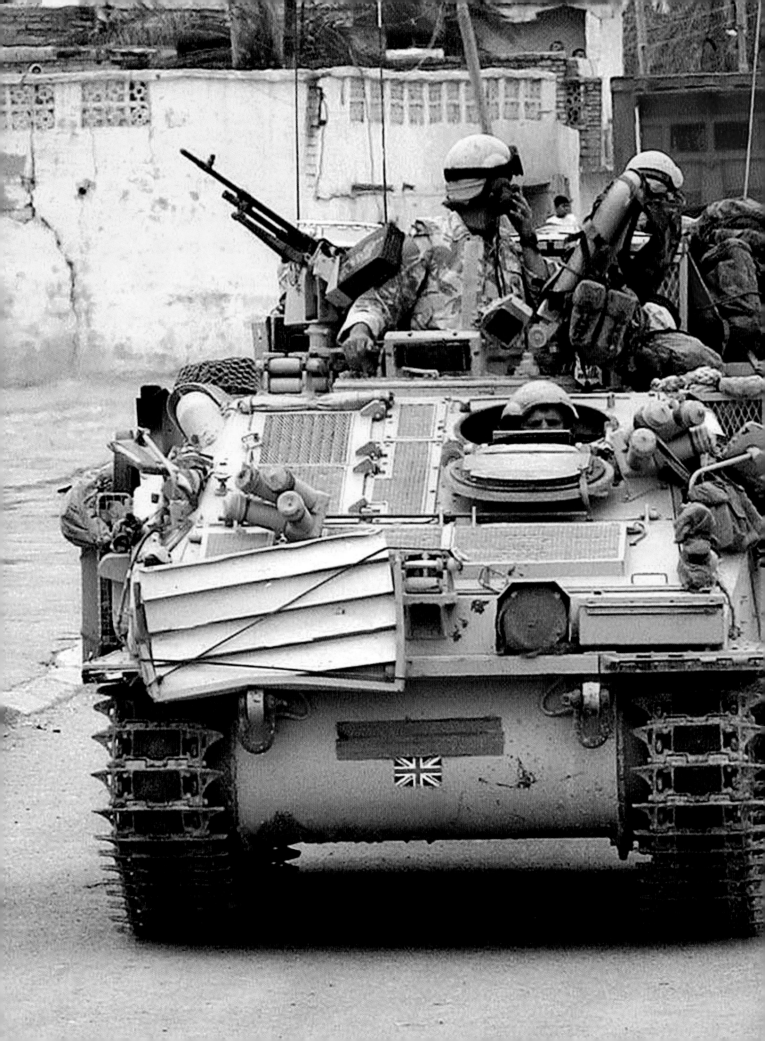

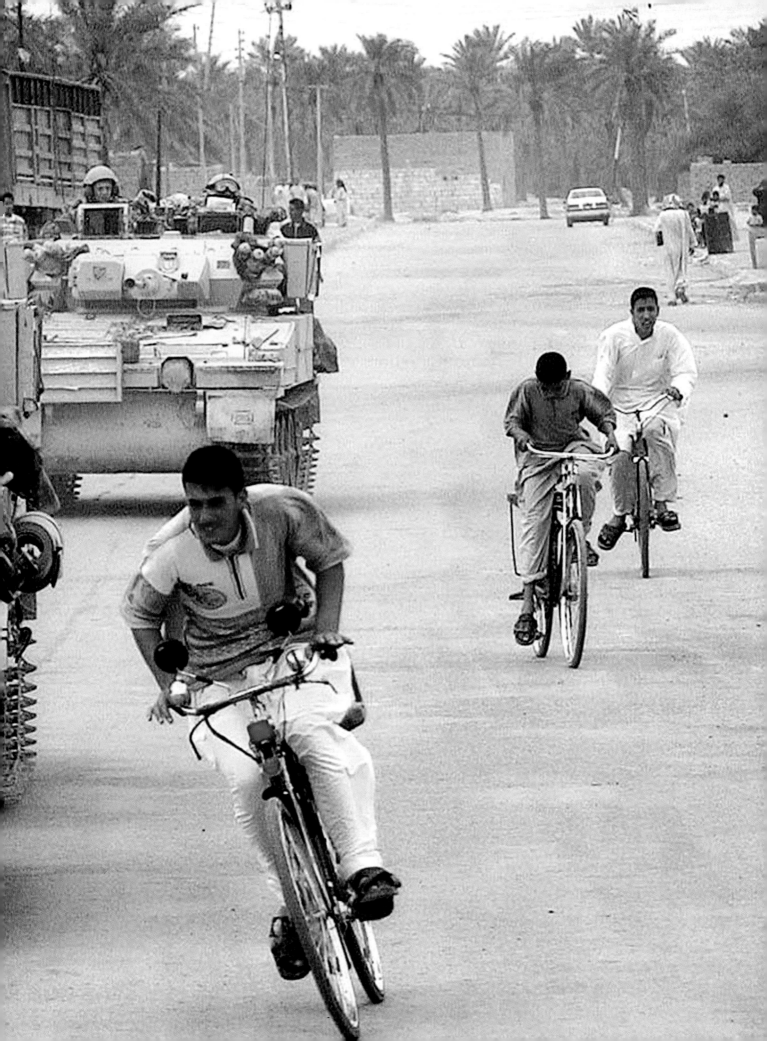

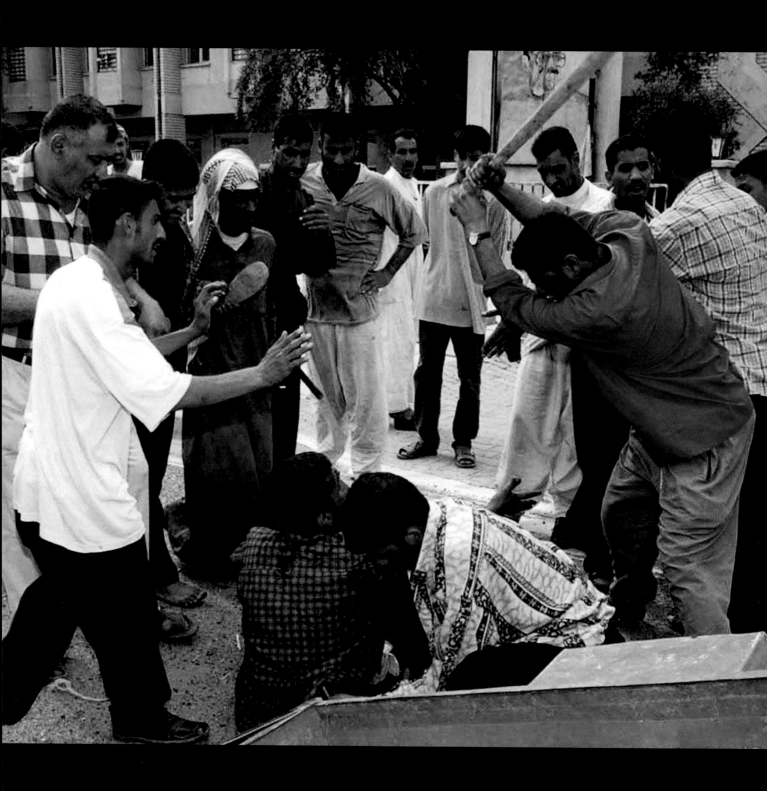

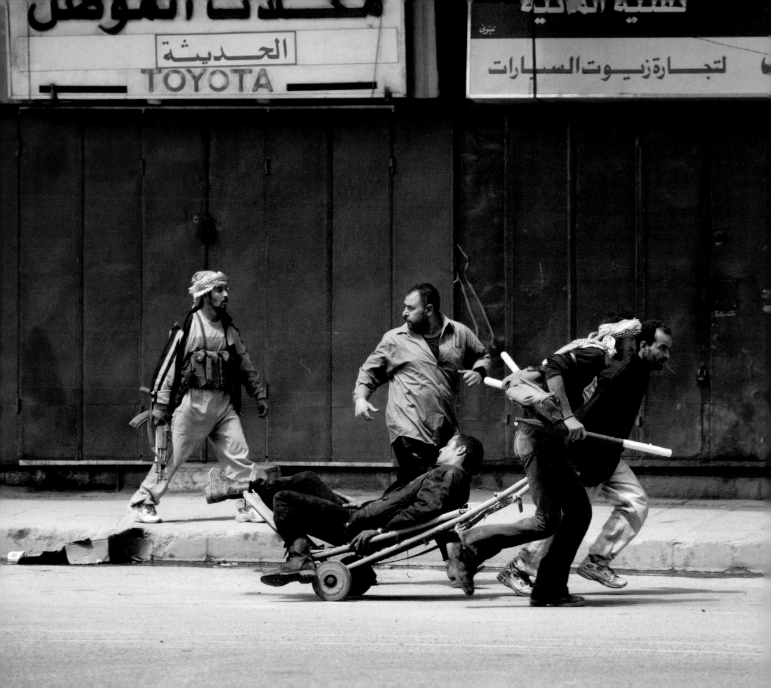

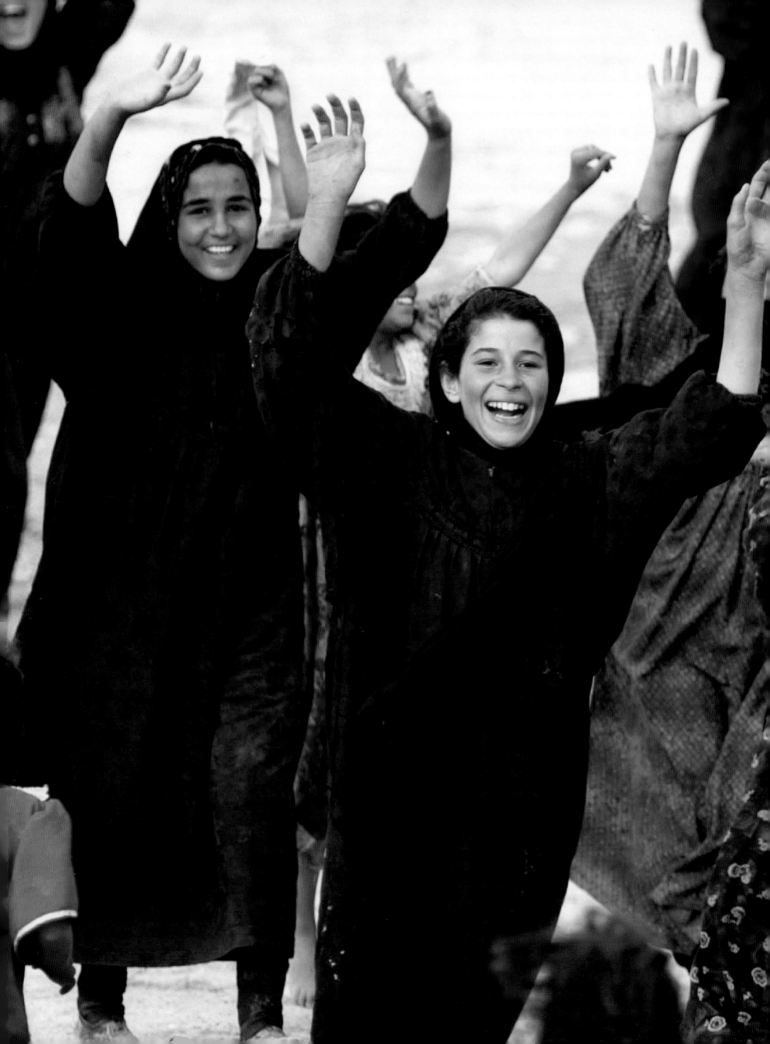

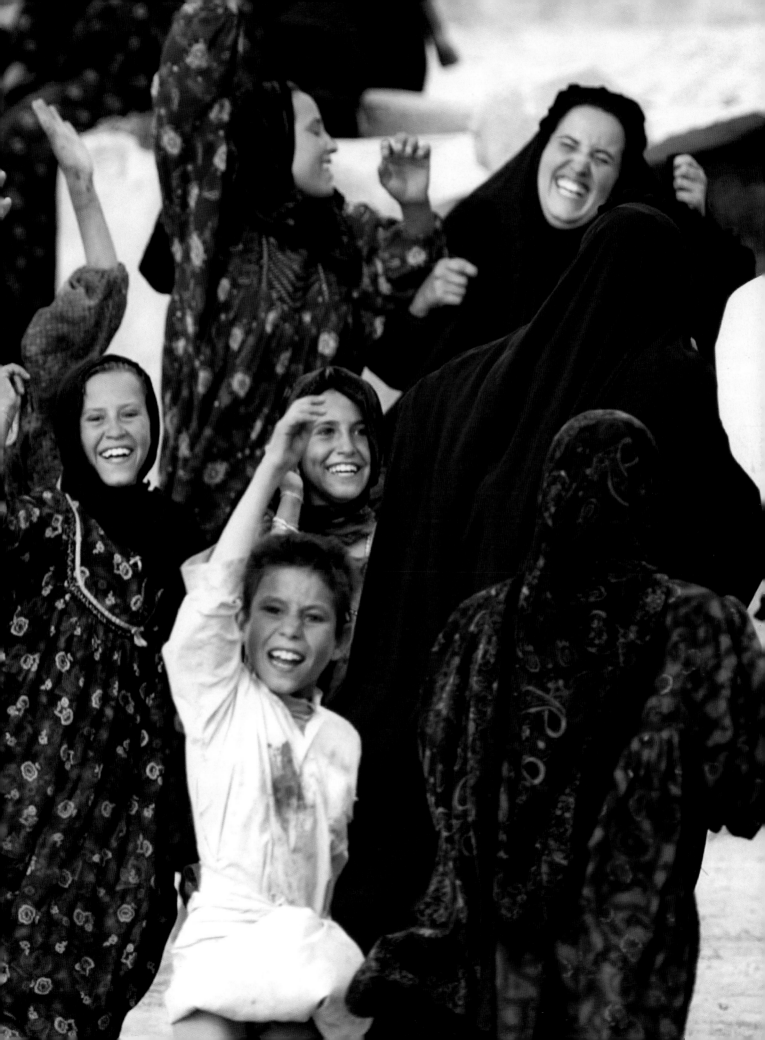

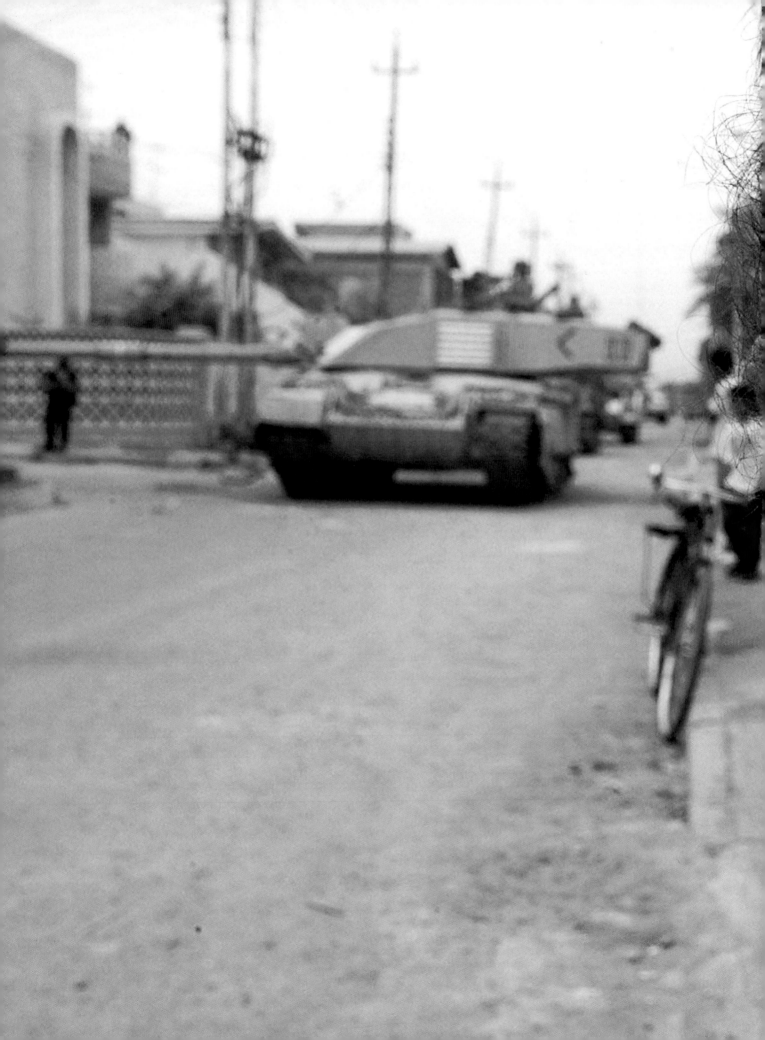

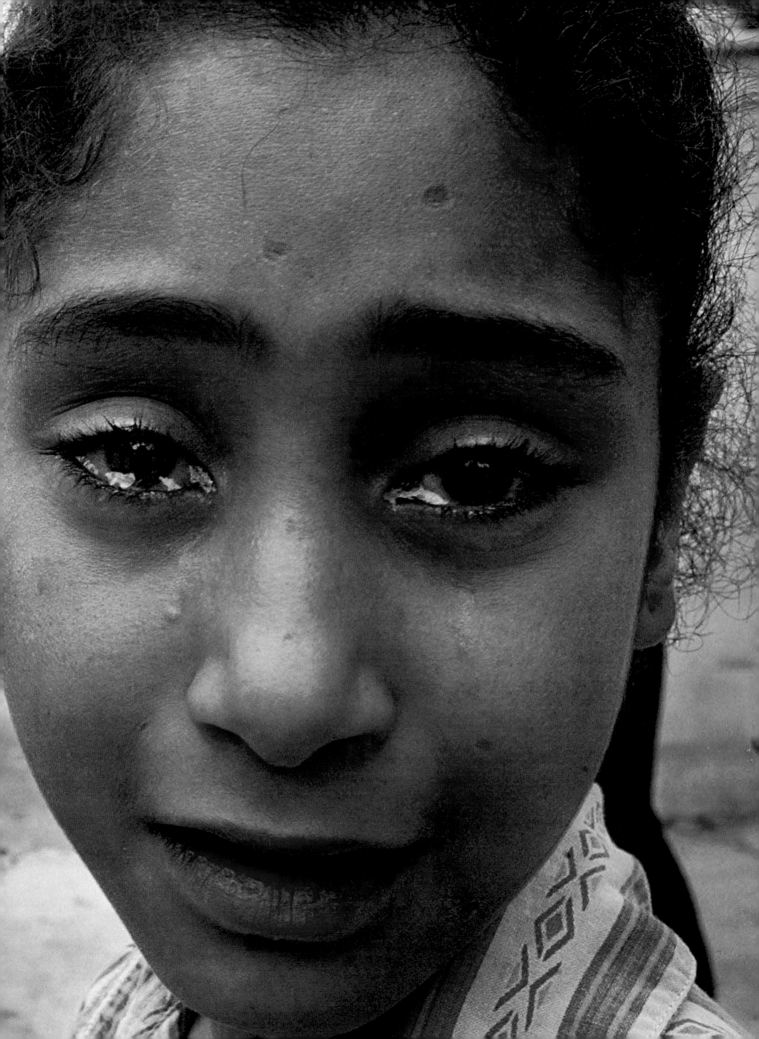

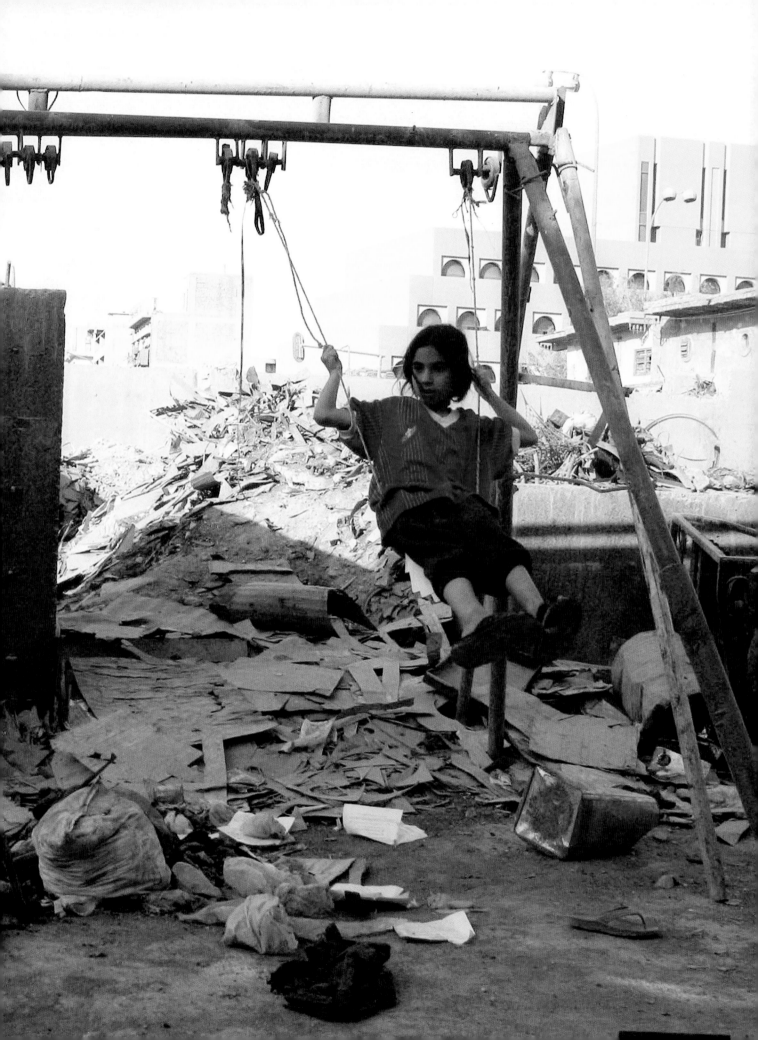

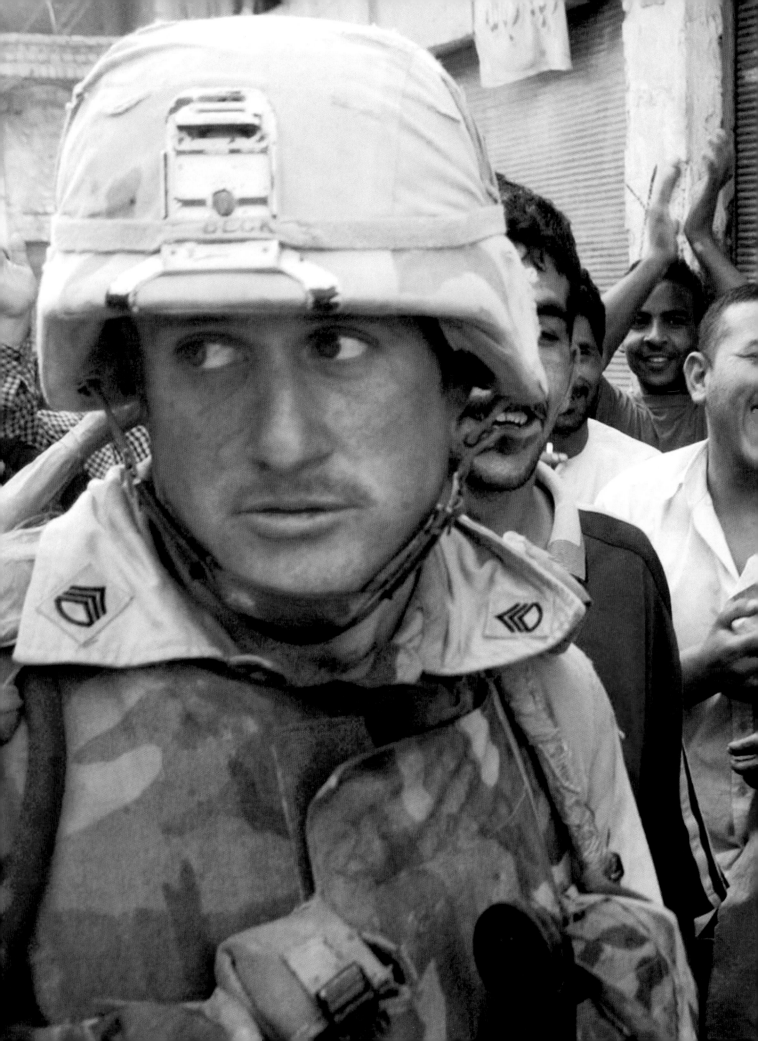

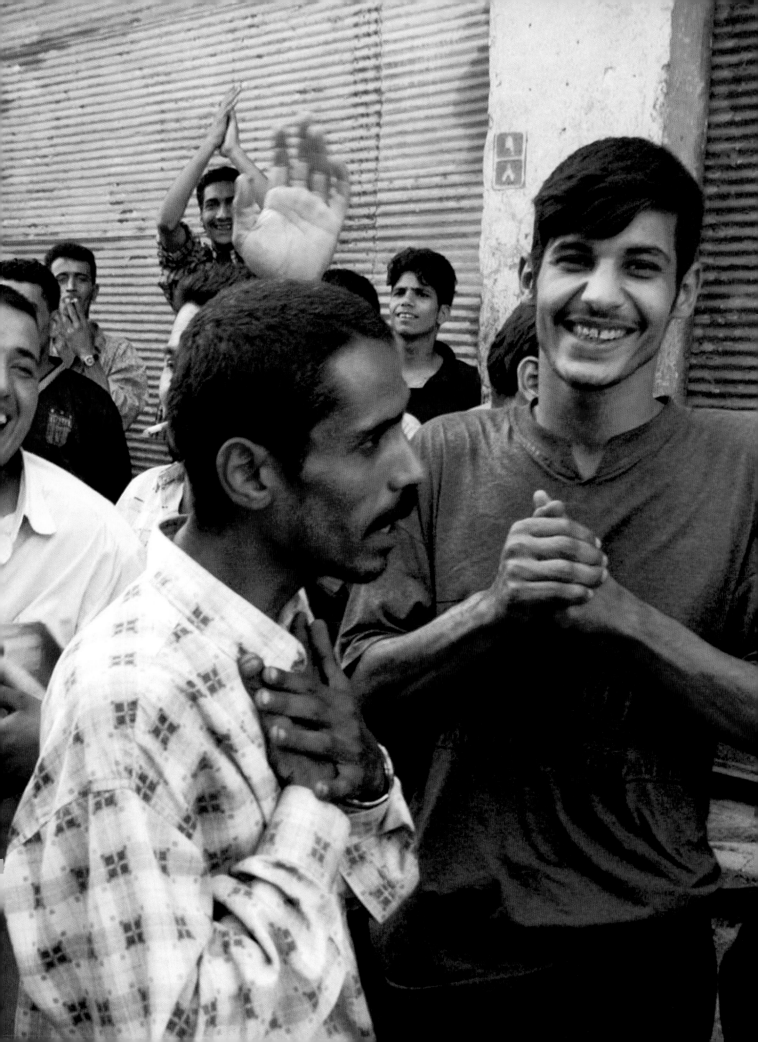

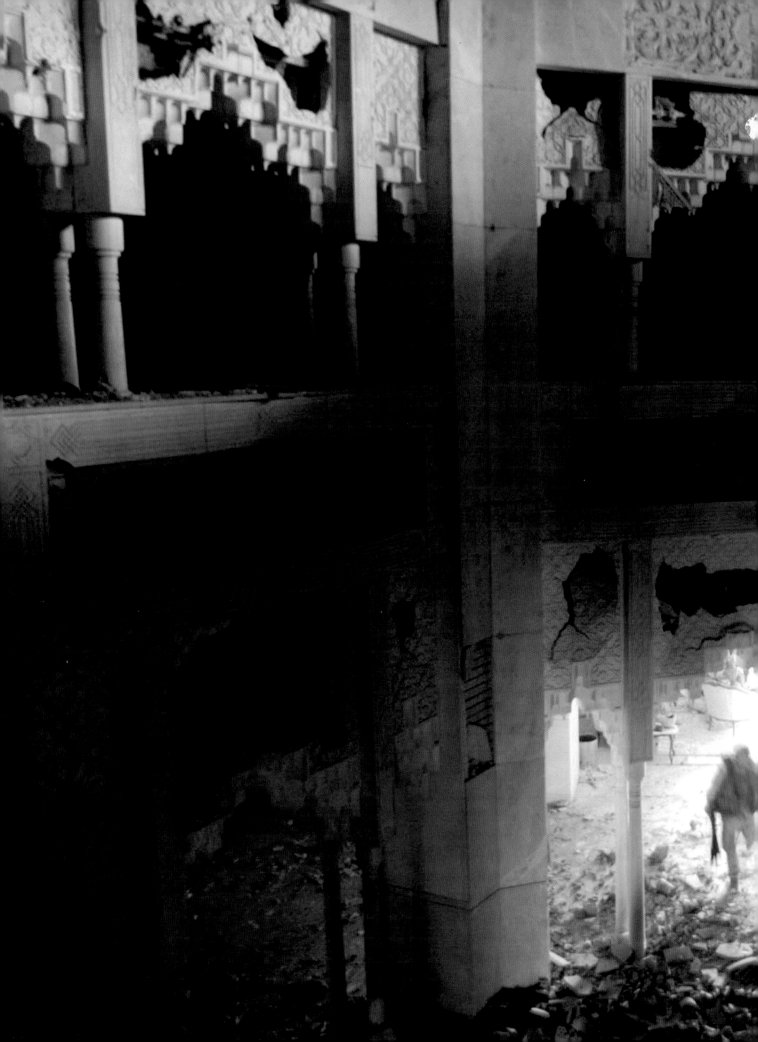

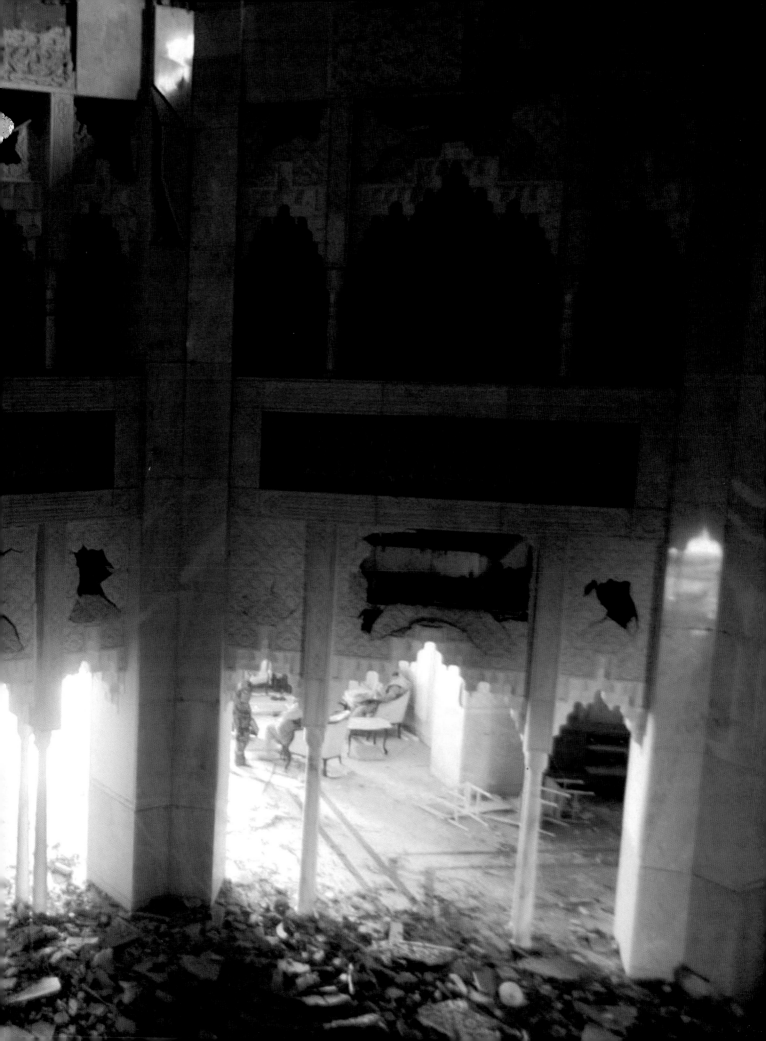

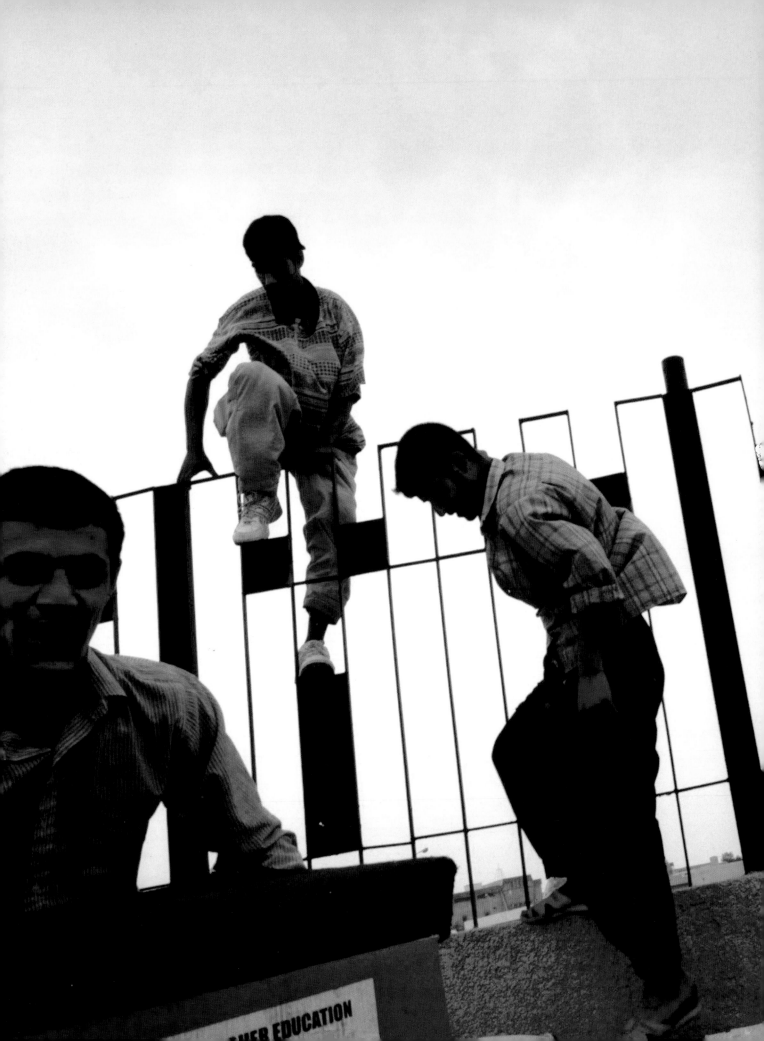

HER EDUCATION

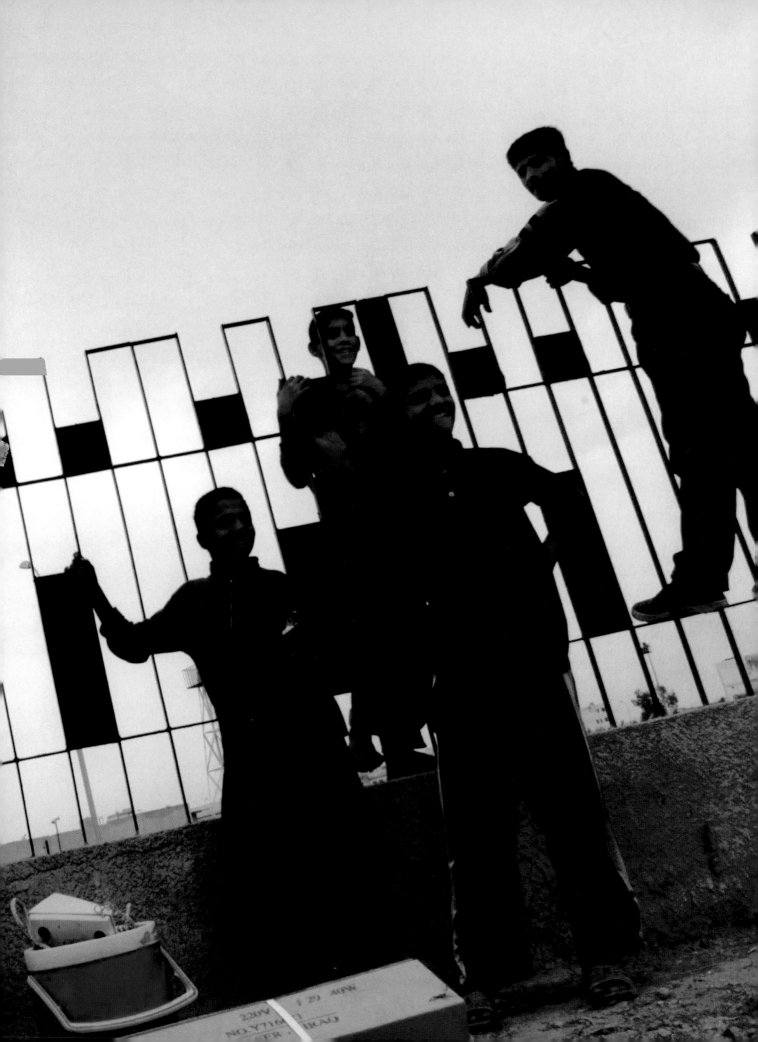

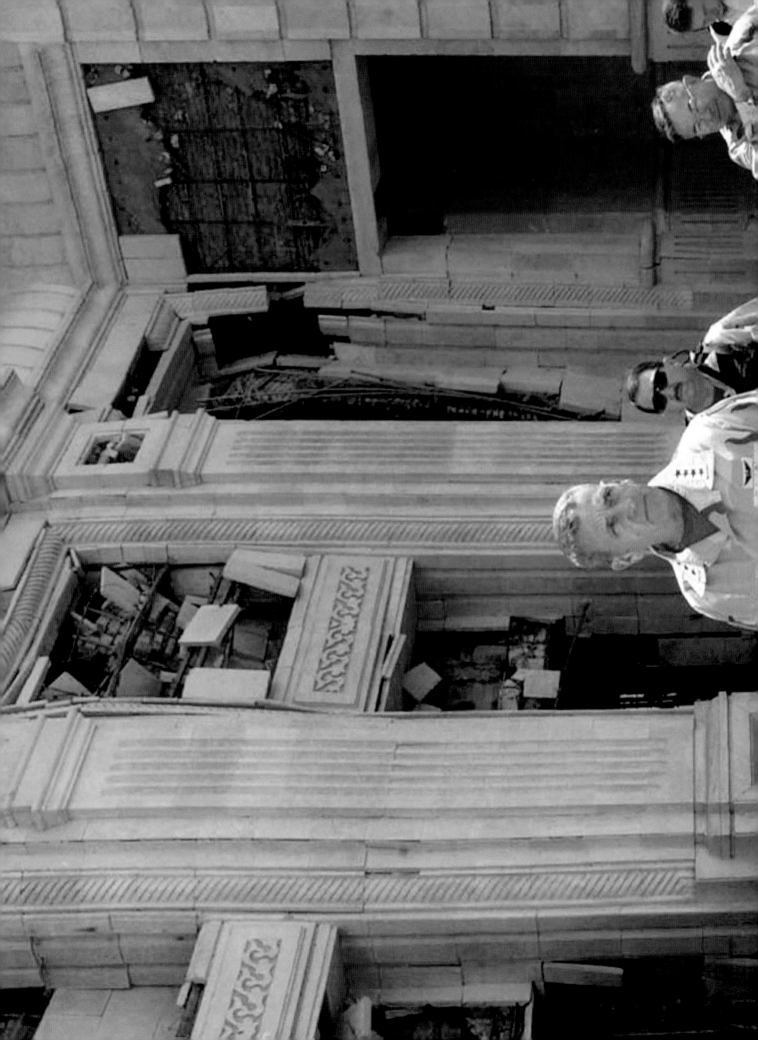

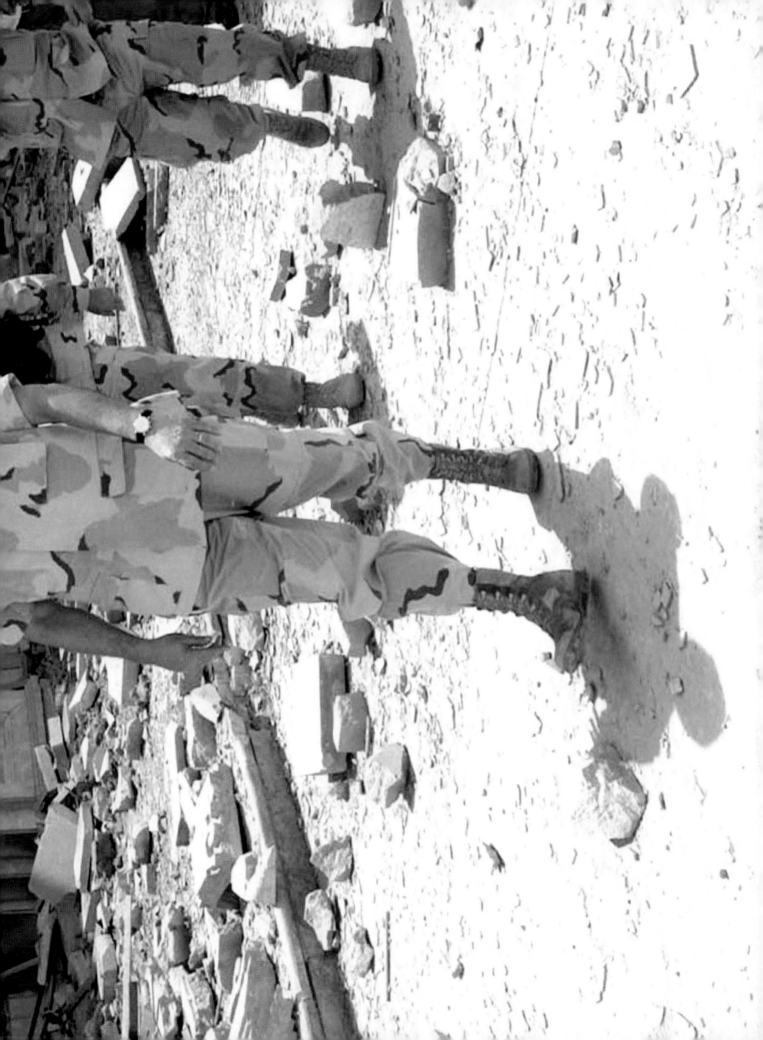

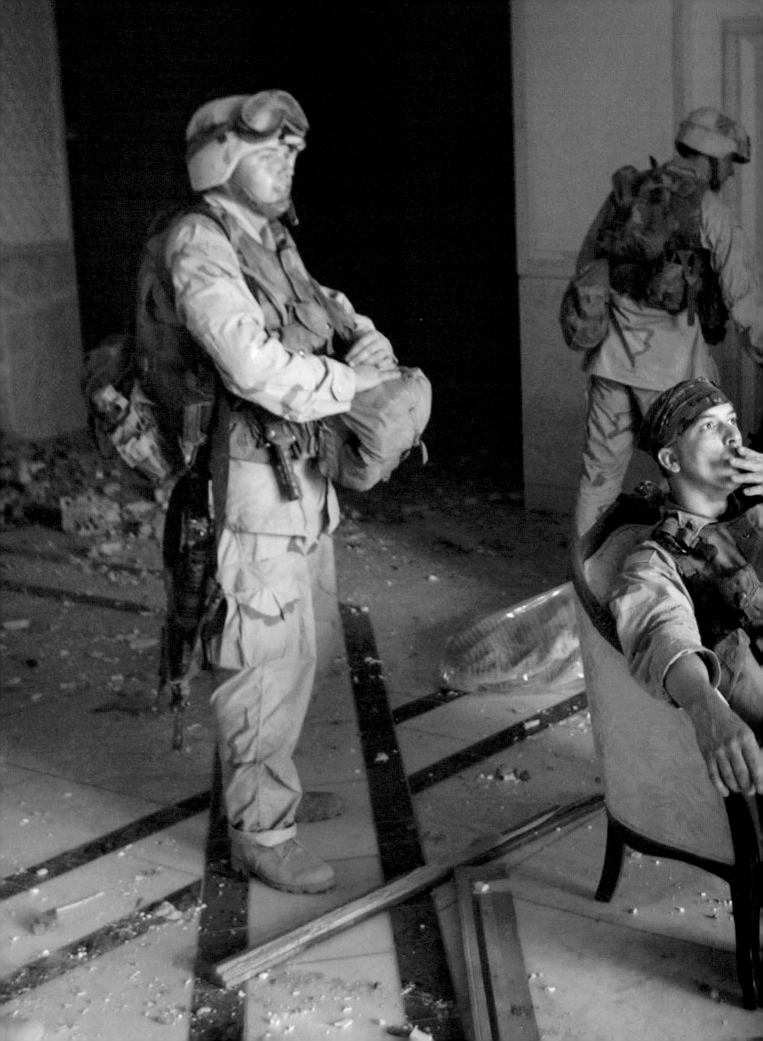

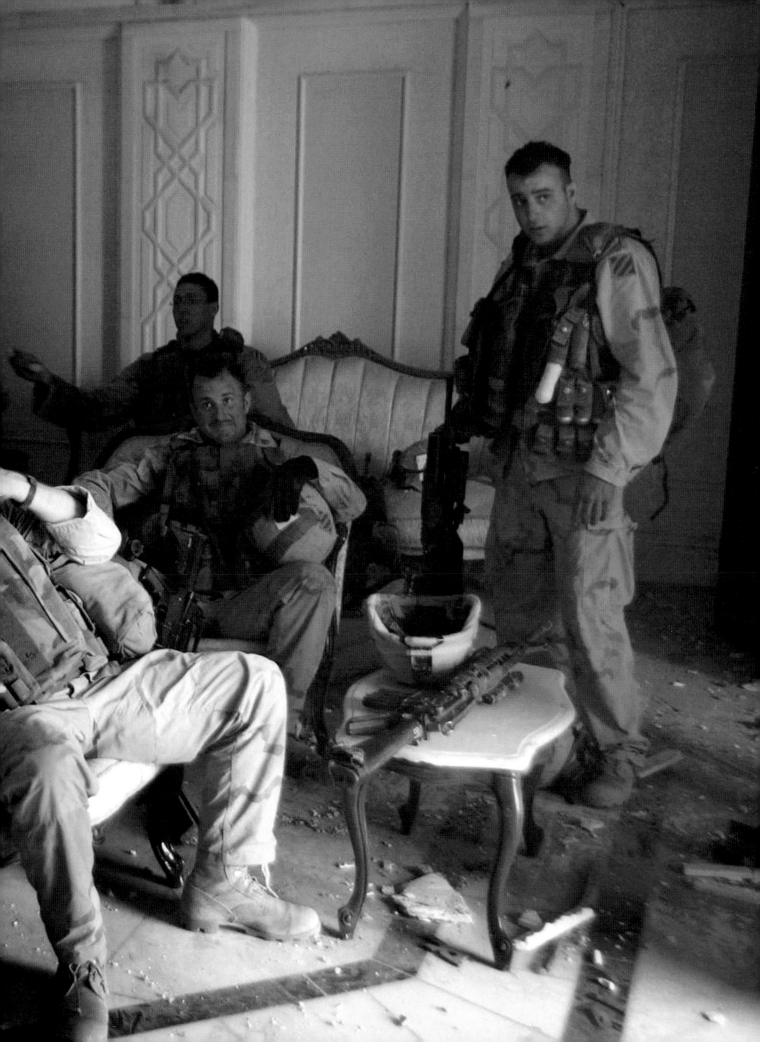

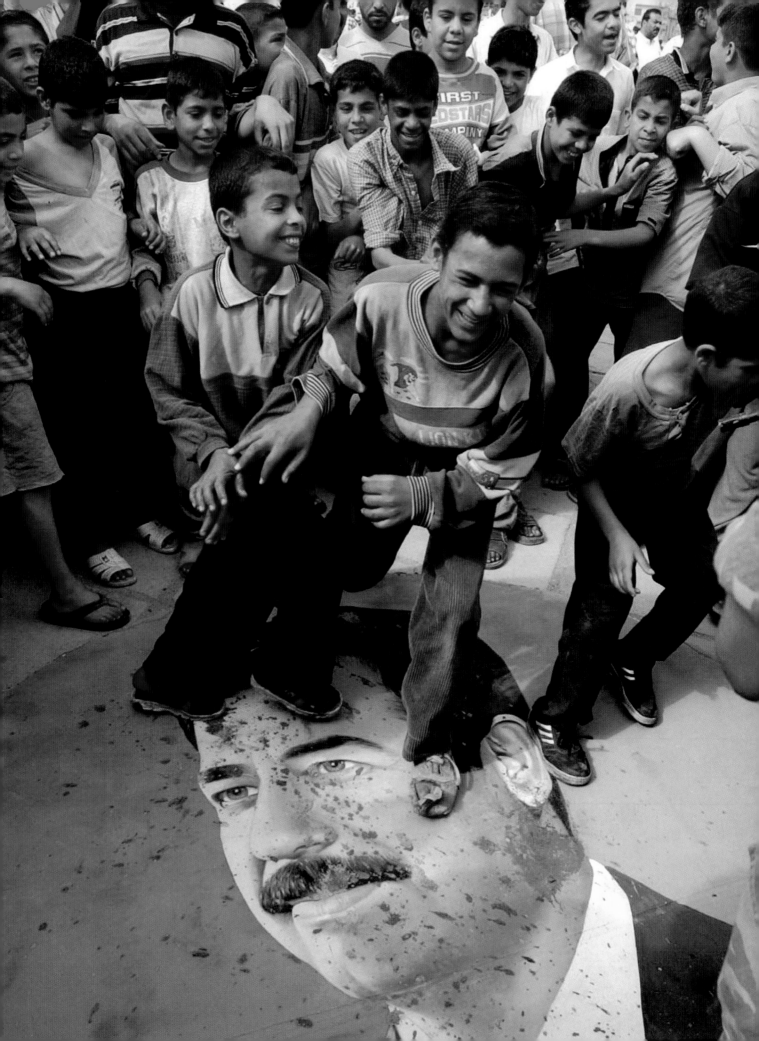

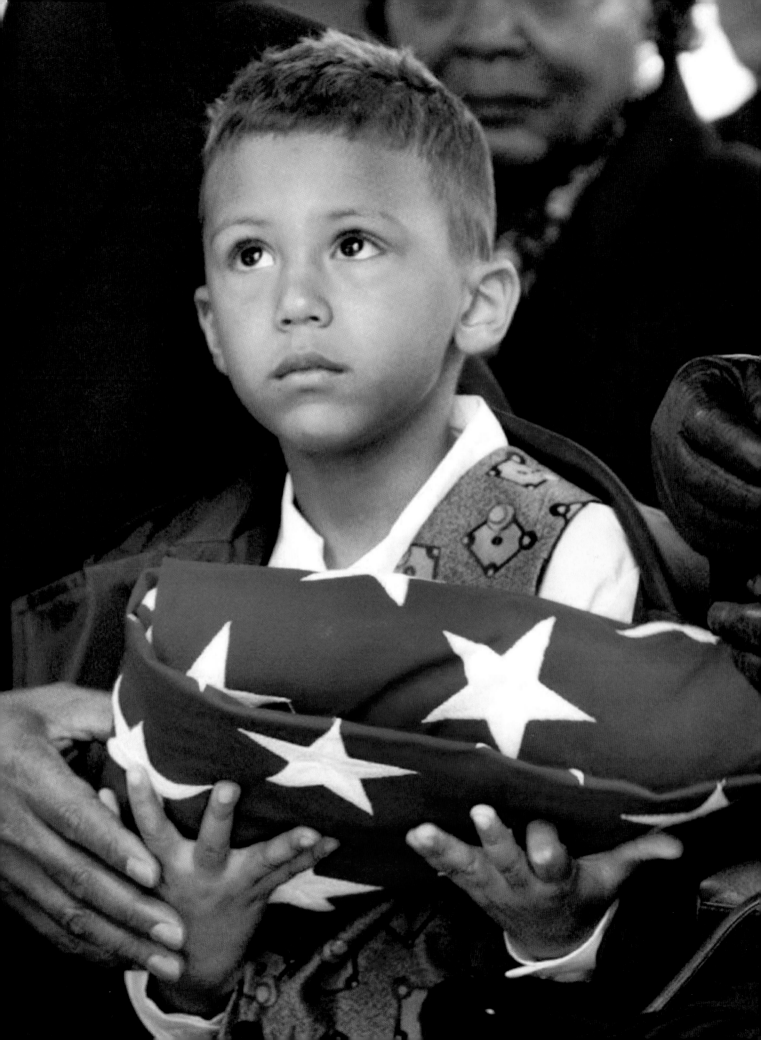

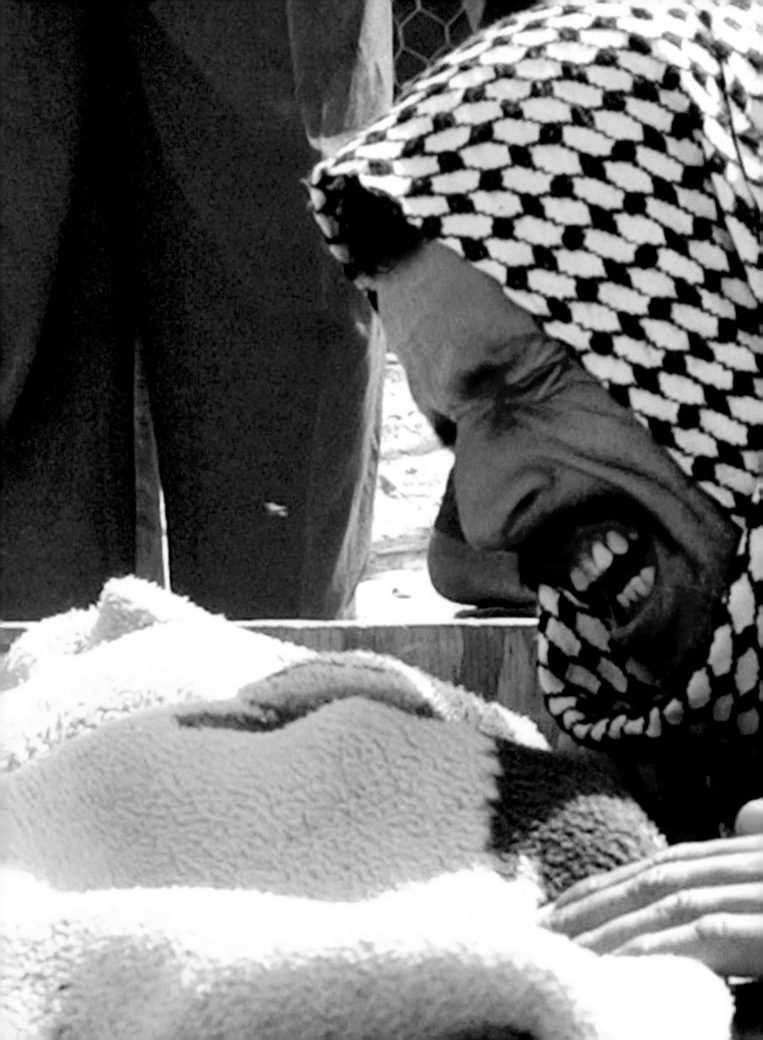

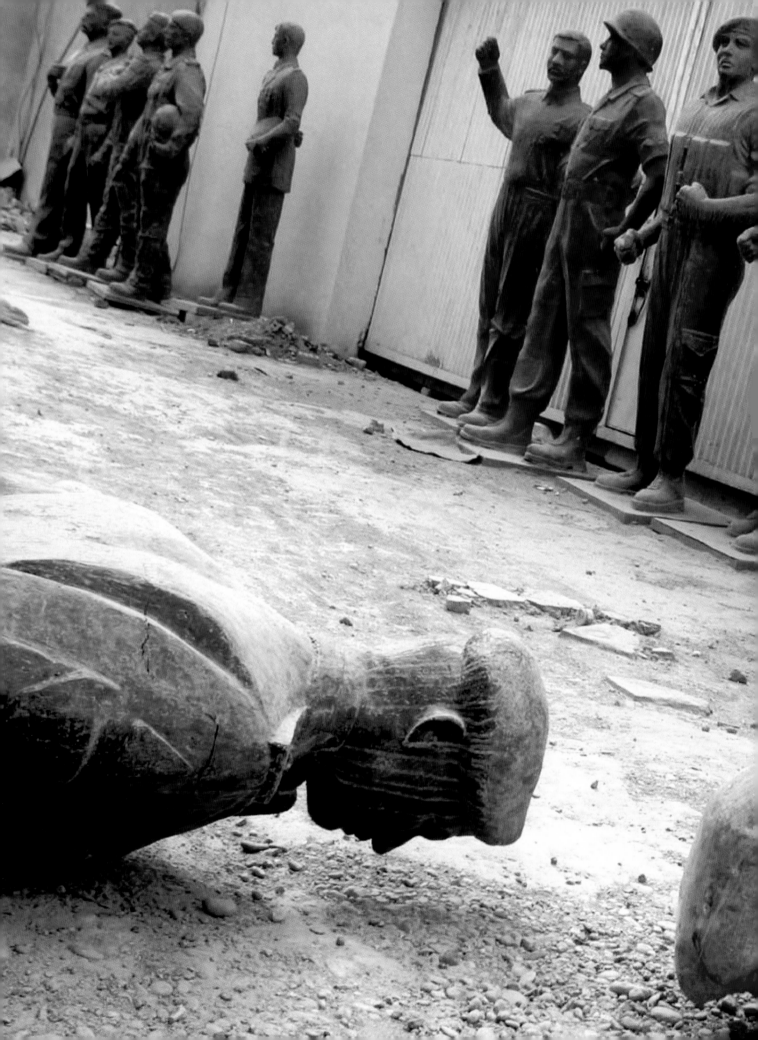

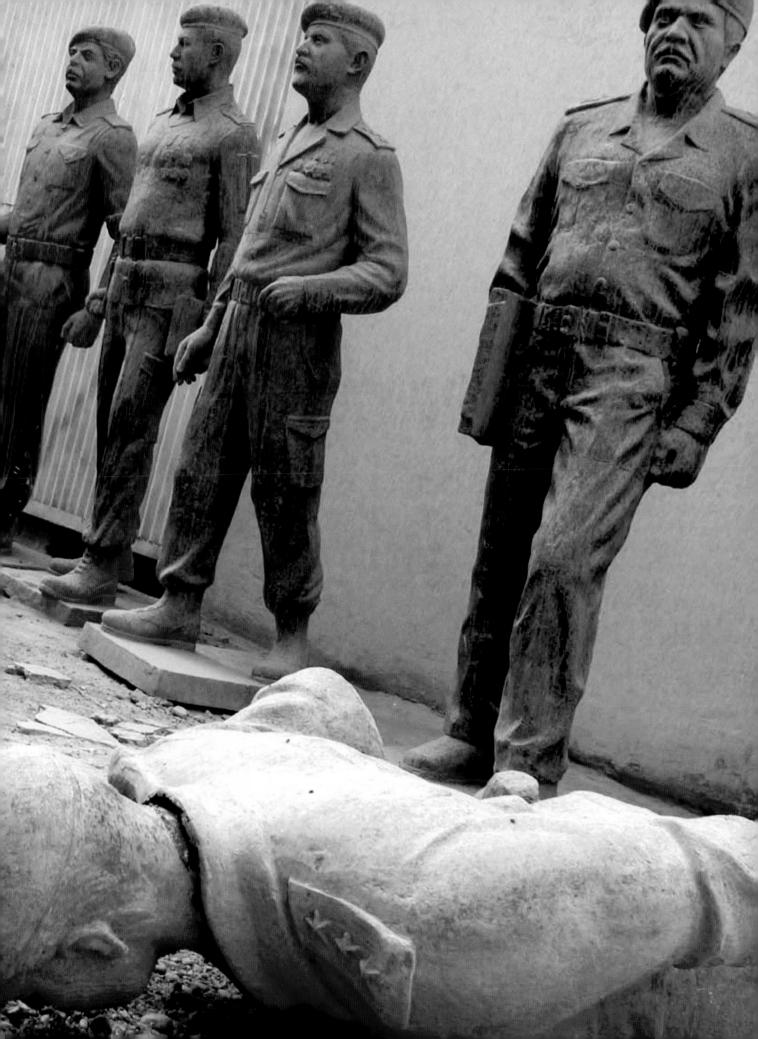

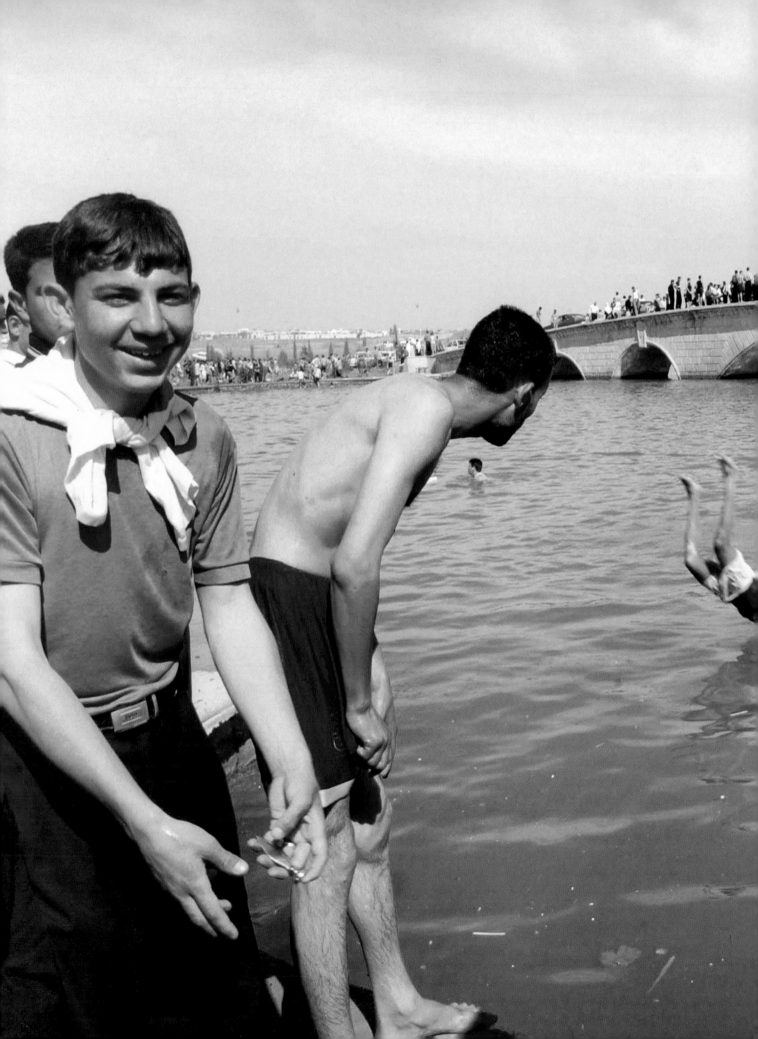

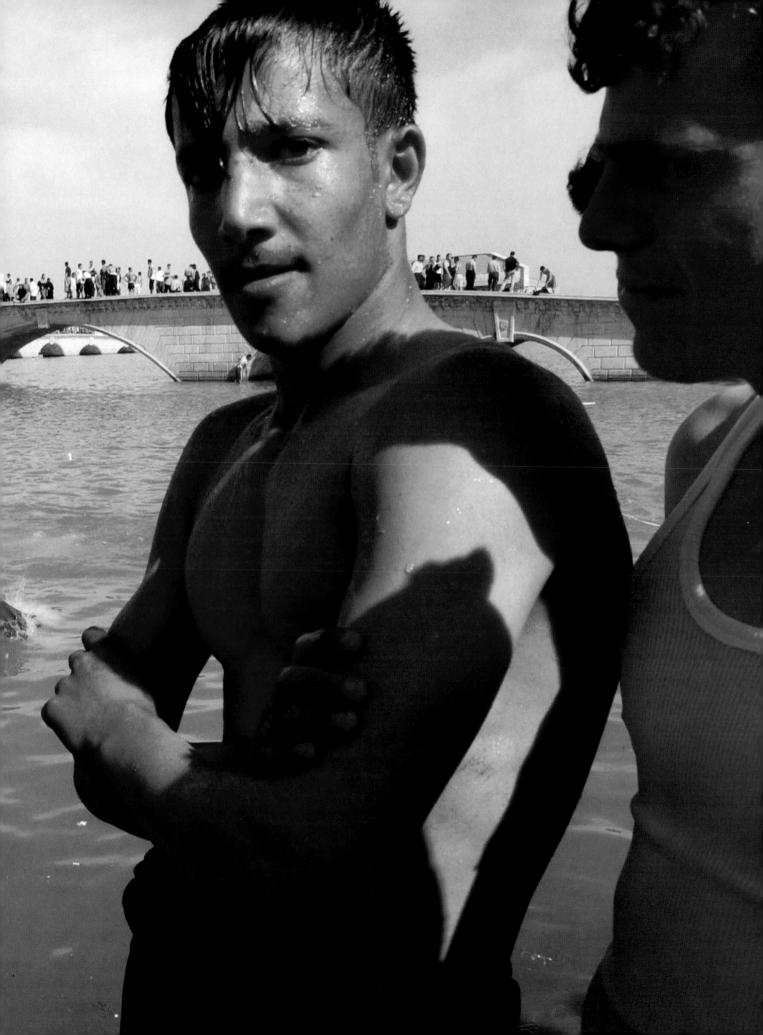

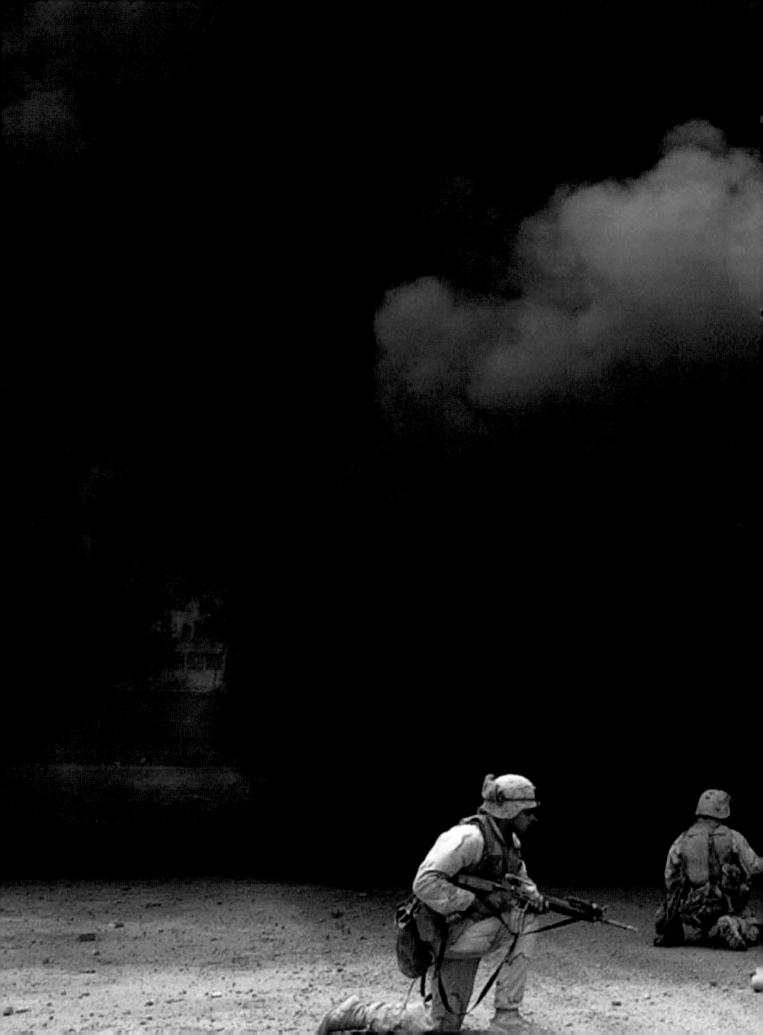

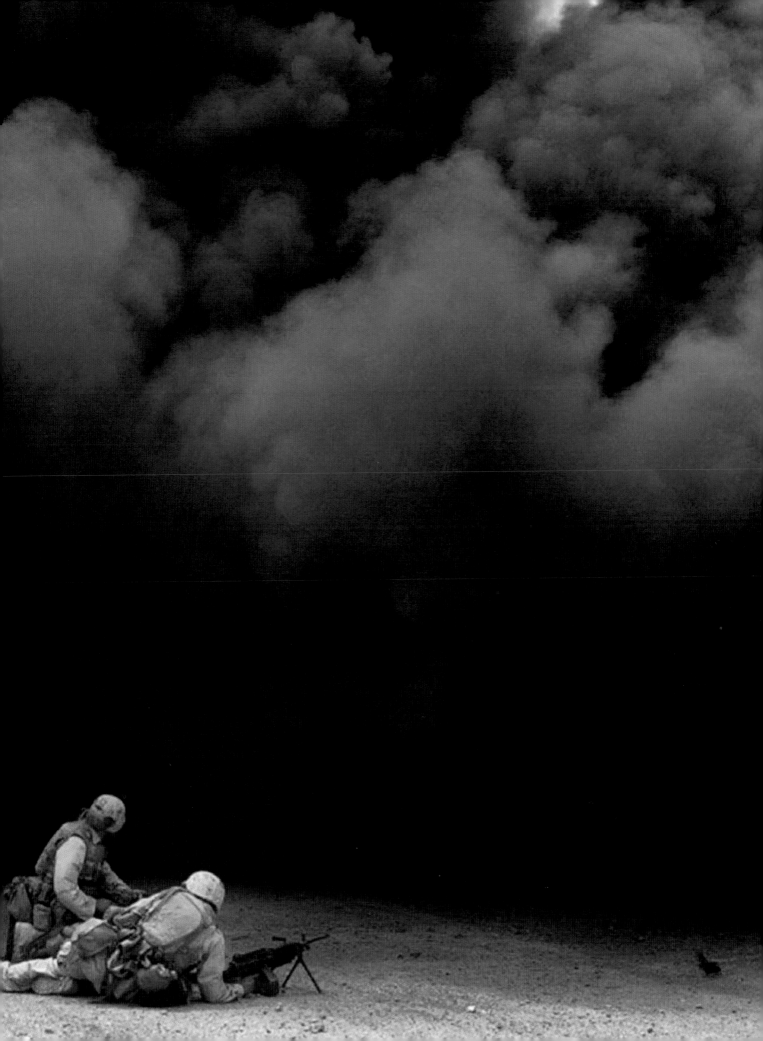

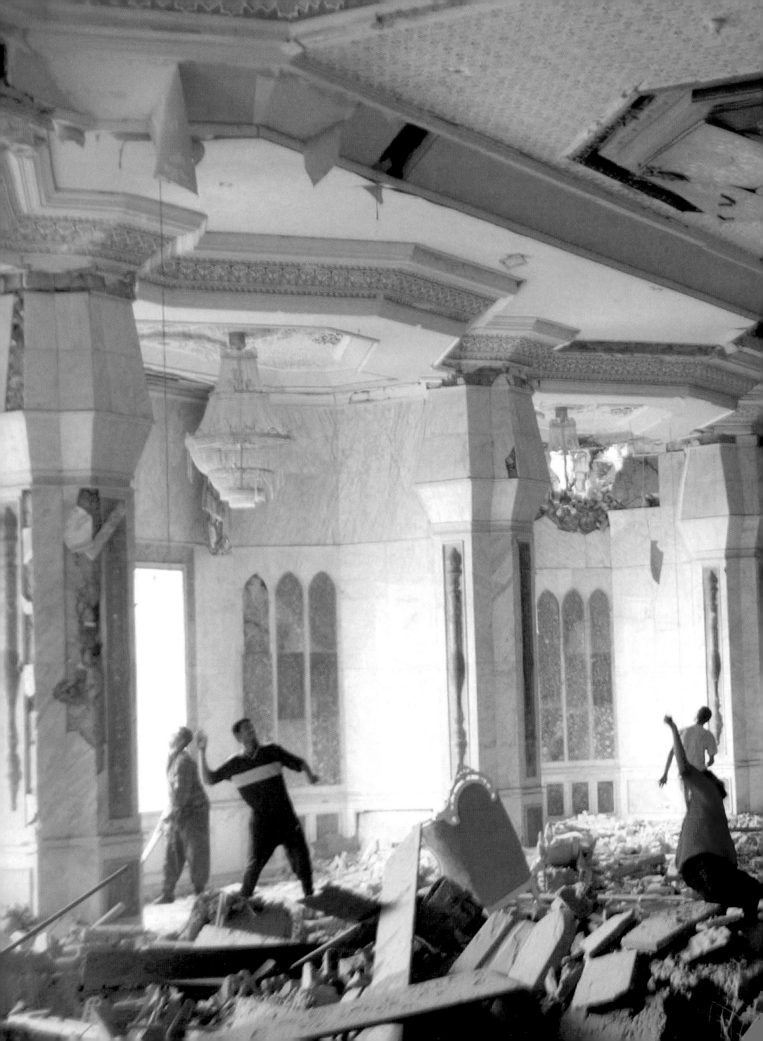

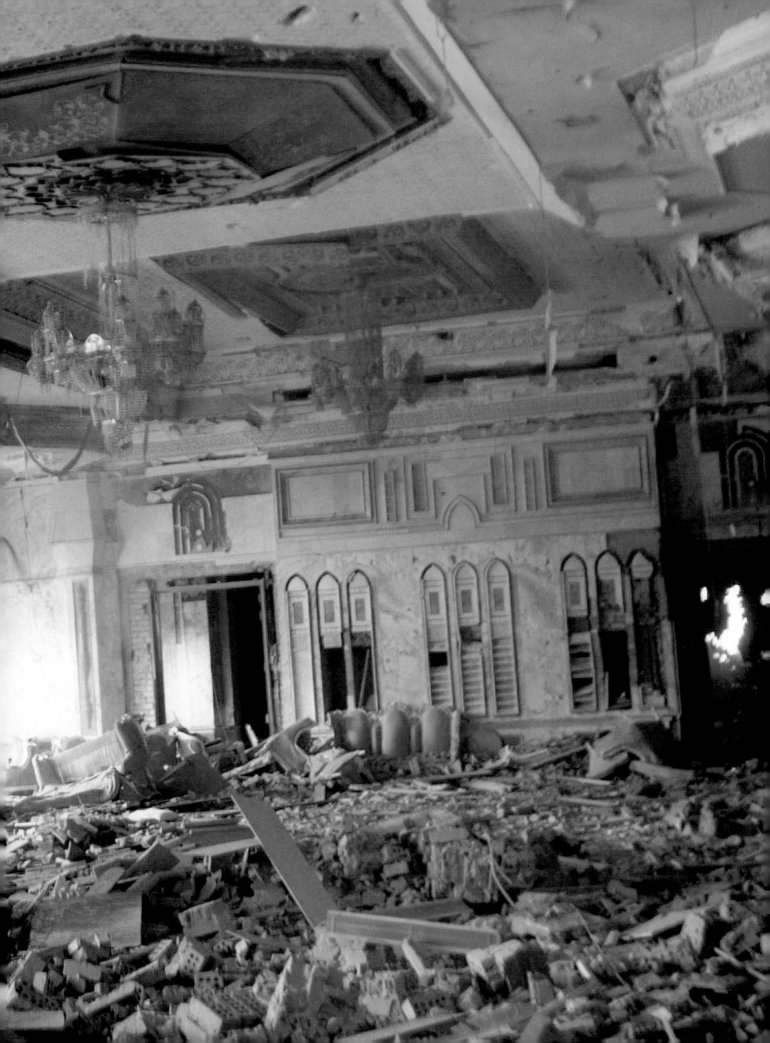

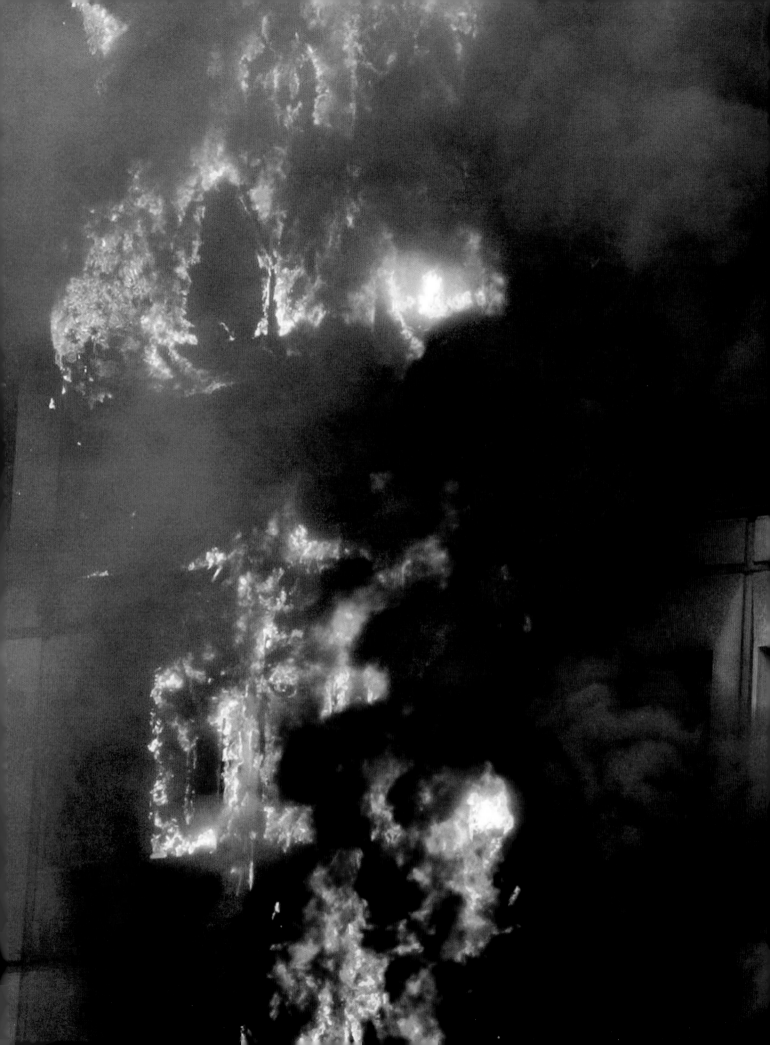

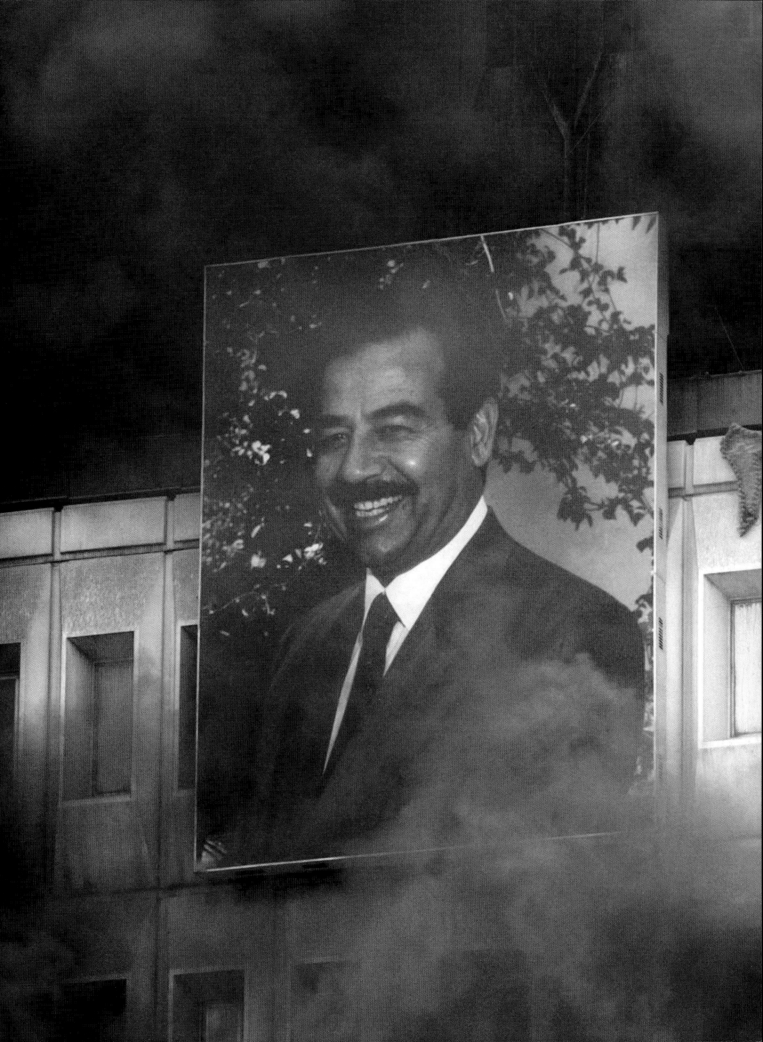

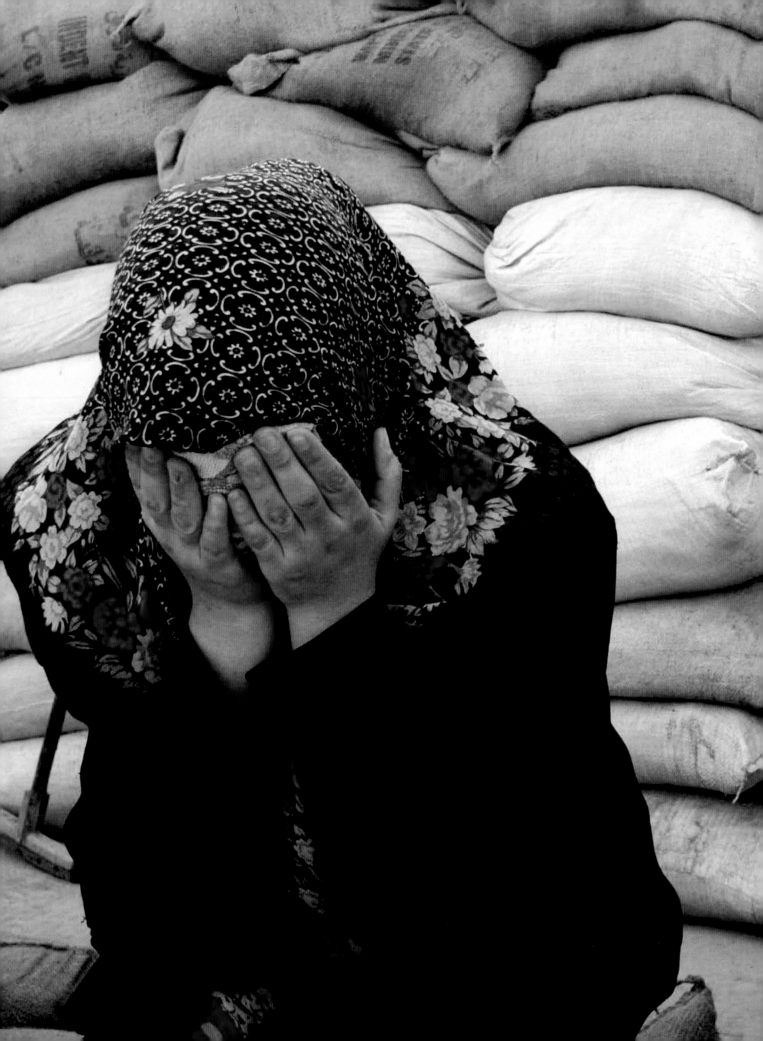

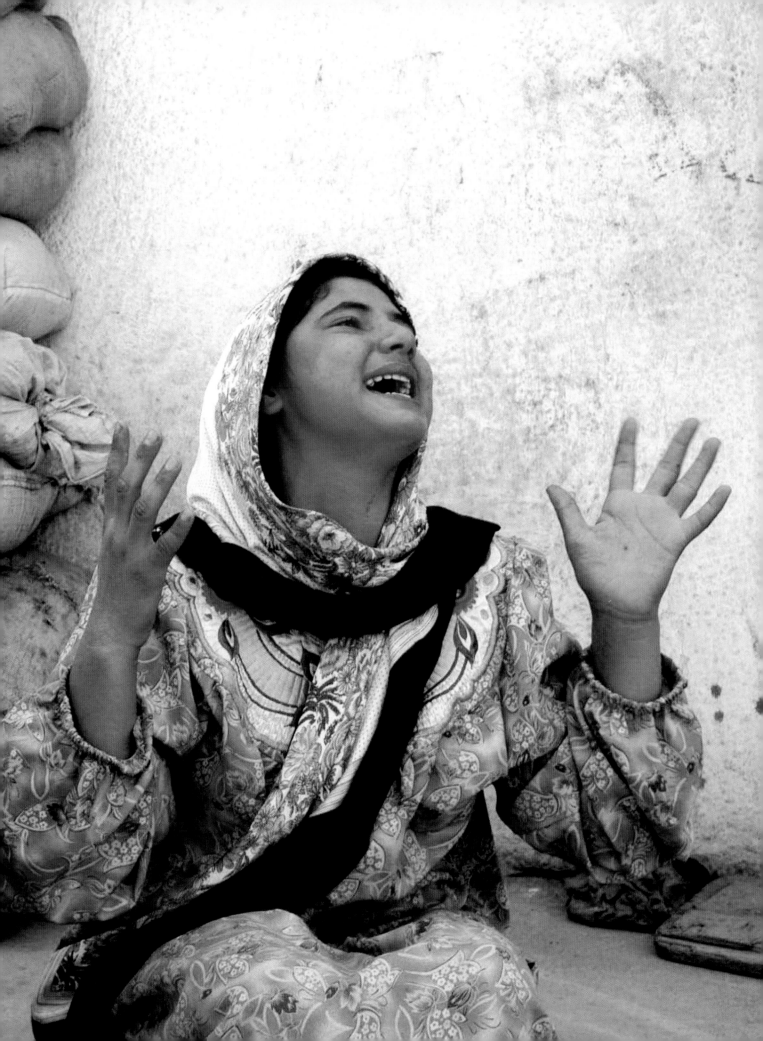

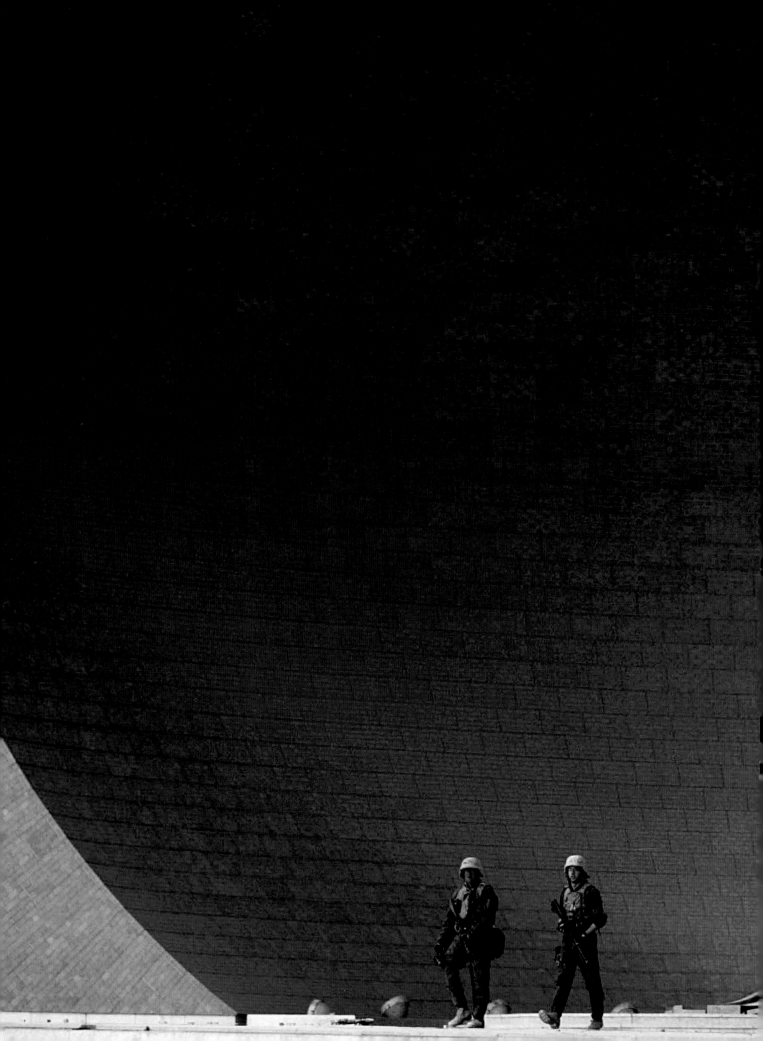

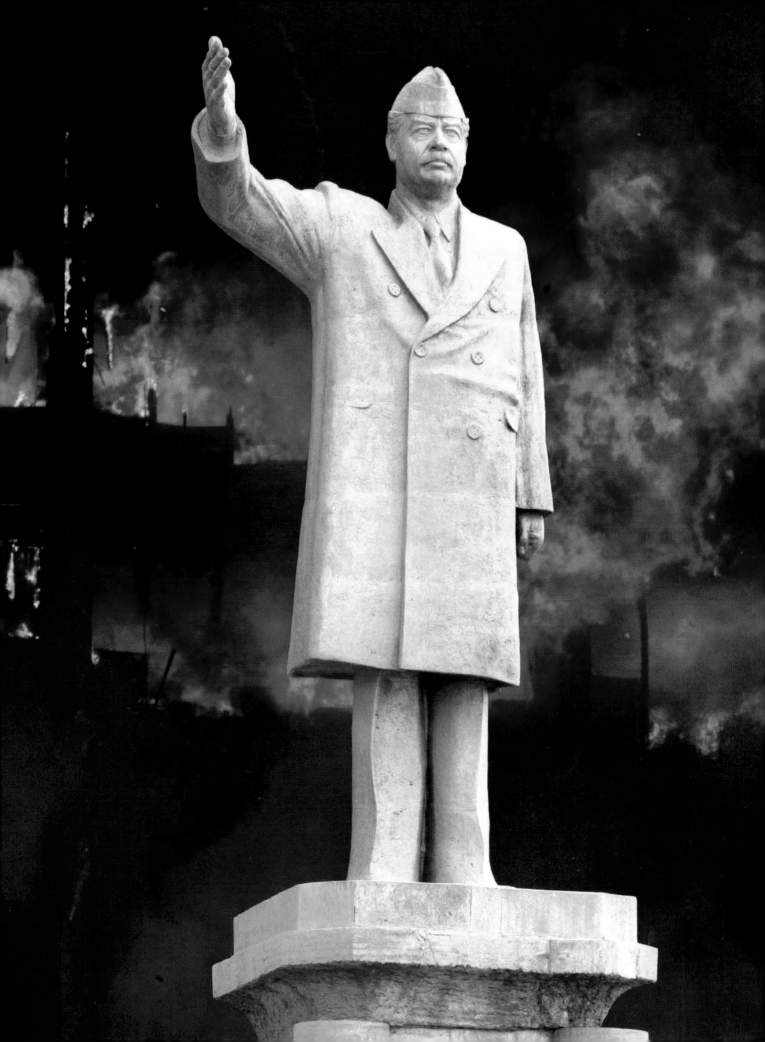

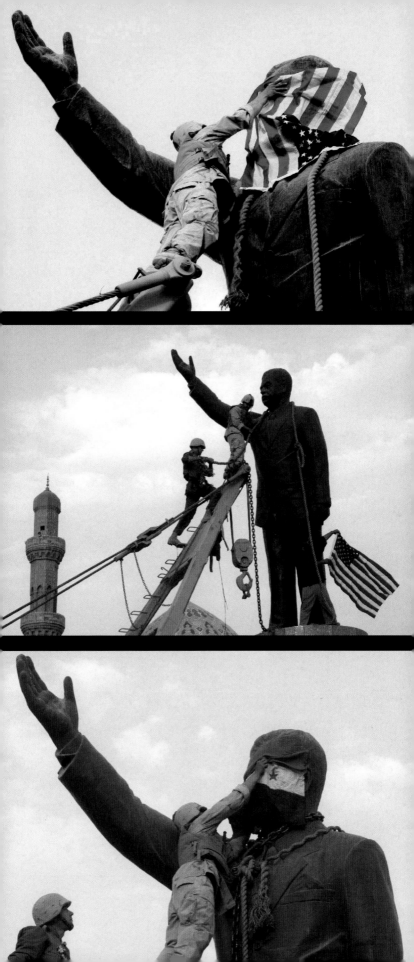

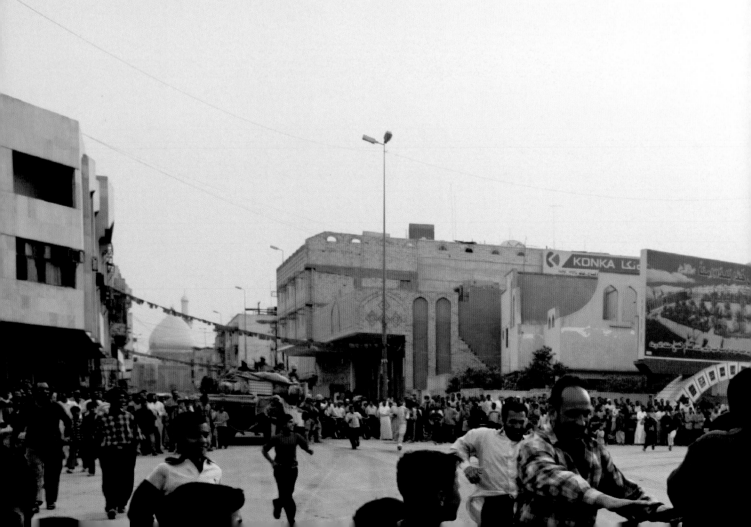

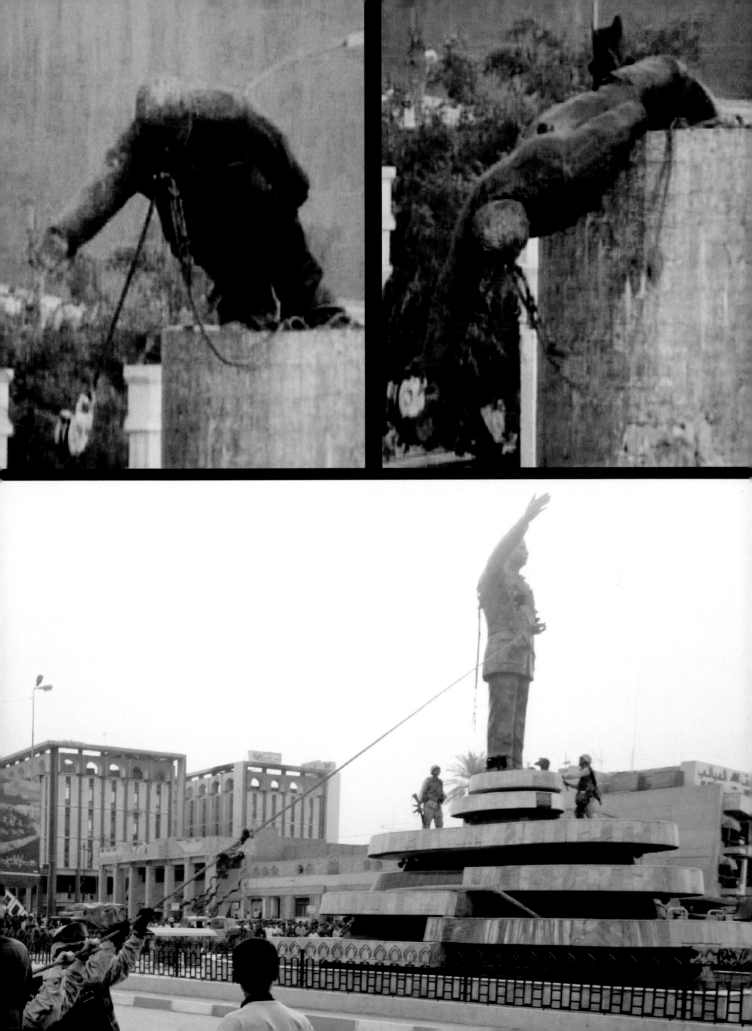

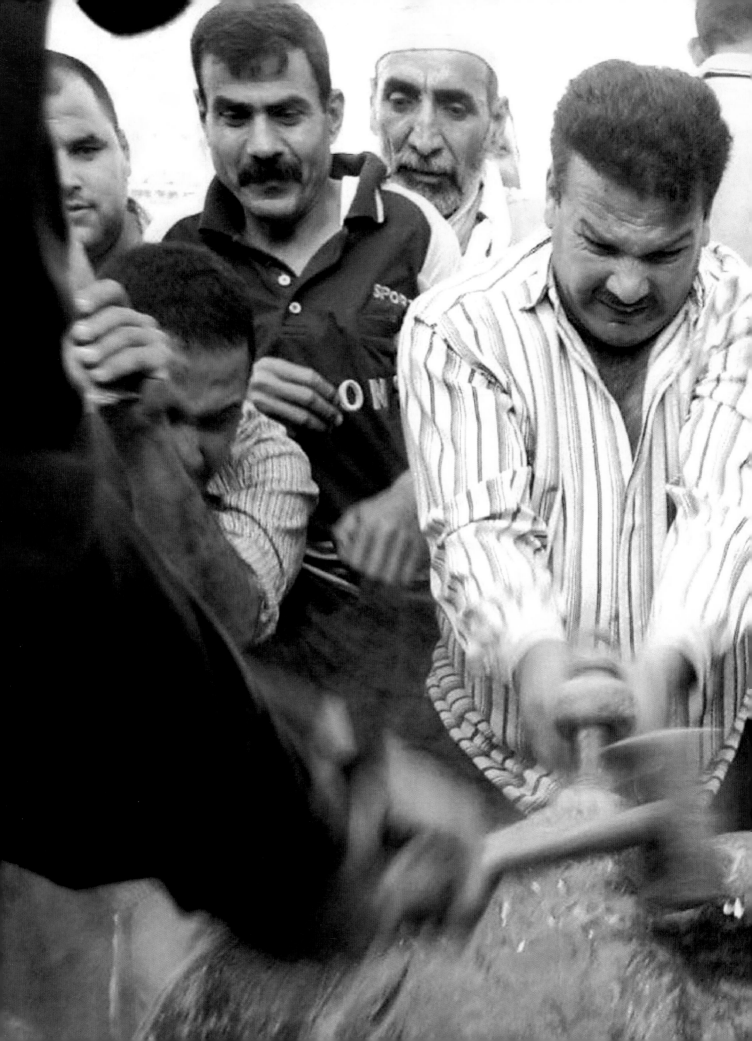

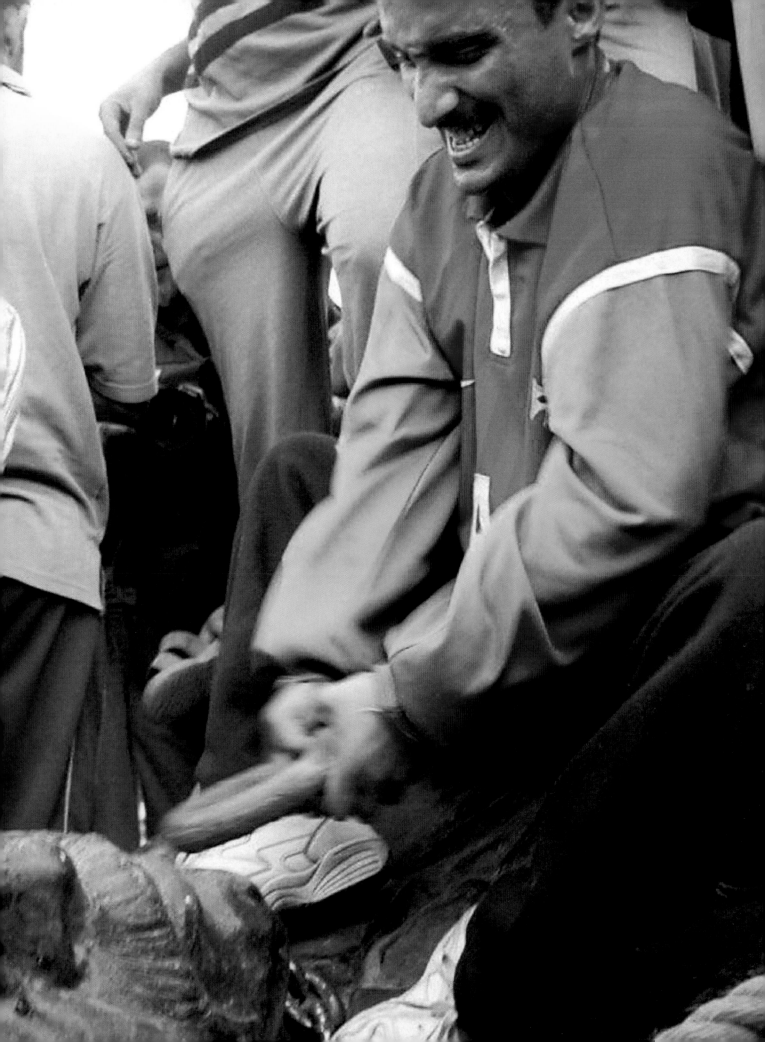

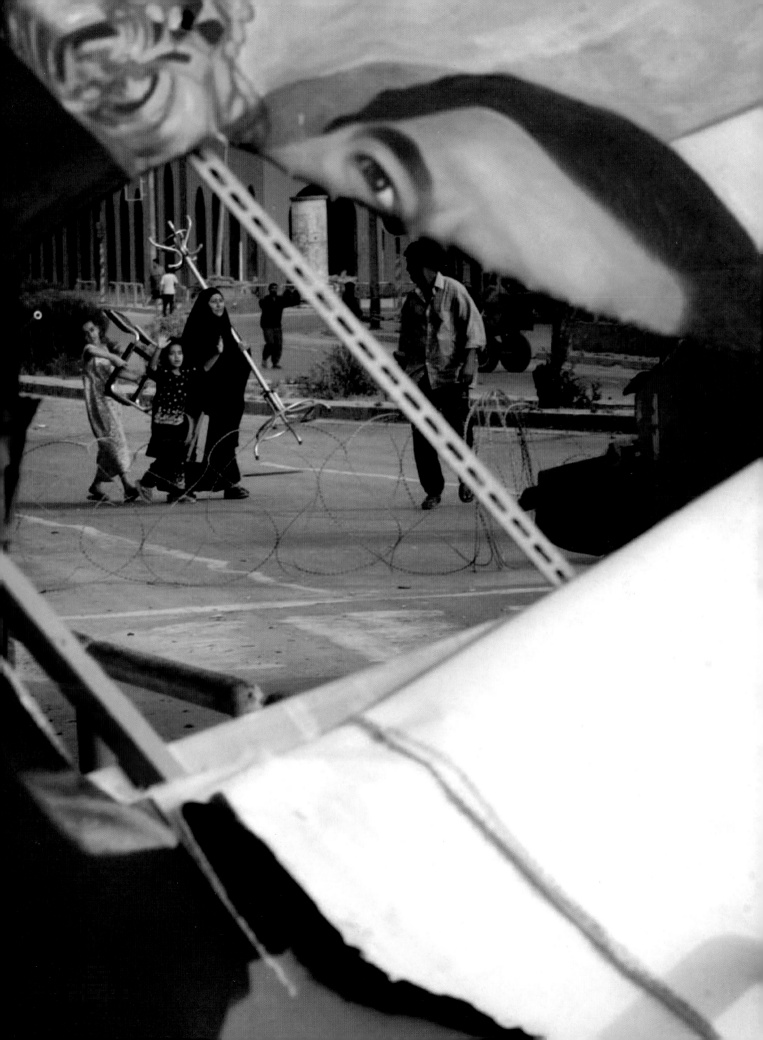

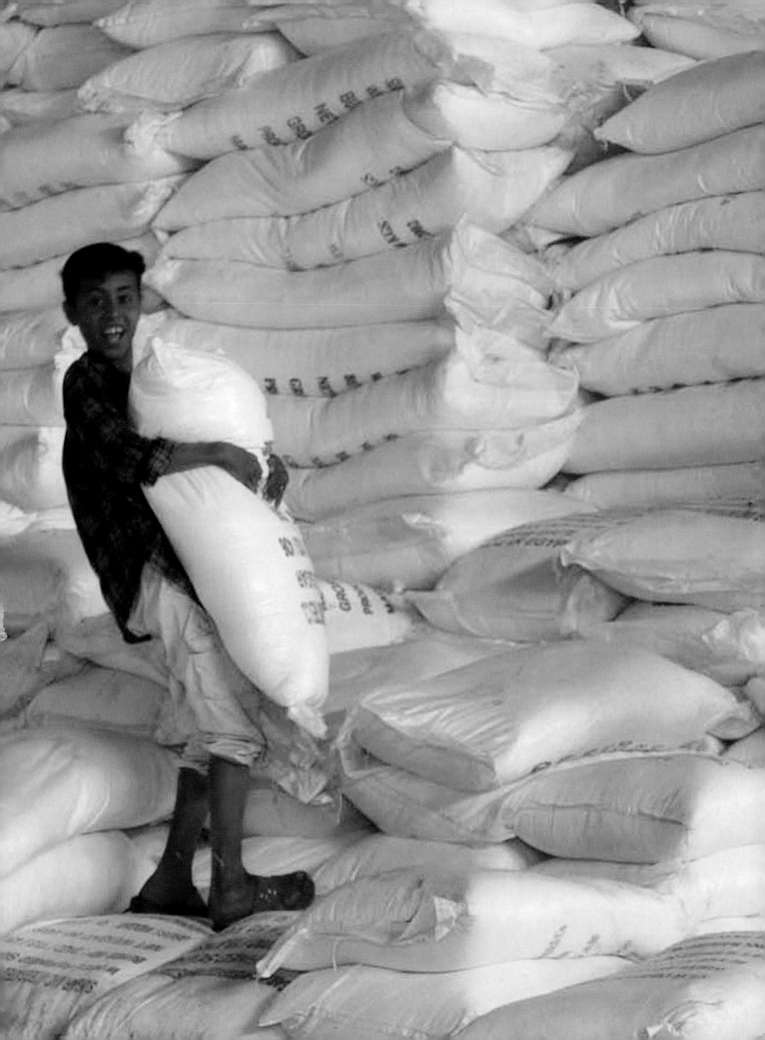

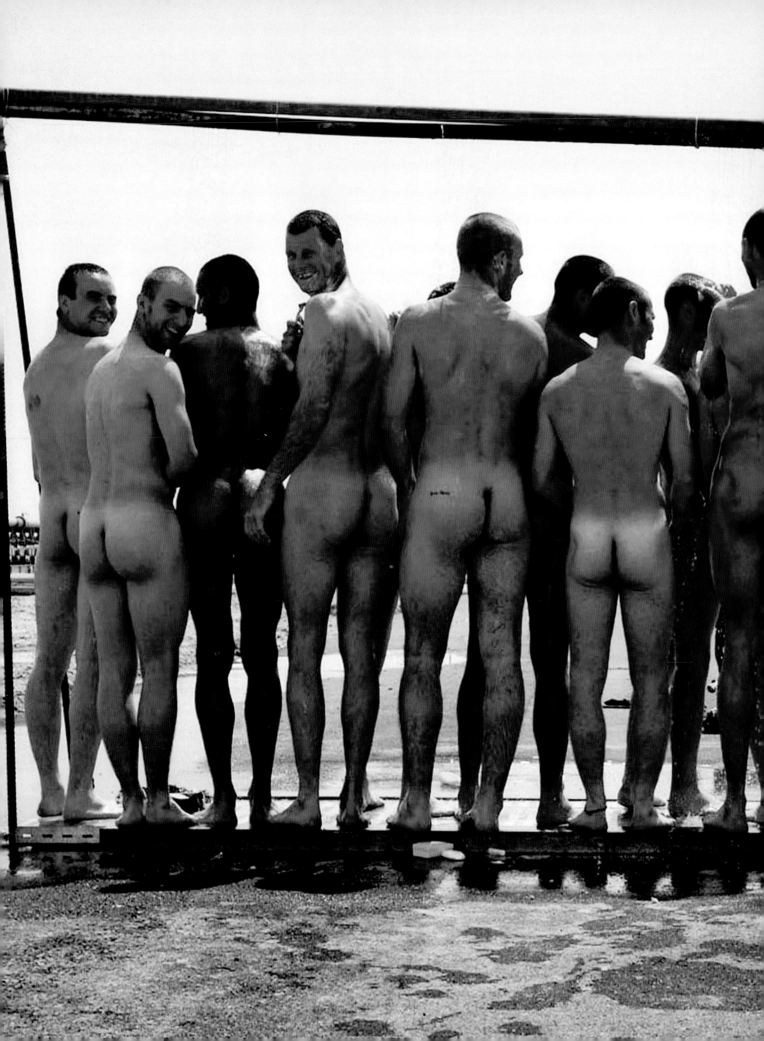

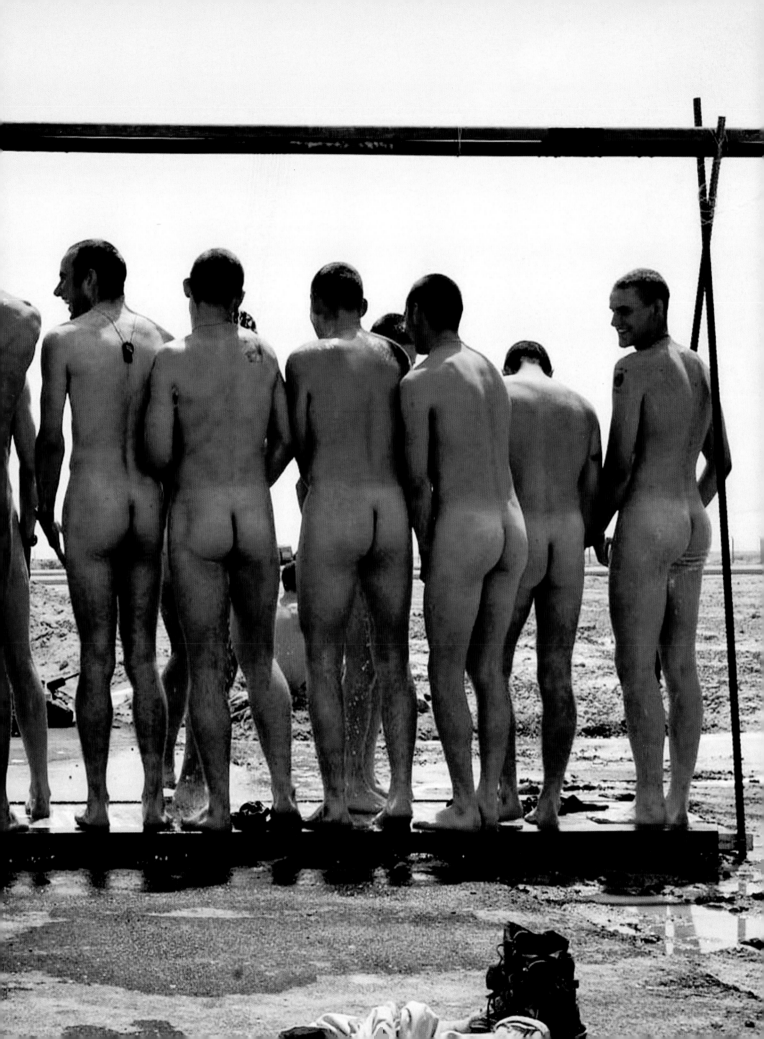

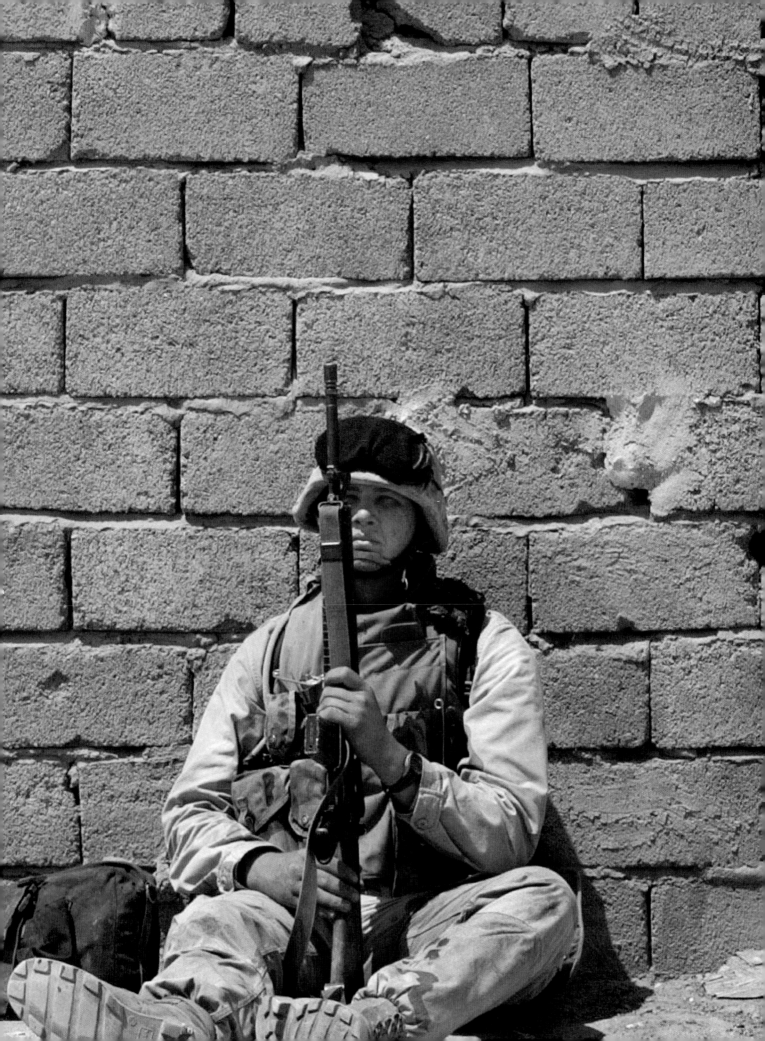

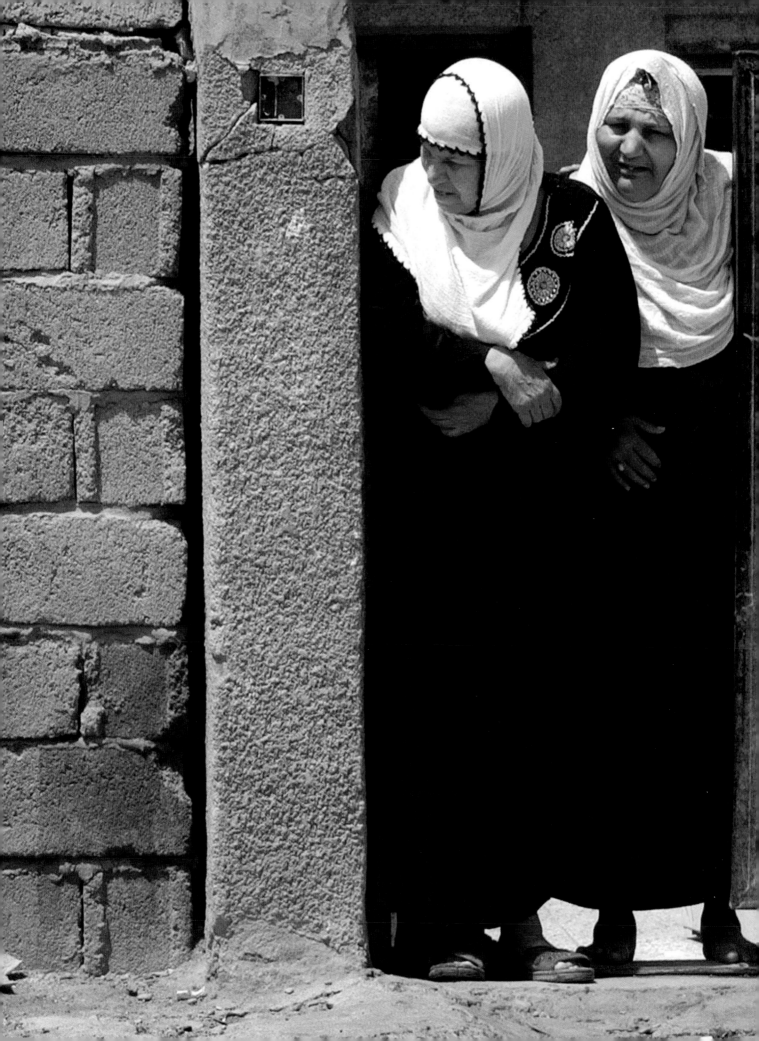

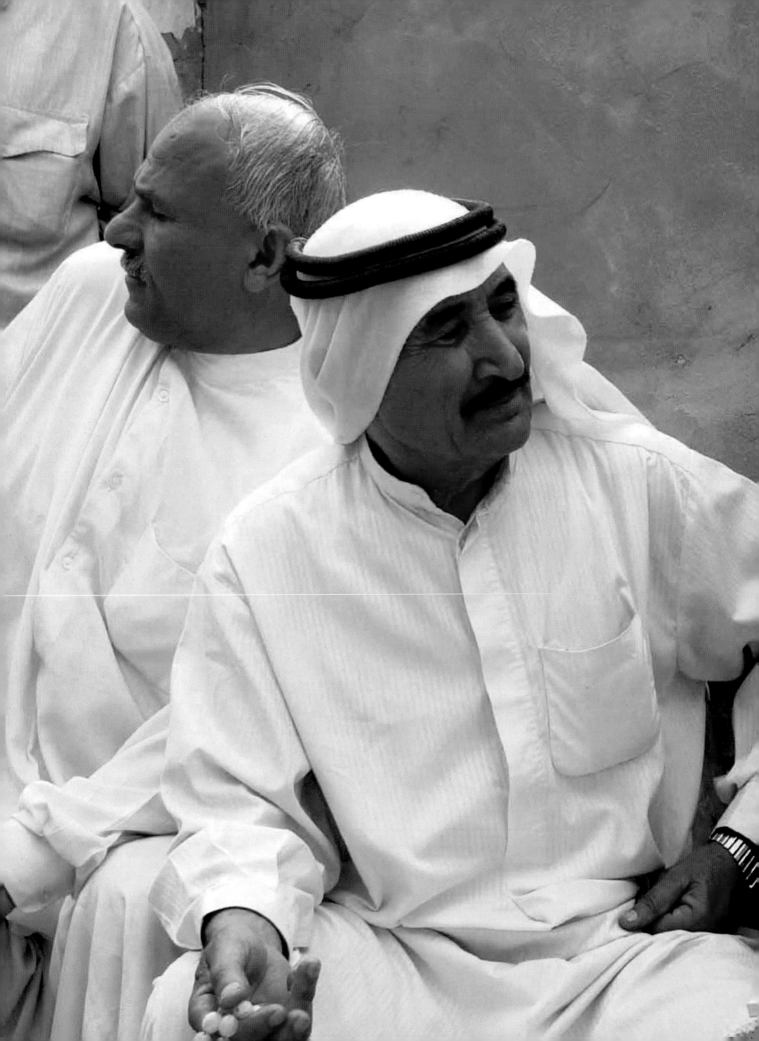

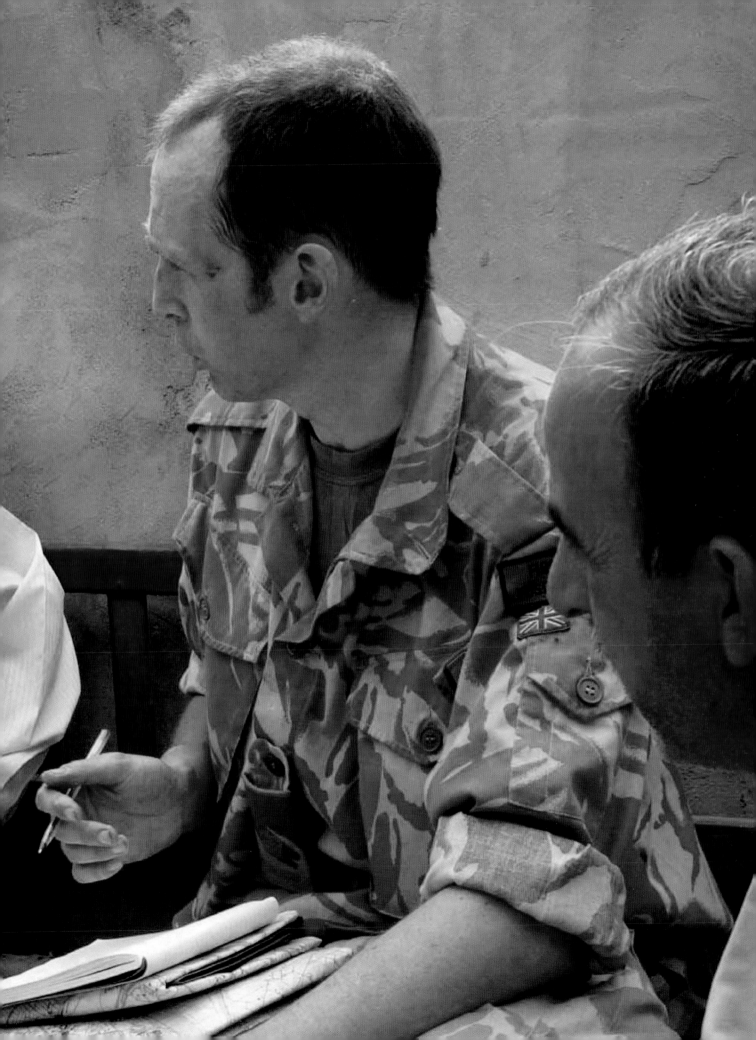

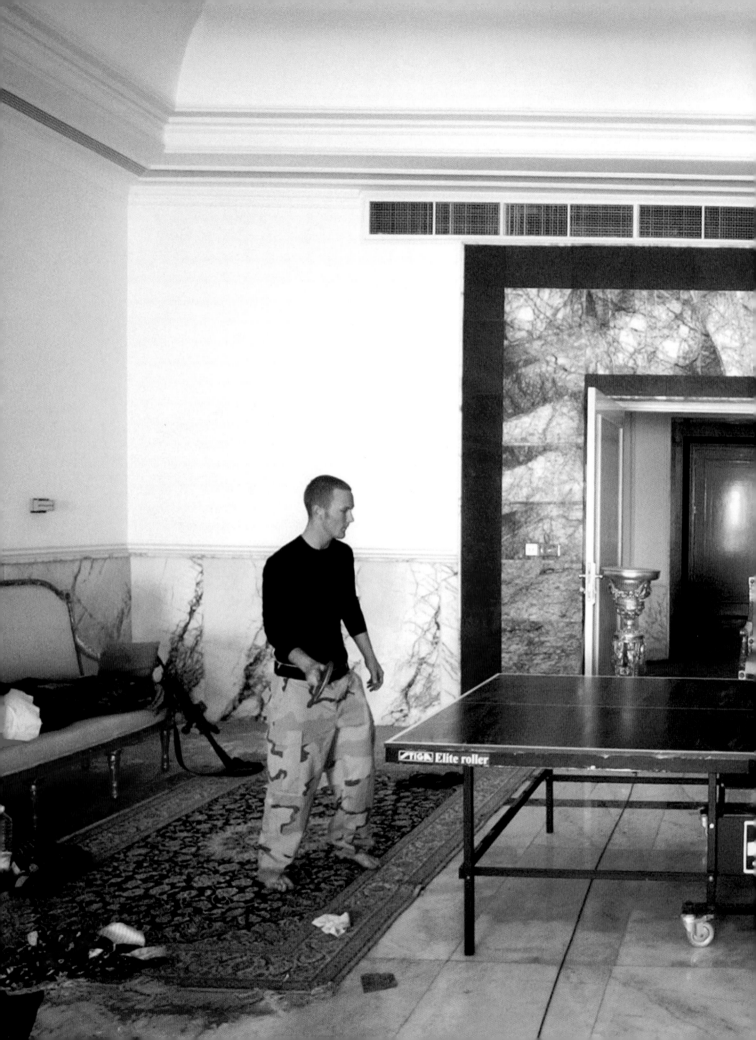

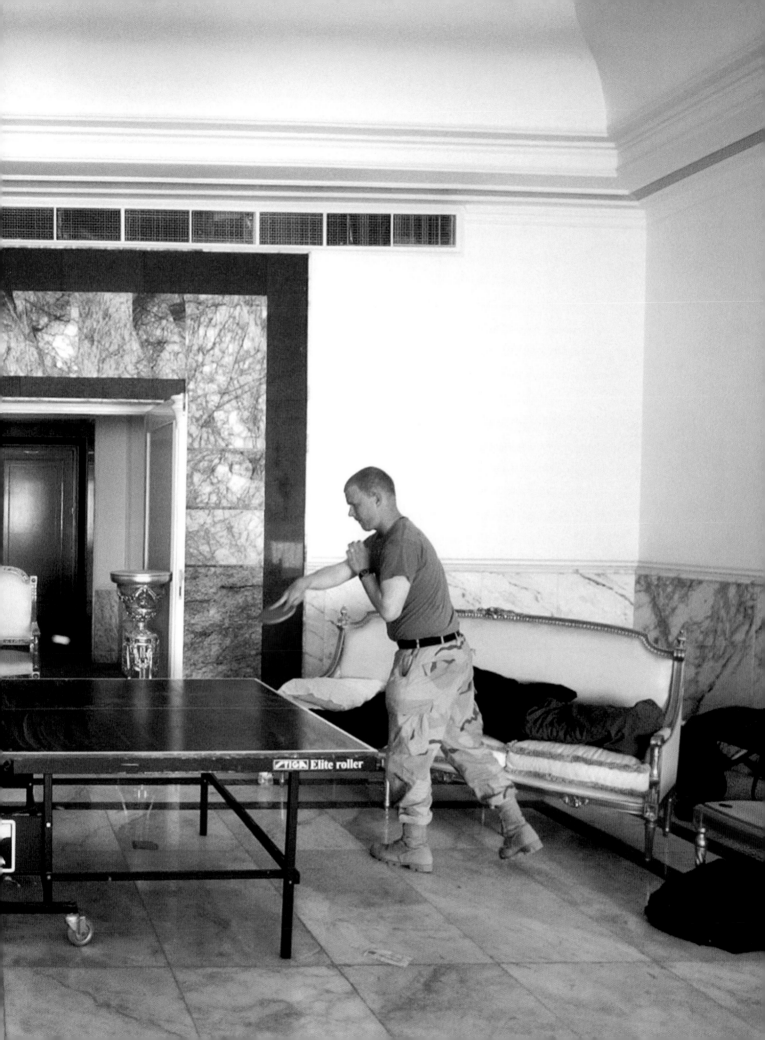

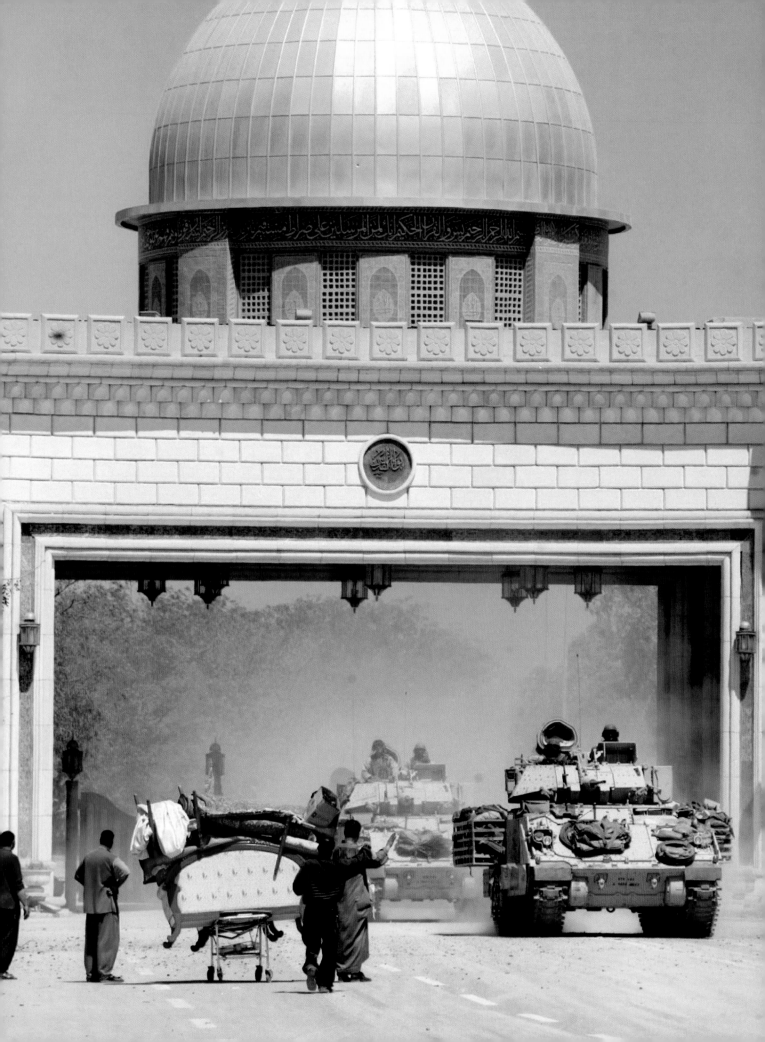

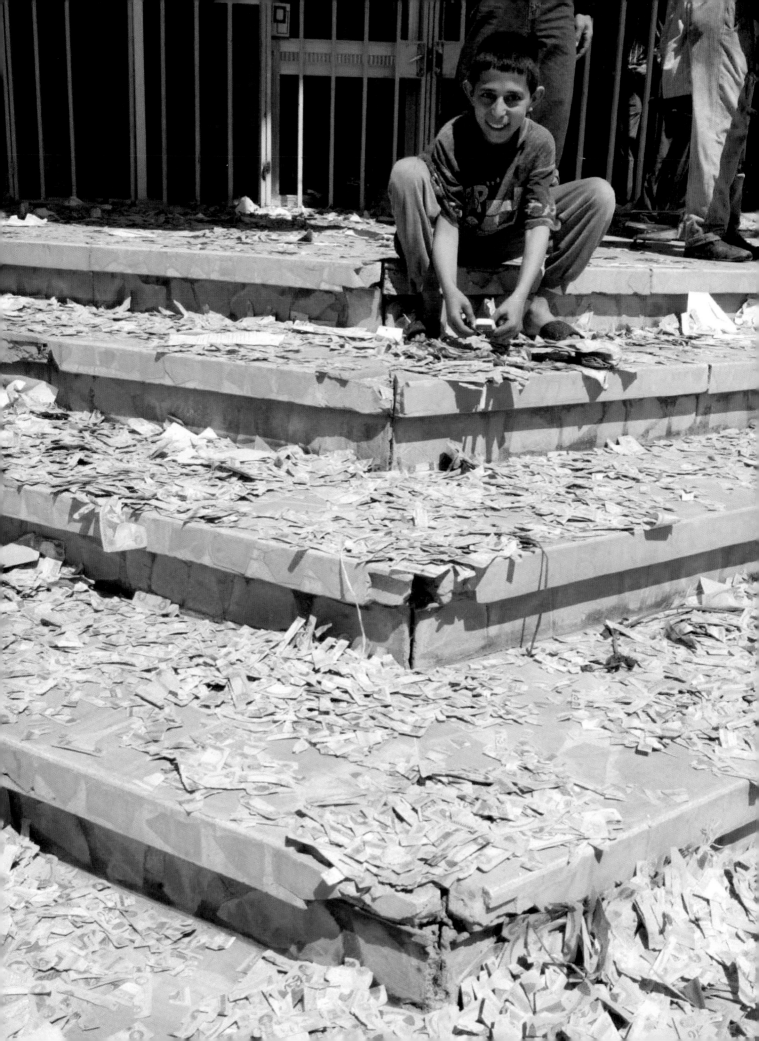

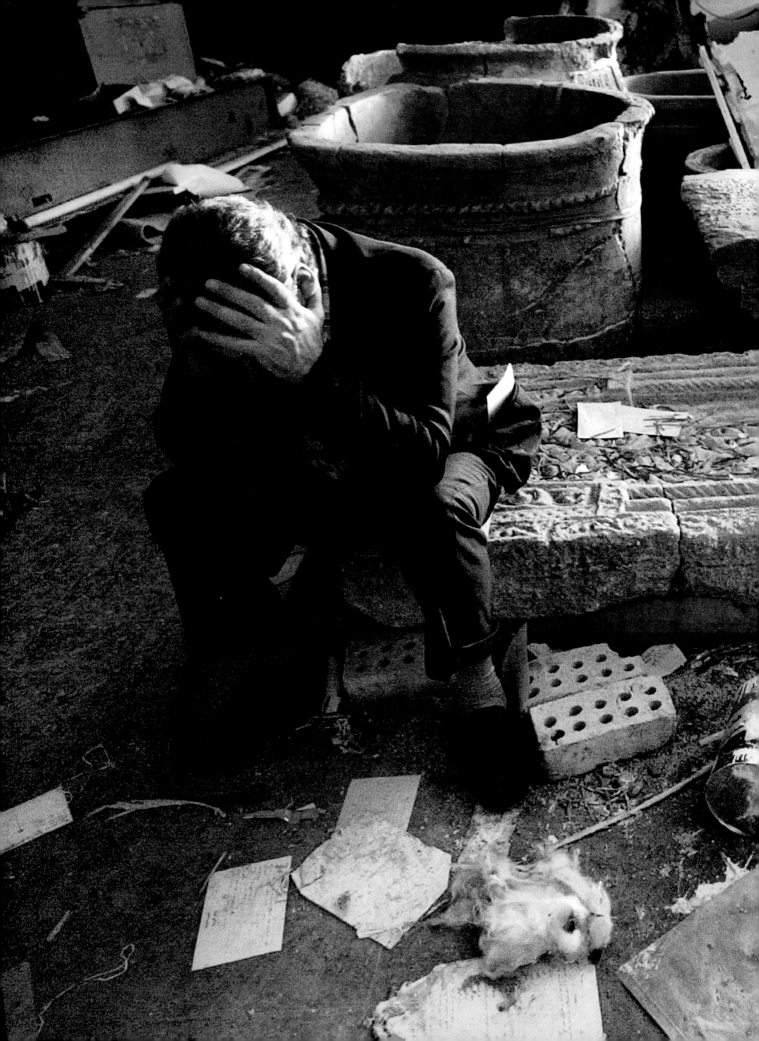

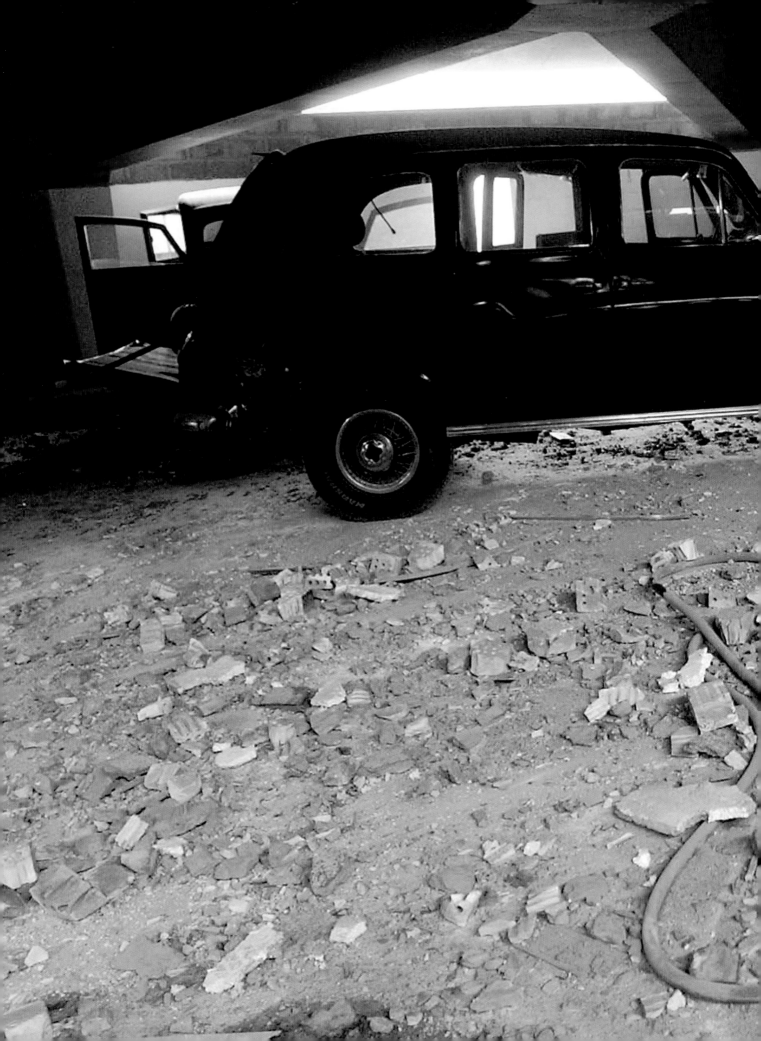

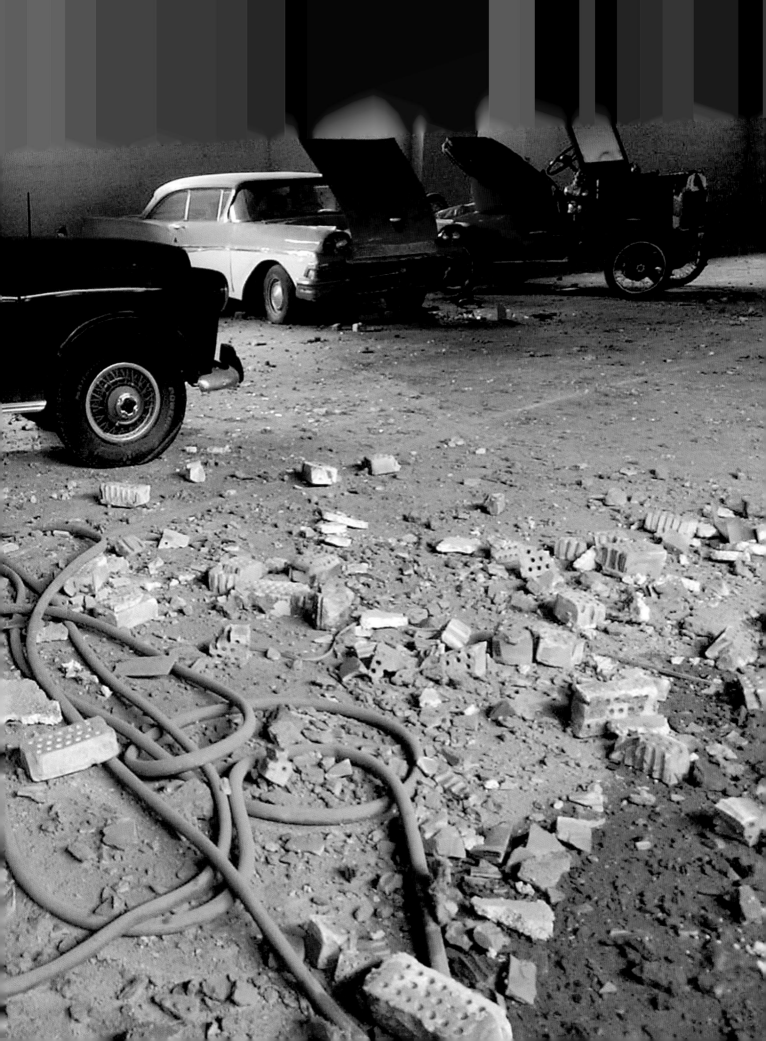

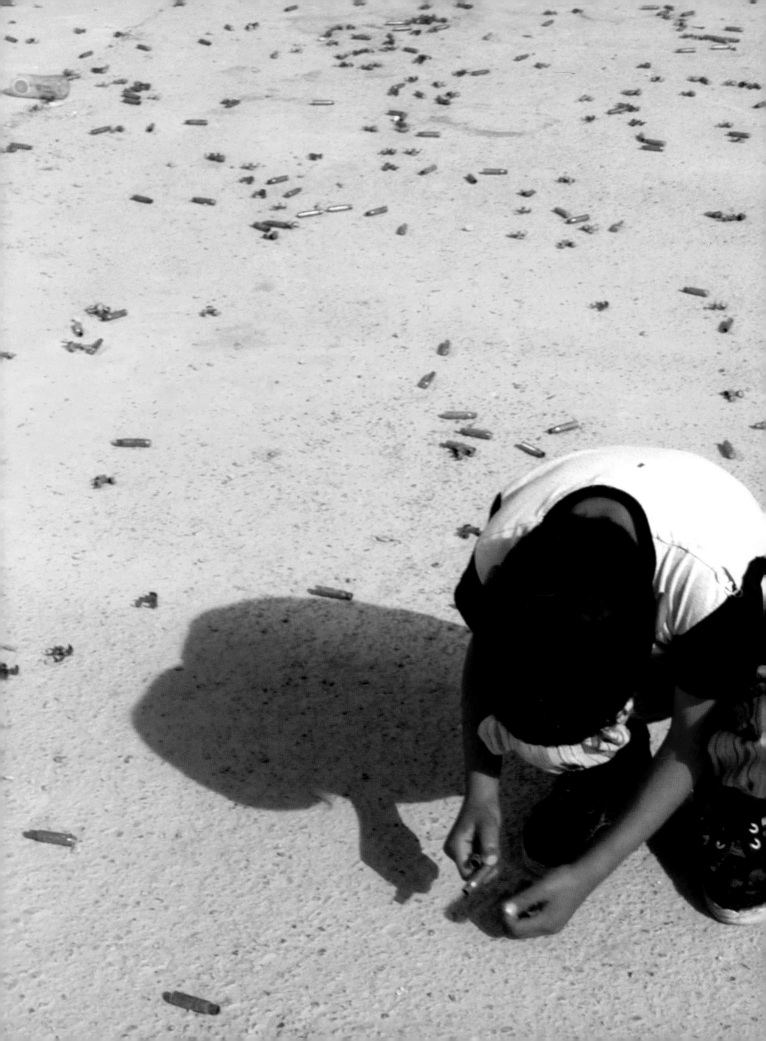

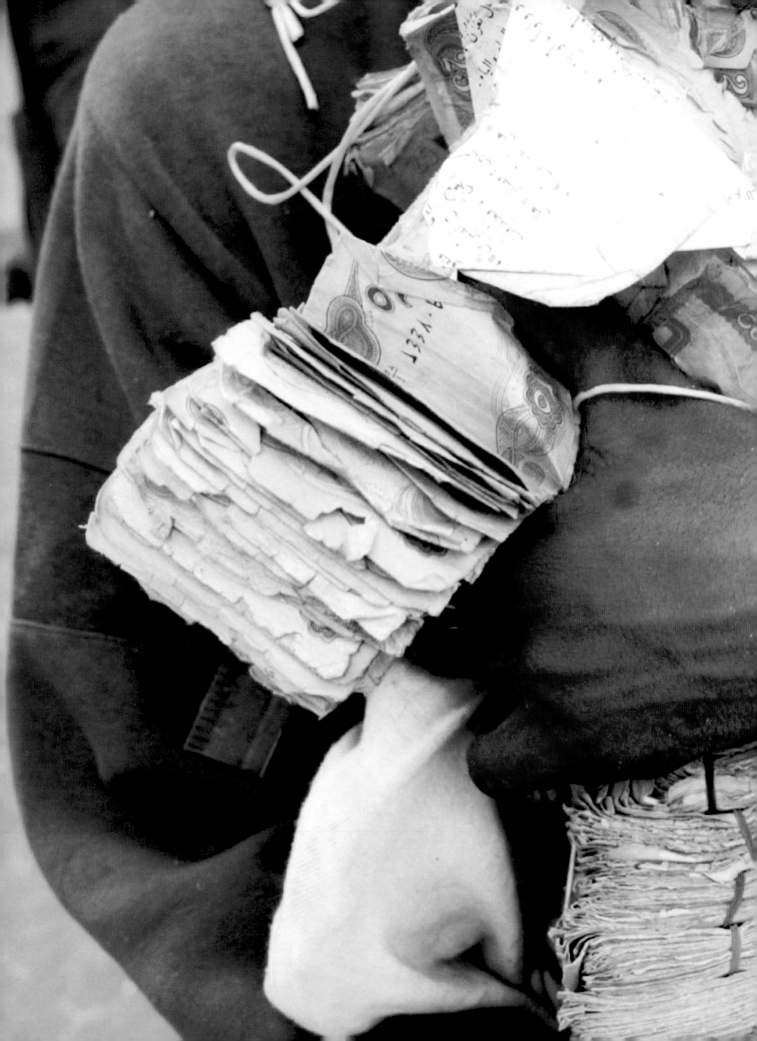

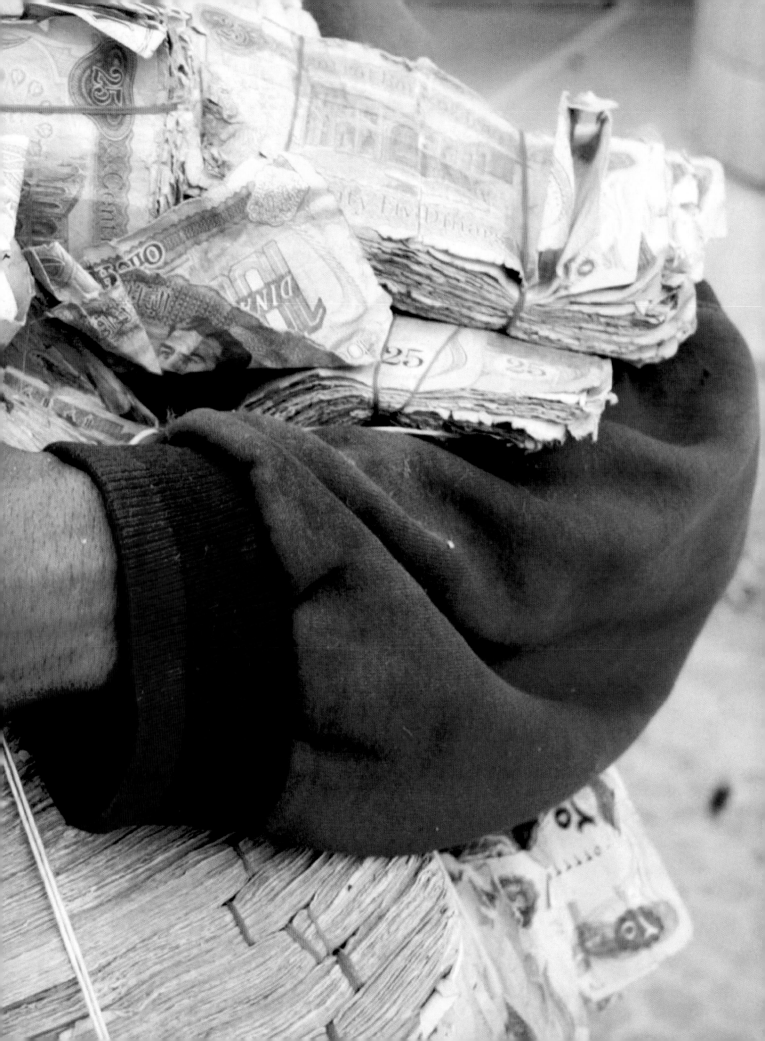

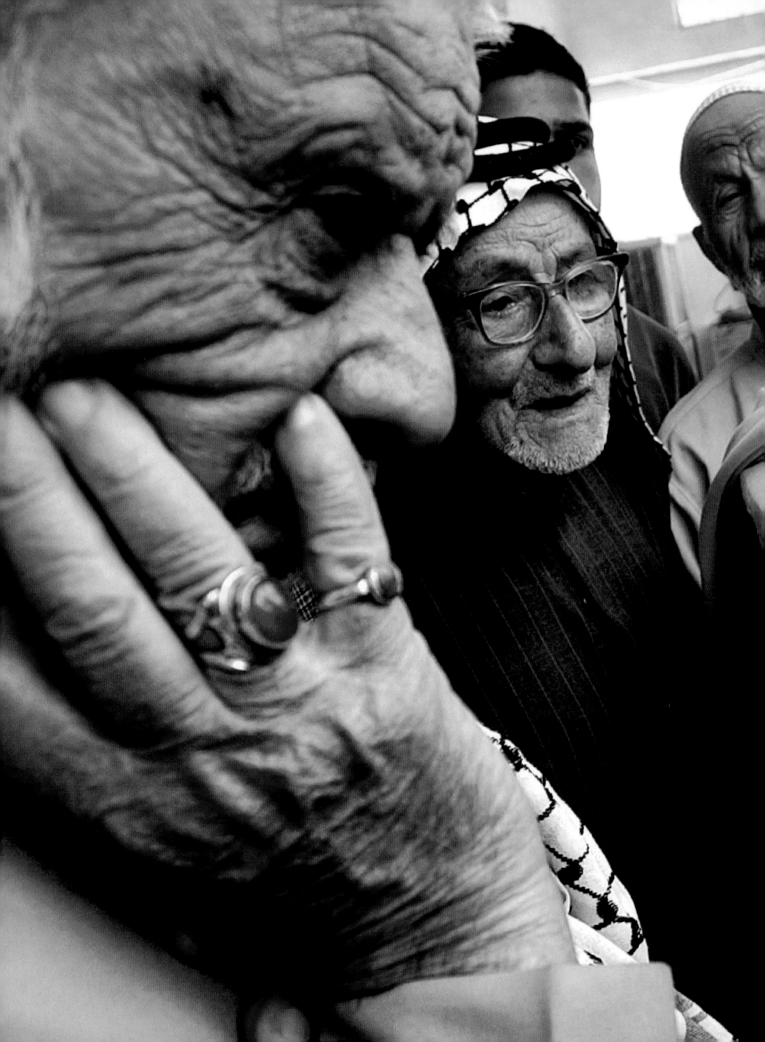

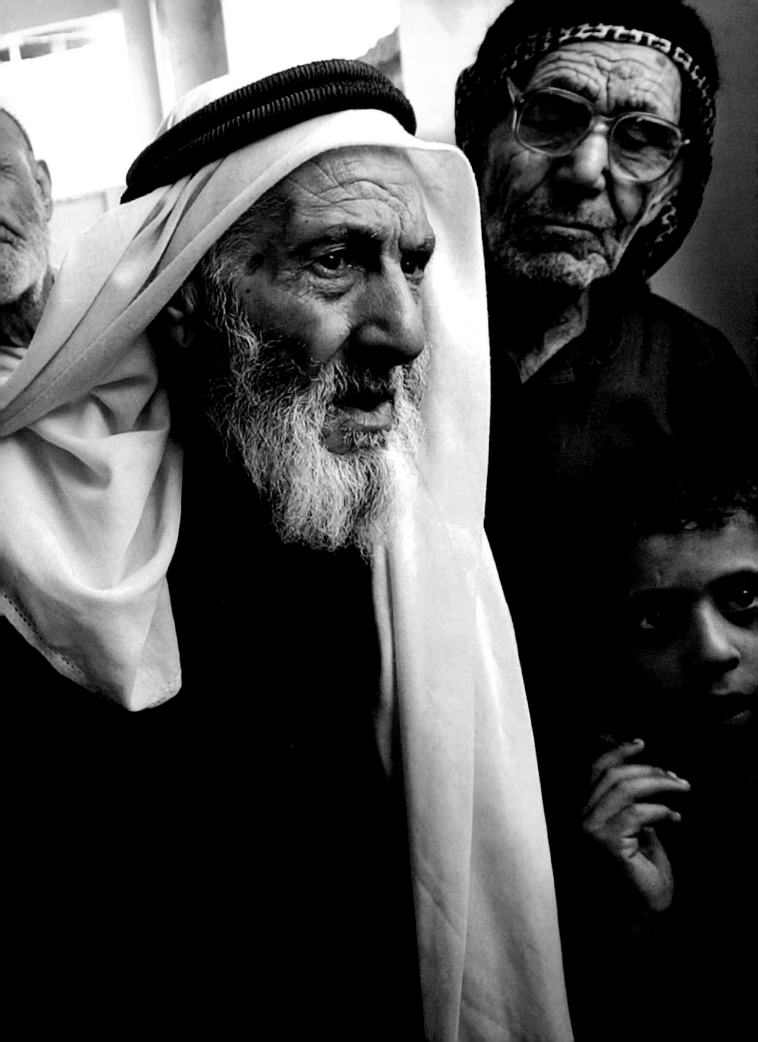

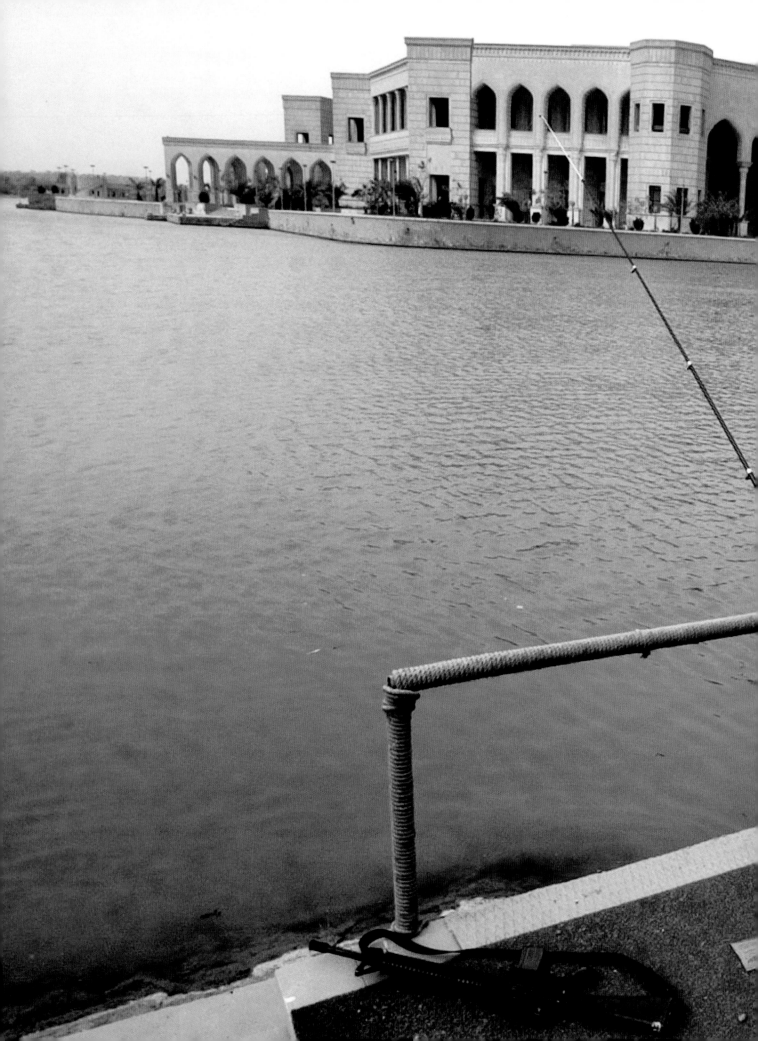

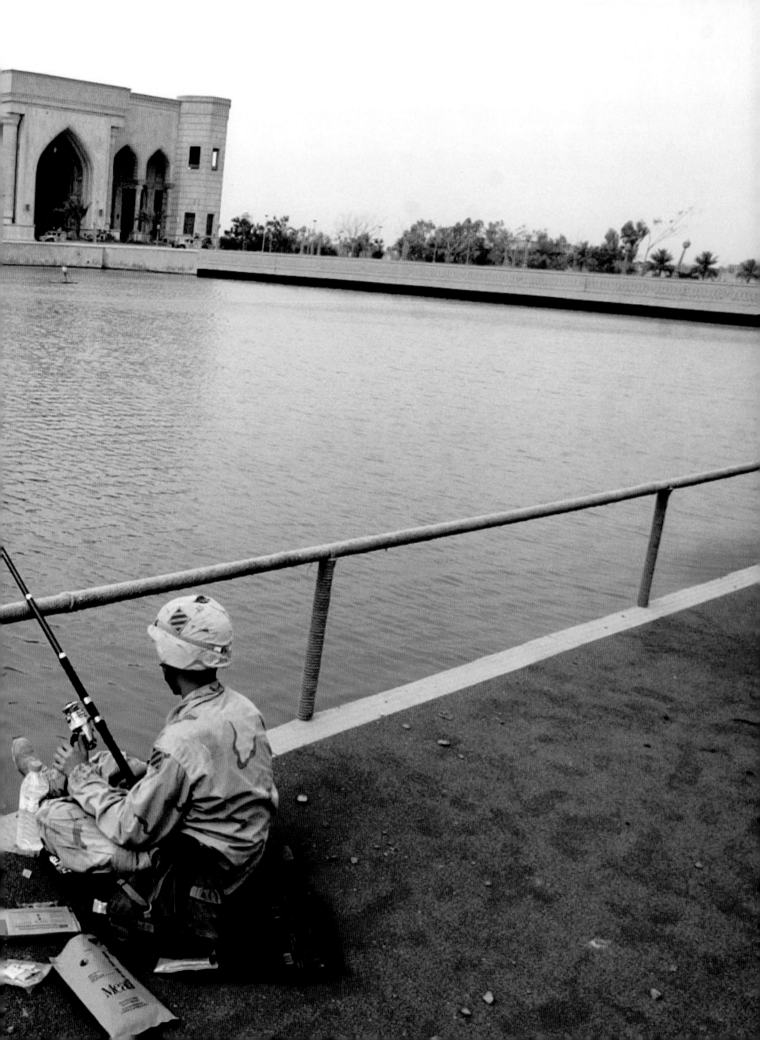

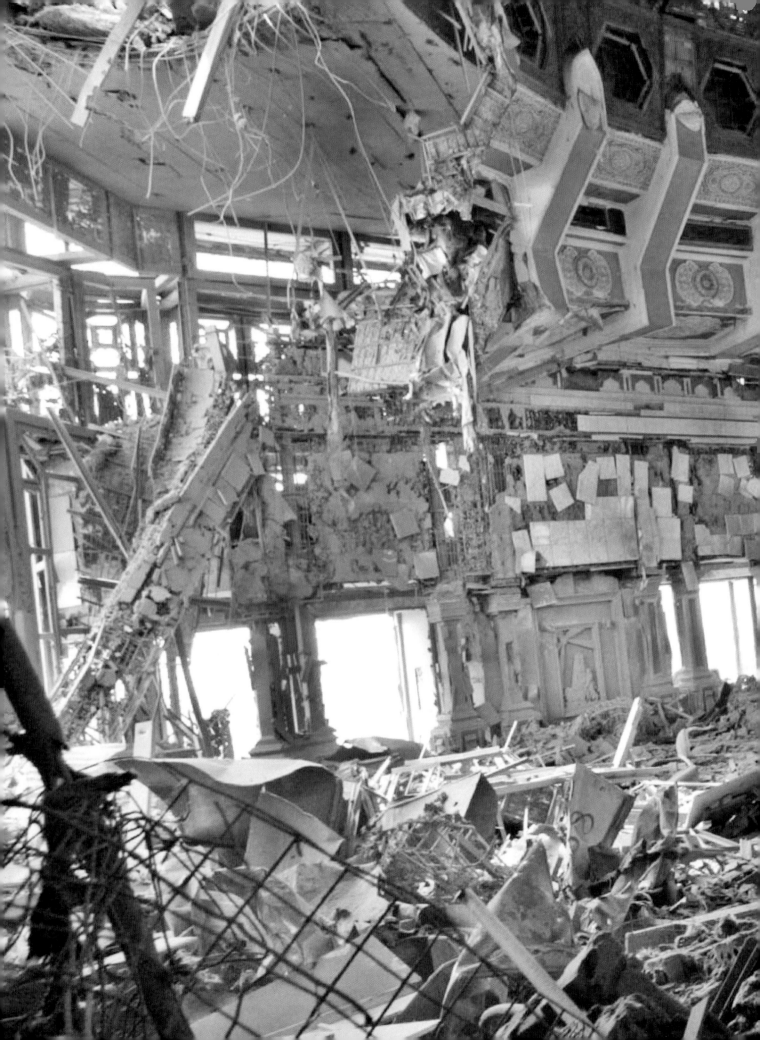

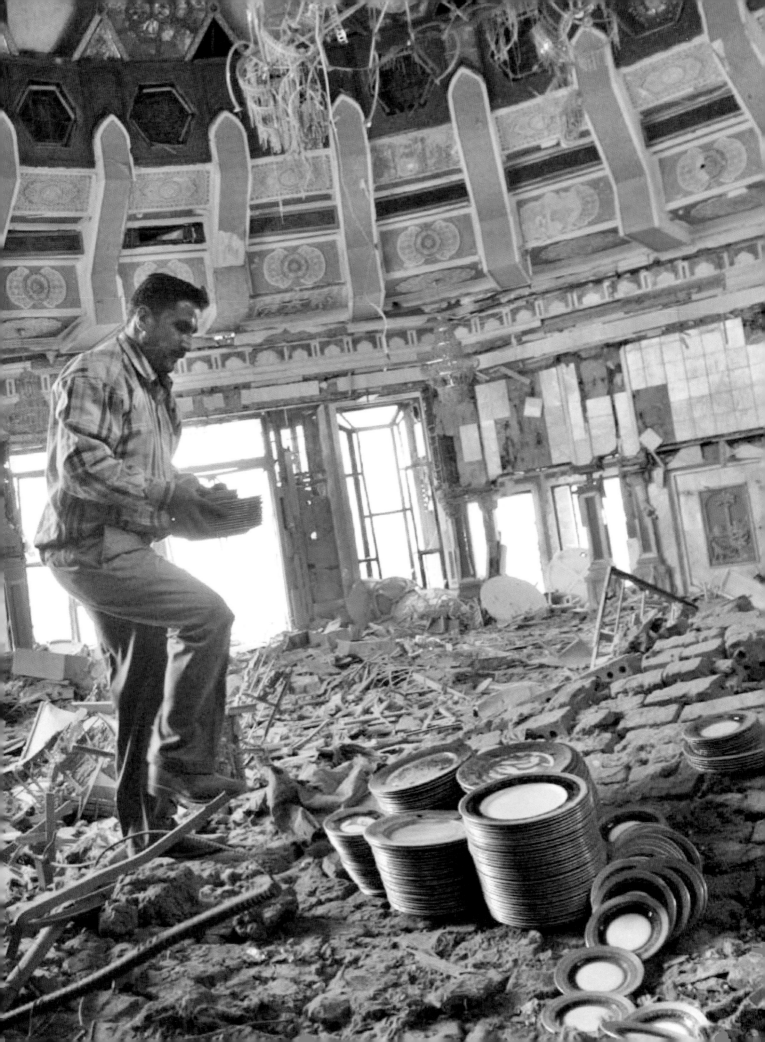

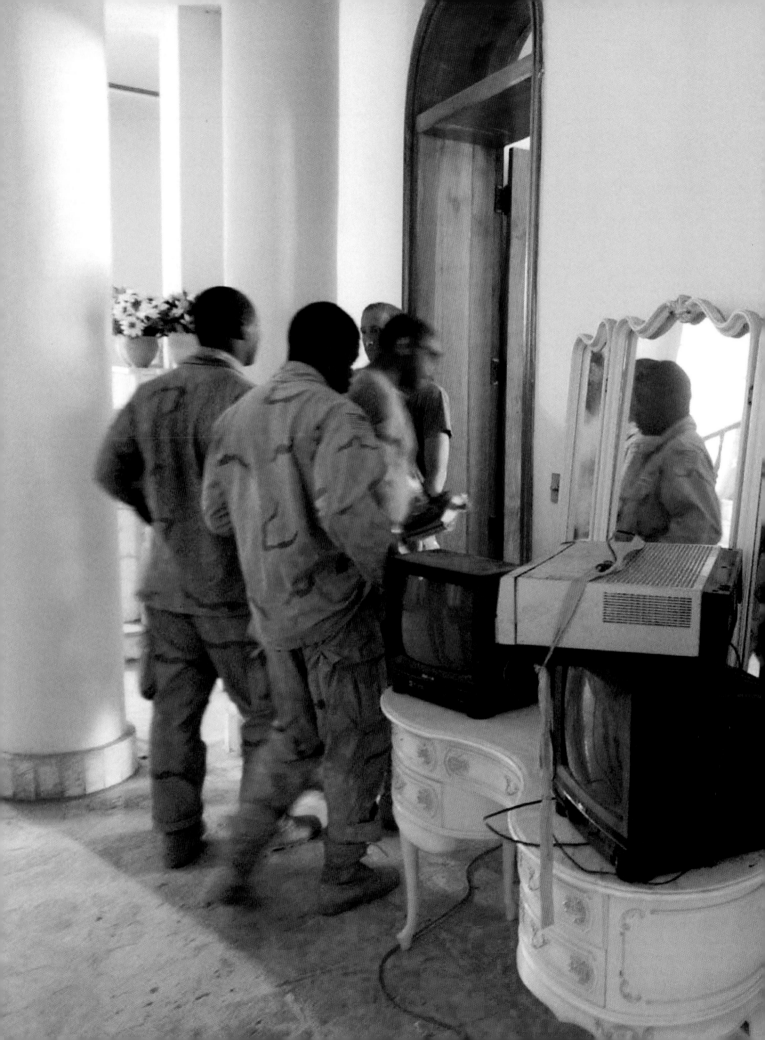

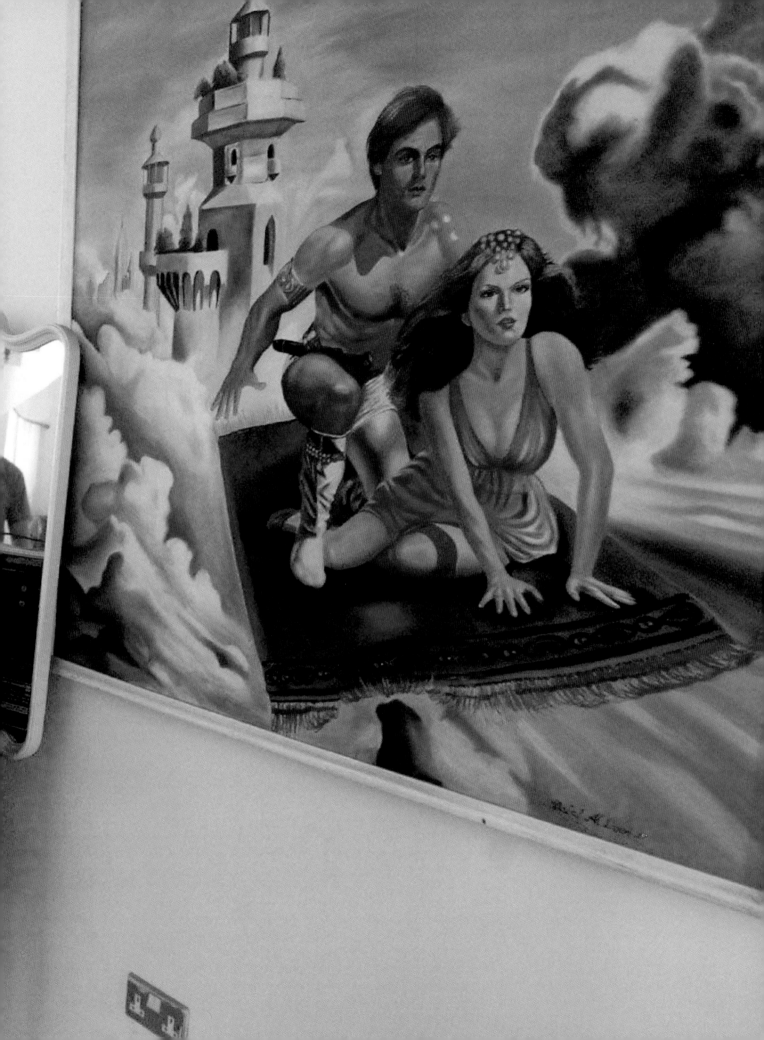

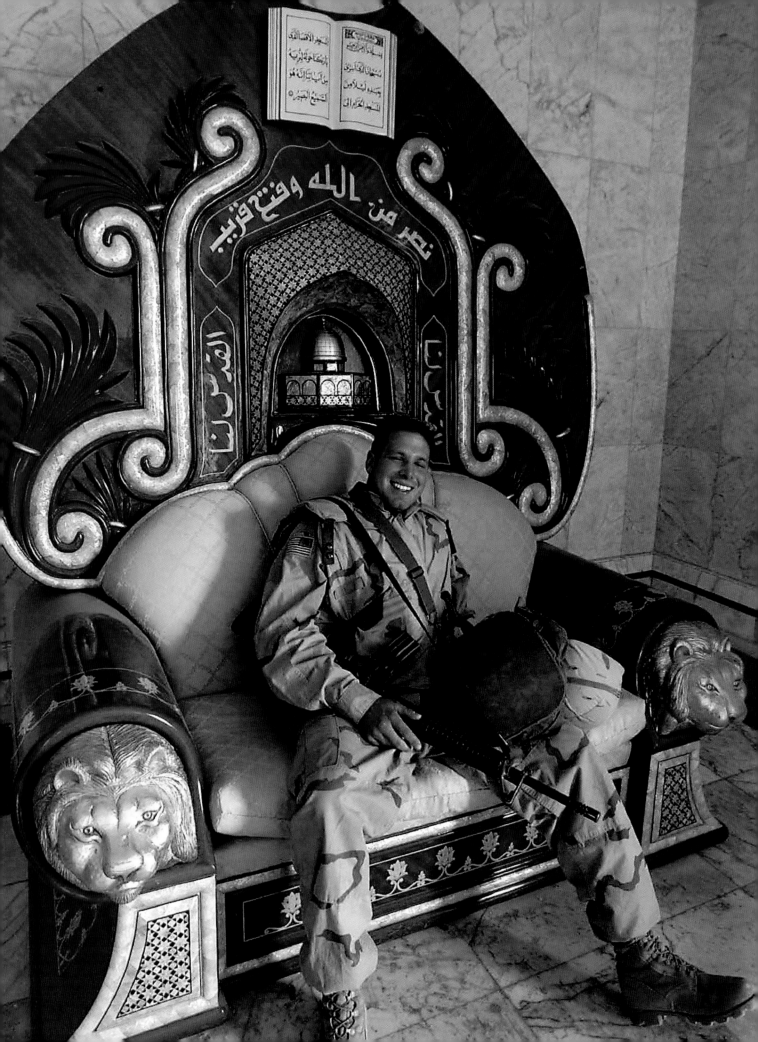

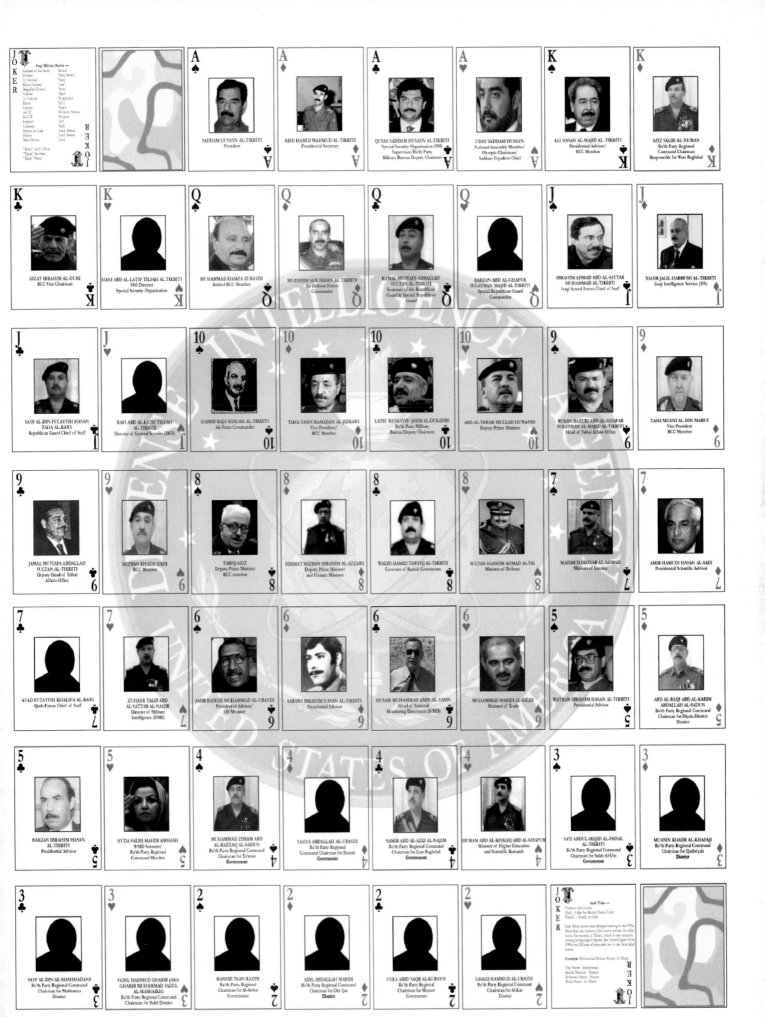

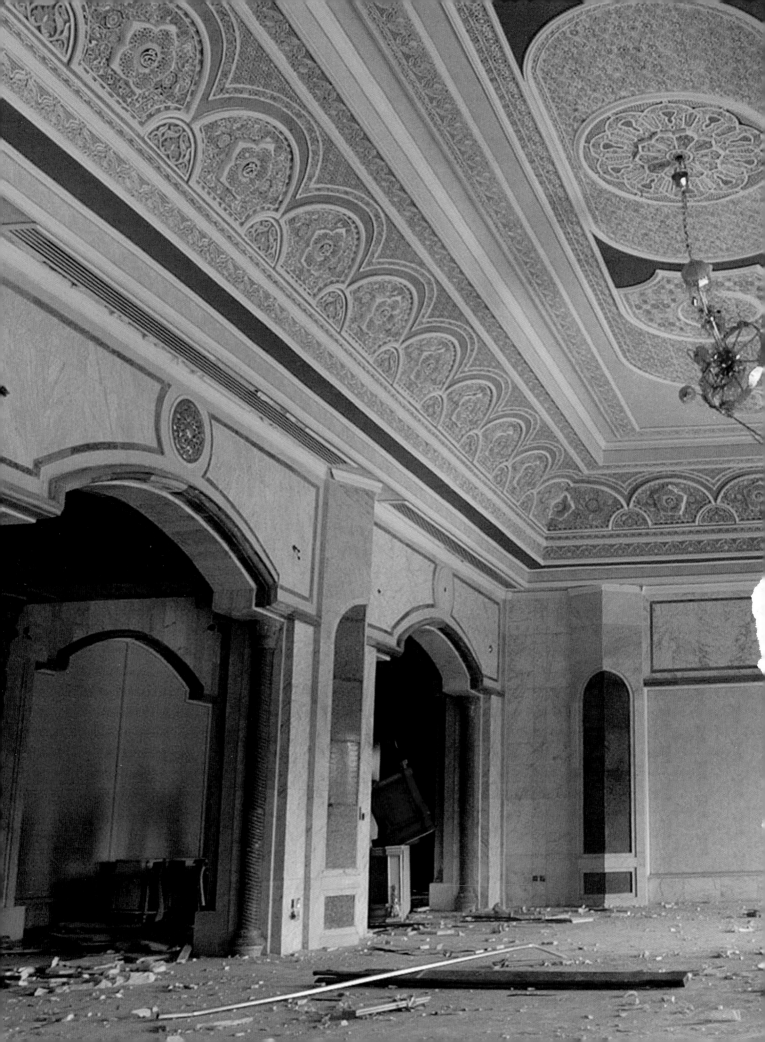

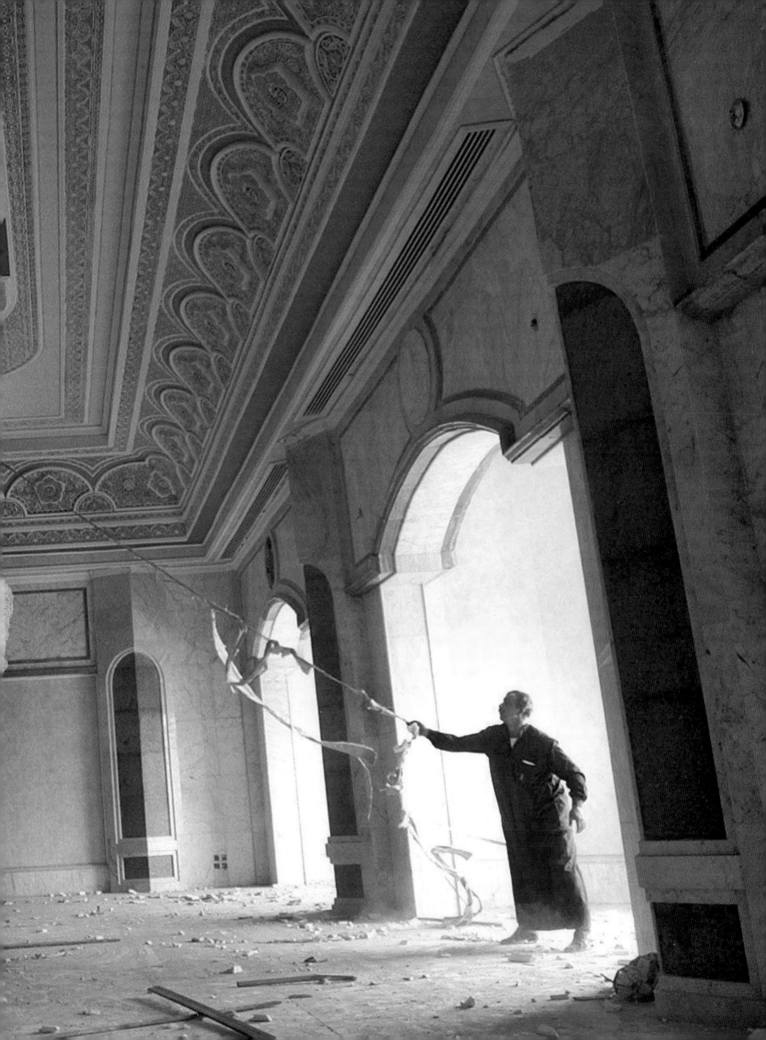

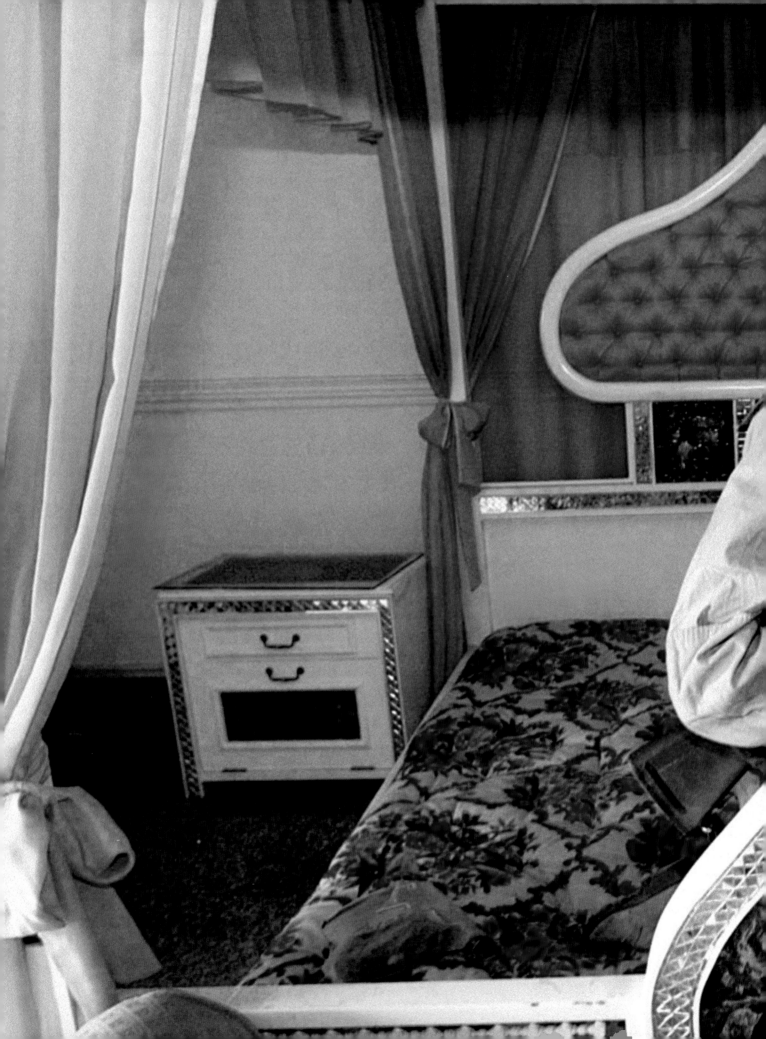

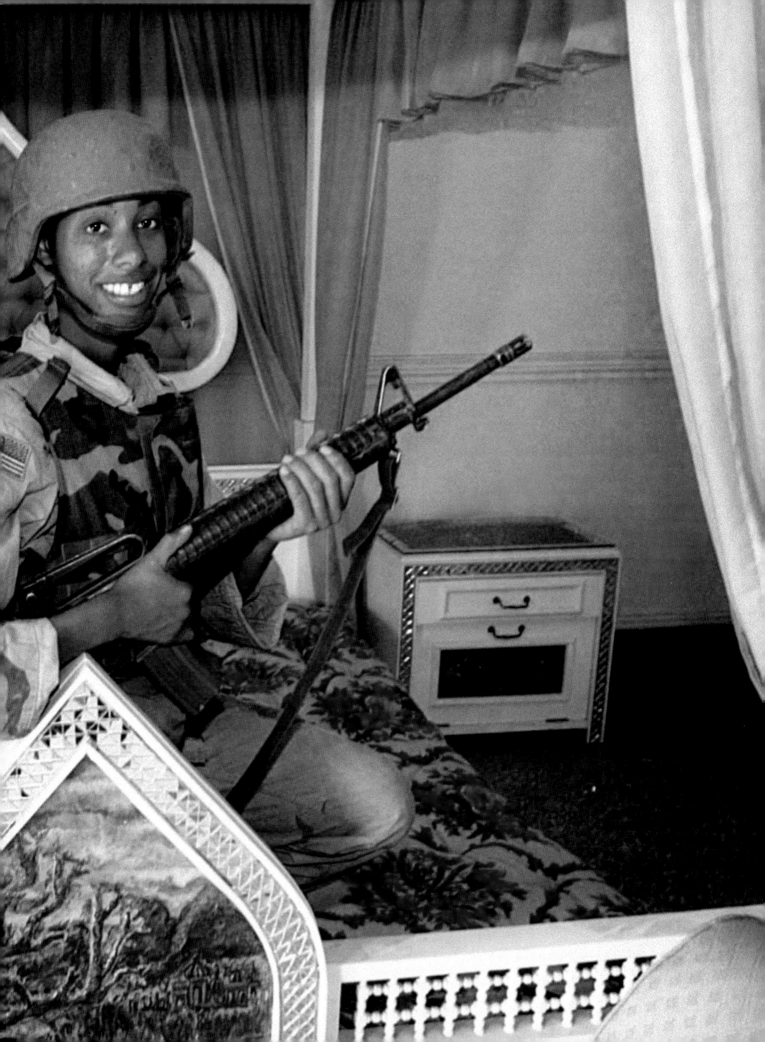

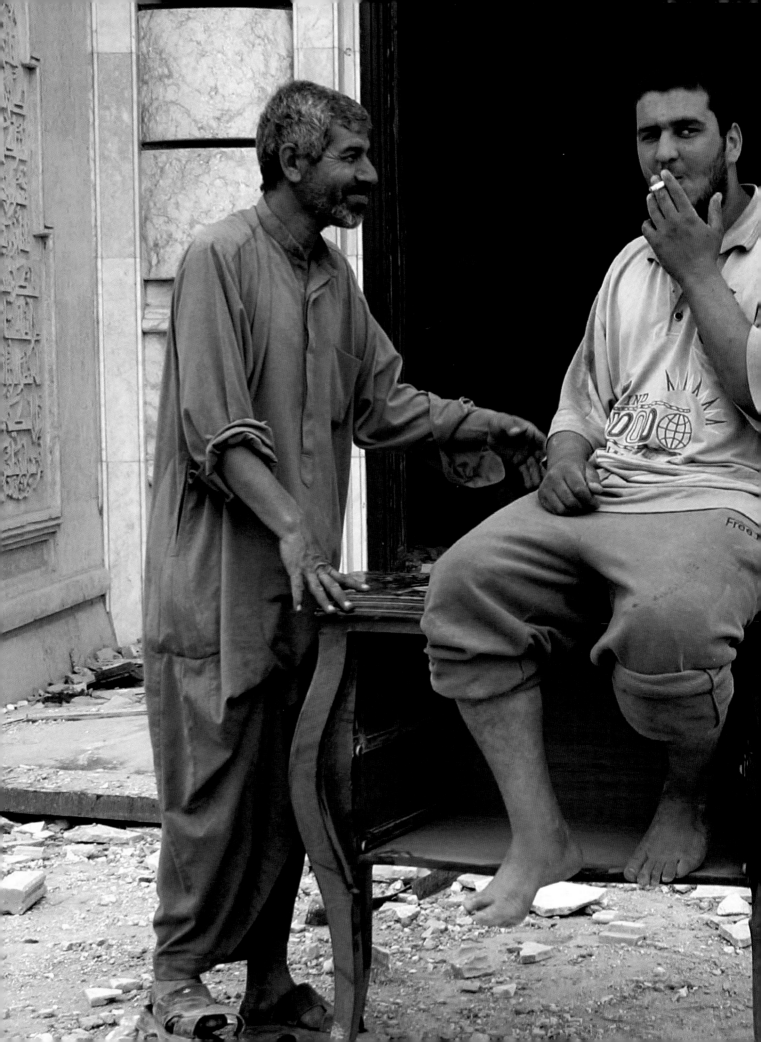

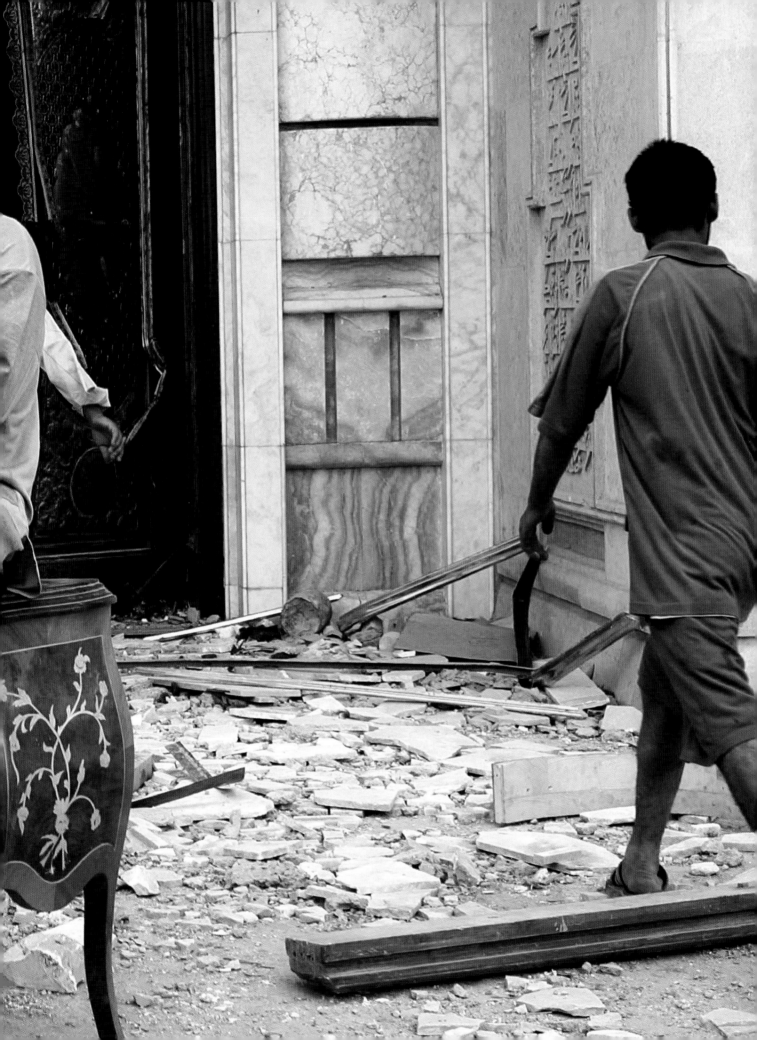

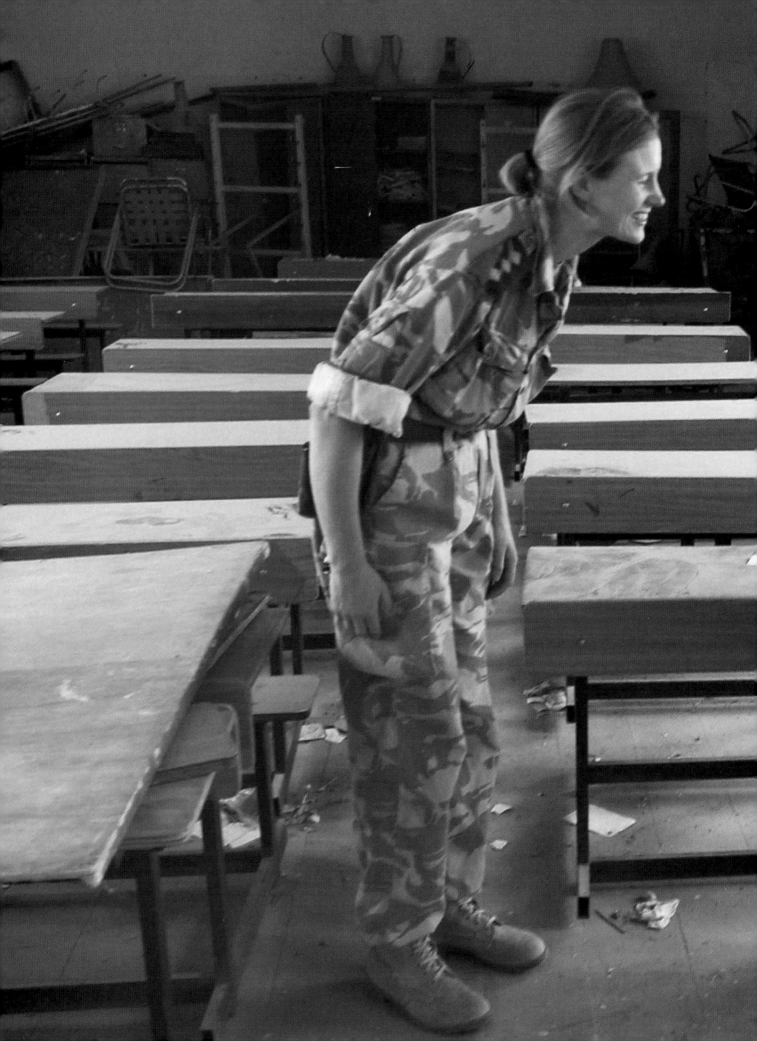

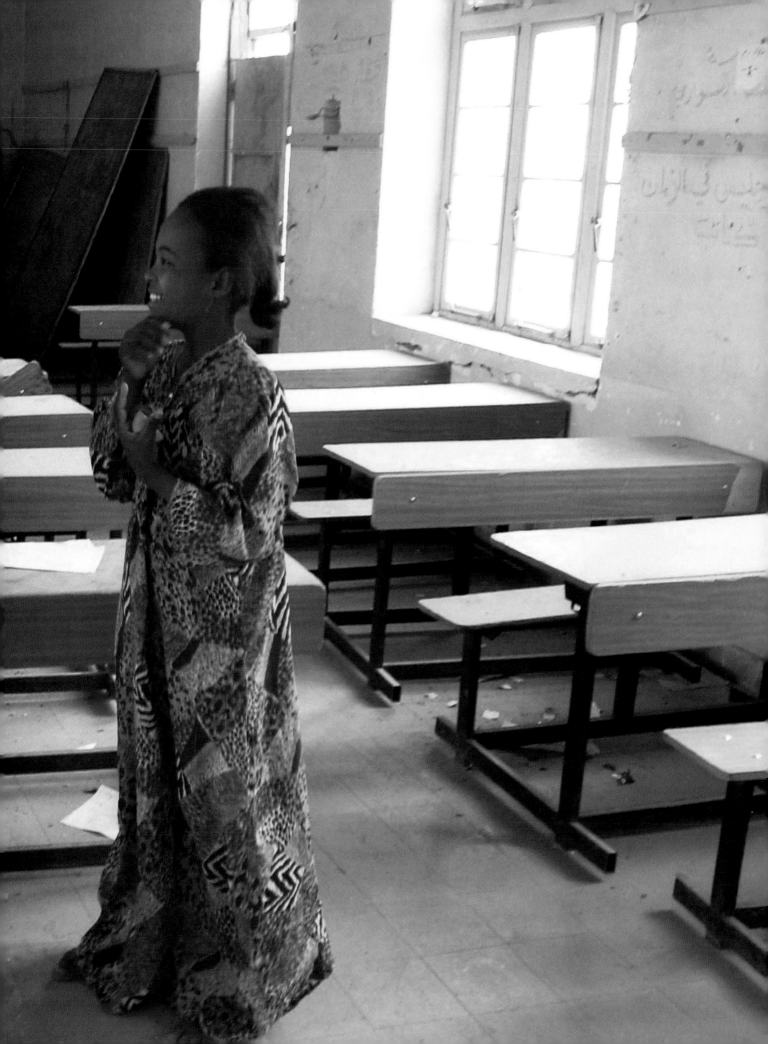

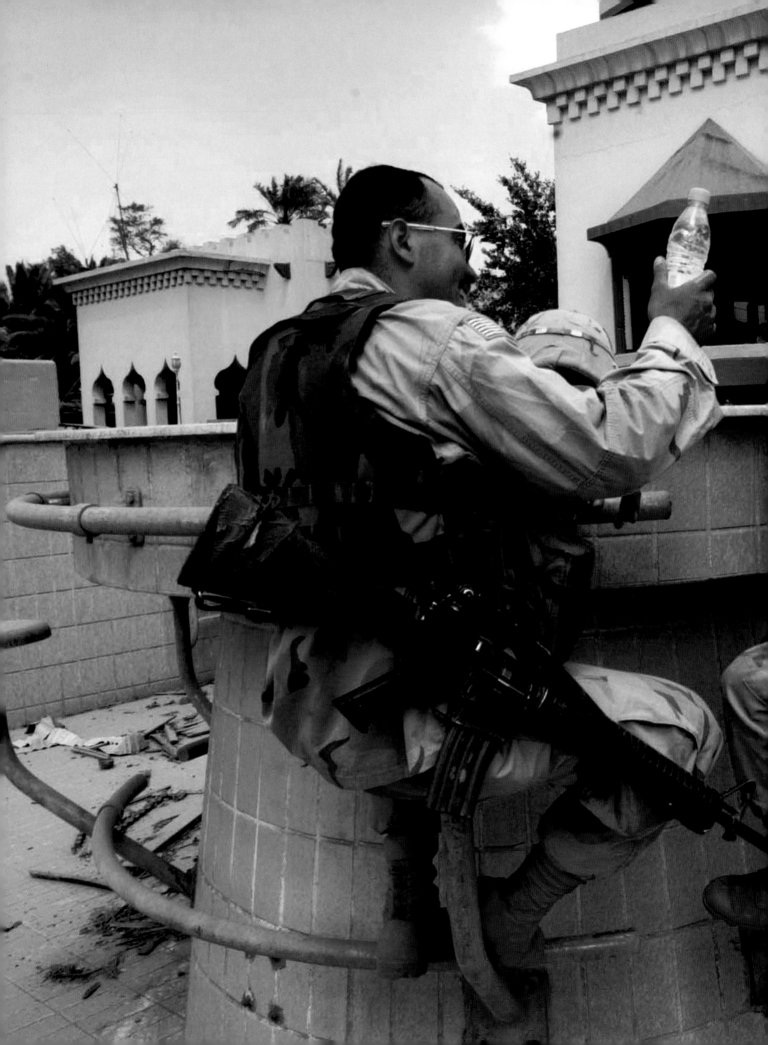

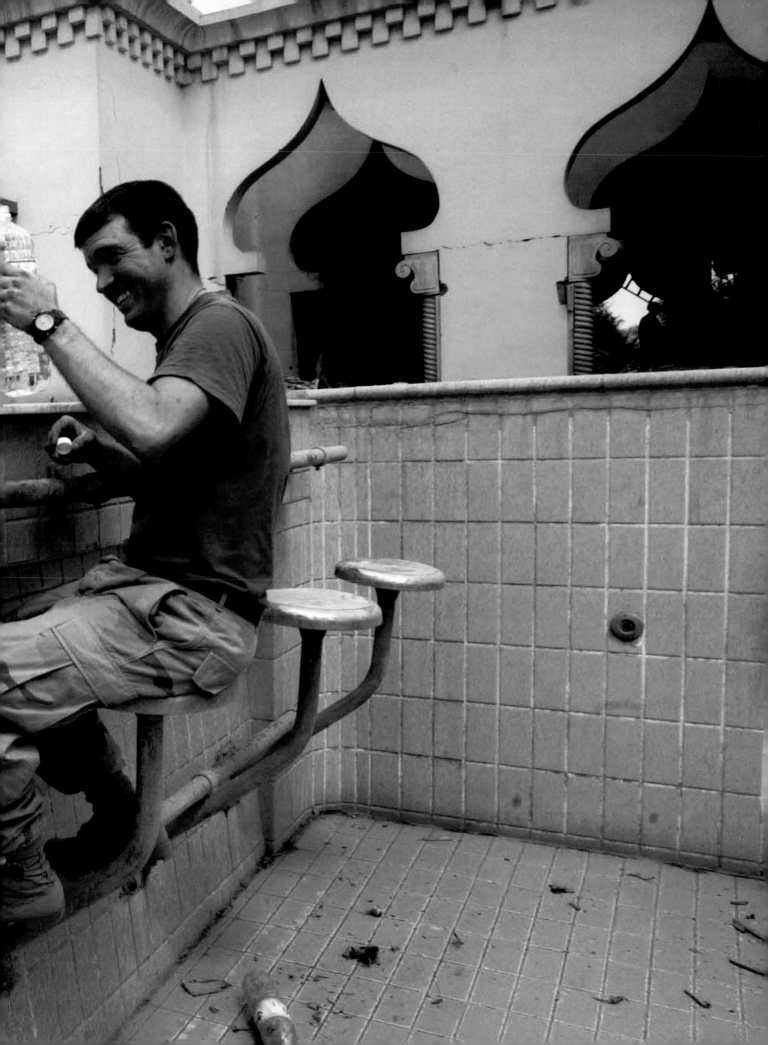

US MILITARY

Edgar Hernandez

Army Spc.
Joseph Hudson

Arm
Shoshaw

RAQ WAR POW

Spc.
Johnson

Pfc. Patrick Miller

Sgt. James Riley

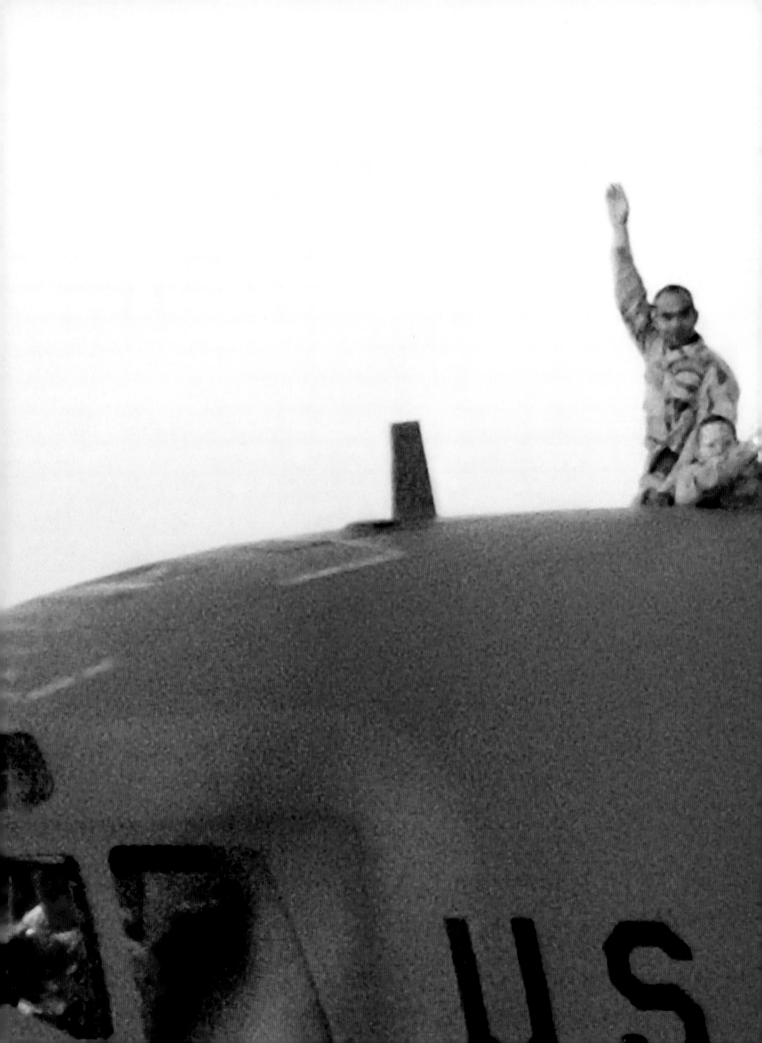

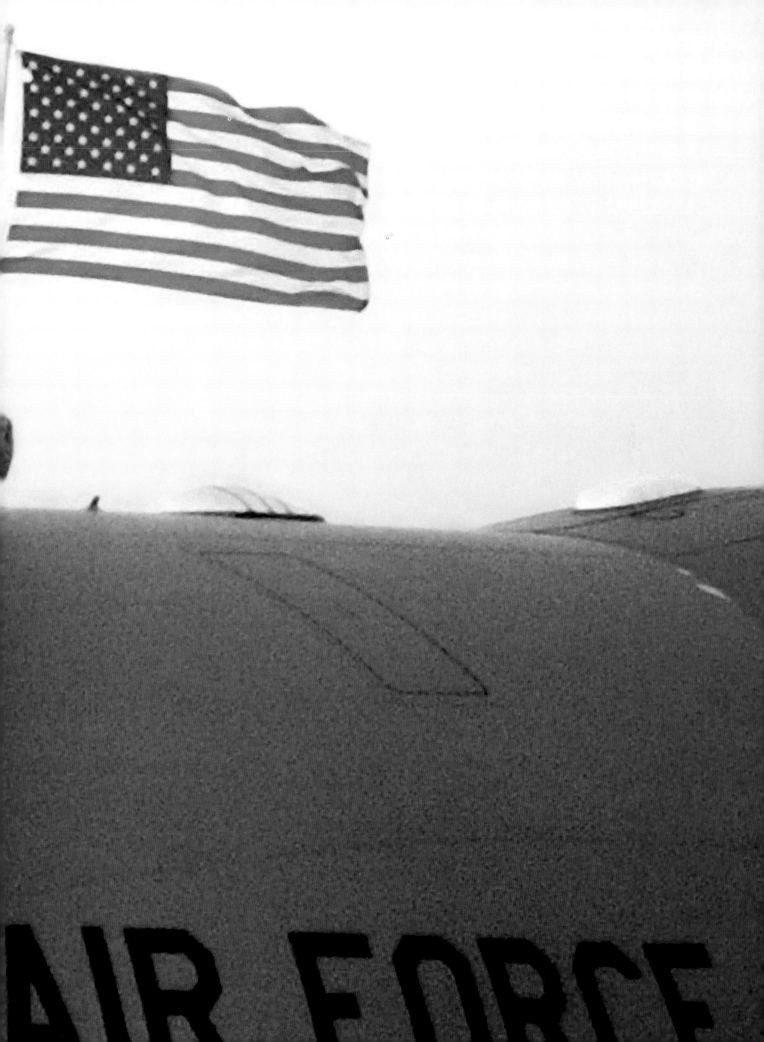

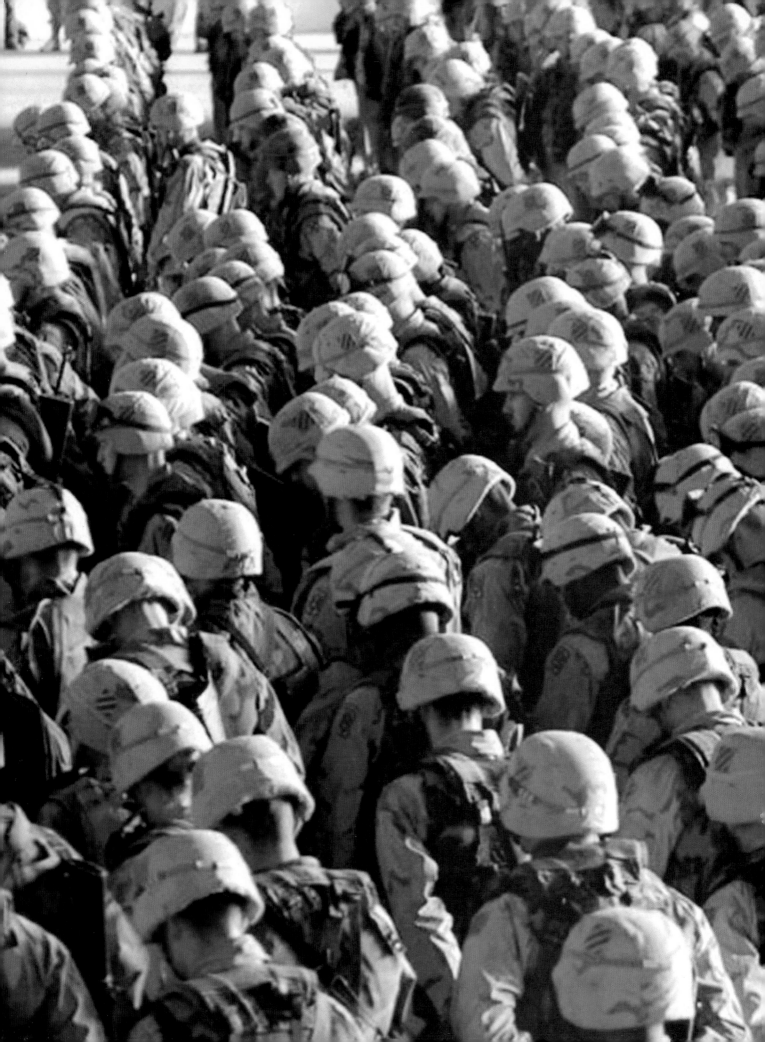

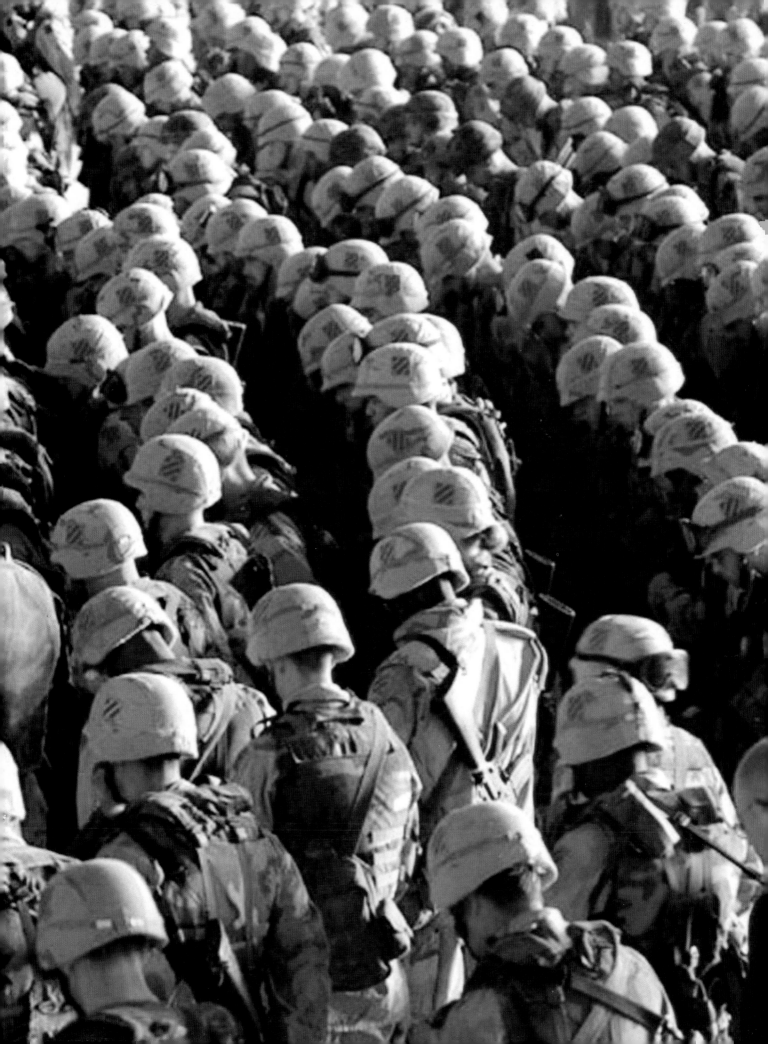

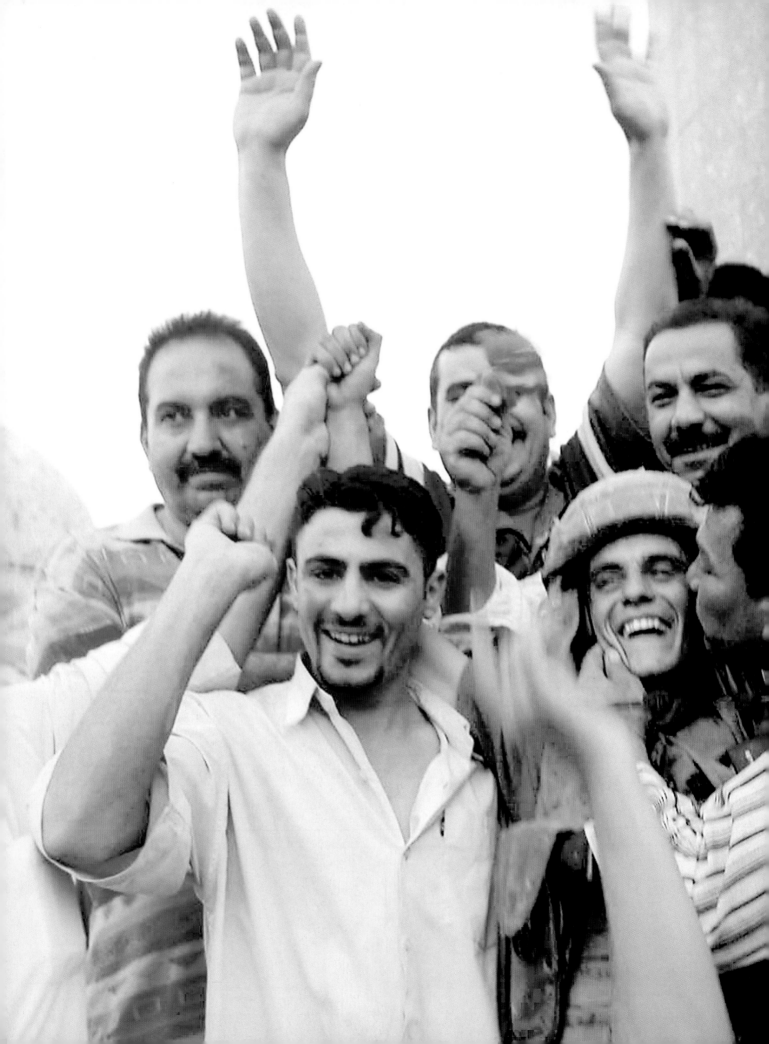

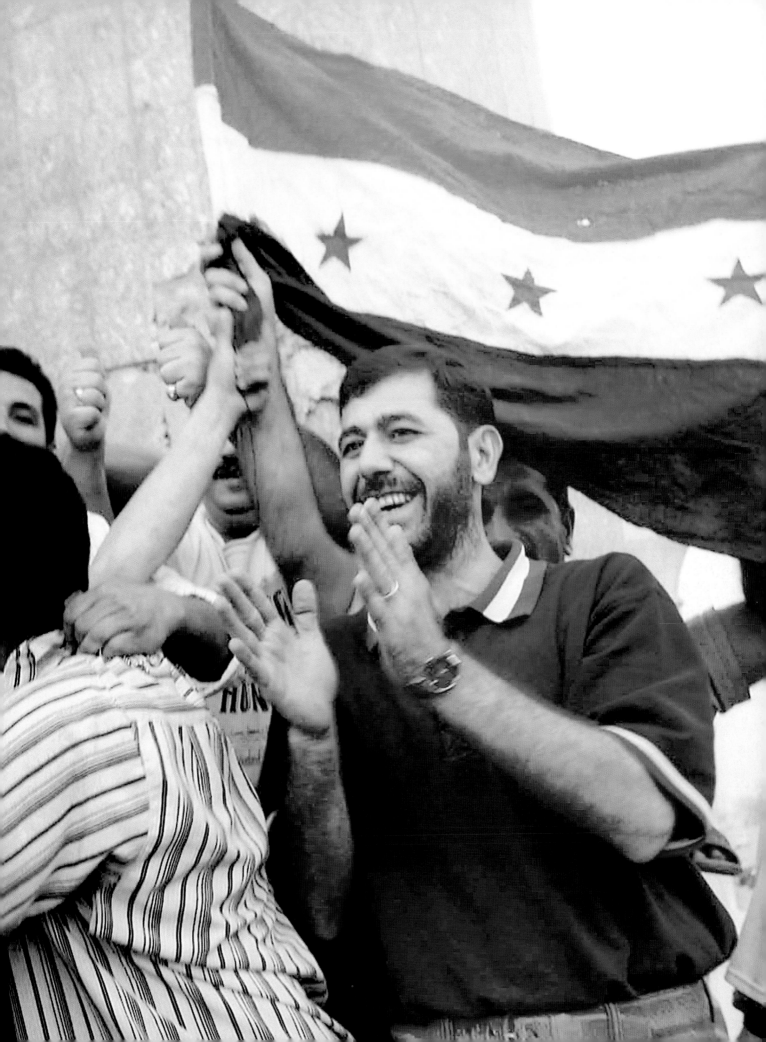

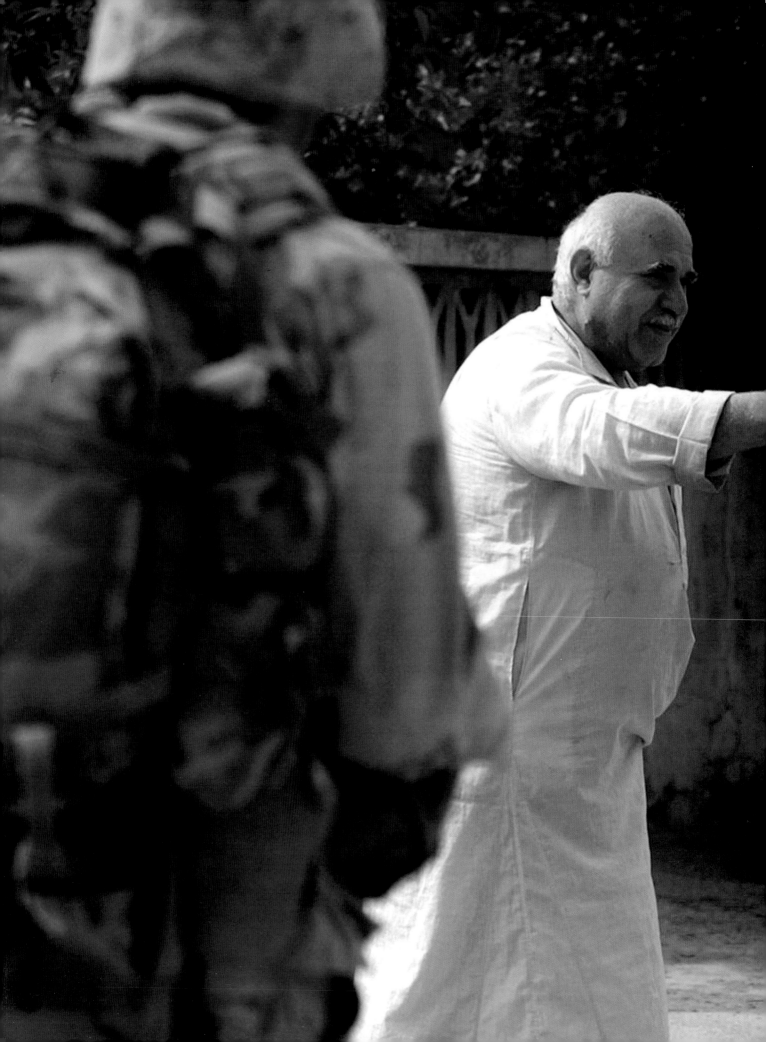

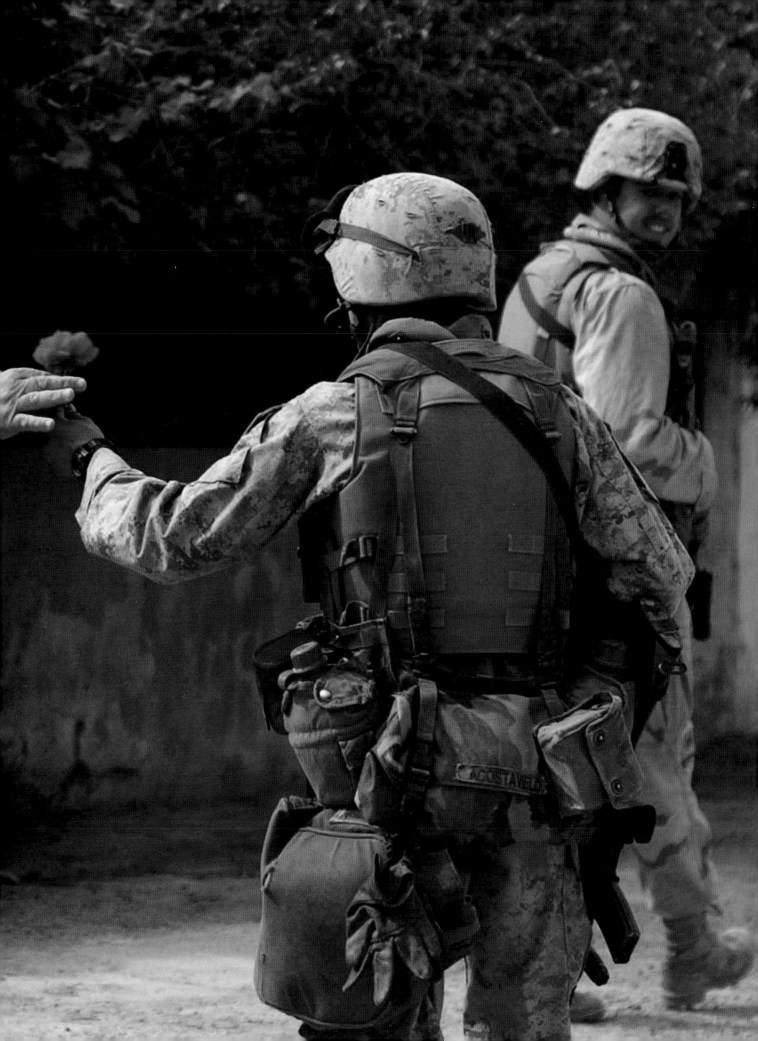

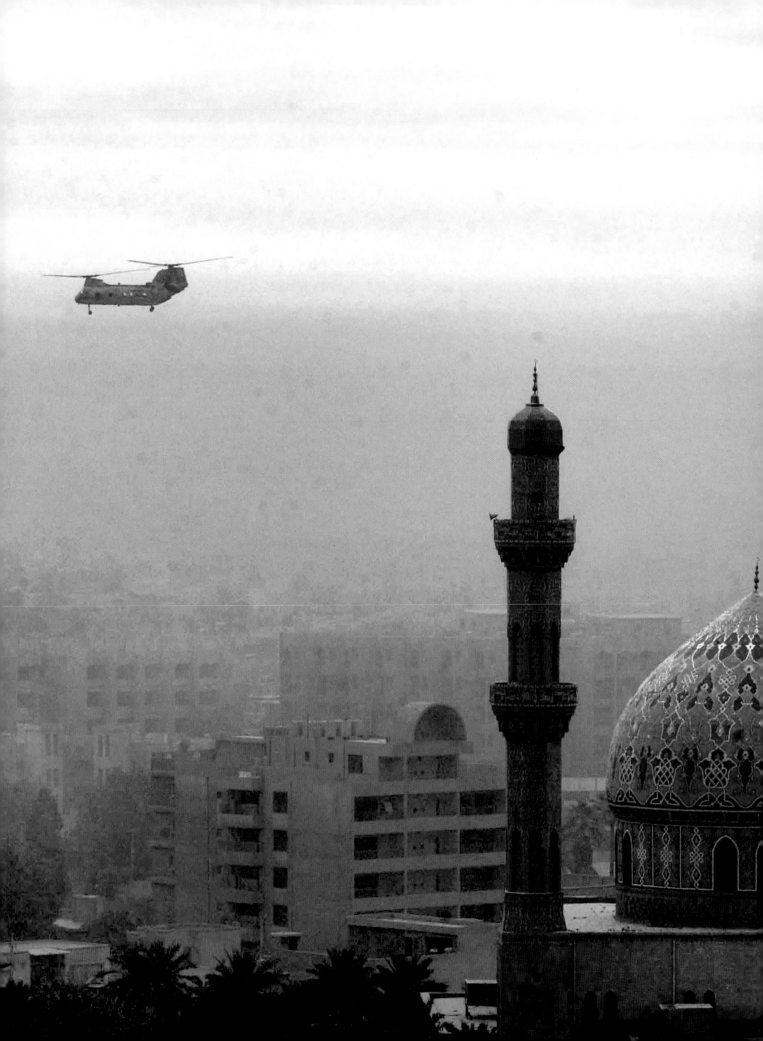

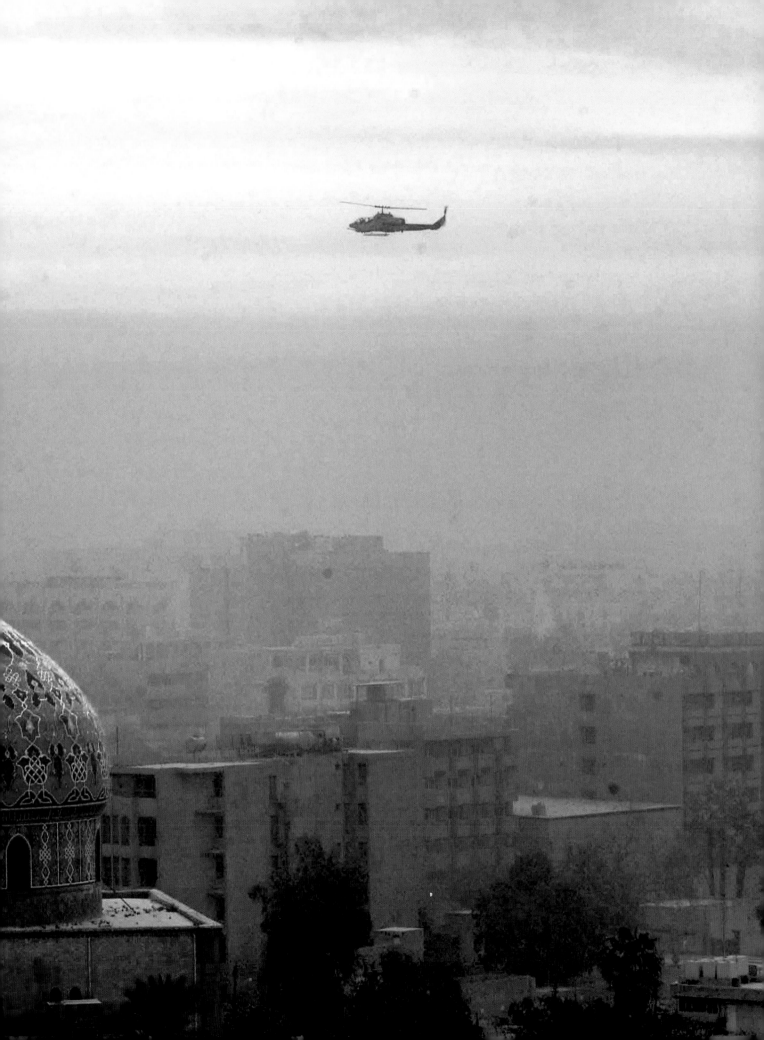

ii–iii. Camp Pennsylvania, Kuwait, March 15, 2003: A soldier with the 101st Airborne Division during a training operation.
Benjamin Lowy/Corbis

iv–v. USS Theodore Roosevelt, Eastern Mediterranean Sea, March 10, 2003: A fighter leaves the deck at sunset.
Findlay Kember/Polaris

vi–vii. Southern Iraqi desert, March 28, 2003: Marines from the 3rd Battalion hold their positions on the road to Baghdad.
Kuni Takahashi/*Boston Herald*/ReflexNews

viii–ix. Southern Iraqi desert, March 22, 2003: A Marine takes cover as Iraqis fire flares into the early morning sky.
Kuni Takahashi/*Boston Herald*/ReflexNews

THE ROAD TO WAR

2–3. Najaf, Iraq, April 7, 2003: General Tommy Franks (left), commander of the U.S. forces in Iraq, addresses soldiers from the 101st Airborne Division.
Benjamin Lowy/Corbis

4–5. Washington, D.C., October 16, 2002: President George W. Bush signs the congressional resolution authorizing use of force against Iraq.
Chris Corder/UPI Photo Service

6–7. Baghdad, September 16, 2002: Civilians walk past a mural of Iraqi president Saddam Hussein on horseback.
Amr Nabil/AP Wide World Photos

8. New York, March 17, 2003: United Nations Secretary General Kofi Annan answers questions from the media.
Jason Szenes/Corbis Sygma

9. Baghdad, January 18, 2003: Iraqis protest the presence of United Nations weapons inspectors outside United Nations headquarters in the capital.
Hussein Malla/AP Wide World Photos

10. (top) Baghdad, October 2002: Saddam Hussein praised on Iraqi television.
Thomas Dworzak/Magnum Photos

10. (bottom) Baghdad, October 2002: Memorial commemorating the anniversary of a school being bombed on the outskirts of Baghdad during the Iran-Iraq war.
Thomas Dworzak/Magnum Photos

11. Baghdad, March 26, 2003: Outdoor market during a sandstorm.
Jerome Delay/AP Wide World Photos

12–13. Baghdad, February 20, 2003: Iraqi men in a café.
Bruno Stevens/Cosmos/Aurorqa

14–15. Lajes, Portugal, March 16, 2003: President George W. Bush at a press conference.
Lionel Cironneau/AP Wide World Photos

16–17. As Sayliyah Base, Qatar, December 12, 2002: Secretary of Defense Donald Rumsfeld (right) and General Tommy Franks address members of the U.S. military.
Karen Ballard/Corbis Sygma

18. New York, February 5, 2003: U.S. Secretary of State Colin Powell holds a vial that he described as one that could contain anthrax during his presentation on Iraq to the United Nations Security Council.
UN/DPI photo by Mark Garten/Corbis Sygma

19. New York, February 5, 2003: Iraqi Ambassador to the United Nations Mohammed Al-Duri reacts to Secretary Powell's presentation to the United Nations.
Lorenzo Ciniglio/Corbis Sygma

20–21. Washington, D.C., February 5, 2003: President George W. Bush watches the broadcast of Secretary Powell's presentation to the United Nations.
Eric Draper/White House Photo/Corbis Sygma

22–23. USS Abraham Lincoln, Arabian Sea, February 12, 2003: A Navy flight deck attendant preps an E-2C Hawkeye for takeoff.
Adam Butler/AP Wide World Photos

24–25. Fayetteville, North Carolina, February 13, 2003: Brigade General Abe Turner addresses members of the 82nd Airborne, 2nd Brigade Combat Team, before deployment to Kuwait.
Ellen Ozier/Reuters

26. Baghdad, date unknown: Muslim volunteer prepares to fight.
Markus Matzel/Black Star

27. Baghdad, date unknown: Iraqi forces prepare to fight.
Markus Matzel/Black Star

28. USS Abraham Lincoln, February 21, 2003: Flight crew members talk as an F-14 Tomcat takes off.
Leila Gorchev/AP Wide World Photos

29. Baghdad, July 12, 2001: Young militia volunteers.
Karim Mohsen/Getty Images

30–31. Kuwaiti desert, December 20, 2002: U.S. military vehicles take part in exercises.
Anja Niedringhaus/AP Wide World Photos

32. Baghdad, March 5, 2003: Iraqi soldiers brandish weapons at a military parade.
Naim Assaker/Corbis

33. Killeen, Texas, March 27, 2003: Soldiers with the U.S. Army 4th Infantry Division say good-bye to friends and family before deployment to Iraq.
Brad Loper/*Dallas Morning News*/Corbis

34. USS Abraham Lincoln, Arabian Sea, March 21, 2003: Skids of ordnance wait in the hangar bay to be transferred to the flight deck.
Jason Frost/AP Wide World Photos

35. Fort Campbell, Kentucky, December 2, 2003: Staff Sergeant Calvin Coats demonstrates camouflage paint application to members of the 101st Airborne Division.
John Sommers/Reuters

36. USS Abraham Lincoln, Arabian Sea, February 11, 2003: A weapons and ammunition handler sits on the wing of a fighter.
Adam Butler/AP Wide World Photos

37. Fort Benning, Georgia, January 6, 2003: Cody Sochocki, six, says good-bye to his father, Staff Sergeant John Sochocki, as the 3rd Brigade, 3rd Infantry, prepares to deploy to the Middle East.
Robin Trimarchi/*Columbus Ledger-Enquirer*/Corbis Sygma

38–39. Baghdad, February 6, 2003: An Iraqi fisherman prays by the Tigris River.
Bruno Stevens/Cosmos/Aurora

40–41. St. Petersburg, Russia, February 14, 2003: Russian matryoshka dolls on display.
Alexander Demianchuk/Reuters

42–43. New York, March 23, 2003: Demonstrators rally in Times Square in support of President Bush and American troops.
Susan Meiselas/Magnum Photos

44. (far left) New York, February 15, 2003: Antiwar march.
Diane Bondareff/AP Wide World Photos

44. (middle) Madrid, February 15, 2003: Antiwar march.
Paul White/AP Wide World Photos

44–45. Paris, February 15, 2003: Antiwar march.
Laurent Rebours/AP Wide World Photos

45. (middle) London, February 15, 2003: Antiwar march.
Andrew Parsons/AP Wide World Photos

45. (far right) Berlin, February 15, 2003: Antiwar march.
Jan Bauer/AP Wide World Photos

46. (top) Washington, D.C., January 18, 2003: Antiwar rally.
Jason Turner/AP Wide World Photos

46. (middle) Edinburgh, Scotland, February 14, 2003: An antiwar protester holds up a banner as British prime minister Tony Blair arrives at the Royal Infirmary.
Jeff J. Mitchell/Reuters

46. (bottom) Madras, India, February 14, 2003: Students at a rally aimed at promoting peace.
L. Anatha Krishan/Reuters

SADDAM HUSSEIN'S ART & PHOTO ALBUM

303. (top) *Baghdad, April 9, 2003:* U.S. Marines cover the face of a Saddam Hussein statue with an American flag.
Daily Mirror Gulf coverage/Mirrorpix

303. (middle) *Baghdad, April 9, 2003:* U.S. Marines prepare to pull down a statue of Saddam Hussein.
Ramzi Haidar/Agence France Presse

303. (bottom) *Baghdad, April 9, 2003:* U.S. Marines cover the face of a Saddam Hussein statue with a pre-1991 Iraqi flag.
Patrick Baz/Agence France Presse

304–305. (top) *Baghdad, April 9, 2003:* A forty-foot statue of Saddam Hussein is pulled down in Ferdowsi square.
APTN/AP Wide World Photos

304–305. (bottom) *Kerbala, Iraq, April 6, 2003:* Iraqi citizens and U.S. soldiers pull down a statue of Saddam Hussein.
Peter Andrews/Reuters

306–307. *Baghdad, April 9, 2003:* Iraqis destroy a statue of Saddam Hussein after it was pulled down by a U.S. armored vehicle.
Karim Sahib/Agence France Presse

308–309. *Baghdad, April 9, 2003:* Iraqis loot furniture while walking past a torn portrait of Saddam Hussein.
John Moore/AP Wide World Photos

310–311. *Basra, Iraq, April 9, 2003:* An Iraqi boy helps himself to sugar from a warehouse.
Jon Mills/AP Wide World Photos

312–313. *Outside of Basra, Iraq, April 9, 2003:* British troops cool down under an improvised shower.
Giles Penfold/Reuters

314–315. *Baghdad, April 10, 2003:* Iraqi women peek from their doorway at a U.S. Marine taking a break from patrolling.
Kuni Takahashi/*Boston Herald*/ReflexNews

316–317. *Basra, Iraq, April 10, 2003:* British officers meet with local Imams.
Mark Richards/*Daily Mail*/AP Wide World Photos

318–319. *Baghdad, April 8, 2003:* A1C Nick Taylor (left) and Specialist Bryan Slick play Ping-Pong during a day off at one of Saddam Hussein's palaces.
Sobhani/*San Antonio Express*/Zuma Press

320. *Baghdad, April 12, 2003:* U.S. Army armored vehicles pass a group of looters.
John Moore/AP Wide World Photos

321. *Mosul, Iraq, April 11, 2003:* An Iraqi boy collects money in front of a bank.
Joseph Barrak/Agence France Presse

322–323. *Baghdad, April 13, 2003:* Iraqi National Museum director Mushin Hasan amid the ruins of his museum, which was severely looted.
Mario Tama/Getty Images

324–325. *Baghdad: April 15, 2003:* The remains of Saddam Hussein's vintage car collection, which had been looted.
Hyoung Chang/*Denver Post*/Polaris

326–327. *Baghdad, April 12, 2003:* An Iraqi boy picks up bullet casings.
Olivier Coret/*In Visu*/Corbis

328–329. *Baghdad, April 10, 2003:* An Iraqi looter displays money notes taken from a downtown bank.
Laurent Rebours/AP Wide World Photos

330–331. *Baghdad, April 13, 2003:* Imam Hassin Abraham and elder Muslims speak with reporters in front of the Hassin Mosque.
Kuni Takahashi/*Boston Herald*/ReflexNews

332–333. *Baghdad, April 8, 2003:* PFC Mark Bennett fishes in a lake surrounding one of Saddam Hussein's palaces.
B. M. Sobhani/*San Antonio Express*/Zuma Press

334–335. *Baghdad, April 13, 2003:* An Iraqi looter takes stacks of china from the bomb blasted dome of Saddam Hussein's Al-Salam presidential palace.
David Guttenfelder/AP Wide World Photos

336–337. *Baghdad, April 14, 2003:* A painting taken from the tales of the *Thousand and One Nights* hangs in Uday's wing of Saddam Hussein's main presidential palace.
Ramzi Haidar/Agence France Presse

338–339. *Basra, Iraq, April 7, 2003:* Royal Marine Stuart Lawley stands in a corridor of one of Saddam Hussein's palaces.
PA Photos

340. *Baghdad, April 13, 2003:* U.S. Army Specialist David Buchanan poses in a huge chair in one of Saddam Hussein's palaces.
Romeo Gacad/Agence France Presse

341. Iraq's Most Wanted playing cards.
Command Central/Dept. of Defense

342–343. *Baghdad, April 12, 2003:* An Iraqi looter attempts to pull down a chandelier inside one of Saddam Hussein's palaces.
Kuni Takahashi/*Boston Herald*/ReflexNews

344–345. *Baghdad, April 10, 2003:* U.S. infantrywoman Felicia Harris on a bed in Uday's palace.
Mike Moore/Mirrorpix

346–347. *Baghdad, April 12, 2003:* An Iraqi looter takes a couch from an upper-class home.
Benjamin Lowy/Corbis

348–349. *Baghdad, April 16, 2003:* Iraqi looters take a break outside of Saddam Hussein's main presidential palace.
Christophe Calais/*In Visu*/Corbis

350–351. *Umm Qasr, Iraq, April 12, 2003:* A British soldier and an Iraqi girl speak in a classroom.
Graeme Robertson/Getty Images

352–353. *Baghdad, April 10, 2003:* U.S. infantrymen at the pool bar of Uday's palace.
Daily Mirror/Mirrorpix

354–355. *Baghdad, March 24, 2003:* Photos of U.S. POWs taken from Iraqi television after their convoy was ambushed near Nasiriyah, Iraq. They were later rescued.
AP Wide World Photos/Iraqi TV via APTN

356–357. *El Paso, Texas, April 19, 2003:* Former POWs Joseph Hudson (left) and Patrick Miller celebrate their return to America after landing at Fort Bliss.
Ellis Neel/Corbis

358–359. *Baghdad, April 12, 2003:* U.S. soldiers attend a memorial ceremony for six soldiers killed during combat operations.
Handout/Getty Images

360–361. *Baghdad, April 9, 2003:* Iraqis celebrate with a U.S. Marine during the fall of Baghdad.
Timothy Fadek/Polaris

362–363. *Baghdad, April 12, 2003:* An Iraqi man offers a carnation to U.S. Marine Sergeant Jose Acostavelo as his squad patrols a neighborhood in the capital.
Julie Jacobson/AP Wide World Photos

364–365. *Kirkuk, Northern Iraq, April 15, 2003:* An Iraqi man passes by a painted wall.
Patrick Barth/Getty Images

366–367. *Baghdad, April 14, 2003:* U.S. Army helicopters patrol the skies above Baghdad.
Jobard/SIPA